D0375915

By John Walker

Great American Paintings from Smibert to Bellows, 1729–1924
(with Macgill James)

Paintings from America

Bellini and Titian at Ferrara: A Study of Styles and Taste

The National Gallery of Art

A Pageant of Painting from the National Gallery of Art
(edited by John Walker and Huntington Cairns)

Self-Portrait with Donors: Confessions of an Art Collector

Self-Portrait
with
Donors

© KARSH, OTTAWA

Self-Portrait with Donors

Confessions of an Art Collector

JOHN WALKER

An Atlantic Monthly Press Book
Little, Brown and Company — Boston – Toronto

COPYRIGHT © 1969, 1970, 1971, 1972, 1974 BY JOHN WALKER
ALL RIGHTS RESERVED. NO PART OF THIS BOOK MAY BE REPRODUCED IN ANY
FORM OR BY ANY ELECTRONIC OR MECHANICAL MEANS INCLUDING INFOR-
MATION STORAGE AND RETRIEVAL SYSTEMS WITHOUT PERMISSION IN
WRITING FROM THE PUBLISHER, EXCEPT BY A REVIEWER WHO MAY QUOTE
BRIEF PASSAGES IN A REVIEW.

FIRST EDITION

T 10/74

Portions of this book have appeared in *Amerika, The Atlantic, Horizon,*
and *The Connoisseur.* Mr. and Mrs. Charles Wrightsman have granted
permission to use chapter 12, which appeared in *The Wrightsman Collec-
tion,* Volume V, copyright © 1973 by The Metropolitan Museum of Art,
distributed by the New York Graphic Society.

LIBRARY OF CONGRESS CATALOGING IN PUBLICATION DATA

Walker, John, Dec. 24, 1906–
 Self-portrait with donors.

 "An Atlantic Monthly Press book."
 1. Walker, John, Dec. 24, 1906– 2. Art — Collec-
tors and collecting — United States. 3. U. S. National
Gallery of Art. I. Title.
N856.W34 069'.9'70924 [B] 74-9511
ISBN 0-316-91803-2

ATLANTIC–LITTLE, BROWN BOOKS
ARE PUBLISHED BY
LITTLE, BROWN AND COMPANY
IN ASSOCIATION WITH
THE ATLANTIC MONTHLY PRESS

Designed by Milly Robinson

*Published simultaneously in Canada
by Little, Brown & Company (Canada) Limited*

PRINTED IN THE UNITED STATES OF AMERICA

c.2

To Marghie
with love

AUG 14 1975

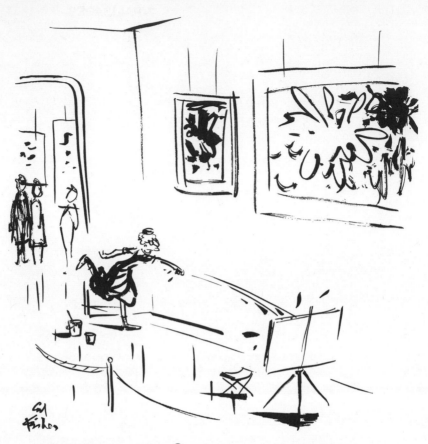

DRAWING BY ED FISHER. © 1973 THE NEW YORKER MAGAZINE, INC.

Acknowledgments

My pleasure in working on this book has been enhanced by the continued friendship and assistance of so many of those about whom I wrote. My special thanks go to Paul Mellon, who with his usual courtesy and wit reviewed the chapter on himself and his sister Ailsa; to Charles and Jayne Wrightsman, delightful subjects to write about, and delightfully sympathetic to my efforts; to Armand Hammer and his brother Victor, who provided me with photographs and detailed information on their eventful lives; and to my English colleagues, Francis Watson, John Pope-Hennessy, and Kenneth Clark, who accepted my affectionate portrayals of them with good-natured grace.

I am deeply indebted to Mary Dale for giving me access to new, unpublished material on her late husband; to Rollin van N. Hadley, Director of the Isabella Stewart Gardner Museum, Boston, for his helpful suggestions regarding the chapter on Mrs. Gardner; and to Mrs. Rush Kress and Mary Davis, Vice-President of the Kress Foundation, for photographs and additional facts relating to Sam and Rush Kress.

The book, I must add, would never have been completed without the assistance of Carolyn Wells, who typed and retyped the manuscript and endlessly checked facts and performed various types of research. But, much more important, she pointed out with immense tact what she thought worth including and what she felt should be left out.

Lastly, I want particularly to acknowledge the help I received from Edward Weeks, Consultant and Senior Editor of the Atlantic Monthly Press. Just before I retired he suggested I write a book of recollections, and then during the following four years constantly kept after me to do it. I cannot adequately express my gratitude for his encouragement and invaluable criticism. Lucky the author who has such an editor!

JOHN WALKER

Foreword

The greater part of my adult life has been spent collecting collectors who would, I hoped, become donors. This was my principal job as a museum curator and later as a museum director, positions I held for over thirty years. During those three decades I came to know the foibles, eccentricities, egotisms, and, let me emphasize, the judgment and charm of a number of very wealthy people. Their wealth, inherited or accumulated, made possible my career; and they, or amateurs like them, affected the lives of those four professionals, Bernard Berenson, Francis Watson, John Pope-Hennessy, and Kenneth Clark, to whom part of this book is devoted. All these diverse people have shared a common passion: the assembling of rare and beautiful objects.

Their desire to collect can be traced far back in history, for the ownership of objects considered precious is among the oldest and strongest of human instincts. Originally it was no more than the desire to possess what others value, but this possessive wish with time has evolved and become more discerning. The ancestors of the collectors in

this book can be found as early as the first Egyptian pharaohs, though collecting in the modern sense does not appear in the West until Hellenistic and Roman times. With the barbarian invasion of the Roman Empire artistic connoisseurship, acquired so slowly, vanished completely. The successor state, the Christian Church, became a different kind of collector. In the Middle Ages the ecclesiastical hierarchy became connoisseurs of the bones of saints, their garments, and the instruments of their martyrdom. Fortunately there were also a few more cultivated churchmen who collected ancient manuscripts and thus helped to keep alive the flickering light of culture.

With the dawn of the Renaissance, collectors with the refined taste of the Greeks and Romans reappeared. We find them in the person of such nobles as the Duc de Berry and Charles V of France, or in Italy among the popes and despots, who were continually competing for works of art.

Over the years tastes, interests, desires have constantly changed. The mutability of fashion has determined what is collected, why it is assembled, and where it is to be found. American collections, to take an example, have evolved in several stages. In the nineteenth century there was the short-lived and failed example of Jarves, who introduced us to Italian Primitives. Then there followed the influence of Mary Cassatt, who taught our collectors to buy the Impressionists. Next came the Steins, Gertrude and her brothers, and the Armory Show of 1913, which combined to make us appreciate such School of Paris painters as Modigliani, Matisse, Picasso, and Braque.

But it is hard to foresee the character collections will assume. Even fashions in Old Masters and antiques vary unpredictably. Wealthy Americans, for instance, have usually admired the British aristocracy even when critical of British institutions. This was particularly true at the beginning of this century when there was a strong desire, perhaps motivated by our colonial history, to reproduce in America the stately houses of England, both those in London and those in the country. This would lead one to suppose that the collections formed by American millionaires would resemble the works of art to be found at Chatsworth, Bridgewater House, or Petworth. Such a supposition would be wrong. What Morgan, Altman, Frick, the Wideners and others of their generation assembled — a medley of paintings, sculpture, Renaissance jewels, rock crystals, Chinese porcelains, faience ware, medals, small bronzes, enamels, tapestries, Medici chairs, Savonarola stools, Louis XV and XVI commodes and fauteuils — is much closer to the *Style Rothschild,*

to Mentmore and the Faubourg St. Honoré, than to the type of works of art brought back from the Grand Tour by English peers. Possibly these Rothschild houses were more accessible than ducal homes, or, what is more likely, the art dealers, whose influence on American collecting has been prodigious, accepted the taste of their Rothschild clients as the *beau idéal* of all collectors.

The *Style Rothschild*, however, had its progenitor, the Fourth Marquess of Hertford. He was an English peer so eccentric as to become a Francophile, and in Victorian times he assembled a collection which remains the model of that mixture of painting, sculpture, and the decorative arts associated with the Rothschilds. But no member of that distinguished family brought together works of art on a scale comparable to Lord Hertford. Some idea of the magnitude of his purchases can be seen today in the Wallace Collection in London. It was this museum which became the model for a generation of collectors on both sides of the Atlantic, and I have written at some length about it in the final chapter.

The emulators in this country of Lord Hertford — Morgan, Frick, the Wideners and others — provided many of the collections distinguishing American museums today. Their wealth drew a seemingly unending stream of works of art across the Atlantic. The reservoirs of Europe were still full, and through their sluices flowed a torrent of masterpieces. Now, however, export restrictions have closed the floodgates. Great works of art have continued to come to America, but the rate has changed from a cataract to a trickle.

Consequently collectors have found fewer and fewer opportunities to buy important Old Masters. They have turned instead to the Impressionists and Post-Impressionists. But with American wealth concentrated on the purchase of French painting produced by a few artists during half a century, their major works are no longer available and have been replaced by minor efforts. Gresham's Law that bad money drives out good applies equally to art. Second-rate productions lessen the aesthetic impact of supreme achievements. Yet with the disappearance of masterpieces mediocre examples have become ridiculously expensive. The irrational prices of the art market in recent years remind me of the tulip madness in seventeenth-century Holland, where a single bulb sometimes brought thousands of dollars, until one day horticultural connoisseurs decided fancy tulip bulbs were a bore. I wonder whether the overswollen bubble of Impressionism may not similarly burst.

Art collecting, however, is thought by many to be a prudent invest-ment. There are even mutual funds for speculation in art. The share-holders point to the steady rise in prices during the last two decades, and they also buttress their position by showing how supply, in their opinion, must always be less than demand. Their conclusions are logi-cal. For museums withdraw from sale a percentage of art objects, while at the same time, museum curators spend millions of dollars each year in a constantly narrowing market. In seventeenth-century Holland one could have grown more tulips, but one cannot produce more Gior-giones, Vermeers, Watteaus, or Seurats. The owners of mutual funds in art believe scarcity will always assure rising prices. But the Metropoli-tan Museum has recently *deaccessioned* (what an absurd euphemism!) and sold a number of important and beautiful works of art. If this practice is followed by other museums, the argument of scarcity may seem less impressive.

But there are certain other assumptions underlying this theory of scarcity which might be questioned. The most basic is that museums will remain the same. There is, however, persuasive evidence that their role in society is changing. Their search for "relevance," a term its proponents never clearly define, is symptomatic. The desire to be con-sidered "relevant," vague as it is, seems to denote fewer funds for col-lecting and more for social purposes. I fervently hope my colleagues will regain faith in their original mission, which once was to assemble and to exhibit masterpieces. Although this is a subject I shall discuss at length, I must insert here my firm belief that galleries for art are as important to a community as auditoriums for music, and that giving visual delight in an art museum is just as valid as offering auditory pleasure in an opera house or a concert hall. If museum directors would accept this analogy they would put aside much of their dubiety and self-reproach.

Nevertheless some uncertainty about their role in our culture would remain. One reason for misgiving is that recently museums have lost an important function. They are no longer the training school for future artists. When one reads about the passionate desire of the Impression-ists, and even the Post-Impressionists, to study in the Louvre, of the Pre-Raphaelites in the National Gallery, of the Nazarenes in the Italian museums, one realizes that contemporary art is not rooted in the past in the same way. Even thirty years ago, when I came to the National Gallery of Art, there were painters educating themselves by copying. Their number was larger elsewhere, at the Metropolitan, the Boston

Museum, the Chicago Art Institute. Today virtually no one trains himself in this way. For years I have not seen a copyist in the National Gallery learning to paint. (Figure 1 is, I believe, a graphic explanation!) Modern painting appears to be cut off from the tradition of Western art, and artists themselves to have grown hostile to the repositories of this tradition.

Will their altered attitude change the focus of museum collecting? Will an enthusiasm for the Old Masters diminish? Fashion, always closely related to contemporary creativity, may shift. The purchases made by museums may be increasingly the work of living artists. All this represents a possibility, remote I admit, but one that the organizers of mutual funds seem to have overlooked.

There is another contingency they may also have disregarded. A market limited in opportunities may chill the interest of buyers, which in turn may lead to a decline in values. This has not yet happened, and prices are still rising spectacularly. But I have begun to notice a slight apathy toward certain schools of the Old Masters. The market is sluggish in the field of early Italian painting, work of the thirteenth, fourteenth, and fifteenth centuries. It is only when a picture of the importance of Leonardo's portrait of Ginevra de' Benci is available that a price commensurate with its rarity is reached. As collectors become indifferent, so does the public, for it is the predilections of collectors which determine popular taste. The Early Italian rooms in the National Gallery of Art and the Metropolitan Museum are the least visited of all.

Furthermore one should recall that even in our times the valuations of works of art have fluctuated tremendously. Take for example the Widener Collection. When it was designated in 1940 for the National Gallery by Joseph Widener, it was necessary to have an immediate appraisal for tax purposes. From documents in the Gallery's archive it is evident that the two Wideners, father and son, spent roughly twenty-five million dollars on their works of art, but the federal government's appraisal of the collection amounted to $3,877,010; the Commonwealth of Pennsylvania's was $7,141,060; and the valuation of the appraiser appointed by the National Gallery came to $4,953,060. Thus between the time these paintings, sculptures, and examples of the decorative arts were bought, a period covering the first quarter of this century when the value of money was far higher than in 1940, the worth of the collection declined over two-thirds in the opinion of three independent appraisers. Today I feel sure the same appraisers would place a valua-

tion of between one hundred and two hundred million dollars on the same works of art. But can one be sure a similar decline may not occur again?

Though the number of collectors has not diminished, there are fewer and fewer who are willing to devote time and money to the search for supreme masterpieces. To find such works of art today one must have determination, diligence, and discrimination. But how much easier was such a quest in the past! Take for example Andrew Mellon, the last American collector with almost unlimited opportunities. Of the three qualities that I have mentioned, he needed only one, discrimination. His entire collection was bought from only two dealers, Knoedler and Company, and Duveen Brothers. They brought him the greatest masterpieces they could acquire, knowing that what he rejected others would buy. Museums like the Hermitage in Leningrad and the Kaiser Friedrich Museum in Berlin were parting with some of their treasures. Thus, his two agents could propose purchases not only from their own stock, but also from several of the world's greatest art galleries. Inheritance taxes had forced the British nobility to sacrifice many of their artistic possessions, and England still had no export restrictions. The Golden Apples of the Hesperides were lying everywhere, only waiting to be gathered by the dealers and offered to Andrew Mellon. The same situation had existed during the first quarter of the century. The Wideners, Henry Clay Frick, Benjamin Altman, J. P. Morgan, and others needed only wealth and good judgment to fill their houses with masterpieces.

Collecting today requires far more of those other two qualities: determination and diligence. The ranks of the dealers in Old Masters, for instance, have been sadly thinned; and auction houses have become magnets attracting private collectors as never before. But to go on a specific day and hour to Sotheby's or Christie's, or even to commission an agent to bid, is more troublesome and uncertain than ordering pictures on approval for a leisurely inspection at home, the usual procedure with dealers. From the museum's point of view also this shift from the art dealer to the art auction has certain disadvantages, which I discuss on page 41. But apart from these drawbacks it is also to dealers that we often owe the education of collectors — instruction naturally motivated by self-interest. Furthermore, although the curator or director may locate the work of art, induce the prospective donor to look at it, use what eloquence he possesses on its behalf, in the end it is frequently the subtle persuasion of the salesman, his handling of his client, that clinches the final transaction. Sometimes the deal is consum-

mated only after a long period of bargaining, with the price decreasing as a result of argument, pretended indifference, procrastination, indecisiveness; and who can say that part of the satisfaction of the purchaser does not come from these protracted negotiations. Many great works of art in our public galleries are there, I believe, because donors have enjoyed this fascinating game. How much less pleasant it is in today's tight market to overbid at auction, as one often does, carried away by the fever of competition; or, in desperation, having failed to acquire the coveted treasure, to seek out private owners, generally with some embarrassment, hoping when possible to anticipate and outbid others equally covetous.

With all these impediments, why do collectors continue to search for and to acquire great and noble works of art? There are many inducements. There is the excitement of the chase; there is the prestige of ownership; there is the intrinsic joy of looking at beautiful objects; and, though perhaps an illusion, there is the security of investment in an inflationary period. But at least in America, there is a deeper motive, one that only a cynic would ignore. I believe a fundamental incentive is the desire to add to the cultural heritage of this country through the enrichment of our museums. American collections remain private for only one generation. In the United States, it is axiomatic that the undertaker and the museum director arrive almost simultaneously!

ii

A question I am constantly asked is, "If the market in Impressionism and Post-Impressionism is overvalued and if there is a scarcity of Old Masters, what paintings should I collect?" The answer is obvious; collect where there is unlimited supply, collect contemporary paintings. When I have bought pictures myself, using my own money and not Other People's, I have usually purchased the work of living painters. I find it exciting to bet on a young and undiscovered artist, to know that my backing may help him, to hope that some day he may win the Grand Prix, whatever that may be. In my early twenties I bought the work of the German Expressionists: Beckman, Heckel, Otto Mueller, Nolde and the rest. At the time they were virtually unknown outside Germany. Later I acquired Eugene Berman, Morris Graves, Walter Stein, William Walton, John Chumley, Lilly Emmet, Raphael Soyer

and others. Some of these artists have had extraordinary success, some are what Chester Dale used to call "sleepers," a Wall Street term applied to firms with assets way above the market value of their stock. I feel sure, however, my "sleepers" will some day achieve the recognition they deserve.

But having given this answer there immediately follows a plaintive, "It's all very well to say what you have bought, but how am *I* to know which artists to buy?" And this, I admit, is the difficulty. Take courage, however. For in terms of money the reward of a discerning eye is fantastic, but the punishment of poor judgment is reasonable. Here are two examples. In 1875 Renoir, along with Sisley and Berthe Morisot, decided to hold an auction at the Hôtel Drouot. As Renoir later lamented to Ambroise Vollard, "After the auction was over the expenses had not been covered; we actually owed money to the auctioneers. A certain Monsieur Hazard had the courage to bid one of my pictures, a *Pont Neuf*, up to three hundred francs [roughly $75.00]. But nobody followed his example." Nearly a hundred years later the value of the *Pont Neuf*, which I persuaded Ailsa Bruce to buy, had risen to $1,500,000. At about the time of Renoir's auction an American collector paid 300,000 francs (roughly $75,000) for Meissonier's *Friedland 1807*, an instance of atrocious judgment. Nevertheless, if he sold the picture today, he would probably get almost that amount. Thus at only a slight risk it seems evident that the best hedge against inflation is an investment in the right painters. But the discovery of the "right" artists of one's time, while they are still unknown, requires taste, insight, and a strong element of luck. Certain guidelines, however, may be useful.

1. Collect when you are young. By the time you are fifty a new generation has replaced the painters and sculptors admired thirty years earlier. But we all tend to see with the eyes of our own generation, and with this handicap after a certain age you will probably fail to perceive the new movement. The difficulty is that when young one rarely has money. I know of only one solution to this dilemma: put faith in some youth, an art lover with a perceptive instinct, a subject I shall revert to on page 27.

2. Watch the museums. They are the tastemakers. But often the taste they make is ephemeral. You cannot rely on them too much. They have been mistaken so often in the past that when museum professionals begin to promote an artist or a movement it is wise to sell out, for you have reached the top of the market — a reaction is bound to follow.

3. Read the art critics. Although they often try to further the reputation of friends, they are apt to be more perspicacious than curators.

4. Beware of fashionable artists, young or old. The coming generation will be determined to destroy them.

5. Spend time in studios. Get to know the painters or sculptors whose work you like. They may introduce you to the circle of their friends. If you are lucky you will hear the best art criticism of all. From them you may gain an insight into the coming movement. You may anticipate curators, critics, and dealers. Then if financial gain is your object speculate heavily.

But above all acquire only what you yourself love. This is the basic law of wise collecting. Have faith in your own predilections. Back your own judgment. Blessed are they who say "I don't know anything about art, but I know what I like," for they may inherit taste. Blighted are those who know all about art but don't like anything, for they will never collect at all.

Contents

Illustrations

Self-Portrait with Donors

1

Learning to Use
Other People's Money

It is not true, as some say, that the rich are usually unhappy. I have spent my life with them, and I have found their quotient of happiness to be very high. They have, however, a problem: what to do with their money. As a museum professional for over thirty years I have helped a number of them reach a solution. In doing so I have had the pleasure of becoming a collector of supreme works of art — not a private collector in the technical sense, though like most museum directors I have looked upon the collection in my charge as my own, but a collector with resources far beyond my wildest dreams. Buying paintings and sculpture with Other People's Money has been the greatest joy imaginable.

A question often asked of museum directors and curators is, do you paint yourself? I usually answer that I used to paint when I was in college. But in fact even then I could not draw a straight line. When a hostess hands me a paper and pencil and tries to involve me in a parlor game requiring the most elementary draftsmanship, I turn green and

ask to be taken home. My deficiency, given my profession, embarrasses me; but there is no reason why it should. Museum directors are buyers, not manufacturers, of art.

Nevertheless, I often tell people that in retirement I intend to begin painting again. I once said this to a delightful British diplomat. He replied that he had similar plans and what was I going to paint? I mentioned landscapes and asked him the same question. He said, "Nudes!" Perhaps after all I *shall* try my hand with the brushes.

An only child, I grew up with a normal boy's passion for football, baseball, and skiing. The last sport, with few American adherents at the time, I owed to a Swiss tutor who was my constant companion when I was ten and eleven. My mother and father were separated, and while I passed back and forth between them my peripatetic education continued under his guidance. I was made to speak French, which has proved useful in my profession, but I now accept that I have no ear for languages. My French is as atrocious as my German and Italian. I once knew a charming Austrian countess who said to me in despair as I sputtered in German, "John, the world is divided between polyglots and glots. You are a glot!" As a paying guest in families in Germany, Austria, and Italy, I struggled to rise from glot to polyglot, but all my efforts ended in failure, not total but embarrassingly close.

Though the product of a broken home, I have had few abnormal or criminal impulses, and I am skeptical of the sociological dogma that the lack of united families explains most of our crimes. Adjusting from one parent to the other is an education in itself, and like many educational experiences fraught with difficulties and unpleasantnesses. But in my case there was at least one compensation. I received a generous allowance from both sides of the family. This I neither questioned nor tried to explain. To this day I do not know whether my mother's brother, or my father's father, my two sources of funds, knew that I was receiving double payment. Anyway, it was the beginning of my training in the use of Other People's Money.

I was for my age excessively affluent, but in other respects I was excessively normal. At thirteen, however, my normality received a blow. I fell ill. In the Adirondacks during the summer of 1919 I suddenly came down with infantile paralysis. "Came down" is an expressive phrase which is literally true in my case. I remember walking one evening from my bed to the bathroom and repeatedly falling down. I thought not being able to walk hilarious. I called gaily to Mother to come and see what was happening. I had been perfectly well until then

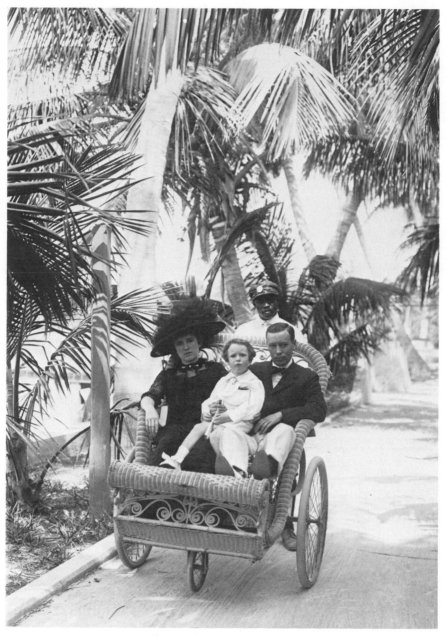

Mother, Father and myself at Palm Beach just before I became the product of a broken home.

and had spent the early evening playing a game which consisted of carrying a boy on one's back. His objective was to pull his opponent from the back of another boy. I remember the damp chill of that evening, and I have often wondered whether there was some causal relationship of dew and evening mists with this mysterious disease, which medicine has nearly stamped out without knowing exactly how it is transmitted.

When the local doctor recognized that I was very ill indeed, though he could not diagnose the illness, he urged Mother to get me back to Pittsburgh as quickly as possible. She arranged for a private car to be added to the night train for New York, where one changed from the New York Central to the Pennsylvania Railroad for the rest of the trip home. On arriving in New York, however, I was much worse. As my family always stayed at the Biltmore Hotel, which could be reached from the Grand Central Terminal by an underground corridor, I was taken there at once. More doctors were summoned. Their diagnosis was poliomyelitis, a disease which two years later was to strike Franklin D. Roosevelt.

It was extraordinary that we were permitted to remain at a hotel, incredible that I wasn't sent to a hospital for infectious diseases. But little was known of infantile paralysis, and the Biltmore manager agreed we could stay provided we repainted our suite. No guests were allowed in rooms adjacent to ours lest germs somehow penetrate the walls. I remember that all who entered my room wore gauze masks, and that for some inane reason cheesecloth was put over the windows, to keep the germs from flying out, I suppose.

I did not want to die, but every night I expected to. Encased in a cast, contrary to modern therapy, my aches and pains probably caused me to exaggerate the chances of my demise. In spite of my fears I shook off the disease, which left my body unimpaired except for one leg which was partially paralyzed. This feeble and atrophied leg, however, meant an end to football and baseball, and I still remember a sense of desolation as I viewed my bleak future without athletics. I could not foresee that my paralyzed leg would be an advantage, keeping me happily out of the perils and hardships of the army and at home during World War Two. I now feel that infantile paralysis was the most rewarding and beneficial occurrence in a life marked by good fortune.

Not only did it safeguard me from the dangers and discomforts of the military, but it also basically gave me my career. I had to live in New York for two years. Between endless and tedious sessions of therapy, I

had nothing to do; and having been born in another city, no friends to be idle with. Where in New York could one go in a wheelchair or on crutches? Mother used to take me up and down Fifth Avenue in an open barouche. I am one of the few people to have been driven around New York day after day in his pajamas. But when I could dress, there were a limited number of places to go, especially pleasant places. Mother suggested the Metropolitan Museum. She respected art and hoped I would come to like it. I had no particular interest, but I had an inquisitive mind, and I was bored.

When she pushed me into the Metropolitan I was a disgruntled child. To my surprise I experienced my first joy since my illness. It was not the beauty of the works of art I found exhilarating; it was the endless corridors where I could wheel myself about and enjoy the illusion of mobility. Those were the days before museum directors boosted their attendance by bringing in thousands of schoolchildren. On weekdays I would be there more or less alone, and there was nothing to tarnish the excitement of discovery. My curiosity about the works of art became increasingly intense, and the only way I could satisfy it was to read serious handbooks. I started with the classical collection, and I was soon enthralled by the mysteries of archaeology and dazzled by the splendor of the ancient world. All my tedium and loneliness vanished. I had found my profession. I wanted to be a curator. A boy who knows what he wants to do before he goes to college has an immense advantage.

I pushed myself from the classical collection to the collection of paintings. They were even more enthralling. I found I could imagine myself a part of the scenes which attracted me, envisage myself partici-pating in the life of fifteenth-century Flanders or seventeenth-century Holland. I had my first love affair, my first romance with a two-dimensional lady. My devotion has continued over the years. She is a blond girl in an Empire dress seated beside a window, the pane of which is cracked, and she looks at the spectator — me. I was shocked when a heartless curator of the Metropolitan downgraded my favorite by removing her from the oeuvre of a superb painter, Jacques-Louis David, to the work of a minor woman artist, Constance Marie Charpentier. I accept that there is documentation to justify this descent in the social scale, but I still believe my first love must have been painted by a greater master.

The advantage of a wheelchair is that one can sit and dream without physical weariness. It is much more difficult to walk into a painted Arcadia or follow a painted road across painted meadows under a

painted sky if your back and legs ache. Empathy is basic in my aesthetic belief, and I find it hard to identify myself with a place or a person when I am upright. For me, being seated is essential.

The ideal way to visit a museum is in a wheelchair. I insisted when the National Gallery opened that we purchase a large supply, and I tried to persuade our visitors to use them regardless of physical incapacity. My success was minimal. The wheelchairs were free, but they remained unused. I suppose it takes moral fortitude to get into one. There is always the chance that friends will spread the rumor that so-and-so won't be with us long. There he was at the National Gallery of Art in a wheelchair and only the other day he seemed perfectly well. Many years later, when I did a national television broadcast on the Gallery, I put in my usual plea for a wheelchair visitation of museums. The next day the guards were overwhelmed by demands. The administrator telephoned me that there was a crisis. The public was asking for something I had recommended which we couldn't provide. I inquired about the scores of wheelchairs I had had purchased a quarter of a century earlier, and was told that they had rusted away. We sent out and bought every available wheelchair in Washington. Then the demand ceased as abruptly as it had begun. It is a subject I never subsequently enjoyed discussing with the administrator. But I still believe a wheelchair offers the best and most relaxed method of visiting an art gallery.

ii

After two years in New York hotels Mother and I returned to Pittsburgh. My family on both sides had lived there for over a century. The Walkers had come from Scotland in my great-grandfather's time and had done well in soap, in bricks for blast furnaces and steel mills, and finally in steel itself. My mother's side of the family had come to America before the Revolution and had settled in West Chester and Hagerstown, Pennsylvania. They had pushed westward, bringing their family possessions across the Alleghenies. They too had prospered. My grandfather Friend owned a half interest in a blast furnace almost in the center of Pittsburgh. Because of its location we could proudly say or blushingly admit that it contributed as much soot to the city as the great Homestead Mills farther up the Monongahela River.

When I was young we had never heard of air pollution. Everyone in

Pittsburgh inhaled the smoke-filled atmosphere. Yet longevity was common. My grandfather Walker died at eighty-three, his wife at ninety-six. A close friend of the family's at ninety bought a Rolls-Royce, saying he wanted a car that would last a lifetime. He enjoyed it for nine years more. Considering that the air we breathed was more polluted with coal dust, sulphuric acid gasses, gasoline fumes, et cetera, than probably any air in the world, Pittsburghers of my generation are understandably skeptical about the terrible effects of air pollution. Perhaps nature provided us with special lungs. We managed to survive.

At night we put cheesecloth over the windows to keep out the larger flakes of soot, and we covered with sheets every piece of furniture. Otherwise in the morning one's pillow was covered with cinders, and the chintzes lasted at most a single season. In this dirt-filled city cleanliness was an obsession. Maids toiled away, continually dusting and scrubbing, and rooms were repainted and redecorated almost annually. Money was easy to make but a large percentage went to the war against grime.

Floods from the Allegheny and Monongahela rivers were endemic. The resultant damp caused my grandmother Friend to become totally deaf, or so her deafness was diagnosed. Grandfather, who seems to have felt some unexplained guilt for her loss of hearing, spent his life, as did one of her sons who never married, trying to make her happy. Each Sunday evening the entire family dined together, and we were never allowed an animated conversation for fear my grandmother would think we were quarreling.

Grandfather, under the misapprehension that his wife might enjoy being on the water, bought a seagoing yacht; but such was her terror of drowning that she would never allow him to cruise anywhere but on the St. Lawrence River. She was particularly fearful of fire, and this caused my grandfather to build the most completely fireproof house erected up to that time, the first years of the twentieth century. It was constructed entirely of brick, tile, and steel. In appearance it seemed a massive cube of terra-cotta, broken with windows and porticoes. In front there was a porch sustained by tile columns, and on the side a porte-cochere with similar pillars. The house itself was built of a peculiarly nasty color of brown brick manufactured by my father's concern. I suppose if asked the architect would have designated the style as "modern." It certainly derived from nothing in the past, nor have I seen another house quite like it.

The interior resembled an expensive men's club, which was probably

my grandfather's inspiration. The rooms were paneled in mahogany, oak, or walnut. The carpets were so thick that I could have fallen from the second floor without injury. The curtains were of velvet, dark brown in the living room, dark red on the stairs. The furniture was bought from antique dealers whose cheating became less outrageous as my mother and my aunt became more knowledgeable. The less said about the paintings they collected the better. Fritz Thaulow and Aston Knight were their favorites.

After my mother and father separated I spent much of my youth in this unedifying but luxurious edifice. My favorite room was the library. It was small, lined with heavily carved Circassian walnut bookcases, above which was cut velvet running to an elaborately stuccoed ceiling. If one made a great effort the room could be shut off from the rest of the house by sliding doors that disappeared into the walls.

This was my sanctuary. Seated on a velvet-covered chair, and under a standing lamp of massive silver gilt, warmed by a gas fire flickering from tiny holes in artificial logs, I read passionately and omnivorously. I was not the only person who took the books out from behind the leaded glass. There were several maids who were endlessly dusting each volume, and from time to time oiling the bindings. Roman numerals were beyond their comprehension, and the order of the books was always chaotic.

These leather-bound sets of the standard authors were status symbols. My family collected them and thus perhaps implanted the seed of collecting in me. They were bought by the foot from itinerant booksellers, figures of fun in those days but nevertheless effective salesmen. My aunt, who had a larger library than my grandmother, had a guilt complex about her unread books. Though she never glanced at a word she cut all the pages.

Cultural snobbism has changed, and these ready-made libraries have disappeared. Today the art dealer has supplanted the bookseller. Instead of buying the standard authors, people now buy the standard painters, and shelves of Thackeray, Dickens, and Jane Austen have been replaced by walls of Monets, Renoirs, and Sisleys. With fewer servants to dust and oil, canvases have proved more practical, easier than books to maintain, and also they have risen in value whereas the standard authors have proved a dead loss. For the moderately affluent there is a further advantage. In small houses and apartments even a single Abstract Expressionist canvas over the fireplace is a cultural diploma, rendering space-consuming bookcases unnecessary. A sophisticated and cultured

way of life can be further emphasized by a few picture books on the coffee table.

When I was growing up there were no art collections of significance in Pittsburgh, though paradoxically two of the greatest collectors America has produced, Henry Clay Frick and Andrew W. Mellon, were Pittsburghers and made their fortunes there. But both used the atmosphere of Pittsburgh as a major reason to remove their works of art, one to New York, the other to Washington. Today one wonders how valid this reason was. The Old Masters left by Mr. Frick in his house in Pittsburgh have survived the smoke of the steel mills as well as anything in his air-conditioned gallery in New York; and ironically, due to rigidly enforced smoke control, Pittsburgh is now cleaner than Manhattan or the capital.

I was always fascinated by the beauty of Pittsburgh. I went often to our blast furnace to watch the molten iron flow into molds known as "pigs." The red light on the sweating workmen, the sparks flying in all directions, the thunderous noise of the cranes, all are a part of my youthful memories. From our garden terrace overlooking the city, we could see the sky illumined every night by Bessemer Converters as they turned iron to steel. The flickering orange light seemed evidence of a distant conflagration, and the fireflies on summer evenings were like the sparks from a burning city.

Once in the middle of the night our blast furnace collapsed. Molten iron flowed down a main street. No one, miraculously, was hurt, but an avenue of glowing pig iron was a marvelous sight. The metal soon solidified, and in cleaning up the mess the Friend family nearly went bankrupt. Eventually the real estate became more valuable than the furnace which occupied it, and the property was sold to an expanding railroad, luckily just before the Depression.

My grandfather Friend collected blast furnaces, coal mines, coke ovens, and banks, and worked himself to an early death. His assets were considerably eroded by the efforts of my grandmother's family to continue her yacht, her gardeners, and her domestic staff. Grandfather Walker, on the other hand, retired in his thirties, and his collection of stocks and bonds lasted on the whole rather better. Unfortunately, he tired of this form of collecting too early, and though he enjoyed spending the rest of his life collecting first editions and reading them, his family felt a certain resentment that his collection of securities was not more complete. But Grandfather insisted he had made enough money. He was at the time a minor partner of Andrew Carnegie. His wife's

brother, Henry Phipps, was a more important member of the firm. The
two men quarreled, and Grandfather, recognizing that he would never
make as many millions of dollars as his brother-in-law, gave up the
competition. For fifty more years he lived off his income and passed his
time happily reading, fishing, and gardening.

By Pittsburgh standards this was madly eccentric. But Grandfather
shocked the community in other ways. He had read Adam Smith and
been converted to Free Trade. He therefore voted the Democratic ticket
in a city where everyone of wealth was Republican. In 1920 his vote for
President went to Eugene Debs, the Socialist. Asked why he had done
anything so idiotic and contrary to his interests, he replied that Debs
was unjustly serving a jail term as a conscientious objector, and that
there was no other way to get him out of jail except by electing him to
the White House.

In the summers Grandfather went to his island in Canada where he
grew every variety of rose in his rock gardens, which were surrounded
by forests of silver birch and pine. Every day except Sunday he would
go fishing for small-mouth black bass and an occasional lake trout in a
steam launch accompanied by a guide, two boatmen, and usually a
grumbling grandson. The grumbles were to some extent justified. Dis-
embarking from the launch, we were rowed to the fishing grounds.
Grandfather lolled in a padded seat in the stern, and the guide with a
back to rest against sat comfortably in the bow, but the grandson had to
sit bolt upright for six hours, on a thwart in the center of the rowboat,
without even a cushion. It was good training for the time I was later to
spend sitting on museum benches; but I still remember what a welcome
break it was when we returned for luncheon and a padded chair in the
launch.

In the winter Grandfather returned to his large, late-Victorian house
in Allegheny. There he read from morning to night, continuing to shock
Pittsburgh by his indifference to business. His daily regime was equally
odd. He decided that two meals a day were enough for anyone and that
breakfast and lunch were the most desirable. Omitting dinner, he went
to bed at seven and rose at three. This gave him four or five hours of
solitude and reduced the time he was apt to see my grandmother, whose
conventionality and religiosity irritated him.

He loved his library, in his day I believe the largest private library in
Pittsburgh. It was carefully catalogued and housed in an imposing L-
shaped room, the walls of which were covered with mahogany book-

Grandfather Friend, the col-
lector of blast furnaces, coal
mines, coke ovens, and books,
who worked himself to an early
death.

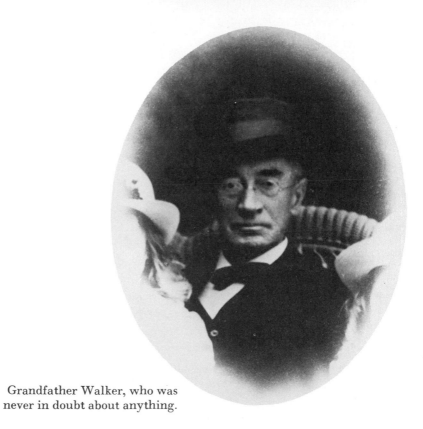

Grandfather Walker, who was
never in doubt about anything.

cases. The furniture was derived from designs by William Morris, and Morris wallpaper covered the space between bookcases and ceiling. The lamps and chandeliers all came from Tiffany's. Thus the room had a certain beauty rare in Pittsburgh interiors. After Grandfather's death the books and furnishings were given to a local college where their setting is still preserved.

When Grandfather was in his late seventies an enormous gas tank directly behind his house exploded. I rushed to see whether he had survived, because a number of people were killed. All the windows were blown out and servants were sweeping up glass. But there was Grandfather in his usual chair, covered with soot, wearing an overcoat and a hat, reading as usual. I asked him how he was. He replied he never felt better. He looked forward with intense pleasure, he said, to suing the gas company, and he knew the joy of the suit would add years to his life. It did and he won a tremendous settlement.

Grandfather looked upon himself as an agnostic. But as he was never in doubt about anything, he could more accurately be described as an atheist. He was haunted by the thought that my grandmother, who was to his disgust forever entertaining Presbyterian ministers, would claim that he had been converted on his deathbed. When at eighty-three he became desperately ill, I was in Florence. I left immediately and caught the first steamer home. When I arrived it was evident Grandfather had only a short time to live. He reached out his hand, looked at me, and said, "John, death ends all." Whereupon he turned to the wall and never spoke again.

Atheists were rare in Pittsburgh. The leading families were with few exceptions Presbyterian. Most of them had pews in the First Presbyterian Church where the minister was a fat, hard-drinking clubman everyone knew. He had married into one of the great steel families and thus formed part of the local aristocracy. On Sunday morning after a late night at the Pittsburgh Club it was impressive to listen to him hurling thunderous anathemas and pounding his pulpit as he addressed his companions of the preceding evening, who were sitting in their family pews with their wives, their children, and their hangovers.

There was a scattering of Episcopalians, who were socially respectable but not very influential. As a boy I knew no Methodists, Baptists, or Jews. I had a few Catholic friends who were very dear to me, but not until much later were they intimate with my family. When Mother became a Christian Scientist her friends looked upon her conversion as bizarre but not shocking. When I became a Catholic my relatives were

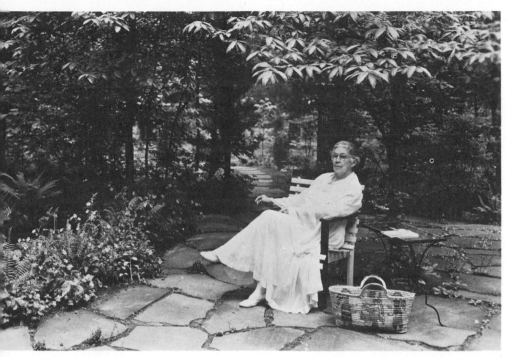

Grandmother Walker, who was forever entertaining Presbyterian ministers.

stunned. Catholicism in Pittsburgh no longer bears the social stigma it once did — too many children of the early Pittsburgh families have married Catholics — but rich Catholics are still rare.

To become rich in Pittsburgh was relatively easy, provided one arrived before 1850 and one was of Scotch or of Scotch-Irish ancestry. Like the Jews, the Scotch created capital by mutual trust. Scotch bankers made loans to Scotch industrialists backed more by good faith than collateral, which was in short supply; and in an expanding economy the loans were almost invariably repaid. The availability of credit made possible the fortunes of Tom and Andrew Carnegie, Henry Phipps, Henry Clay Frick (one of the few non-Scots), Judge Mellon, and his sons Andrew and Richard. These men found a nation of wood and left it of steel and aluminum.

They were the dukes of a rigorously stratified society, which they established toward the end of the nineteenth century and which lasted until the Depression. The less wealthy members of the other steel families, the Olivers, the Chalfants, the Byers, the Laughlins, were a gayer group and represented the earls, viscounts, and barons. It was a

distorted reflection of the older societies of Europe. In two generations it collapsed completely.

My father and mother were a part of this local hierarchy, which was organized around clubs. In the East End, where we frequently lived, to belong to the Pittsburgh Golf Club was essential. It was housed in a Palladian wooden building located on the edge of Schenley Park. The golf course itself, though used exclusively by members, was actually on public property; but no one found this surprising, for in the feudal society of my youth the right of the rich to arrogate public lands was taken for granted. Besides, it was argued that the only day working people could play golf was on Sunday, and in a Presbyterian community like ours sport on the Sabbath was contrary to God's Commandments — at least for the poor! During the New Deal the Pittsburgh Golf Club was deprived of its links, which were then opened to the public. The club still remains, less exclusive than formerly, but available for meals and coming-out parties.

Periodically we lived in Sewickley, a more remote and more beautiful suburb in the hills to the east of the Ohio River; and the Allegheny Country Club, which in those days had an even longer waiting list than the Golf Club, was the center of social life. Soon after it was founded, toward the end of the nineteenth century, father was elected to the House Committee. He chose as his special endeavor the landscaping of the grounds. He was responsible for planting the lovely alley of pines that still leads to the clubhouse, and he was often to be seen hovering around his baby conifers with a watering can and a wheelbarrow of manure. The other members laughed at him, but his attention to husbandry was not disinterested. He had bet a friend ten thousand dollars he could make those damned trees grow. It was one of the few bets he ever won.

Father went to Princeton, but he was expelled. He and some friends had managed to get a cow up the stairs of the president's house and out on the roof. They knew a cow would go up steps but not down. A derrick was needed to remove the president's unwanted guest. Father perforce returned to Pittsburgh and started to work for Harbison Walker, a family firm which sold fire brick to blast furnaces. He soon established his own company, made a good deal of money, which he immediately spent, and then retired, but without assembling his father's collection of securities. When World War One broke out, he joined the Red Cross and had a distinguished and bemedaled career driving a Ford ambulance, rather like Ernest Hemingway.

But he really preferred a sedentary life with a whiskey and soda close at hand. This enjoyable existence took place chiefly at the Pittsburgh Club where, I am told, he was one of the most popular members. It was the small, fashionable gathering place of the more sophisticated men-about-town. The clubhouse was a beautiful Federal building in a former residential area, which had become the business district. In Pittsburgh it was customary for the top executives, most of whom had inherited their wealth, to leave their offices between half past three and four; and Father, having spent the morning reading the newspapers, would join them for backgammon, bridge, billiards, and alcohol. By the time he came home to dinner his gaiety and charm, which his companions found irresistible, were pretty well spent — or so my mother thought. They ultimately divorced, which was unusual at the time. But he remained my hero. When he died I was seventeen. He left me all he had: a Patek Phillipe watch with my mother's picture in it, and a silver cocktail shaker.

Eventually his friends, the inheritors of the steel and coal companies, were replaced by abler and more energetic executives; and the large Duquesne Club, considered by Father's group insufficiently exclusive, took over. The hard-drinking members of the Pittsburgh Club, on the other hand, died off, mostly of cirrhosis of the liver; and their handsome clubhouse had to be sold. The remnant of the membership for a time shared rooms in a hotel with the Junior League. Thus did our Proustian society finally disintegrate!

Mother's character was unsuited to Father's gay, cynical, very masculine temperament. She was sensitive and idealistic. Above all, she was intensely maternal. My infantile paralysis proved a more shattering experience for her than it did for me. Although a Christian Scientist, she called in the best doctors in New York (as well as the best Christian Science practitioners). When I could walk, perhaps because of her Christian Science, she insisted, against the advice of several doctors, that I should not wear a brace. Her decision proved right, and urged on by her remarkable determination I learned to dance and to play golf.

She also taught me to play bridge, and I vividly recall, when I was fourteen, playing as her partner for high stakes. As we were not rich, winning was important, and the peak of my ability at the bridge table was reached in extreme youth. Since then there has been a gradual decline, which with age has accelerated.

Although Mother was a gambler, this was her only vice. For the rest she believed in the finer things of life, which Father laughed at. These

values she wished to pass on to me. My exaggerated compliance with her wishes proved a bitter disappointment. For example, she wanted me to marry into the local aristocracy; I chose instead the daughter of a British peer. She wanted me to be religious; I became a Catholic. She wanted me to like art; I devoted my life to it. She would have been so happy, she often said, if I had only settled down as a Pittsburgh lawyer and married the daughter of one of her friends. Cosmopolitanism, religion, and culture were good things in their way, but Mother thought they could be overdone.

The society of Pittsburgh was never particularly cultivated. The art museum languished by comparison with other American cities of comparable size. It was established by Andrew Carnegie in a building he erected to house a public library and a natural history museum. Under such circumstances no art gallery has ever flourished; but as a further handicap Carnegie insisted that the focus of the museum should be on contemporary art. To that end most of the funds were spent on an international exhibition held at first annually, then biannually, and now triannually.

These international shows in Pittsburgh once had considerable significance. In those days the Museum of Modern Art did not exist, and there were few New York dealers stocking contemporary European painting. In my youth the director of the Carnegie Institute Museum of Art was Homer Saint-Gaudens, the son of the sculptor, Augustus Saint-Gaudens. Though I was critical of the shows he arranged, thinking myself, though still in my teens, quite knowledgeable in art, I now realize that he was an excellent director. He had one great advantage over his successors. He was completely unresponsive to art. Consequently, from an attitude of indifference he selected a cross section of what was being created without a bias toward any particular movement. He was followed by a fanatical believer in Abstract Expressionism, and the Pittsburgh shows in my opinion became monotonously repetitious and ceased to be of great interest. But while Homer Saint-Gaudens was the director no artist subsequently judged significant was omitted. To see what was happening in European painting, anyone in America had to travel to Pittsburgh.

Because of these shows, long before I entered Harvard I knew a good deal about contemporary art. Shortly after I reached college I bought my first painting from the International, a work by John Kane, a local primitive who had submitted his canvases to the jury which selected a few noninvited artists; the jurors that year, bored with the submissions,

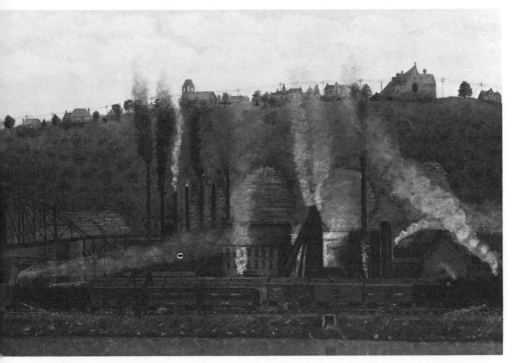

John Kane, *Old Clinton Furnace*. My first important purchase. Price $75.

had insisted his were the paintings most worth hanging. Kane as a result had a minor success. His wife, who was once my grandmother's cook, had deserted him ten years earlier, but he was blissfully happy in his bachelorhood. Unfortunately, convinced that his rise as a painter would enable him to support her, his wife returned. With his unwanted spouse on his hands Kane found his paintings as unsalable as they had been before his tiny boom. Even less affluent, his expenses had increased and his success had proved a tragedy.

The second year he showed at the International Exhibition, he submitted a landscape depicting my grandfather's blast furnace. I admired his work and wanted the picture, not only for its beauty but also for its family connection. The painting was priced at $1,500. I told the saleslady at the catalogue desk that I wished to make an offer of $75. She burst out laughing, but I insisted that she tell Kane, and left the museum indignant at what I considered her rudeness. The next day she telephoned to say that to her chagrin my offer had been accepted. Several years later I was responsible for telling a New York dealer, Dudensing, about Kane; and he eventually bought for a song from the

ex-cook, by then a widow, all the paintings she had inherited. Somehow I have always been glad that in her efforts to exploit her husband, who had so reluctantly resumed matrimony, she ended by being exploited herself.

Another artist, now famous, but at that time scarcely known even in Europe, whom I first saw at the International Exhibition, was Morandi. To have discovered him in the twenties is a tribute to Homer Saint-Gaudens' astuteness. In 1930 I made a pilgrimage to Bologna to meet Morandi. He was astounded to encounter an American admirer. However, admiration was not enough, for he valued his canvases at considerably more than $75 apiece, and I departed without being able to buy anything, much to my sorrow. But I was to be fortunate. A few years later in Rome I bought a five-dollar ticket in a lottery to help young painters and won a large oil by Morandi, one of his more important works. I suppose in the current market it would be worth sixty or seventy thousand dollars. This is the closest I have come to winning the equivalent of at least a minor prize in the Irish Sweepstakes.

But my true good fortune was a friendship I made while still in school. The assistant director of the Carnegie Institute Museum of Art, Edward Balken, and my family had been close friends for two generations. A man of means, a modest collector but a true connoisseur, he might have been the director of the museum had he wished, for he had the advantage over Homer Saint-Gaudens of being a native Pittsburgher, whose family belonged to the local aristocracy. Nevertheless, he wisely preferred to be a curator. He was the first collector that I collected. I realized that he had a knowledge, a sensitivity to works of art, and an intuitive feeling for beauty that I wanted to acquire. He in turn was surprised and delighted that a schoolboy should be so ambitious in such matters. He showed me his collection of prints and drawings. In Pittsburgh these became the staple of my aesthetic delight.

In the permanent collection of the museum there was remarkably little of quality. There was a Benjamin West I loved, probably because it was the only Old Master of any significance, a Winslow Homer of dramatic power, a distinguished Whistler portrait, a very moving study of Mrs. William Merritt Chase by her husband, and an exceptional portrait of a *Young Girl in Riding Habit* by Robert Henri. Otherwise, apart from a few routine Impressionist canvases, the collection was derisory.

But Edward Balken owned some superb prints by Rembrandt, several first-rate engravings by Dürer, lithographs by Whistler, etchings by

Meryon, and a number of modern prints by artists like Bellows. With these as examples he taught me the meaning of line, the difference between a good and a bad impression, the fascination of various states, the arcane mystery of Collectors' Marks. He was delighted by my absorption in everything he said. I was entranced by all he told me. He took a deep interest in my future career.

At my country day school, six or seven of us formed a club and read papers to each other on the history of art. Looking back, these essays seem to me as well prepared as the papers I was subsequently to write in art courses at Harvard. Contests to see who could identify the most paintings were held, and we even tried our eye at the game of attributions. In our vacations some of us were fortunate enough to go to Europe where, Baedecker in hand, we memorized the great monuments of art.

My closest rival for the leadership of the group was a boy subsequently convicted and imprisoned for embezzlement. This taught me that the study of art has a strong attraction for the criminal element, a knowledge that has proved valuable in my career.

iii

Father went to Princeton, and when I was about to graduate from my preparatory school, he told me to select any college I wished, but he hoped it would not be Harvard. There was a strong feeling in Pittsburgh that one ought to go to Yale or Princeton, and that Harvard, which was thought to be snobbish and effete, should be avoided. I made a tour of the three possibilities, Harvard, Yale, and Princeton, and chose Harvard, largely because it had the best Department of the History of Art, but partly, I must admit, because I could have a charming sitting room with an open fire, and a bedroom and bath to myself. Harvard seemed to me the most sophisticated and civilized university this side of Oxford and Cambridge.

For four years I roomed alone. On the walls of my apartment I hung reproductions of the works of the artists I admired, Duncan Grant, John Marin, Picasso, Vlaminck, and others. Like a doctor hanging out his shingle, they indicated that I had intellectual pretensions and was interested in modern art. Thus one day a dark, saturnine, shaved-headed, six-foot youth appeared in my room. He was Lincoln Kirstein. Ever since we have been intermittent friends, but his influence on my

college life was continuous. He had energy, determination, a streak of genius, and a touch of bravura. Disgusted with the mediocrity of Harvard's official literary magazine, he decided to start a review which, though based in Cambridge, would be far more avant-garde and sophisticated than a university publication. The *Dial* had ceased, and there was nothing in America corresponding to the *Criterion* then being edited by T. S. Eliot. This was to be the model for the *Hound and Horn*, as Lincoln entitled his magazine. Its name proved a temporary advantage, for it brought about a considerable sale among the hunting set, who subscribed under an obvious but natural misapprehension.

There were contributions by Yeats, Pound, Eliot, Gide and others considered leaders of literature in Europe and America. Yet there was also a schoolboy atmosphere about the enterprise. I remember the secrecy and excitement involved in selecting the format of the magazine. Lincoln showed me triumphantly the cover design, which he had commissioned from the artist he considered the best graphic designer of our time — Rockwell Kent! Obviously we were not as sophisticated in 1926 as we thought.

My contributions to the *Hound and Horn* were a number of book reviews written in a glutinous prose, but they were enough to gain me membership in the outer circle at least of the intellectual life of Harvard, which centered around Lincoln and his magazine. My interests, however, were split. I always had a number of rich, hard-drinking, bridge-playing friends. These later proved an important asset, for it is in this group rather than among the intellectuals that one is apt to find collectors. Nevertheless they were also a major distraction, and I was determined to get as high marks as possible to further my career as a future curator. To escape from my social life before my examinations, I used to take a room at the Ritz, the most attractive hotel in Boston; and walking up and down with my notes on the mantelpiece, I would memorize myriads of facts, which immediately after the examination I put out of my mind and forgot absolutely.

One course I had to take involved a certain amount of drawing. As I have said, I am the most incompetent draftsman who ever put pencil to paper. I invariably received a range of marks from C— to D—. In an elementary English course required for freshmen I was given with equal regularity an A. I had a classmate who was a competent artist but who could not construct a sentence. Without realizing that I was committing a serious academic crime for which I might have been

expelled, I suggested that he do one of my drawing exercises and I would in turn write his theme. We signed each other's efforts, handed in the drawing and the theme, and to my amazement received exactly the grades each of us had been getting all along. Thus his drawing with my name was marked C— and my theme with his name D+. This has given me a certain sympathy when students protest against grades; and when to my astonishment I was graduated summa cum laude, I was convinced that it was my reputation for hard work combined with moderate intelligence rather than anything I wrote in my examination books that determined my honors. The conviction was reinforced by the fact that my handwriting is and was virtually illegible.

Yet there were professors at Harvard of great distinction who did trouble to read our bluebooks. One of these was Alfred North Whitehead. His course in philosophy was the most rewarding I took, not only for its content but also because it meant an opportunity to attend his Sunday evenings and drink chocolate with his family. Mrs. Whitehead on one of these occasions told me how she had met at dinner just before the First World War Gertrude Stein, who had been tactless enough to say that England was nothing but a vast suburb. This so infuriated Mrs. Whitehead that she insisted her new American acquaintance come for a weekend in the country. During her visit war broke out, and as Miss Stein could not return to Paris, she stayed six months with the Whiteheads. Alfred Whitehead was fascinated by his visitor, and Mrs. Whitehead told me they had endless walks and discussions together. When the final examination for my philosophy course was given there was an essay-type question which offered me a chance to try to demonstrate the similar goals of Gertrude Stein and Alfred Whitehead. My point was that they were both trying to break through the limits of verbalization, to invent a new language, a subtler means of communicating their ideas, and it was through such linguistic innovation that philosophy advanced. Unaware of my conversations with his wife, Whitehead commented with delight on my perceptiveness and gave me an A+. I had expected a C—.

Between 1926 and 1930 the Fine Arts Department at Harvard was by far the best in the country. Kingsley Porter's studies in Romanesque architecture had gained him an international reputation; Chandler Post's *History of Spanish Painting* was acclaimed as it appeared volume after volume. George Henry Chase was an admirable critic of classical art, George Harold Edgell a popular, quail-shooting, architectural his-

torian, Langdon Warner an admired explorer in the Far East and an authority on Japanese pottery, and Edward Forbes and Paul Sachs collectors and founders of the best university art gallery in America, the Fogg Museum.

There were also visiting professors who impressed me deeply: Goldschmidt of Berlin, Hind of the British Museum, Pinder of Munich, Eric Maclagen of the Victoria and Albert. But the professor from whom I learned the most was the least known of all outside Harvard. Arthur Pope was a painter as well as an art historian. He saw works of art with the eye of an artist, and he was a connoisseur able to formulate and communicate the principles of connoisseurship. Until I came to live with Bernard Berenson he did more to train my eye than anyone else.

Paul Sachs, however, was the member of the faculty I was most anxious to know. He was a stocky, strutting little man with an irongray moustache. Originally a partner in Goldman Sachs, his family's banking firm, he had given up business for teaching and above all collecting. He also ran a one-man employment agency for museum personnel. Edward Balken knew him and had given me a letter of introduction; but Sachs could never remember who I was, a disheartening experience for a student who had come to Harvard especially to sit at his feet.

In the end the Harvard Society for Contemporary Art brought us together. This was the second of Lincoln Kirstein's enterprises. We were both deeply interested in modern art; and in the nineteen-twenties and early thirties the words "Modern Art" rang with a challenge. It was a movement to which we were committed and for which we were prepared to fight. The enmity felt at one time toward artists like Picasso, Matisse, Modigliani, Braque and others of the School of Paris seems today incredible. But in my time at Harvard most Bostonians looked on these painters with fierce hostility. A show of their work at the Boston Art Club had threatened to decimate the membership until it was promised they would never again be exhibited. The leading and most influential opponent of the modern movement was Dr. Denman Ross, one of the greatest connoisseurs America has produced, and a collector whose judgment in every field except contemporary art has enriched the Museum of Fine Arts in Boston and the Fogg Museum at Harvard with superb treasures. As a trustee of the Boston Museum and a member of the Harvard faculty his influence was tremendous, and he was as determined as Hitler to prevent the dissemination of what he considered decadent art.

The situation was embarrassing for Forbes and Sachs, the directors of the Fogg Museum; and when Lincoln Kirstein, Edward Warburg, and I proposed opening a gallery in Harvard Square to show contemporary painting, sculpture, and architecture, we received their blessing. They recognized that we would remove some of the pressure from their students to see modern art, and they offered to help us raise funds and to have the staff of the Fogg Museum do the packing and shipping of our exhibits.

We collected money with comparative ease — everyone felt rich in 1927 and 1928 — and we opened our gallery in rooms we rented from the Harvard Cooperative Society. All the furnishings were intended to indicate our devotion to the avant-garde in art. Lincoln and I designed the main feature of the room, a massive monel-metal-topped table resting on four marble legs, acquired from a disused soda fountain. Though our contraption was impressive, it had an inherent defect. Its stability was dubious. In the end, however, our engineering incompetence as furniture designers earned us some much-needed money. We were having a show of modern Japanese handicrafts and we loaded our table with piles of plates, cups, jars, and every kind of Japanese vessel. At the opening of the show, someone leaned against our overburdened and poorly constructed table, and the top slid off the legs with a crash of china I can still hear. That ended the vernissage. But the next day we discovered that our secretary by mistake had insured the collection for its sales value. Thus we earned a profit of 100 percent on every piece which was broken. Perhaps we defrauded the insurance company, but we were saved from bankruptcy.

This was our only successful financial transaction. Very little we exhibited was for sale. Most of our shows were of paintings and sculpture borrowed from private collectors. Chester and Maud Dale were particularly generous, as was Duncan Phillips. We had a board of trustees consisting of Miss Lizzie Bliss, Frank Crowninshield, Mrs. John D. Rockefeller, Congor Goodyear, and Paul Sachs. Our tiny enterprise to some extent inspired the same group to establish the Museum of Modern Art in 1929.

It is hard to describe the excitement forty years ago fighting for the values of the modern movement. Now the innovations of the moment are immediately accepted, and novelty produces no shock. Modern art was once a cause; now it is an investment. One wonders who can possibly be behind the avant-garde since everybody is in it.

But in 1928 there were revolutionary artists like Sandy Calder, in

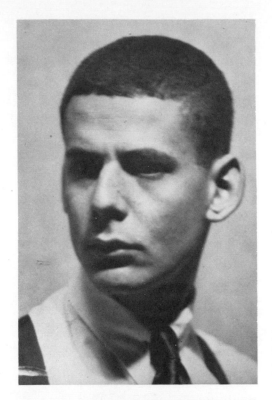

Lincoln Kirstein, now director of the New York City Ballet Company. He had a streak of genius.

Our wedding, February 3, 1937.

many ways the most innovative sculptor of our time. We mounted, I believe, the first exhibition of his *Circus*, later to become world-famous. All the clowns, the acrobats, the animals were made of copper wire. I remember that Eddie Warburg and I got a truck and went to meet Calder's train. I headed for the express office to pick up the boxes containing the exhibition, and Eddie went to the platform to greet our artist. To my horror no boxes had arrived. I joined Eddie and Sandy, and there was the sculptor with a coil of wire over his arm. He said he intended to make the exhibition in the gallery; forty-eight hours, he stated, was plenty of time.

We showed another great American sculptor, then virtually unknown, Gaston Lachaise. How beautiful and original seemed the statue of his wife in shiny brass balanced on tiny feet and revealing, we thought, a new canon of feminine loveliness. We felt ourselves part of the new movement, discoverers and prophets of a new beauty which we found in Picasso, Matisse, Braque, Brancusi, and a host of artists now looked upon as Old Masters. We even promoted architecture and revealed to the world Buckminster Fuller's Dymaxion House, which promised new wonders of efficiency and convenience. The Philistines were ranged solidly against us. Over the years they have suffered defeat after defeat. Now there is no opposition, loyal or disloyal, and art in consequence has suffered.

Lincoln Kirstein was like a setter pointing out the coveys of genius. I remember Frank Crowninshield, then the editor of *Vanity Fair*, asking his advice. Whatever works of art Lincoln said were important Crowninshield bought. I learned then that in searching out new artistic talent one's guide should be under thirty. We see with the eyes of our generation, and only the young discern the young. Frank Crowninshield was wise to follow Lincoln's advice. The sale of his collection years later proved his wisdom, if monetary values can prove anything.

Running an art gallery was excellent training for a museum career, but it took a great deal of time. My studies would have suffered if it had not been for my visual memory, which in courses in the history of art is all-important. I had always loved bridge, and I had developed a faculty for remembering hands long after they were played. Thus, to memorize photographs as we tossed them around the Fogg Museum library before examinations was easy for me. The intellectual content of our courses was slight, and for a rapid reader the reading assignments were scarcely time-consuming. I had no trouble in getting As in nearly all my fine

arts courses, though I always felt history of art at the undergraduate level a somewhat dubious discipline.

<div align="center">iv</div>

My idea of the purpose of museums was unconsciously formulated in those early days at Harvard. I believed then and I still believe that they should be places of enjoyment and enlightenment. I am indifferent to their function in community relations, in solving racial problems, in propaganda for any cause. My beliefs were later reinforced when, after I graduated from Harvard, the faculty of the Department of Fine Arts sent me to Florence to work with Bernard Berenson, the great critic of Italian painting. The most passionate viewer of works of art I have ever known, he felt that museums existed primarily for the satisfaction of people like himself. I adopted the same philosophy: I was, and still am, an elitist, knowing full well that this is now an unfashionable attitude. It was my hope that through education, which I greatly promoted when I became a museum director myself, I might increase the minority I served; but I constantly preached an understanding and a respect for quality in works of art. I have been unchanging in my passionately held opinion that the success or failure of a museum is not to be measured by attendance but by the beauty of its collections and the harmony of their display.

It was fortunate that my concept of museums was so in accord with B. B.'s, as we called him. It made it easier for me to enter into his world of connoisseurship and scholarship. We had never met, but our sympathy for each other when I arrived at I Tatti, the Berenson villa, was immediate. It was teatime, and I remember him entering his library with his quick, light step. He was small, wiry, and bald, with a gray pointed beard and beautiful gray eyes. I was particularly impressed with his hands, with their long tapering fingers. He was fastidiously dressed, as usual in gray, and he had his customary pink carnation in his buttonhole.

He opened the conversation by saying that he understood that I had a reputation at Harvard as a promising young scholar. I replied that I was afraid this was undeserved. I was eager to unburden my conscience to him, though my sense of guilt was due to circumstances I now consider to have been beyond my control. I explained that though I was a

rather diligent student, the Harvard Fine Arts faculty wanted more from me than that. They had a problem, and they thought that I could solve it. It was generally agreed that in America Harvard had the most brilliant faculty in the history of art, but these learned professors had had to put up with an annual frustration. Each year the College Art Association organized a competition between the undergraduates of those universities teaching art history. Each year Harvard entered a candidate, but he never won. The irritation at the Fogg Museum, where the department was located, had grown intense.

The faculty decided that I would right their wrongs and beat my contemporaries from Yale, Princeton, and the other competing colleges. This would make Harvard number one, which it should be. I was assigned a special tutor, and I went into training like a one-man football team with a fanatical coach.

The winner was decided on the basis of a thesis and a written examination. The subjects for the thesis were given out in the late autumn and the examination was held in the early spring. I was delighted to find that the Harvard faculty announced for the second half year a course in baroque architecture, particularly as one of the subjects I might choose for my thesis was the architecture of Bernini. When I began attending these lectures, which were brilliantly given, I found to my surprise that the baroque seemed to begin and end with Bernini. There was lecture after lecture on every aspect of his work, his origins, his achievements, his influence. We finally got around to Borromini and the other baroque architects, but by a remarkable coincidence we reached this stage in the course just after my thesis on Bernini had to be handed in.

Finally the day for the written examination arrived. The paper containing the questions was sent to each university, and the competing student was assigned a room and a proctor to see that he did not cheat. I was told to go to such-and-such a location in the Fogg Museum. I was startled at the place I was to take the examination. It was not a classroom but an exhibition gallery, which was closed to the public on that day. The proctor handed me my paper. I read it and found that the examination consisted of an essay on a single topic — Minoan culture. I was sitting in the Fogg Museum's gallery of Minoan art. This was probably another coincidence, but it has amused me to think the faculty were taking no chances. I won, but I must have won by too much. The competition was never held again.

B. B. was delighted with the questionable actions of the Harvard faculty. From that moment we became firm and affectionate friends. I lived with the Berensons almost as though I were their son for three years. I was still waiting for my curatorship, but forty years ago these were not easy to come by. Now, with the proliferation of museums, they are more plentiful. As nothing turned up, I accepted the position of professor in charge of fine arts at the American Academy in Rome. I also acted as assistant director. My work was not onerous, and I could continue to see B. B. and by writing about Italian painting try to build up a reputation which would some day entitle me to a curatorship.

My chief delight in my job at the Academy was sightseeing with my charges, the Prix de Rome fellows in music, painting, sculpture, architecture, and landscape architecture. Bundled into a buslike Fiat car I had bought, we traveled all over Italy. As we drove I sketched out the history of Italian art and talked about the monuments we would see; and when we arrived they in turn showed me with artists' eyes many subtleties of beauty and design I might have overlooked. In this exchange I think I gained more than I gave.

What an enchanting country Italy seemed under Mussolini! Poverty is the great protector of beauty, and the Duce kept the Italians very poor. When through the disasters of war, they rid themselves of their incompetent and bombastic leader, they immediately became affluent. With the riches that poured in after World War Two they destroyed more of nature and art than had all the barbarian invaders. But in the glorious thirties there were no developers, industry was at a standstill, pollution at a minimum. People were too poor to buy automobiles, and consequently the cities were almost devoid of cars, and the highways, rough but adequate, were virtually empty. There were few billboards, except those proclaiming the slogans of Mussolini, which were usually funny. I recall one of these which particularly delighted me. It read: "Don't be the slaves of Roosevelt!" I was motoring with an important and rich American collector. The name Roosevelt catching his eye, he asked me to translate. I did, and he said with extreme satisfaction, "How smart Mussolini is! That is what I've always said."

When the Abyssinian war came, even the tourists stayed away. I have often thought I owe a happy marriage of thirty-seven years to some extent to Mussolini's African campaign. I hoped to marry Margaret Drummond, the oldest daughter of the British ambassador, and because the Duce disliked Great Britain's opposition to his truculent foreign policy, no Italian was allowed to enter the embassy. Margaret

was isolated, and I had little competition. Though my life at I Tatti had conditioned me to be a premature anti-Fascist, looking back, I must acknowledge my debt to Mussolini.

But on the other side of the ledger, Mussolini deprived my wife and myself of a very valuable gift. As an engagement present Mother decided to give my fiancée the most important piece of jewelry she owned, a diamond necklace. She brought it with her to Rome and, fearful of theft, turned it over to my future father-in-law to place in his safe. A week or so later Margaret returned from skiing in Austria, and my family and the Drummonds lunched together at the embassy. After luncheon Mother said she wanted to see Margaret wear the necklace because she thought it should be lengthened. Sir Eric Drummond, as he then was, went to the safe and brought back the usual British red leather dispatch box with the royal arms embossed in gold on the cover. He took his key from his pocket, unlocked the box, and looked into it with horror. All the most secret British codes and dispatches were there, but the necklace had vanished, never to be seen again.

We soon discovered an Italian spy had been regularly opening the safe and conveying to Mussolini the most confidential British decisions and plans, as Ciano says in his diary. But when the spy saw a diamond necklace he thought the time had come to renounce his profession and commit the perfect crime, one far more profitable than spying. He was sure the police would never try to catch him for he was a government agent, and they could not afford a scandal. It was a heaven-sent opportunity to give up espionage with a diamond necklace as a retirement present. How could he resist? We knew who he was, an Italian employed for years in the embassy. He left his job at once, and we watched him with some bitterness build a most attractive villa on the Via Appia.

2

Curators, Directors
and Donors

After four years in Rome I learned of a new museum to be erected in Washington with funds provided by Andrew Mellon. I wrote his son, Paul Mellon, one of the trustees and an old friend, and asked him whether there would be a place for me on the staff. I received a polite, noncommittal reply, and as nothing further happened, put the idea out of my mind. I was thirty-one and had never worked in a museum. I saw no likelihood that I would be offered a curatorship of any kind. To my surprise, some months later I was asked to come to Zurich for a conversation with Paul. He said David Finley, a lawyer, a passionate lover of art, and Andrew Mellon's personal assistant, who had brilliantly worked with him from the beginning on plans for the Gallery, had been selected to be the director, and that the trustees would like me also to be an executive officer and the chief curator. Considering my lack of experience this was a somewhat unusual choice. It meant that I would be directly in charge of all the works of art.

But such is the perversity of human beings that when I was offered

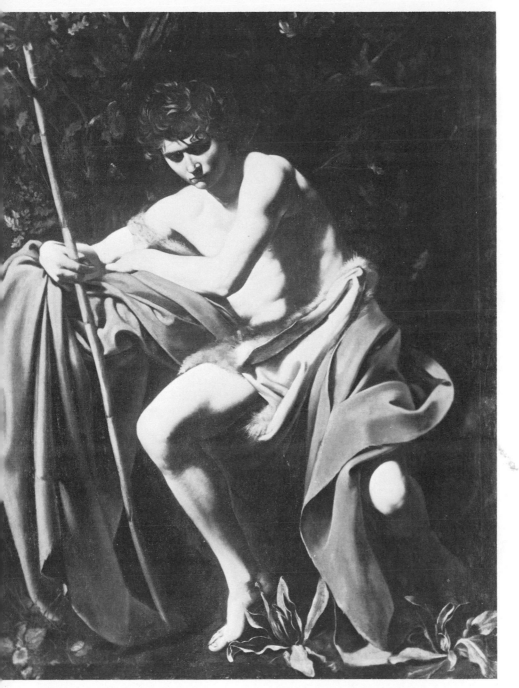

Michelangelo da Caravaggio, *St. John the Baptist*. Nelson Gallery —
Atkins Museum, Kansas City, Missouri. This was the most important
picture I failed to acquire when I might have.

what I wanted most, I almost refused. I loved Rome and thought I wished to spend the rest of my life there. My wife, however, felt that I was too young to become an expatriate and soon talked me out of my folly.

Besides delighting me for thirty-seven years, how much I owe her! A wife in any career is important — in a museum career she is vital. Perhaps this is truer of America than of Europe. In the United States museums are still growing rapidly, and this growth is dependent on gifts. These involve social relations. The director of a large institution must know how to entertain with a certain sophistication and charm. If his wife is inexperienced in these matters, though he may have scholarly ability, skill as an administrator, remarkable connoisseurship, the result can be, as I have seen with many of my colleagues, disastrous. The trustees are unhappy, donors are put off, and those various receptions, so important in American museums, are given awkwardly. Margaret's many years of embassy training were invaluable. She could handle people with self-confidence and ease.

I am glad she was never drawn into my professional activities other than helping me with social obligations. To come home and not to have to talk shop was always a joy. But she developed a remarkable eye for works of art. When we met, her knowledge of paintings and sculpture was limited more or less to the tours of Rome, which she reluctantly gave important visitors to the British embassy. But when we began going to museums together, she quickly learned to discriminate, to find the really beautiful object in each room. With my children and me she is known as "The Bird Dog." We lead her into an exhibition gallery and tell her to point to the best works of art. She never fails us.

When I became chief curator and then director of the Gallery, I often used her eye to check my judgments. I wish I had always followed her advice. The most important picture I did not acquire when I might have, a St. John the Baptist by Caravaggio, now in Kansas City, I lost when I ignored her recommendation. The picture had once belonged to her relatives in Yorkshire, and I thought she was prejudiced. I made a mistake which still haunts me.

In every crisis Margaret's support has made all the difference. Perhaps my hesitation in accepting the post of chief curator was due not only to a love of Rome but also to a lack of self-confidence. Margaret said I was perfectly qualified for the job, better qualified than anyone she knew. But as I was the only art historian who had crossed her path,

except B. B., who adored her, I was not sure she had a good basis of comparison.

It is noteworthy that all the top executive officers chosen with me in 1938 were without the slightest museum experience. Unlike other employees at the National Gallery we were not under Civil Service. Our salaries came from an endowment fund Andrew Mellon donated for that purpose. He felt the selection of the most responsible officers should not be hampered by any mechanical standards established by the government. Certain qualities — charm, sophistication, savoir-faire — all of them important in carrying out our major objective, to snare collectors, he realized were not recognized by the bureaucrats who drafted the Civil Service regulations. This point of view helped to make possible the success of the National Gallery of Art, but it is also true that we were quite ignorant about museum management.

Our ignorance was matched by that of all our trustees except one, Duncan Phillips, who became my dearest friend and greatest supporter. He created and ran the Phillips Memorial Gallery, an institution unique in the world, which seems to some of us the perfect museum. It has the charm of a private collection — comfortable chairs, ashtrays on tables, soft carpets, absence of guards — without the drawback of the presence of the private collector. To wander into it is to enjoy what can only be described as spiritual refreshment, tarnished as those words may be. In no other museum have I so enjoyed the contemplation of paintings, though there are only a few masterpieces and these mostly of modern art.

But the National Gallery was another matter. It was intended to be a large public institution, and in planning it we had to think in terms of millions of visitors. Nevertheless, we always kept in mind the delight afforded by the Phillips Gallery. Duncan Phillips, David Finley, and I held the same basic philosophy. We believed quite simply that museums exist for enjoyment, a belief echoed by my three English colleagues, to whom I have devoted chapter 13.

Andrew Mellon decided from the outset that he wanted a palatial building. He wished it designed in a classical idiom, and he chose as architect the greatest master alive of that style, John Russell Pope. Mr. Mellon felt that people, especially in America, have a need for buildings more magnificent, more spatial, and less utilitarian than the apartments and small houses they normally inhabit. To identify oneself, even peripherally, with the ownership of an edifice harmoniously propor-

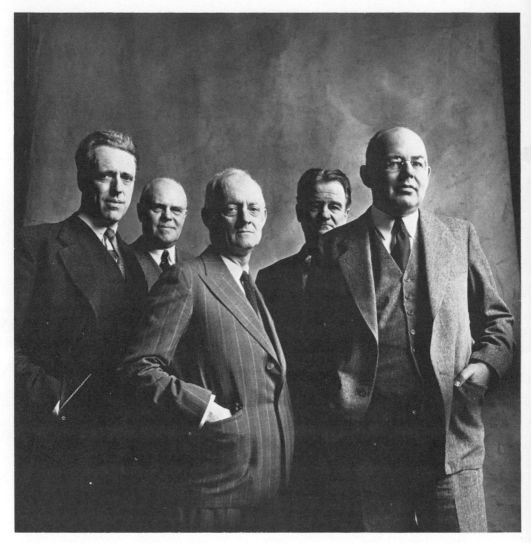

The executive officers of the new National Gallery. From left to right:
John Walker, Chief Curator; Harry A. McBride, Administrator; David
Finley, Director; Macgill James, Assistant Director; Huntington Cairns,
Secretary and General Counsel. We believed the new gallery was to have
a brilliant future.

tioned and conceived on a grand scale affords a pleasure as definite as it is difficult to describe. I know from innumerable interviews that the public enjoys the nobility and splendor of the Gallery's architecture.

The new building was a hole in the ground when I arrived. John Russell Pope had just died, having postponed an essential operation for cancer in order to complete the elevations of what he considered to be his masterpiece. His successors were less experienced, and for that reason more amenable to suggestions. David Finley, his wife Margey, and I laid out the arrangement of the rooms. Both Finleys loved architectural plans, and Margey might have been a distinguished architect. Much of the beauty of the building is due to their discriminating judgment. We agreed on relatively small exhibition spaces lending themselves to a chronological sequence. We also felt strongly that works of art should be given becoming backgrounds, that they are more than documents of culture, that they exist to stimulate and please the human eye. Just as acoustics affect the enjoyment of music, so do the size and shape of galleries and their backgrounds affect the delight we receive from works of art. Such pleasure is enhanced if the spectator is able to contemplate each painting or sculpture as a separate entity. We spaced the collection more generously than any other museum I have ever seen, and to gain greater isolation for each picture and statue we used panels in many rooms. These provide a second frame, so to speak, but their disadvantage is that they do limit flexibility. Perhaps that is why they have been so little used.

But then what sacrifices have modern museums made to gain flexibility! Most paintings and sculpture were created to be looked at in circumscribed areas: rooms, corridors, courts. They were rarely intended to be seen, as they are today in so many museums, against movable screens. But flexibility was and still is fashionable, and I too insisted on a large and completely flexible area for temporary exhibitions. The architects at my request designed walls on rollers, and with these I intended to form a changing pattern of exhibition spaces depending on the show I had to install. But the designers, with notable incompetence, made my wedge-shaped partitions just too large to go through the doors; and as they were too costly to dismantle, though I could move them around a little, I could never get them out of the Gallery. How I came to hate them, and at long last they have been destroyed. So much for my efforts to achieve a modern look.

Apart from my unsuccessful search for flexibility and an overabundance of monk's cloth, which we soon ripped out, both vestiges of a

course in museology I had taken at Harvard, the rooms we designed were intended to resemble the interiors for which the works of art were originally created. We found that galleries with plaster walls for the early Italian and Flemish paintings, damask for the later Italian schools, wood paneling for the Dutch and Flemish pictures, and walls painted and paneled for canvases of the eighteenth and nineteenth centuries seemed to enhance the beauty of the works of art hung against them. The result was different from other museums we had seen and, to our delight, what we had done was widely acclaimed, though it has been little imitated.

I have always thought our lack of experience may have been fortunate. At least we had no preconceived ideas. We found operating a museum was like running any large enterprise. Organization and common sense were basic. The added requirements were taste and scholarship. David Finley, though not a scholar, was a man of impeccable taste. My scholarship was sound if not remarkable, and I felt confidence in my own taste. We believed the new Gallery was destined to have a brilliant future and we were able to convey this belief to others.

I had one particularly useful characteristic. B. B. used to say I was the most admirable recipient of favors he knew. I suppose he meant that I always seemed deeply grateful and made my benefactor feel my appreciation. This, I believe, is vitally important in a good museum director. His enthusiasm for the gifts of others will draw collections to his institution. No matter how inconsequential a work of art offered to a museum may be, it is usually significant to the donor, and its donation represents, at least in his mind, a sacrifice.

But the converse of being a good receiver is to be a good refuser. This too is important in a museum director. It is folly to accept gifts which cannot benefit the institution through an inability to say *no*. Works of art received and permanently stored can cause lasting rancor. I made one mistake of this kind which caused me to lose a friend and the Gallery a possible benefactor. A very wealthy man deeply interested in the Gallery asked me whether we would like to inherit his collection which was in his apartment in Paris. I said on my next trip to Europe I would come and see it. When a few months later I arrived in Paris, I called on him. His apartment was charming but dimly lighted and the works of art difficult to see. My friend showed me a letter with valuations by a well-known art dealer. These were high, and if his treasures were as good as the dealer indicated, then the collection was not one to

be missed. I looked as best I could and felt some misgivings; but then I remembered the valuations, thought of the estate we might receive, and reminded myself that the owner, an oldish man, would be dead when the Gallery had to decide what to exhibit. Finally I said I would recommend the acceptance of the collection. He told me he intended to give it piece by piece, keeping the works of art during his lifetime but receiving a tax deduction, which was at that time legitimate.

All was well until a crisis with Russia over Korea occurred. He was convinced that the Russian armies would sweep across Europe and that when they invaded Paris, his collection would be carried off to the Soviet Union. Therefore he cabled me that he was making an immediate gift and shipping everything to Washington. The works of art were duly received and to my consternation proved on the whole mediocre. There were only a few I could possibly exhibit and the rest went into storage. Meanwhile the crisis had passed and my friend had remarried. His new wife found herself in a bleak apartment, which looked as though it had been looted. Full of resentment, she persuaded her new husband to come to Washington to see the collection in its new setting. She found this to be a series of screens in our storage vaults. They both were furious. "At least," my friend said, "give me back my paintings and sculpture and I'll reinstall them in my apartment." But, alas, a gift to the government is irreversible. He never spoke to me again, and his residual estate went to another institution.

Every museum director has on his conscience bequests he has lost. One evening I was seated at dinner next to the president of a small university. He was very affable, and when we were finished and we had had several drinks, he said he wanted to thank me for all I had done for his institution. I was surprised as I had only vaguely heard of his college. He asked me whether I remembered a certain New York banker who had given the Gallery a portrait of George Washington. I did indeed and I told him the picture had been for a number of years on loan to the White House and was hanging in the President's private study. Mr. Truman had asked for it, and I had written the banker to find out whether he minded if we made the loan. He had agreed, and I had not heard from him since. "That," my dinner companion said, "is the reason we have a new art building. Your friend the banker got in touch with me and said he had intended to leave a bequest to the National Gallery. But since they were idiotic enough to lend his picture to 'that man' he had taken them out of his will and the money would come instead to my college!"

These are the only disasters I have on my conscience. There have been many counterbalancing successes. I attribute some of these to a protective vocabulary of meaningless adjectives and phrases I call "weasel words," which I have often used. Let me explain. One is asked to see a collection owned by some very affluent person who might be interested in one's museum. The paintings prove to be duds. In some cases it would be folly to tell the collector he has been swindled. One must be intuitive. It is possible he can be won around to asking one's advice; he may want to do better in the future. Outright lies are inadvisable: "weasel words" are essential. These are adjectives like "interesting," "fascinating," and phrases like "What an enviable possession," or "I prefer picture X to picture Y." None of these statements makes any commitment; the collector is not unhappy; and the museum director escapes with his reputation intact.

But there are times when the collector really wants to know the truth, and to recognize this, intuition is important. I remember during the war being taken to see a collection in a suburban house near a large city. It was not an impressive milieu, not the kind of place where one would expect to find works of art which would do the Gallery any good, and when I saw the paintings I knew at once that about half were fraudulent. The collectors were young and seemed eager for appreciation; but some instinct told me that they had a problem and that they hoped I would solve it. On this hunch I decided this was not the time for "weasel words," and I pointed out the pictures I thought were mediocre or of dubious authenticity. They revealed for the first time that that was why they had asked me to come. A friend who knew something about art had been skeptical, and they were worried. Fortunately they had not paid for the doubtful pictures and there was still time to return them. They were grateful, and for some years never bought anything without asking me first. In the end we became close friends and they told me that at their death the collection, now of considerable importance, would come to the National Gallery. As they are both young, I hope this will be in the remote future.

Intuition about people is important in a successful museum director, but there is another qualification often overlooked — a tolerance of sheer mind-destroying boredom. The egotism of some collectors passes description. I have listened to some dilate upon the perfection of their works of art until I have felt as though I were drowning in cold grease. This is the unpleasant side of my profession. Curators are often spared this tedium, but as David Finley, when he was director, and I worked as

a team I was not so lucky, even when I was chief curator. At times I have agreed with the head of the Hermitage Gallery in Leningrad who told me how fortunate he was in one respect. He had no donors! Thus he could devote all his time to scholarship and his proper museum activities.

But among our benefactors egotists were exceptions, and my Russian colleague, though he was spared periods of excruciating boredom, missed the opportunity for some deeply rewarding friendships. I became very attached to many of our donors, and my job would have been far less satisfactory had I, like the director of the Hermitage, worked with a static collection and been deprived of the friendships I formed with many of the benefactors of the National Gallery. Some were charming, modest, even diffident about their gifts. Others, apart from their great donations, worked indefatigably for the museum, harder than if they had been on the staff. Still others gave without reservation the immense sums of money which have made possible the excitement of new acquisitions.

For there is no doubt that one of the principal joys of a museum director is finding works of art to buy with Other People's Money. Buying from a dealer is relatively simple; the board of trustees, having examined the work of art, will do one of three things: vote the funds, ask for a reduction, or refuse the purchase. But buying at auction is more complicated. The director must make his estimate and persuade his trustees to underwrite a specific sum. Unlike the private collector, he cannot change his mind at the last minute and decide to go above this fixed amount. If he thinks he has discovered a competitor who will outbid him, he has no remedy except another board meeting or dissuasion. If he tries the latter, he is faced with a horrid possibility. He may be sued for "chilling" the sale, or in legal terms for "conspiracy in restraint of trade." This is a law intended among other things to discourage "rings," a group of dealers who ally themselves to keep auction prices low, but the principle can be widely applied.

I once tried to "chill" a sale, and the result was exactly the opposite. In London it is considered poor form to bid oneself, and for various reasons museums nearly always use agents. This custom can sometimes be harmful, and it once caused me to make a bad decision, which proved very costly. We wanted a little St. George and the Dragon by Rogier van der Weyden, a picture so small one should look at it through a magnifying glass. We asked Byam Shaw, the recently retired head of Colnaghi's, an important firm of London art dealers, to bid for us. He

agreed, and I told him our maximum offer which was way above all estimates. The day before the sale he phoned and asked me to come to see him at once. When I arrived he was very agitated and said that Colnaghi's principal client, a Count Seilern, for whom they had always bid, had to their astonishment asked Colnaghi's to act for him and to bid on my *St. George and the Dragon*. They had accepted my request only because Seilern had said that he did not intend to make further purchases for a long time. Would I therefore get someone else to bid for the Gallery. I refused, pointing out that they knew my maximum bid and that this would be unfair information if they acted for another party. "Well," Shaw said, "then may I tell Seilern we are acting for the National Gallery of Art, in which case I am sure he will withdraw, realizing that he cannot outbid your Gallery?" I knew Seilern pretty well, and I decided to gamble. I thought that out of friendship and the goodwill that he had always shown the Gallery (he's half American) he would not bid against us. How wrong can one be! When he learned from Shaw that we were bidding, he exploded with anger and declared that the picture was a jewel of the rarest quality, but that it was far too small for a museum and was exactly a collector's type of painting. He was now determined, he said, to get it at all cost and to discourage museums going after such pictures. He employed another firm and was the underbidder at $620,000. As his agents and ours were the only bidders above half a million dollars, my wrong decision was very expensive.

This was not my only frustration in the auction room. My saddest experience was a diptych which should have been a triptych. The chief curator of the National Gallery of Art while I was director was a brilliant scholar, Perry Cott. He urged me to buy a panel by one of the rarest artists of the early sixteenth century, Miguel Sithium. For five years I tried to acquire from a Swiss collector the treasure he wanted. Finally the owner conceded the picture was worth something less than the Swiss National Debt — we never reveal actual figures except in the case of auctions when they are public knowledge — and we bought it. We knew it was small, but, alas, when it arrived from Switzerland and was hung, it looked like a postage stamp on the Gallery wall. A little later, however, two related pictures turned up at Christie's, the London auction house. They were by a lesser artist, but they were from the same altarpiece. This meant that if I could get them I would have a decent size triptych. I asked for estimates from Christie's and from dealers, the usual procedure, and I then doubled these and recom-

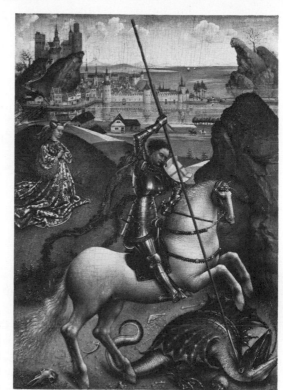

Rogier van der Weyden, *St. George and the Dragon*, Flemish, 15th Century. National Gallery of Art. A jewel of the rarest quality. Ailsa Mellon Bruce Fund.

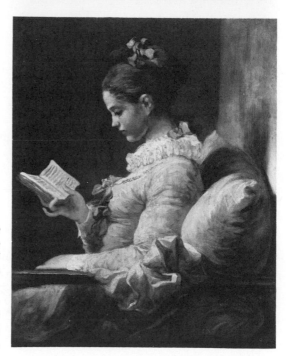

Jean-Honoré Fragonard, *La Liseuse*, French, 18th Century. National Gallery of Art. A young enchantress who caused me to spill a disproportionate amount of tea. A gift of Ailsa Mellon Bruce in memory of her father, Andrew Mellon.

mended the purchase to our trustees, who gave me the necessary authorization.

On this occasion, as it is important to change agents frequently, I commissioned Geoffrey Agnew, one of the most prominent picture dealers in London, to bid for us. I said the Gallery was prepared to pay $360,000 for both panels. The first painting to my delight went for just over $120,000, thus leaving us approximately $240,000 for the second, which I thought somewhat less beautiful. I had a false sense of security, for I did not know that Mrs. Jack Linsky of New York, a most discerning collector, had decided that she wanted number two. Up we went. I was sitting behind Geoffrey, and I watched his perfect timing, his variations in the amounts of his bids, all the tricks one uses to discourage a competitor. The bidding was in guineas, which are a shilling more than a pound. I was frantically converting dollars into pounds and then adding twelve cents to each pound to determine whether we had reached our limit, or rather how far above it we had gone. Geoffrey turned and looked at me for further instructions. In bewilderment I told him to go on. I recognized that I had committed more than my trustees had authorized — I had no idea how much more — and that I was probably in deep trouble. But I didn't need to worry. No one could have outbid Mrs. Linsky. And that is why our diptych never became a triptych. When I was director of the Gallery I tried in every way I knew to touch the heart of Mrs. Linsky. I still hope I did. A museum director is a little like one of those donors in primitive paintings. He is always on his knees with his hands together in prayer!

One of my characteristics is that I fall in love with works of art, and this makes me a poor negotiator, but a good persuader. My desire, I admit, is often stimulated by subject matter. If I cared only for handling, design, color, the formal values fashionable at present, which are, of course, of the greatest significance, I would be more detached. But instead I have often been attracted beyond these basic factors to the more intangible values of content. I like to imagine myself, for example, a participant in the humanized landscape created by Claude or Poussin, or a wanderer through the Suffolk countryside dappled with sunshine, which Constable depicts, or a sailor clinging to a dory threatened by Turner's monstrous waves. The *joie de vivre* implicit in the great Impressionist canvases makes me tingle with delight. On the other hand, I sometimes feel myself in communion with that mood of sadness and high tragedy conveyed by Rembrandt's noble portraits and figure

compositions. I could go on, but my point is that such empathy seems to me a justifiable reaction to works of art.

I even admit on a lower level of appreciation that from boyhood, as I have said, I have found myself in love with two-dimensional ladies. I remember when I was still in college I was taken to see the collection of Mrs. Erickson in New York. Though she owned Rembrandt's *Aristotle with the Bust of Homer,* a masterpiece of brooding melancholy, it was a young minx by Fragonard who caught and held my eye. I was captivated at once. Dressed in warm yellow, her hair tied with a ribbon, she sits propped up on pillows of sepia tones, and with a demure air reads her book, lost in the world of her private thoughts.

Years later when I had become chief curator of the National Gallery, I used to call on Mrs. Erickson frequently. We always had tea just under *La Liseuse,* as the painting was called, and carrying on a sensible conversation with my hostess while looking out of the corner of my eye at my enchantress led to the spillage of a disproportionate amount of tea. My admiration was so apparent that I persuaded myself Mrs. Erickson would certainly leave the picture to the National Gallery of Art. I was wrong. At her death the Erickson Collection was put up for sale at Parke-Bernet and Fragonard's unknown model was destined for the auction block.

I rushed to our principal benefactress, Mrs. Mellon Bruce, and took her to see *La Liseuse* just before the sale. I told her of my devotion going back a quarter of a century, and she became equally bewitched. There were only two pictures she told me that she had ever desperately wanted: one was *Lady Caroline Howard* by Reynolds, which her father, Andrew Mellon, had given to the National Gallery of Art, to her intense sorrow, saying it was too important to be privately owned, and the other was *La Liseuse.* She asked how much I thought it would bring. I took the highest price ever paid for a Fragonard and multiplied by five.

It was fortunate that I asked for such an outrageous sum. Another man, Charles Wrightsman, a close friend about whom I shall say more later, had also been ensnared by *La Liseuse.* Knowing his taste, I guessed he would be our major competitor. I immediately went to see him and told him the Gallery wanted the Fragonard, and I hoped we would not be bidding against each other. He said if we were going to bid, he knew he didn't have a chance, and I came to the happy conclusion that he would withdraw.

The night of the auction, Chester Dale, the president of the Gallery, and I sat in the front row. When *La Liseuse* came up for sale, the bidding for the first half million dollars was brisk. With bids coming from all over the room it was impossible to recognize our real enemy. Then suddenly all the bidding came from one place. My heart sank. It was my friend — a very rich and determined man. We could not shake him off. My nerves were on edge. We were running out of money and the decision to go on had to be made in seconds. With almost nothing left from Mrs. Bruce's huge donation, Chester Dale proposed a final effort, a bid of three times the amount of the previous raises. I agreed. There was silence. Until the auctioneer's hammer fell I suppose thirty seconds passed. But they seemed as long as the thirty years since that tea party when I fell in love at first sight. Then crash and *La Liseuse* was ours.

The next morning I called Mrs. Bruce and told her the results, which she had already seen in her morning paper. I explained that as she loved the picture so much, she could, under the law at that time, pay for it, give it to the Gallery, and keep it during her lifetime, receiving the same tax benefit as she would from an immediate gift. She repeated what her father had said about *Lady Caroline Howard* — that it was too important a picture for private ownership — and she insisted that it come at once to the Gallery. Nevertheless, for the remainder of her life she longed for *La Liseuse*, as she also longed for *Lady Caroline Howard*. I have always admired and wondered at her sacrifice.

ii

The excitement of an auction is intense but brief. Buying a picture from a private collector when many millions of dollars are involved may take years and in the process turn the director's hair gray. To purchase *Ginevra de' Benci* took me sixteen years and almost cost me my life.

Ginevra captured my heart in the winter of 1931 when I was a young student in Vienna. One icy day in January I finally received permission to enter the glacial Liechtenstein palace and to shiver in front of a portrait of a cold, melancholy Florentine lady, as she was depicted by Leonardo da Vinci. Was it the double chill, I have often wondered, which formed some kind of dry ice searing my mind and leaving a lasting desire for the portrait? I was enthralled by her moon-pale face

enframed by an umbrageous juniper, in Italian *ginepro*, a pun on her name, Ginevra. Her expression appeared withdrawn, almost hostile. I felt in her a sense of secret bitterness, of sad disillusionment. It was only much later that I came across the probable explanation of this mood. Contemporary poems tell of her despair at the departure from Florence of her apparent lover, Bernardo Bembo, Venetian ambassador to the court of Lorenzo the Magnificent. Ginevra was at that time the wife of a respected Florentine businessman, and was described as a deeply religious but highly emotional woman. She must have suffered an intolerable conflict in mind and spirit. Two sonnets by Lorenzo de' Medici are devoted to her. In one he says: "If in tears and sighs you sometimes sow in this your blessed madness . . . Let them talk" — presumably a reference to gossip about her love affair. Like her princely friend, she too was a poet, but her poems have all vanished except for two lines which are preserved in a quotation. They seem to fit her portrait. "I ask your forgiveness. I am a mountain lion."

Memories of that stony, resentful stare, of that grim, unforgiving mouth haunted me when I returned to Florence to continue my work with Bernard Berenson. I did not realize until recently that I was then staying, as a paying guest, in the same palace, 16 Via de' Benci, which was Ginevra's home from the age of five until her marriage at sixteen. My room might well have been hers!

Twenty years passed before I again saw Ginevra's portrait. It was on loan for a short time just after the war to the National Gallery in London. She was more fascinating than ever. I had worried about her wartime destiny, and for several years she had led an adventurous life.

With the rest of the Liechtenstein collection Ginevra was removed from Vienna to Salzburg and then to Gaming, where she was kept in a monastery. However, with the advance of Russian troops, Prince Liechtenstein felt that Vaduz, his capital city, offered more security. The Germans at first refused permission to move the paintings, but they eventually conceded that some "household goods" might go to Liechtenstein. Under this humiliating description Ginevra set out on a journey. She had nevertheless the honor of being the only painting to travel with the prince in his private car. In Vaduz she found shelter in the wine cellar of the castle. Only a direct hit by a bomb could have disturbed her.

I tried on various occasions to storm the castle in Vaduz and to see Ginevra in her dungeon, to which she had been returned after her brief

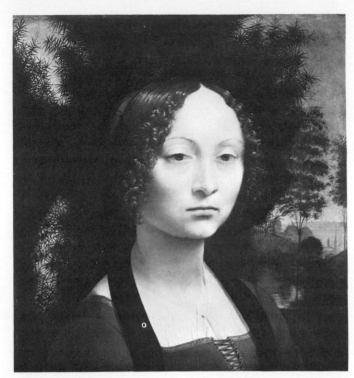

Leonardo da Vinci, *Ginevra de' Benci*, Florentine, 15th Century. National Gallery of Art. Memories of that grim, unforgiving mouth haunted me. Ailsa Mellon Bruce Fund.

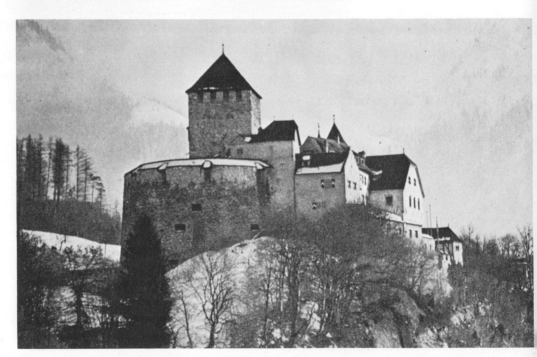

The Castle at Vaduz, Liechtenstein, where *Ginevra de' Benci* found shelter in the wine cellar during World War II.

sojourn in London. Other paintings were on exhibition in the museum the Prince of Liechtenstein had built in his capital, but Ginevra was too precious to be hung with the rest of the collection. To see her was even more difficult than it had been in Vienna. Finally, in August 1960, permission was given, and guided by the prince's curator, we went into the cellar where there was a trapdoor balanced by a huge counter-weight. The trapdoor was lifted, and we descended more narrow stairs to a deep subcellar, where a few of the prince's greatest treasures were stored. This high stone chamber, with its massive walls, though under the castle, is above ground, because the building follows the contours of a precipitous hill. Thus with ample security, there is no excessive dampness, no sudden changes of relative humidity — a kind of natural air conditioning.

There, on a nail, I saw Ginevra hanging, just beside the entrance. Her pallid beauty seemed to irradiate the dusty room with a strange, lunar light. It was hard for me to look at the other pictures, wonderful as they were. I was spellbound, but at last I had to tear myself away, and we started up the endless stone stairs. As a result of polio, my left leg is weak, but stairs have never presented a problem. This time when I was near the top I realized with terror that one step was too high, and that my left leg had failed me. I started to fall backward, to hurtle down those stone steps. I had an instantaneous vision of my mangled body picked up just under Ginevra's portrait. Dr. Wilhelm, the prince's curator, grabbed me, held on, and probably saved my life. I was grate-ful to emerge from the castle with all my bones intact, but Ginevra remained as inaccessible as ever.

I made several more trips to Liechtenstein, sometimes alone, some-times with colleagues; we bought other pictures, hoping always to be able to negotiate for the great prize, yet trying never to reveal our eagerness. All our efforts failed. The prince invariably refused to part with Ginevra. Each trip was more frustrating than the last.

In 1963, the prince's eldest son, Hans Adam of Liechtenstein, came to Washington to stay with Senator Pell. We entertained him, and when I learned he was going to visit Harvard, thinking a friend at court might be useful, I asked my son, then an undergraduate, to take him out to lunch. I said I would, of course, pay all expenses. When my son came home for Christmas vacation, he presented me with a bill for $124.00. I protested that lunch could not have been that expensive — perhaps in New York, but certainly not in Cambridge. My son replied that it was a princely lunch and that when we bought Ginevra, he suggested that I

could add the $124.00 to the overall cost. It was obvious that my son would have a brilliant future with expense accounts, but it still seemed highly unlikely that my $124.00 would ever be absorbed in the price of Ginevra.

Then word began to reach us that the painting was at last for sale. We were skeptical. Over the years it seemed whenever the *New York Times* ran out of art news there was a box, regularly printed on the front page, saying *Ginevra de' Benci* by Leonardo da Vinci had just been sold, usually to Canada. I would have a heart attack, only to inquire and find to my joy that the picture was still hanging on that nail in the cellar at Vaduz. But this time an actual price was mentioned, $10,000,000. We said immediately that this price was unrealistic. A short time afterward we were told that the portrait could be bought at a somewhat lower figure. Then serious negotiations began, which lasted several years. Finally in 1966 we arrived at a price fantastically high, but since the picture is priceless, not illogical. In agreement with the prince we have never revealed the amount.

So far I had avoided all leaks, a remarkable feat in view of the financial transactions involved, the insurance which had to be placed, the number of staff members at the Gallery who had to be told, and the people in Liechtenstein, who must have been suspicious of the unusual influx of Americans from the National Gallery of Art. Security in moving the painting I felt depended on maintaining this secrecy. We therefore developed a code with Ginevra referred to as the "bird." A cablegram saying, THE BIRD COOKS AT 44 AND IS WET TO 55% STEADY meant that the temperature in Ginevra's cell was 44° Fahrenheit and the relative humidity 55 percent.

As Ginevra was painted on a panel, which I knew would react to changes of temperature and humidity, I decided to employ the system used a few years before when we moved the *Mona Lisa* from Paris to Washington and back.

We lined a container with Styrofoam, which minimizes atmospheric changes. The container for Ginevra was a plain suitcase. A gauge was devised which constantly recorded the temperature and humidity content within the valise. Nevertheless, if the gauge had shown that the plane's pressurization had reduced moisture content drastically, there was very little that our restorer, who carried the suitcase, could have done, except, as he said, employ wet towels to raise the humidity and dry martinis to calm his nerves. Luckily such drastic steps were unnecessary. There was absolutely no change in relative humidity.

To conceal the date of departure, three first-class seats were reserved on several days, one for Ginevra, and two for her companions. At the Gallery we didn't know the day of the flight until we received a cable: BIRD FLIES. We had arranged for a private plane to be at Kennedy airport to bring Ginevra to Washington. The day before it had snowed fiercely, but the weather had cleared, and we were delighted.

What we did not realize was that it had been impossible to shovel the snow off more than one runway at Kennedy, and this resulted in one of the worst air traffic jams in the history of the airport. As day turned to night the "bird" continued to fly around New York and then around New England. Finally at an airport remote from Kennedy she landed. Then after a time she repeated her vigil above New York. Hours later she put down at Kennedy, was transferred to a private jet, and with an entourage of guards at last arrived. The "bird," 210 square inches of painted wood, the most expensive square inches in existence, had flown safely to a new home. This was the climax of my career.

Anxieties such as I have described, as well as conflicts with the trustees, have shortened the lives of numerous directors. James Rorimer of the Metropolitan Museum, for example, died prematurely, as did Francis Taylor. Other directors have lived longer, but of these some have suffered from nervous indigestion, some from insomnia, some from alcoholism, and still others have developed unusual aberrations of one kind or another.

But in spite of such occupational hazards museum work has had for me tremendous compensations. An addiction to collecting is as hard to break as an addiction to drugs, and I have been addicted. The rise in prices, however, has made the acquisition of great works of art virtually impossible, except for the colossally rich and for museum directors or curators using Other People's Money. The use of OPM I found one of the great charms of a museum career. Without it I could never have satisfied my craving to collect paintings and sculpture of supreme quality.

I was fortunate to begin my career when the National Gallery was a hole in the ground. But even if one cannot participate in the building of a new museum, a directorship or a curatorship in an existing institution is still a delightful way of earning one's living. And yet most graduate students trained in the history of art reject museums in favor of universities. They seem to prefer the turmoil of the campus to the tranquillity of the gallery. Not that museums are tranquil until the public leaves. But when the doors are closed a metamorphosis occurs,

and the director or curator is transformed into a prince strolling alone through his own palace with an occasional bowing watchman accompanied by his dog the only obsequious courtier. The high, vaulted ceilings, shadowy corridors, soaring columns, seem to have been designed solely for his pleasure, and all the paintings and sculpture, those great achievements of human genius, to exist for no one else. Then, undisturbed by visitors, he experiences from time to time marvelous instants of rapt contemplation when spectator and work of art are in absolute communion. Can life offer any greater pleasure than these moments of complete absorption in beauty?

3

Anxieties
and Adventures

I feel that I have been fortunate to have been both a curator and a director. The terms "director" and "curator" are often used by the public interchangeably. This is wrong. The director is like the president of a college and the curators are the faculty. In England curators are called keepers, which is a more descriptive term. The curator or keeper is an expert who is responsible for maintaining, cataloguing, and installing his part of the whole collection. He also recommends further acquisitions in his field.

The director's job is to see that his institution operates efficiently, and then to raise money for purchases and to meet his budget. He must also frequently pacify his trustees in their often acrimonious internecine fights. He is their spokesman with the public, and the curators' spokesman with the trustees. His training should be as much in diplomacy as in art history. His major objective is to keep peace with everyone. His major task is to collect collectors. These, their quantity and quality, are in my opinion a measure of his success.

I used to think that except for moral turpitude of the grossest kind no director was ever fired from a museum. The explanation seemed simple. There were too few replacements. Nevertheless, in the last few years, in spite of the scarcity of candidates, a spate of museum directors from New York to California have been dismissed. Their eyes may have been discerning for works of art, but they were myopic in a more important respect. They could not see that the center of museum power is the board of trustees.

I found that an able museum director should act like an intelligent wife, who persuades her husband to accede to what she wants with benign complaisance. Such a relationship to trustees may seem humble, but it is effective.

I was happier when I was the chief curator of the National Gallery than when I was the director. Although I did not know it at the time, I now realize I preferred the cloistered atmosphere of the library, the fun of writing, of cataloguing, of research. I liked my sheltered life. I did not have to worry about attendance, public relations, minority and ethnic groups, the impact of exhibitions, contracts and lawsuits. I was in much closer contact with the works of art.

I had my anxieties, however. There is the perennial question of restoration. My policy was simplicity itself; restore only for preservation; clean only when the work of art is so obscured by dirt that its aesthetic significance is gone. Curators spend much of their time with the "conservator" in the "laboratory," as the picture cleaner and his studio are now grandiloquently termed. They believe they can control the restorer, somewhat as though a general practitioner might think he could tell the surgeon how deep to cut. But if their control is illusory, they have at least an enjoyable time. It is a heady experience to watch grime and yellow varnish dissolve and the solvent reveal brilliant colors, perhaps not quite in the relationship the artist intended but in any case dazzling. If the picture is structurally a little weaker, it will nevertheless outlast the curator's life. It was with considerable self-restraint that I deprived myself of the joys of cleaning.

In this age of vandalism, curators have to worry about the protection of the works of art in their charge. We have taken glass off paintings so that the public can see them better, but we have made them more vulnerable to the vicious and the insane. Should we reglaze, now that an effective though expensive low-reflecting glass has been developed? Would glass have preserved a painting by Hobbema in the National Gallery of Art which was permanently damaged by a woman with a

nail file? When her defense attorney attempted to prove that she had
not really meant to injure the picture since she had not cut through the
canvas itself, she interrupted him to say that she had tried but the
varnish was so old and tough she had not been able to penetrate it — an
unusual but valid argument against cleaning! She was put in an
asylum, released, and in a few months destroyed utterly a second
museum painting.

Then there is the problem of the amount of illumination to permit. I
take credit for being among the first to prove that oil and tempera
paintings, which had always been considered impervious to fading,
were actually losing intensity of color. We now use filters to remove
those rays like ultraviolet which are in any case invisible to the human
eye. But, alas, it is the whole range of the spectrum which causes
fading. Ideally the illumination should be so low that the public would
only dimly discern the works of art. I worried constantly about balanc-
ing the light so as to preserve the colors and at the same time please the
public.

Although not directly involved in security, the curator is always
apprehensive about theft. I was fortunate that during my thirty years
at the National Gallery of Art nothing was stolen. Our security pre-
cautions are too elaborate to describe, but apart from electronic surveil-
lance I can mention that at night the Gallery is constantly patrolled by
guards, and for a time these were accompanied by a police dog. One
Sunday evening there was an attempted theft. After the public had been
cleared out of the building and the great bronze doors had closed, a man
was found in a telephone booth. He slumped to the floor and said he had
had a heart attack. The guards rushed for a wheelchair, pushed him to
the rear exit, and commandeered a taxi. As he was getting into the taxi
his coat fell open and revealed a pistol. The guards dismissed the taxi,
escorted their thwarted burglar back to the guard office, this time
walking, searched him, and found tools for cutting wire and glass, and
other instruments of burglary.

The next day I congratulated the guards and said how lucky it was
we had Prince, our police dog, to smell out thieves. "Oh, no!" said the
guard captain. "Prince only works government hours and he was off
duty." Prince was fired and afterward we got on perfectly well without
a police dog.

Prince had always been something of a problem. As soon as we got
him he was sent to a police training school. After months, when he was
ready for graduation, one of our guards who had also had special train-

ing, gave him his final workout. The guard was to whistle, at which Prince was to come running to him. Instead, our student sat on his haunches and looked glumly at his master. The infuriated guard, rushing over to punish him, tripped on his lead. This choked Prince, and his throat was badly lacerated. He then bit the guard as savagely as he could. Both ended up in the hospital, and Prince was flunked.

By then our investment in Prince was so heavy that we sent him back to school with a new handler. On his second try he passed his examination with flying colors. At last he was ready to receive his diploma. On his graduation day I remember trying to reach various members of the staff and to my indignation I found they were all at Prince's commencement exercises. He wasted everyone's time. He was a charming pet but otherwise a disaster.

I have often wondered where he was when some disgruntled artist managed without detection to hang one of his own canvases in a main gallery between a Matisse and a Picasso. We still have the picture but we never apprehended the painter. I suppose I should consider my administration lucky — nothing was stolen and we were one painting to the good.

These were some of my worries. But my delights far outweighed them. There is the satisfaction of a beautiful installation. When an arrangement seemed inevitable and perfect I felt as though I were the successful director of an orchestra. It was my taste and sensitivity which caused these geniuses to be seen in the best possible relationship to each other, or so I hoped. For it is true that an ugly arrangement of works of art can destroy their beauty, much as a poor performance by an orchestra can ruin a composer's music. But even here the curator's pleasure is not unalloyed. There are the nerve-racking moments when men on steep ladders balance at great height irreplaceable paintings, often of considerable weight. I confess that anxiety caused me occasionally to close my eyes. But these brilliant ballet dancers in overalls never dropped a work of art.

A museum director's responsibilities are more varied than a curator's, and sometimes only peripherally related to his museum. I may have conveyed the impression that his time is spent contemplating a purchase and deciding how much to spend for its acquisition; or that he is occupied wining and dining with collectors, who are willing either to empty their purses or strip their walls; and that occasionally with the curator he goes into the galleries themselves and, comfortably seated in a folding chair like a Hollywood movie director, supervises harmonious

and ingenious installations. Alas, what a small amount of his day is spent in these delightful pursuits!

Washington is a city of committees, and I sat on far too many, most of them ineffective and time-consuming. But then, the National Gallery of Art is in a way exceptional among American museums. During most of my career it was the government's Department of Fine Arts. More recently its position of pre-eminence has been challenged by the Smithsonian Institution, but for a quarter of a century, whenever the federal government found itself involved in an artistic problem, the responsible agency turned for assistance to the Gallery. For several years, to take an example, we operated on behalf of the State Department a Latin-American office for the exchange of cultural materials. Or, to choose another, when the war came the National Gallery was the center for the government's efforts to protect works of art and historic monuments in war areas. A commission was established at the Gallery to recommend the personnel for our Monuments, Fine Arts, and Archives Corps, and to provide guidelines and maps for our bombing missions. Its full title, perhaps the longest in Washington, was "The American Commission for the Protection and Salvage of Artistic and Historic Monuments in War Areas"; but it was known as the Roberts Commission from the name of its chairman, Justice Owen J. Roberts.

A few weeks after the surrender of Germany, while I was still chief curator, I was sent to Europe by the State Department to report to the Roberts Commission on the best methods to return looted art. I made a tour in Germany of our zone of occupation, and with Bancel La Farge, a major in the MFA&A Corps, as my escort, visited the great German depositories where thousands of works of art, some from German museums, some booty from invaded countries, had been assembled. I remember the excitement of my visits to the Austrian salt mine at Alt-Aussee, an enormous warehouse where more than twenty thousand paintings and sculptures of looted art were stored, and across the mountains to the mine at Lauffen where the collections of the Vienna museums had been sent for safekeeping.

It was at Lauffen that we received our most desolating report. We were met by a minor curator of one of the Viennese museums, and we asked him to let us inspect what he was guarding. Within the salt mines were long corridors at different levels. These were lined with hastily constructed bins to hold paintings and sculpture. We went up in an elevator five or six stories through the center of the mountain, stopping to extract a sample of the works of art on each floor. When I reached

the top I still had not seen the greatest treasures of the Kunsthistorisches Museum in Vienna: the Bruegels, Dürers, Altdorfers, Titians, and Rubenses.

I asked the curator where they were, and for the first time he admitted that they had been taken from him. A band of SS troops, he said, had arrived just before the surrender and had carried off in a convoy of trucks and armored cars the best of his pictures. He had no idea what had become of them. Our hearts sank, and Bancel and I departed from Lauffen in dejection.

We drove on to Salzburg and the next morning as usual called on the American Property Control Officer for that region. We asked him whether he had any works of art we should examine. He said there was a storage warehouse on the outskirts of town where we would find a lot of gold and, he thought, some old pictures — all captured, he had been told, a few weeks earlier. We were welcome to inspect whatever was there. He would send an escort with us.

The warehouse was well guarded, for on the ground floor there were stacks of gold ingots. The troops we spoke to were absorbed by their responsibility for this enormous hoard of bullion. They said, however, we would find some "art," as they called it, lying around upstairs if we wanted to look at it.

On the second floor, covered with dust, and frameless, were the greatest paintings of the Vienna Museum. I lovingly picked up each picture, the missing Bruegels, and all the rest, noting with joy that luckily nothing was of great fragility, and I found that they had all miraculously escaped serious damage. The SS had been surprised, and, unable to destroy their booty as they had planned, had run away after a brief skirmish, abandoning the convoy with the gold and the paintings.

The trucks had actually been located a few weeks earlier by Charles Kuhn, an MFA&A officer, who ordered everything sent to the nearest large town, Salzburg. But after unloading the trucks, the troops previously stationed there were moved; and when their replacements arrived, all they were told was that there was a mass of gold to be guarded. The new Property Control Officer had no idea of the immense responsibility his predecessor had dumped on him. This was typical of the way communications between different sections of the army after the German surrender were constantly breaking down.

The GIs on guard were incredulous when I told them that what they had on the second floor was worth many times all the gold they were so carefully guarding. The Property Control Officer, when we reported to

him, was equally amazed. I still remember how relieved he was to be told that experts would soon arrive to help him look after this collection of masterpieces, for which he unknowingly had become responsible.

Shortly thereafter Perry Cott, my future assistant at the National Gallery, ably undertook the difficult task of returning the pictures to Vienna, where they all arrived safely. Some years later he had the exciting experience of installing many of them in Washington in a great loan exhibition of Hapsburg treasures.

When I returned to America I reported on the problem of safekeeping and restoration in our zone, where most of the works of art, both looted and belonging to German museums, were stored. My basic recommendation accorded with the advice of the MFA&A officers I talked to. In fact they had already begun to act along the same line. It was to return the looted art as quickly as possible to the country of origin and let the authorities there decide on ownership. This would work some hardship on private owners in areas occupied by the Russians, but no other procedure seemed possible under circumstances of such urgency. There were, I pointed out, virtually no restorers available in Germany for first aid to works of art which were deteriorating, and no materials in any case to work with. Losses from depositories had occurred and probably would recur. Conditions were still chaotic, with troops being constantly moved, and the civil population stunned and apathetic. Conditions in Salzburg, which I have described, were characteristic of the widespread disorganization at the end of the war.

Given the situation, General Mark Clark decided to ask whether he might ship at least two hundred of the best paintings from the Berlin museums to America. He thought it highly desirable that the National Gallery of Art should be their temporary custodian and provide whatever conservation was required for their preservation.

This seemed to me a wise proposal, and the Chief Justice, Mr. Stone, the chairman of our board, authorized the Gallery to cooperate. I was astounded when a number of the MFA&A officers, many of them colleagues from various American museums, signed a statement saying that their own government, in asking them to arrange for this shipment, was compelling them to act like the subordinates of Hitler, Goering, and others we had indicted at Nuremberg. They apparently doubted the good faith of the President and the Chief Justice, who both expressly stated every painting would go back to Berlin as soon as conditions were satisfactory.

The paintings, 202 in number, arrived at the National Gallery in

The most precious cargo ever to cross the ocean. Paintings from the Berlin museums arrive at the National Gallery of Art.

December 1945. In May 1946 another resolution protesting the removal of these works of art was signed by over a hundred museum directors, art historians, and other professionals involved in the arts, many of whom had been MFA&A officers. The point of the resolution was that "disinterested and intelligent people . . . may find it hard to distinguish between the resultant situation and the 'protective custody' used by the Nazis as a camouflage for the sequestration of the artistic treasures of other countries" — this in spite of the word of the President and the Chief Justice!

Needless to say everything was returned, but one of the most prominent museum directors who had accused the government of duplicity in bringing the pictures to America testified in 1948 before a Senate subcommittee that it was the duty of the army and the National Gallery of Art to send the 202 masterpieces on a tour of the United States before returning them to Berlin. I protested that such a tour would adversely

affect the more delicate panels and I begged that at least the most fragile pictures should be returned directly to Germany. I pointed out in my testimony that ". . . pictures are like people, they have a definite span of life. They usually require, after a certain age, the equivalent of medical treatment for their preservation; and among them none are so delicate as those on wood panel, of which there are one hundred and forty-one among the two hundred and two German pictures at the Gallery.

"We do what we can to lengthen the life of such paintings, but when a picture has seriously deteriorated and when all our means of restoration are exhausted, there is nothing to do except embalm the corpse with repaint, and when this is done the panel or canvas ceases to be of museum quality. . . . None of the German paintings are in this condition, and I hope none will be for many years to come. But many of them are fragile and ancient invalids, equivalent in human beings to people in their nineties. The less traveling old people do the better, and the same is true of certain works of art."

I also told the committee that the pictures we were discussing were now more fragile than they would have been if Hitler had not made war. I continued, "Their sojourn in a salt mine was injurious, and some will forever bear the scars of this war. . . . The panel pictures, especially those of the thirteenth, fourteenth, and fifteenth centuries, should not be exposed to sudden changes of temperature and humidity, which will cause the wood to expand and then to contract, loosening the paint on the surface. To these pictures, particularly, shocks and vibrations will be harmful, and travel during excessively hot or cold weather."

In spite of what eloquence I could summon up my plea was obviously not succeeding until a member of the Committee on Armed Services, Senator Robertson of Wyoming, came to my rescue and told his colleagues, "I know from experience that wooden furniture taken from sea level to an altitude of five thousand or six thousand feet shrinks, no matter what age it is, and cracks, and I happen to know it because my home is six thousand, one hundred feet above sea level, and it is antique furniture which has been in my family for many, many years, that I have taken out there, and it has almost become ruined."

I would have admired my profession more if the same point had been made by my colleagues in connection with the tour they were demanding. But the testimony shows how little concern they had for my old invalids. Nevertheless, the Committee on Armed Services permitted me to withdraw from the tour 105 of the 202 pictures.

There is always risk involved in the shipment of works of art, and for this reason Andrew Mellon made a stipulation in his gift to the Gallery that none of his paintings on panel might ever be borrowed, and Chester Dale went further and insisted that nothing whatever from his bequest go out on loan. I favor such provisions, and I wish other museum benefactors would similarly inhibit loans of fragile material.

Yet I have been involved in loan exhibitions I believe never should have taken place. My only excuse is that in every case the initiative was that of the lender, and to have refused to accept these exhibitions, mostly from Europe, and thus to have deprived the American people of an opportunity to see masterpieces from European museums, would have necessitated my resignation. But looking back I know I should have resigned rather than cooperate, and I shall always harbor a sense of guilt.

The most traumatic of these shows, for which against my will I was made responsible, involved only one painting. One day in 1962 the White House telephoned, and it was Mrs. Kennedy. She said she wanted to see me as soon as possible. I went immediately, as one does when summoned to the White House, and Mrs. Kennedy, whom I had known since she was a child, received me and said a most remarkable letter had just come. It was from M. Malraux, the French Minister of Culture, a close friend of the Kennedys. He wrote that a newspaper reporter, when he was in Washington a few months earlier, had asked whether the Louvre would not lend an American museum the *Mona Lisa*. At the time he had been taken by surprise, but he had been thinking over the question and had come to the conclusion the French government should cooperate and make the loan as a gesture of gratitude to the United States. The *Mona Lisa* would be sent to America, he said, as a personal loan to the President and Mrs. Kennedy, and they could arrange for its exhibition. He also proposed to lend "Whistler's Mother" as a companion piece.

Mrs. Kennedy and I chuckled a bit over the thought of the two pictures side by side and decided that Leonardo was too strong a competitor for Whistler. We agreed that the two loans should not be made simultaneously. Then the blow fell. Mrs. Kennedy said she had discussed M. Malraux's proposal with the President, and they had decided that as the loan, to their amazement, was being made to them, they would have to find someone to be responsible for the safety of the picture from the time it arrived in America until it was returned to the

Louvre. I was the obvious choice. She handed me a letter signed John F. Kennedy spelling out my ghastly responsibilities.

Shortly thereafter Madame Hours, the Head of Conservation in the Louvre, arrived in Washington to discuss plans. She told me at once that the whole staff of the Louvre was horrified at being ordered by M. Malraux to send so fragile a painting across the ocean; that when a maniac a few years earlier had attacked the picture, she had taken it at once to her studio to see whether any damage had been done, and that because of the change of relative humidity, within a few hours the panel had curved and nearly broken; and finally that, as the x rays she had brought with her showed, there was an incipient split in the panel which if prolonged would run right through the celebrated smile. After listening to her my horror far exceeded that of the officials of the Louvre!

The visit of the *Mona Lisa* proved one thing: if you are willing to spend the money, you can move the most fragile object back and forth across the ocean without damage, provided you take sufficient care and put into effect certain precautions. We decided first of all that the painting must be protected from any change of temperature or humidity. An aluminum case lined with Styrofoam was fabricated in Paris, and the unframed panel was slid into a narrow slit in the middle. Meanwhile at the Gallery our engineers had delicately adjusted the air-conditioning system to duplicate throughout the Gallery the temperature and humidity which existed at the Louvre. Though the Louvre itself is not air-conditioned, because of its huge spaces enclosing vast volumes of air there is no rapid change during the year in relative humidity. This was the environment the *Mona Lisa* was accustomed to, and we knew any deviation might be disastrous. Thus, before she arrived, the atmosphere of her temporary home simulated the very air she had breathed in Paris.

The cost of her trip, which was borne by the French government, was considerable. She traveled in her own cabin on the S.S. *France,* with on one side a cabin for guards, and on the other a cabin for French curators. One evening some joker put a pair of women's shoes outside her door! She had been transported in a special van to the ship, and I met her in New York with the Gallery's truck, which had been padded with foam rubber. We motored to Washington with an escort of police, some riding with us and others joining us in relays.

Our delicate lady arrived just before Christmas, but as the President

and M. Malraux were on holiday, the unveiling could not take place until January 8, 1963. This allowed her a period of convalescence. Her lady-in-waiting, Mme. Hours, was in constant attendance, and I visited her daily.

Finally the great moment for her debut arrived. I had arranged in the West Sculpture Hall her throne, and around it, on a dais, seats for the President, Vice-President, Cabinet, and the Supreme Court; and opposite, on another dais, places for M. Malraux, the French ambassador, and other French officials. Everything was in order, and I went to a special entrance of the building to receive the most distinguished guests ever to come to the Gallery at one time.

The President, Mrs. Kennedy, the Vice-President, and Mrs. Johnson arrived together, followed by M. Malraux and his entourage. I escorted them with their Secret Service guards to a special elevator, which was to take them to the main floor. We entered; we waited; the elevator did not rise! The President, not wishing to be trapped, bolted for the elevator door, which was still open, and ran up the stairs. The Vice-President, who had just suffered a coronary, bravely followed. The Secret Service and I scrambled after them, and I guided them and the French delegation to their seats.

M. Malraux was to open the ceremonies with a speech. I had read it, and it was of great eloquence and beauty. His mouth opened and closed, but no sound reached the senators, the congressmen, the diplomatic corps, and assorted government officials massed in front of him. The loudspeaking system had collapsed. He continued heroically addressing people now restive and increasingly noisy as they heard nothing. When he finished, Mr. Kennedy rose to reply. I never admired the President more! He shouted defiantly, and with a voice trained by many political campaigns, made the audience, now somewhat quieter, hear a certain amount. He extemporized, told jokes, and saved what was possible to save of the evening.

I had reached a point where any sharp instrument would have invited suicide. In utter misery I accompanied my distinguished guests to their cars. As Mrs. Johnson was leaving, she took my arm and drew me aside. She said she knew how I was feeling. But she added, "I feel worse! I did not look at the invitation which read 'black tie,' and I told Lyndon he had to wear a white tie."

The Vice-President, sitting on the dais next to the President, had been the only person in the entire assembly in full evening dress. After that night, so far as I know, he never wore a white tie again, and when he

The unveiling of the *Mona Lisa* at the National Gallery of Art, January 8, 1963. The loudspeaker system had collapsed and President Kennedy shouted defiantly, with a voice trained by many political campaigns. Mrs. Malraux, Mrs. Kennedy, and André Malraux seated at left.

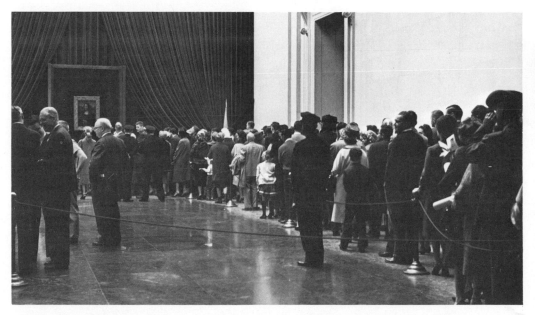

Crowds line up to view the *Mona Lisa* on display at the National Gallery of Art in January, 1963.

became President tails were never to be seen at the White House. Mrs. Johnson's few words that night, however, restored my will to live and I have been grateful to her ever since.

The next morning I received a letter from Mrs. Kennedy I shall always treasure. She wrote,

> Dear John,
> The President feels . . . that it was a wonderful occasion. . . . You mustn't brood and make it worse in your mind. . . . It is, as Malraux said, part of the magic of the Mona Lisa, almost an evil spell. She made it worthwhile and continues to do so every day. . . . If you think a microphone going off was bad — wait until you see what happens when they see the Blue Room white! [This refers to the redecoration of the White House which I mention on page 257.] So please don't ever have a backward thought again, and just think about how beautifully you have hung the picture, and how happy it makes everyone to have it there with you watching over it.

New York was added to the *Mona Lisa*'s tour, and in the next two months over two million people queued up to glance quickly at one painting and pass on. The Super-Star was so carefully guarded that no untoward incident occurred, except that her ever-present lady-in-waiting, Mme. Hours, was almost bayoneted by a marine when she leaned forward to inspect her charge. But there were amusing happenings: for example, the arrival at the National Gallery of His Excellency Signor Fanfani, at that time the Italian Prime Minister, for a press conference to point out that Leonardo da Vinci was Italian, not French; and the small boy who waited in line for hours and when he got to the picture opened his coat and let his dog peek out for a quick glimpse, then vanished before the guards could stop him. Such occurrences made me laugh, but I was not amused by the man who asked one of our guards in my presence what the building was used for when the *Mona Lisa* wasn't there!

But what was the significance of those endless lines of people who waited for hours for a quick glimpse of a sinisterly smiling lady? This is a question I asked myself many times as I accompanied her back to her home in the Louvre. The problem absorbed me, for here, I felt, was a basic clue to the significance of my profession. On a recent visit to Japan I had noticed the same phenomenon. I had seen thousands of

Japanese in temples and shrines filing past famous statues, giving them a rapid glance and passing on. These busloads of tourists were obviously worshipers, but they were worshiping in a new way, with guidebooks and cameras. Wasn't the *Mona Lisa* also, I wondered, an icon of this novel religion, cultural sightseeing? In Communist countries, apart from devotion to the state, it is the only faith encouraged. In the free world, judging by tourism and attendance at art exhibitions, conversions have been spectacular. I decided I was the custodian of a precious relic belonging to a sect whose priests are professionals like myself, whose evangelists are writers on art, and whose pilgrimage sites are either architectural monuments or works of art assembled in museums.

As with other religions the communicants are divided between the superficial and the truly devout. In the first group are those who expect to acquire grace by merely looking at certain famous buildings or objects. Scrutiny, analysis, contemplation they consider unnecessary. Recognition is all that is required; presence alone entitles the spectator to an emanation of culture somehow beneficial. Most of the people who queued up to see the *Mona Lisa* subscribe to this heresy. Then there are the true believers. To them works of art are sacraments to be consumed with profound attention, even reverence. They are the people who return constantly to museums. They justify the maintenance of public collections. They are the elect.

That there are splendid galleries for them to visit is due largely to private collectors — very few great works of art have been acquired with public funds. In the following chapters I have sketched the profiles of a number of outstanding benefactors who have made or intend to make immense donations to American museums. There is a solitary exception, Calouste Gulbenkian, whose benefactions slipped through my fingers. I have also included the portraits of a few critics and scholars whose writings and activities have helped to spread the worship of art, the only religion waxing in our modern culture. They are all people I have known more or less intimately, again with one exception, Isabella Stewart Gardner. In her case my communing has been with her ghost, but so powerful was her personality that a ghostly impact is still embedded in my mind, and during my college years her spirit enthralled me.

4

The Ghost
in Fenway Court:
Isabella Stewart Gardner

As I have said, Isabella Stewart Gardner is the only collector in this book I have not known personally; but although she had died two years before I arrived at Harvard, she still haunts Fenway Court, the museum she established; and if I did not know her in the flesh, I certainly knew her in the spirit. Of all collectors she is the one I am most curious to meet in the next world. There are so many questions I would like to ask: What did she really think of Boston? Was she Bernard Berenson's mistress? Who were her lovers or were there any? Who gave her the brilliant idea of immobilizing the installation of her museum by saying that if anything were added or the general arrangement changed, all her real estate and treasures were to be sold and the proceeds to go to Harvard? I could talk to her endlessly. She was our American Cleopatra. No wonder Bernard Berenson always referred to her as The Serpent of the Charles. He also used to call her a "pre-cinema star" which she certainly was.

Mrs. Gardner with the utmost skill ensured that all her paintings

would remain in her museum. It did not occur to her to ensure that all the paint would remain on her paintings. On page 54 I expressed my reservations about the modern passion for cleaning pictures. Restoration usually represents major surgery and is often necessary; but under the knife of even the most skillful surgeon the human patient during an operation runs a risk and afterward requires time to convalesce. Nature may eventually heal the wound, but nature does nothing to help works of art recuperate.

The Gardner collection since I left Harvard has been thoroughly cleaned. As a consequence the famous Pesellino *Triumphs* might now be entitled *Triumphs of Death,* for a number of the figures look like exhumed corpses; Rubens' *Earl of Arundel* seems to have lost his left arm; Lucretia in Botticelli's *cassone* plunges her dagger into some amorphous substance once her breasts. I could go on, but suffice it to say that a number of the pictures are to my eyes wraiths, as though they wished to join their mistress in her astral form. Fortunately this is merely due to the application of vinyl acetate covered with a layer of wax in emulsion. The removal of this now discredited surface coating without damaging the pigments underneath, though a delicate operation, is feasible. This done, many of the paintings should then recover their pristine beauty.

But much more important is whether these and thousands of other pictures have been harmed by cleaning. There is no doubt that it is necessary to clean certain paintings. About this there can be no possible argument. But statements I have heard from many restorers linger in my memory. When they clean a picture they so often say, "We have, of course, removed only old repaint. But what a tragedy it is that so much of the original was lost in an earlier cleaning!" Is it not possible that the previous cleaner may have made the same remark and so on back to the first time the work of art was restored? Is it not possible that each cleaner is a little guilty, that each has dissolved a bit of the original? How many hundreds of pictures I have seen where everyone agrees that in the past they were overcleaned! But, the restorers complacently remark, this will never happen again. All the original pigment and all those delicate glazes so difficult to distinguish from old varnish will be perfectly safe this time. There is nothing to fear, they say, as their swabs of cotton loaded with solvent brush across the surfaces. I hope so but I am not sure.

Endlessly controversial are the discussions about whether to compensate for losses revealed by cleaning. There is a standard argument

against repainting. Basically it is that we no longer patch up old statues. Therefore it is justifiable to show paintings in their ruined condition. But the analogy is fallacious. A statue is an existent, three-dimensional object. A painting is an illusion. Destroy this illusion and much of the pleasure we get from the picture also vanishes. Pictorial effect in the Old Masters depends on the suggestion of reality, whereas a piece of sculpture is reality itself. I am sure Mrs. Gardner would agree. If she is in Purgatory and is aware of what is happening on earth, the cleaning of her pictures and their coating with dull wax must be a disillusionment and possibly a torment. Forty years ago I knew her paintings well, and their present appearance in certain cases I must admit saddens me greatly.

While I was an undergraduate I loitered so many days in Fenway Court that the circle of Isabella's friends and/or lovers whose portraits, photographs and letters surrounded me might have cried, "La Belle Dame sans Merci hath thee in thrall." I read about her, talked about her, dreamed about her forty years ago, and I find her spell still lingers.

To write about her Venetian palace in the Boston Fens, an amazing monument to her pride, is a nostalgic experience, but also, for an aging museum professional, a perplexing task.

In the first place, one is not sure whether it is the best or the worst museum in America. Many of the paintings are badly lighted, they are often crowded, there is everywhere a multiplicity of details which distract from a concentrated observation of any one feature. There is some attempt at a chronological arrangement, but it is so flexible that paintings by Bartholomé Bermejo and Louis Kronberg are hung in the same room. The whole is an anachronism in an age of well-ordered museum collections; and yet it is far closer to that age of connoisseurship *par excellence*, the eighteenth century, than any other museum in America. People who lived during the *ancien régime* lacked our visual sophistication and liked art for very impure reasons such as subject or association — but still art played a more important role in life at Versailles than it does today. We are better savants but inferior connoisseurs.

Mrs. Gardner's collection is that of a remarkable connoisseur, even though her connoisseurship depended on others. When her group of advisors persuaded her to make a purchase, her reaction was emotional, not intellectual; and this was the response she also wanted from those who were finally allowed to enter her museum. She did not hesitate to stimulate their emotions in unorthodox ways. Thus when one enters

one is still overwhelmed by the heavy scent of flowers, while in the old days, though, alas, no longer, a song would drift down from a Venetian balcony sung by one of the guards in a neat, blue uniform. One was led to expect entertainment rather than instruction. Mrs. Gardner would have been horrified by the thought of the science of "museology" being applied to Fenway Court.

She had her own theories about museums, however, and she was a lady of strong convictions. In 1907 she wrote a friend from Europe, "I feel about the Louvre and many museums as I did about the Prado. If only I could take hold! Some things are so wonderful and yet so badly presented and such a lot of not-good. Poor museums! Strength of mind they do need — and taste."

Mrs. Gardner "taking hold" of the Louvre and the Prado is a charming thought. Also there is no doubt she had "strength of mind" and we must grant her "taste" — but in psychology she was less gifted. In creating her own museum there was something she overlooked: people are apt to find mausoleums slightly unpleasant. At Fenway Court one has the impression that a funeral is just over. The plethora of flowers, fewer now than in the days of the first director, Morris Carter, suggests the undertaker's recent departure. I am so vividly aware of this mortuary atmosphere that, being naturally superstitious, I expect to see Mrs. Gardner's apparition in every room. For not only did she impress her salient personality upon a hard and resisting society in a way that has lasted half a century, but she so interwove it with her palace and her collections that they can never be disassociated.

It may have been some consolation to her when she arrived in Boston in 1860 to know that by converting the family name of Stewart, through some personal alchemy, into the royal name of Stuart, she could claim Mary Queen of Scots as an ancestress. Backed by this distinguished, if dubious, genealogy, she was later to meet the hostility of the dowagers of Boston with the same courage Mary showed toward Elizabeth.

But probably the coldness of her reception in Back Bay did not make a great deal of difference. She was twenty, completely absorbed in her love for her husband, and by nature shy and retiring. That her father was a New York millionaire who had made his money first as an importer and then in mining seemed no disgrace to her. Nevertheless, by the elaborate caste system of Boston, then the most rigid in the whole Republic but since surpassed by many midwestern towns, Jack Gardner

had obviously married below his station; but, as events turned out, it was his wife who carried him along in the wake of her almost unbelievable popularity.

Shortly after her marriage her first and only child was born, and she was told that she could never have another. For that reason this quiet, demure, little person, who did not like society, centered her whole being on her son, Jackie. But he was very delicate, and three years later, in 1865, he died.

Mrs. Gardner was prostrated. Her extremely sensitive nature was unable to recover from so intense a sorrow, and she became ill and melancholy to an alarming degree. For two years her depression continued until at last the only chance for her recovery seemed to be a change of scene. She was taken to a steamer in an ambulance and carried aboard on a stretcher. Many of her friends thought the trip would kill her, and for a time no one could tell what the result would be.

Then a change occurred. Her health improved, and she approached life from a different angle. She slowly developed a new character. She became the Mrs. Gardner of legend. What brought this about is, like every other vital mental alteration, a mystery. When Plato wrote, "Men . . . betake themselves to women and beget children — this is the character of their love; their offspring, as they hope, will preserve their memory and give them the blessedness and immortality which they desire," he stated the motive of many human actions. It probably applies in the case of Mrs. Gardner. While she had the hope of living through her child, her family was all-important. The apparent continuity of life made death too distant to matter. But when her baby died, that "remote and lonely shore" suddenly came appallingly close. For the first time she recognized impermanence and oblivion. She was stunned, but then she recovered, and in turn became above everything greedy for life. "World, World, I cannot get thee close enough." Such a reaction to her tragedy would explain many of her actions, and with this in mind her escapades take on a new and touching significance. They are simply the attempts of a sensitive but not very gifted nature to press from life every possible experience and to leave behind some permanent memorial.

When she returned to Boston, she was quite different from the demure and retiring wife she had been. Instead, she had become gay, effervescent, exuberant, reckless. She could have had any man she wanted, married or single, witty or dull. Her entrance into the Assemblies with her arms full of bouquets sent by admirers was the excite-

ment of the evening. When a rival tried the same trick, collecting as many bouquets as she could, Mrs. Gardner arrived with a single flower pinned to her dress.

She became a prodigious flirt. Once at a musicale she found the guest of honor captivating, but during the concert she saw that he had been captured by two dowager guardians. She pretended to be taken ill, coughing enough to call attention to herself, and then dashing from the room. Her alarmed hostess asked the guest to see if he could assist her. The gentleman left his seat and never returned. Certain Boston ladies looked upon themselves as certified accountants of her love affairs, but they had little to go on, for she always followed an admonition inscribed above her bathtub, "Think much, speak little, write nothing."

They could, however, justifiably claim that she was an exhibitionist. She paraded around the zoo with a lion on a leash; she sat in the front row of prizefights; she drank beer instead of sherry at Pops concerts; she wore dresses from Worth so décolleté and tight-fitting that she was conspicuous everywhere. She had innumerable friends among men but very few among ladies. Scandal was ever-present but always nebulous. Nevertheless, many mothers would not let their daughters associate with her. At last in exasperation, when asked to subscribe to the Charitable Eye and Ear Infirmary, she replied that she did not know there was a charitable eye or ear in Boston. But through it all remains the dim figure of her husband still loyal, willing even to hire a locomotive for her when she had missed her train, and always declaring that he enjoyed the admiration that other men gave his wife.

He must, however, have felt it a relief when they were in Europe. They had sailed the second time because the death of Mrs. Gardner's brother had meant mourning, and she could not bear to waste a moment in inactivity. But wherever he went on that or any other trip, he could never feel really secure. In Paris there was Jimmy Whistler, in London Henry James, in Florence Bernard Berenson, in Rome the king of Italy himself, whom Mrs. Gardner somewhat startled by a gift of flowers, and whose wife sent a special equerry to ask an elucidation, throwing the whole American embassy into turmoil.

As she grew older, however, the tempo of her life slowed a little and became steadier. She turned to the cultivation of friendship "per se." At her house there were always charming people, James Russell Lowell, William James, Henry Adams, Oliver Wendell Holmes, Julia Ward Howe, Higginson, and Charles Eliot Norton.

Her musicales were famous. When the Boston Symphony Orchestra

came several times to her home to play and Paderewski and the De
Reszke brothers gave private recitals for her, society at last capitulated.
It was ridiculous to refuse Mrs. Gardner's invitations. Think what one
might miss! She might be excessively ostentatious, but she was generally
on the side of the angels as far as clever people went.

As her life became quieter a dread of oblivion returned. It is sig-
nificant that the only thing Mrs. Gardner ever admitted being afraid of
was the dark. She always slept with a light, and if she went to a play
where she knew there would be a moment of blackness she would use a
flashlight. Her fear of ceasing to exist was expressed subconsciously by
this terror. Darkness meant for her extinction.

But outwardly her dread took the form of having innumerable
portraits painted, something she had not had time to do for the first
forty-eight years of her life. Whistler was first with a pastel. Then
came Sargent's celebrated painting of 1888, which caused so much
comment that the mild Mr. Gardner ordered it should not be exhibited
while he was alive. Others followed, until she had probably sat to as
many painters as any woman of her time. Besides Whistler and Sargent,
Zorn, Passini, Bunker and other minor artists all found a remarkable
amount of inspiration in portraying her over and over again. And yet
she was far from perfectly beautiful, though she had fragments of
perfect beauty of which her arms were an example; but because her
small head with its tightly-pressed reddish-blond hair, her wasp waist,
and her striking carriage were so entirely devoid of prettiness or
superficial grace, painters were faced with a subject that required
unusual dexterity of handling to show forth her indubitable charm; and
as a result, whatever else may be said of Fenway Court, it does not
contain a single mediocre portrait of Mrs. Gardner.

The same desire to be remembered is expressed in her collections,
which were begun about this time. Letters, inscribed books, autographs,
jewels, anything that might remain after her death and remind people
of her, she gathered together. The plan of a museum did not come until
later. Though a bequest of $2,750,000 from her father caused her to
make a few desultory purchases of works of art — an unfortunate
Filippo Lippi and a Cranach that turned out to be studio work — she
was more interested in the Barbizon painters than in the Old Masters.
Her many sightseeing expeditions in Venice do not seem to have
improved her taste. It took Bernard Berenson's persuasive rhetoric, as
will be seen in the next chapter, to make her a collector. He did what
her friend Charles Eliot Norton, the exalted Harvard professor, who

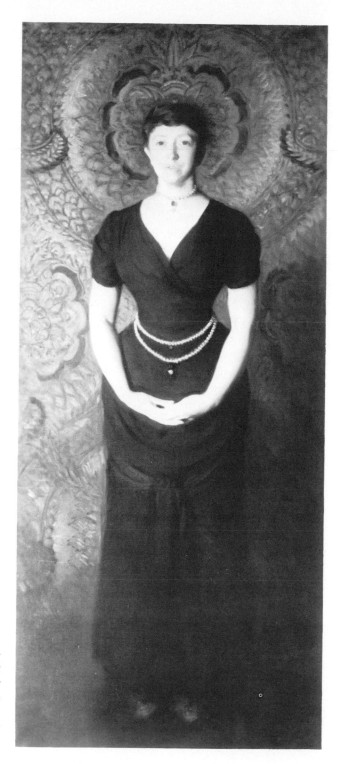

John Singer Sargent, *Portrait of Isabella Stewart Gardner*. Mr. Gardner would not allow it to be shown during his lifetime. Isabella Stewart Gardner Museum, Boston.

taught the history of art without mentioning painting, could not do —
he gave her some standards of quality. He acted as her agent, receiving
5 percent commission; and on his advice she bought amazingly cheaply.
The art consciousness of American millionaires was still unawakened
and masterpieces were going for almost nothing. Take, for example, the
painting by Vermeer for which she paid only seven thousand dollars
and which is now worth at least two million dollars. Berenson used to
say, perhaps unfairly, that though she did not greatly appreciate art,
what she bought staggeringly appreciated!

Many of the paintings in her collection Mrs. Gardner never saw until
after their purchase. Berenson would cable that a Titian or Velázquez
was for sale and would she buy it? After a tantalizing delay she usually
answered yes, and then when the picture had arrived the United States
Customs would hold it for some exorbitant duty. Finally, with endless
trouble and occasional lawsuits, it would be released. In those days it
often cost as much to get works of art into this country as it did to buy
them and ship them out of Europe.

Though it must be admitted that Mrs. Gardner depended heavily on
advisors in the acquisition of her masterpieces, still, Fenway Court,
where they are now hung, is entirely her own creation. It was started in
1899 shortly after Mr. Gardner's death. She was under the mistaken
impression that a great part of her capital had vanished, and later she
felt called upon to practice the strictest economy.

In youth extravagant, in old age niggardly, she never ceased to hold
the attention of the public. She gave up her horses, reduced the number
of her servants, fed her guests so little that the rugged Zorn said he had
nothing to eat on one visit but oatmeal, and constantly lamented her
poverty. Someone suggested that she should go begging for alms,
wearing her seven ropes of pearls and playing her Stradivarius. There
is a charming story of her sending Morris Carter, her biographer and
later the director of her museum, to the corner store every day to buy
an orange. Frightened as he was of his patroness, one day he decided he
would save himself a trip and buy two oranges. The scale of his pur-
chase surprised the clerk. "The old lady going to throw a party?" he
asked.

Perhaps such rigid economy was after all necessary to pay for a
Venetian palace built almost entirely of material brought from Europe.
She had the love of some Americans for everything old, and the corre-
sponding irrational hatred of modern methods. There were to be no steel
girders in Fenway Court, no matter how cleverly hidden, and the whole

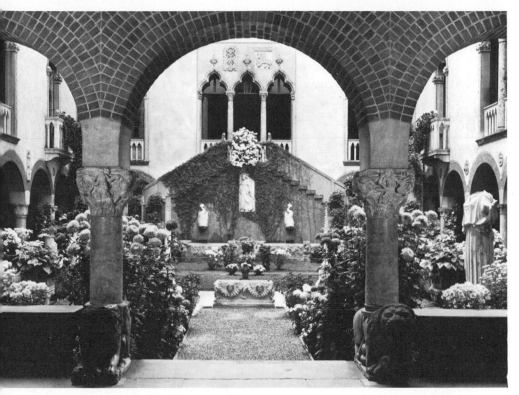

Fenway Court, Boston, which Mrs. Gardner built as a memorial to herself.
Isabella Stewart Gardner Museum, Boston.

building was to rest on ancient Venetian columns. The contractors said it could not be done, but Mrs. Gardner stuck to her motto, "C'est mon plaisir," and Fenway Court is still standing, though some steel had finally to be added to the columns after one gave way. In the court the painters wanted to give a smooth, shiny finish to the walls, but to their horror Mrs. Gardner mounted the scaffolding, grabbed a sponge, and showed them how to make everything look as though it had been rained on for centuries. Every day while the house was being built she came early in the morning and stayed until late at night, even eating her lunch with her workmen.

Aline Saarinen, the widow of the famous architect Eero Saarinen, has written feelingly about the sufferings of Mrs. Gardner's two architects, Willard T. Sears and Edward Nichols. "The professional gentlemen were treated, at best, as competent draughtsmen, and, at worst, as irritating obstacles who fussed about such irksome details as city codes and structural safety. . . . Her imperiousness reached its zenith. . . . She

took personal charge of logistics. The hundreds of cases of architectural paraphernalia were unpacked and placed in the warehouses in the exact order in which she wanted them used. . . . One of the Italian workmen, Teobaldi Travi, called 'Bolgi,' became her favorite and acted as her personal attendant . . . He would summon the master workmen she wanted by playing various numbers of toots on a cornet. She dealt with them directly. . . . Sears was constantly torn between workmen who wanted to quit because Mrs. Gardner had 'pitched into them' and an owner who kept dictatorially ordering him to discharge all the carpenters, fire all the masons, send all the plasterers away. . . . Only once did he take sides: he discharged the floor layers in the Gothic room for mimicking her when she chided them for not working."

There was never a greater showman than Mrs. Gardner. She had built Fenway Court as a memorial to herself. But when completed she wanted it to be the focus of everyone's interest; therefore she made it the mystery of the day. No one had the least idea of its purpose, or even what it was to be like. She had imported all of her workmen from Europe. They were sworn to secrecy, and moreover, could not speak English. When the building was nearly completed, it was necessary to try out the acoustics of the music room. As she wanted no one to see the inside of her house until it was finished, she sent for an orchestra from the Institute for the Blind. Things like that filled the newspapers, and Mrs. Gardner was discussed everywhere.

When at last the evening came to open her house, she invited everyone who had ever snubbed her, and in a regal manner received their homage, not a little to their discomfiture. But the humiliation was forgotten in the splendor Mrs. Gardner had conjured up, which contrasted so strikingly with the drabness of the rest of Boston.

From then until her death, she opened her house for three days each year to the public. Only six hundred tickets were sold, and reservations were made weeks in advance. No one was allowed to revisit a room, and when it was time to close, everyone was hurried out. In that way no one's curiosity had a chance to be entirely satisfied, and Mrs. Gardner could be assured of continued interest.

She lived in Fenway Court for more than twenty years until her death in 1924. It seemed impossible that she should not sit there forever serving tea to friends. She who had lived so intensely and triumphantly surely could not cease to exist or ever be forgotten. That was her own belief, and when her final sickness did come, she could not be persuaded of its importance. It had taken sixty years to get rid of the fear her

baby's death had implanted in her, and now her faith in the stability of life was not to be easily shaken. Her illness was nothing; she would be all right soon. Surrounded by so many immortal works of art, she could not believe in her own mortality. Nevertheless, she died. But Fenway Court remains her imploring cry, still to be sought after by the living. Flowers were once kept in front of her portrait, which seems appropriate, and it is a pity they are no longer there.

After fifty years it is still an eerie experience to revisit Fenway Court, which is in so many ways like an Egyptian mastaba. The astral body of Isabella Stewart Gardner is omnipresent. She attained her goal, the goal of many collectors, survival through her works of art; and therefore though I never met her, because of her connection with Bernard Berenson and thus indirectly because of her effect on my life, it seems fitting that her ghost should be included in my collection.

5

Life At I Tatti: Bernard Berenson

Bernard Berenson, or B. B. as he was known to his friends, insisted he was not a collector himself. Having spent much of his life with collectors and having made his fortune from reassuring their uncertainties, he emphatically refused to be placed in that category. He owned a number of works of art, certainly, but he had never formed a collection. This was a distinction he insisted on. Everything he bought was acquired to form part of the decoration of his home, a villa outside Florence called I Tatti. Each work of art was intended for a particular place. If one moved an object for any reason, B. B. would immediately notice and crossly ask for an explanation. Even if one shifted a bronze a few inches there would be a reaction, and his trembling fingers almost unconsciously would return it to its original location, and to its exact position.

Such fussiness may seem unlovable, and yet those who knew him well loved him dearly. His death in the autumn of 1959 at the age of

Nicky Mariano, Bernard Berenson and John Walker. What happiness they gave me!

The chair B. B. sat in, under the *Madonna and Child* by Domenico Veneziano. (Bazzechi Fote)

ninety-four left a void in my life. Though I lived with him only three years, I continued to reside in Italy for about eight years, during which time we were together a great deal, and after World War Two until his death I visited him every summer.

It is difficult to say what my role in the household was. I was certainly a pupil, though I received no formal instruction; I was something of a research assistant, though my undergraduate education had given me little preparation for the high level of scholarship required; and I was undoubtedly a disciple, eagerly absorbing some of the most brilliant conversation of our time. When B. B. died I was one of the two executors of his will, under which I Tatti became a branch of Harvard University, his alma mater.

Friendships are unpredictable. Mine with B. B. would probably never have begun had it not been for Nicky Mariano, B. B.'s secretary. It was the warmth of her greeting that first day, when I had a strong inclination to bolt and return to America, which caused me to stay. Over the years I came to know how often she shielded the intimidated visitor from B. B.'s searing comments, how skillfully she turned aside those thunderbolts of teasing, which were so often entirely disproportionate, and which without her intervention would have struck his visitors with what I came to fear most, taciturnity. For then there would have followed the ghastly void, when all conversation ceased, something never to be permitted, something always avoided by Nicky's tact.

But on that first afternoon there was no lack of conversation. By the time B. B. had entered the room Nicky's presence had restored my courage. We discussed many things, including modern architecture. While at Harvard I had become a friend of Buckminster Fuller, then a young man. In the Harvard Society for Contemporary Art, we had shown, I believe for the first time, his Dymaxion House. My enthusiasm for American architecture was unbounded. I felt our skyscrapers to be the great artistic achievement of the twentieth century. B. B. disagreed, and I had the courage to argue violently, which he liked. I recall his saying that the towers of San Gimignano gave a more impressive effect of mass and volume than the tallest skyscraper in New York; that American buildings looked like toy models, since there was nothing to give them scale. I had just been at San Gimignano, and I remembered looking up from the valley at those tall towers silhouetted against the evening sky. What B. B. had said was a revelation, and I admitted the truth of his remarks. That cemented our friendship. There was nothing

he loved more than a discussion which ended in agreement — agreement that he was right.

I soon had my desk in the library, and a little later the occupancy of a wisteria-covered *villino* in an adjacent olive grove. The happiness of those years is impossible to convey. Daily life had a routine. After a leisurely breakfast before a fire in winter, or on the terrace of my *villino* in other seasons, I would walk the few hundred yards to I Tatti. Then would follow two hours of solid work, writing one's own articles or helping B. B. with his catalogue of Florentine drawings. At eleven he would appear in the library, ready for a walk in the garden. A butler would ceremoniously wrap him in shawls, help him on with his coat, and hand him his cane.

We would then stroll slowly down a long grass-covered slope, carpeted with wild flowers much of the year, and walk beside a stream which flowed through the less cultivated part of the garden. Further on there was the traditional *"bosco"* where dappled sunshine fell through the thickly wooded grove. Then up another slope with an alley of cypresses. Usually we avoided the central part of the garden. It had been laid out by Geoffrey Scott and Cecil Pinsent. It was planted in the formal style of the eighteenth century with parterres and box. B. B. tended to shun these geometrical paths, perhaps because they were not shaded, possibly because there were too many steps, but most likely because they reminded him of the taste of Geoffrey Scott, his former secretary, dead for some time, with whom B. B.'s two ladies, his wife and Nicky Mariano, had fallen successively, if not successfully, in love.

We then returned to the house to work for an hour more. B. B. wrote in his study, to which one was occasionally summoned when he could not find a photograph or a book he wanted. But most of the time I wandered around the library continuing my desultory research.

Nicky's sister, Alda Anrep, was the librarian. She came to B. B. without the slightest training, and she devised her own system of cataloguing. As she knew every book in the huge library, however, it was always easier to ask her to find what one wanted than to consult her leather-bound catalogues. Only occasionally was she at a loss to locate anything, and then it was because some visitor had replaced the book incorrectly. When this happened, and B. B. wanted that particular volume, there would be rages and tantrums in his study, and Nicky would come to us pale and shattered. A moment later B. B. would follow her into the library, exclaiming bitterly that he had worked better when

I Tatti, now a branch of Harvard, which was always B. B.'s dream.

B. B. and Mary. Theirs was a marriage which could have ended in disaster but it was held together by the woman who would have benefited most by its dissolution, Nicky Mariano, adored by B. B. and regarded with affection by Mary.

he had only a few books and knew where they were. We, his secretary, his librarian, and whatever I was would divide up and scan every shelf until the delinquent book was found. Afterward we would sit down and curse B. B.'s hospitality to itinerant scholars.

At one o'clock a gong would sound announcing lunch. The staff, Nicky, Alda, and I would assemble in the *salone* with whatever guests were staying in the house or had been invited for the meal. We would all stand more or less in a circle sipping vermouth until the arrival of B. B., who would greet each in turn, in much the same way that royalty customarily receives visitors. Then we would proceed to the dining room.

At first one talked to the person on either side, in a variety of languages, mine impossibly accented and grammatically erratic. (B. B. claimed to know twenty-four languages, which was probably only a slight exaggeration.) The trick, however, was to stop these duets at the right moment, and shift to general conversation so that the master could cast his spell over us all.

Lunch finished, most of the year we repaired to an *orangerie*, a kind of loggia, overlooking the garden, where coffee was served and conversation continued. At about three B. B. would dismiss his court and retire for his siesta. After an hour's rest we would reassemble, and B. B. with Nicky and myself or a favorite guest would climb into an ancient Fiat and be driven by Parry, the chauffeur, who had been in attendance even longer than the car, to one of a number of walks above Settignano, each with its name for Parry's identification. Until he was over ninety B. B. scrambled up and down these stony Tuscan paths, talking endlessly, stopping occasionally to point out some beauty he loved or to make a particular point to his auditors.

Parry would then meet us farther down the road to I Tatti and we would drive back for tea. By then new visitors would have arrived and would have to be rotated to the chair beside B. B. From six to eight one worked again, then dressed for dinner, always black tie, sipped vermouth in another *salone*, and awaited our host's arrival, usually making conversation with a third set of guests. Dinner, when the weather was warm, was served in the garden with the candles twinkling amidst swarms of fireflies, one of the sights I remember with the greatest delight. Then back to the library for more talk unless we were alone. On those rare but joyous occasions when there were no guests Nicky would read aloud. How enchanting was her lovely Baltic accent, each word so clearly enunciated, and yet a marvelous speed maintained; and then

when the reading had stopped B. B.'s beautiful modulated voice commenting on what he had listened to. Sometimes his wife, Mary Berenson, would read. I can still hear her slight lisp and Oxford pronunciation so carefully cultivated that nothing of Philadelphia, her birthplace, remained.

I have not spoken of Mary before, because during the years I spent with B. B. she was so often confined to her room with illness, real or imaginary; yet her presence, even when she was not with us, was a central factor in life at I Tatti. B. B. once told me of the first time he met her. He had sat next to her at a dinner in London. She was very beautiful, and was dressed, he recalled half a century later, in pink. It was love at first sight. She was the daughter of a well-to-do Quaker revivalist, who had brought his family to England. She had become a Catholic and married a leader of English Catholicism. They had two children, but neither the Church nor her family responsibilities prevented her departing with B. B. for Fiesole. There they seem to have lived together for several years before the death of her husband made possible their marriage. Meanwhile B. B. had also joined the Catholic Church. One wonders how this was reconciled with adultery, or perhaps their love remained until their marriage platonic. In any event both soon left the Church and Mary Berenson eventually became bitterly anti-Catholic.

She was one of the most complex and difficult characters I have known. Ceaselessly intriguing and indescribably avaricious for the children she had deserted; ready, as B. B. would say, "to cut us all up for the benefit of a new friend"; exuberantly optimistic one day, miserably depressed the next, with all of the symptoms of a manic-depressive, this fantastic being was kept in some sort of balance, at least enough to avoid suicide, by Nicky's patience and affection. Yet all of us loved her and admired her intellectual honesty and generosity of spirit.

Relationships at I Tatti were potentially explosive. B. B. and Mary were totally different, not only in appearance but also in character. He was slight and delicately built; she was majestic and massively proportioned; he was deliberate and fastidious; she was impulsive and untidy; he was cosmopolitan with that adaptability to all cultures characteristic of his Jewish ancestry; she was parochial, with that intensification of national characteristics which sometimes follows on expatriation. B. B. adored the New England in which he grew up; Mary hated her Philadelphia background. Yet he remained European, and she never ceased to be American. It was a marriage which could have ended in disaster. But

it was held together by the woman who would have benefited most by its dissolution, by the enchanting and romantic Nicky Mariano, who was adored deeply by husband and wife.

Joubert once said, "Choose in marriage a woman whom you would choose as a friend if she were a man." This is not the romantic way B. B. chose his wife, but it is an excellent way to choose a secretary. With time, however, Nicky Mariano became much more than a secretary to the Berensons. She became the essential support of their lives. Yet just after the First World War, when Mary Berenson brought this impoverished and beautiful young woman, half Italian bourgeoise and half Baltic noble, to I Tatti, she was employed as a mere secretary-librarian, with no experience, as she said, in either job. Ten years later when I arrived and found myself a part of the small Berenson court, Nicky was both majordomo and prime minister, both guardian angel to the king and lady-in-waiting to the queen. But though the king adored his guardian angel, the queen was never jealous of her lady-in-waiting.

How beautifully Nicky managed her miniature court! No one ever passed her office on the way to the library, without her beckoning, making life gay and delicious with her smile, asking each person just the question he wanted to be asked. Yet all the time she was seeing that the food was what B. B. liked, that the guests were transported from a dozen Florentine hotels simultaneously, that they had a way to return to the city, that they did not stay too long, that B. B. would not be overtired, that the favorites remained to join him on his walk, especially pretty women, for B. B. never ceased falling in love, that a new group arrived for tea, that another came for dinner, that his rages and flirtations were calmed or encouraged, that all of us were divinely happy.

She was to teach me the most intricate game I have ever played, the game of conversation. I learned how with adroit questions to keep the dialogue going, how to protect B. B. when talk became ponderous or pedantic, how to interject a light remark when the going was hard, how to applaud with laughter an aphorism, how to underline with gravity the profound. When I had become a part of I Tatti I realized that Nicky and I were like stage managers of a production which required that one never permit a moment of silence. Always the conversational ball must be kept in the air so B. B. could show his most brilliant strokes. It was fun, but it was tiring. Nicky's face always lighted up a bit more, I thought, when the butler brought in the camomile and the curtain was ready to descend.

Often B. B.'s guests were not easy. The king of Sweden, for example,

during his sojourn, wished to relax and discuss art and archaeology, not politics, so politicians and journalists were excluded. Prince Paul of Yugoslavia, the regent of that unhappy country, was another frequent visitor. It was vital that he avoid anyone who might compromise his difficult situation. Walter Lippmann, on the other hand, wanted to know what was happening in the opinion of the anti-Fascists who swarmed to I Tatti and whom he could see nowhere else. But perhaps most difficult of all was Edith Wharton, one of B. B.'s favorite guests. Ineffably shy, she could only be exposed to friends she had known. There were not many of these in Florence, and Nicky was delighted to find on one occasion that the novelist Winston Churchill, an old friend of Mrs. Wharton's from New York days, was staying at a local hotel. He was asked to lunch. Afterwards the two novelists were seated on a sofa together, and Mrs. Wharton, making one of her rare efforts to overcome someone else's taciturnity, said, "Mr. Churchill, I have always enjoyed your novels so much, but you haven't published one for years. Why?" "Because," he replied, "I have been locked up for years in an insane asylum." Mrs. Wharton had a coughing fit and fled.

Usually, however, our visiting sovereigns were better protected. Our court life on the whole ran smoothly, but the extraordinary fact remained that there was a court at all. How did it come about that the son of a poor Jewish immigrant from Lithuania should have established the principality of I Tatti, of which Kenneth Clark has written, "There are many more spectacular villas in Italy but none that have played a greater part in the cultural life of Europe — and the United States — for over half a century. People from all over the world — clever people, stupid people, journalists, GIs in uniform, crackpots, philosophers — streamed in through the door and walked rather gingerly up a slippery marble corridor in order to have an audience (this is really the only way of putting it) with Mr. Berenson."

To explain how this came about one must know something of B. B.'s biography. His parents on both sides were Lithuanian Jews. Though not a rabbi, his father, whose name was Valvrojenski, was a man of culture, a student of the Talmud, and of Jewish literature and history. He was in the timber business. Perhaps he would never have left Lithuania, if a fire in 1875 had not destroyed the family homestead. In any case, he departed and with his family arrived in Boston the same year.

It is a tribute to nineteenth-century America that our free educational system could have offered B. B. the intellectual training and

stimulus he received. Let us hope that similar resources are still available to the gifted. With no money spent on education, for there was none to spend, B. B. graduated from Harvard in 1887 with high honors, though not the highest. One of his professors wrote of him, "Bernard Berenson is still very young. I regard him as a man of unusual ability and brilliant promise. 83½%, his average grade, measures his work largely philologically, whereas his heart is in work of a different kind."

What that work was to be Bernard Berenson himself on graduation really did not know. He had contributed to the Harvard *Advocate*, and with George Santayana he had become one of its editors, rising in 1887 to the position of editor-in-chief. What he wrote, reviews, poems, stories, was not much above the average of undergraduate writing. But even as an undergraduate he expressed ideas which he was to develop all his life. For example, a hero of one of his stories had, as he said, "the profoundest admiration for Christianity, not only as an historic fact and still living force, but for its successful symbolization of human life. It is for this reason that he thought Christianity the greatest work of art in the world." This is an opinion B. B. often expressed in later years, and many other similar examples could be cited of the germination of his opinions in his extreme youth.

Even as an undergraduate B. B. was a lover of society. It is extraordinary how his Bostonian values, established when he was at Harvard, remained with him. He was never impressed by the royalty or the nobility of Europe, among whom he had many friends. It was the old families of New England for whom his admiration from a social point of view was reserved. Boston society might be provincial but it was firmly structured.

His principal patroness, Mrs. Jack Gardner, as I have said, was one of the few successful interlopers in those restricted circles. She had become friendly with B. B. when he was an undergraduate, and when he came in second for the Parker Traveling Fellowship she was one of several friends who contributed $750 to send him to Europe. They knew his determination to go abroad and his heartbreak at failure. Europe was his spiritual home; and though he remained throughout his life firmly attached to Boston, its values, its society, the landscape of its environs, he knew from the first it could not provide the life he was resolved to lead. This, he told me, was the life described by Walter Pater in *Marius, the Epicurean* — a book that made such an impression on him that he did not leave his room for several days. It inspired him to try to express in modern terms the ancient philosophy of Epicurus.

This savoring of the delight of existence was to be his goal, but he also had hopes, as he said, of becoming "a poet, a novelist, a thinker, a critic — a new Goethe, in short."

His friends at Harvard who had contributed the munificent purse of $750 to bring about the birth of this new Goethe were less enchanted by the passive pleasures of Epicureanism. They kept a careful eye on their investment and awaited impatiently the hoped-for Goethean transformation. It took longer than they expected. It did not really occur, as we shall see, until the Second World War, some fifty years later. Mrs. Jack Gardner had more faith than the other members of the syndicate and lent B. B. a second $750, which he eventually repaid.

But she too apparently became restive and probably querulous. B. B. was producing nothing. "Time," he admitted, "was slipping through my hands." Her communication with him ceased. During that period he was supported by a friend he never named. Finally in 1894 when his first publication, *The Venetian Painters of the Renaissance,* was in print, he had his publishers send her a volume and wrote, "Your kindness to me at a critical moment is something I have never forgotten and if I let five years go by without writing to you, it has been because I have had nothing to show you that could change the opinion you must have had when you put a stop to our correspondence."

After receiving this indication that her money had not been entirely squandered, Mrs. Gardner felt more kindly toward her protégé, and they arranged to meet in London. In spite of what he said, B. B. had not wasted his time. During these years he had become interested in Italian art and had read Morelli, Crowe and Cavalcaselle, and the new school of art historians who were more scientific and less rhapsodic than their predecessors. To save money he had settled down at Monte Oliveto, a monastery near Siena, and he told me how he used to accompany the abbot on his travels, riding with him in his buggy to the various churches of the region. While the abbot talked to the local priest and collected his tithe, B. B. would look at the altarpieces, frescoes, and devotional paintings.

When he met Mrs. Gardner in London, his ability to discriminate between artists, and his talent for verbalizing his appreciation of their work, were already brilliantly developed. The "Serpent of the Charles," as he used to call her, asked him to take her through the National Gallery. B. B. expounded his views on the various paintings with such eloquence that Mrs. Gardner, who until then had looked upon Landseer as the limit of art, and whose purchases of Old Masters had been dis-

astrous, asked whether it would be possible for her to procure some of the great works of the Renaissance. Remembering the Tuscan churches, the private collections, and the antiquaries he had so often visited, B. B. assured her that nothing would be easier. A business arrangement was worked out, and the collection at Fenway Court was begun.

B. B. was now a collector for others. His first offering to the Gardners was the Ashburnham *Lucretia* by Botticelli, for which they paid $16,500. Today at auction the first bid on such a painting would be thirty to forty times this amount. Though they had had to wait for some years, their $750 investment had paid off handsomely! From then on they bought extensively from B. B. Connoisseurs by proxy, there were very few pictures they ever saw before they were unpacked. Photographs and Berenson's eloquent words were enough.

The climax of his collecting for the Gardners was the purchase of Titian's *Europa and the Bull*. Isabella Gardner had wanted *The Blue Boy*, a picture much more to her taste; but the owner, after fixing a price, had in the end refused to sell. She was angry, and B. B. realized that he had to come up with an alternative quickly. He learned that for £20,000 Lord Darnley could be persuaded to part with his *Europa*. But to get that much money from Mrs. Gardner for one picture, he told me, was a Herculean task. He resorted to the device of saying there was another lady in Boston who had the first refusal, but that if he was authorized to act quickly he could get it away from her. It was a good but insufficient ploy. Mrs. Gardner still hesitated. He then played his ace and pointed out that the painting had originally been intended as a wedding present for Charles I, but when his marriage to the Spanish Infanta fell through it was never delivered. Mrs. Gardner, B. B. knew, had employed a genealogist to trace her descent from the royal Stuarts; and since the *Europa* was originally intended for a Stuart, it "should," as he wrote, "at last rest in the hands of one." She cabled $100,000 at once, and B. B. exclaimed, "Why can't I be with you when the *Europa* is unpacked? America is a land of wonders but this sort of miracle it has not witnessed." Titian's *Europa*, he said, "was the finest picture that would ever again be sold" — words he was to use all too often, but in this case no exaggeration.

These purchases for the Gardners represented the turning point in B. B.'s life. He had started his career as an expert. His new profession gave him for the first time financial security. He could travel at a moment when travel was easy, the countryside and cities still unspoiled. He could participate in a society whose exclusiveness proved no longer a

handicap. He could browse in libraries, search for documents in archives.

With the money from the works of art sold to Mrs. Gardner, he took advantage of his opportunities. He stored his mind with an encyclopedic knowledge of the art and literature of the world, and he trained his eye with a vigorous discipline of connoisseurship. He had a passport which took him everywhere. This passport was his enchanting and stimulating mastery of the spoken word, not only in English, but in all the major European languages.

It is difficult to say whether B. B.'s avocation was talk and his vocation the study of Italian art or vice versa; but certainly his connoisseurship, unfailing in its instinctive response to quality, was what gained him his reputation. Dealers have sometimes tried, by sponsoring the publication of articles and even entire books, to make certain attributions stick to paintings they wish to sell; but all this expensive and often voluminous bibliography fails to do for a picture what the words "Signed Bernard Berenson" would have done. For there is scarcely a desk of a curator of painting in any museum in the world on which Berenson's *Italian Pictures of the Renaissance* in English or in translation is not to be found.

Yet B. B. despised that part of his life spent in expertising. He never escaped a sense of self-betrayal. "I took the wrong turn when I swerved from the more purely intellectual pursuits to one like the archaeological study of art, gaining thereby a troublesome reputation as an 'expert,' " he wrote. "The spiritual loss is great and in consequence I have never regarded myself as other than a failure."

I have quoted these passages of wistful self-accusation, because they are an important part of the chiaroscuro that models B. B.'s portrait. These shadows of regret were cast by the jungle of Fifty-seventh Street, of Bond Street, of the Rue de la Boetie. B. B. was literally dragged into this jungle by the late Lord Duveen of Millbank, who pulled him away from the looser coils of the "Serpent of the Charles," Mrs. Gardner.

It was my impression that Duveen knew very little about paintings and sculpture. He was, however, a man who had the courage of other people's convictions. Once B. B., for example, had attributed a picture to Botticelli, there was never any question in Duveen's mind who had painted the picture, though there might be a lingering doubt in B. B.'s. For it was part of B. B.'s genius that he was always refining his judgment, always looking with a fresh eye.

This infuriated Duveen, and often confused his clients. B. B. came to

know many of them well, Widener, Johnson, Frick, Kress and others. But he was reluctant to talk about these American "squillionaires," as he disparagingly termed them. He knew they were often victimized by the dealers; and he felt as though he were the tethered goat used to attract the prey. Moreover, he found the collectors had little interest in art they did not possess. Possessiveness of this kind bored him; and the owner-ship of art, he noted, had often a dire consequence, a kind of ego-inflation, as though the collector had assisted in the creation of what he bought.

B. B.'s life and fortune were made baptizing works of art. In his parish, as he called it, in baptismal rites for Italian painting from the thirteenth century to the middle of the sixteenth century, he was pre-eminent. His eye for the autograph of the painter has never been equaled. His intuitive conclusions about the authorship of pictures have often been proved correct by documents subsequently discovered. But among the many books he wrote, devoted to scholarship of this type, the only one he really respected was his *Drawings of the Florentine Painters*, perhaps because it had no association with dealing.

What then was B. B.'s relation to the art trade? It was admittedly a relationship which has caused his integrity to suffer many vicious attacks. From frequent conversations with him on this subject I believe, apart from Mrs. Gardner and possibly a few early commissions, he had nothing to do directly with the sale of works of art. There may have been exceptions to this statement, but I know of none. He did, however, receive from Duveen Brothers a retaining fee, as a lawyer would from a client, and for this remuneration he advised on the purchase of Italian paintings and wrote "certificates" authenticating and sometimes unduly praising these pictures.

This association with Duveen Brothers coincided with a change in B. B.'s point of view toward the Renaissance masters. The first lists he compiled and published as a young man were marked by their exclu-siveness. As he grew older he became absorbed by the invention of the master rather than the execution. He recognized that virtually all Italian Renaissance paintings were the product of a shop with assistants almost invariably at work on some part of the picture. He came to care less for the autograph of the master himself than for the evidence that the fundamental drawing, composition, and coloring were his. Conse-quently his lists became more inclusive; and this his numerous enemies claimed revealed a magnanimity, an optimism, traceable to the money he was receiving from Duveen Brothers.

I do not agree, but the case is impossible to prove either way. There is some evidence, however, which should be introduced. For instance, when he was still very young and needed money badly, he came across a portrait of Isabella d'Este, which had been recently sold as an authentic Titian. He brought it to the attention of Isabella Gardner, whose connoisseurship was always favorably affected by likenesses of other and more famous Isabellas. Though the picture was generally accepted as by Titian, B. B. insisted she buy it as a work of Polidoro Lanzani. She paid £600, but if he had told her it was a Titian she would probably have paid £6,000.

I could give other examples, but I shall restrict myself to one in which I played some part. This was the only time, according to Berenson, that Duveen tried to influence his judgment. As a consequence their relationship ended. The incident resulted from an exhibition of Italian paintings held in the early 1930s at the Royal Academy in Burlington House. For the show Kenneth Clark borrowed a picture well-known to students of Italian art, but one that had not been cleaned or exhibited for many years. It was the Allendale *Nativity*, and it proved to be one of the most brilliant stars in that galaxy of masterpieces.

Some time after the close of the exhibition I was with B. B. when a telegram was delivered, which he showed me. It said, PURCHASED ALLENDALE NATIVITY FOR 60,000 GUINEAS [$300,000 at the time] SIGNED, JOE. B. B. said, "If Joe Duveen paid that much for the picture, he must think it is by Giorgione, and it isn't. It is by Titian. Obviously, he thinks he can sell a Giorgione to Mr. Mellon, whereas he can't sell a Titian. He is capable of pretending I too think the picture by Giorgione. Please write his son, who is a friend of yours, and tell him my opinion, so there can be no question." I did; but David Finley told me the picture was never offered to Mr. Mellon. Duveen intended it for a new client, a collector B. B. then knew very little about, Samuel H. Kress. It was sold to Mr. Kress with an attribution to Giorgione. B. B. was furious. Thereafter he would have nothing whatever to do with Duveen Brothers, though this meant the termination of his retainer. It was an expensive break; and, as further evidence of his integrity, it should be remembered that at the end of his life, he published the Allendale picture in his revised list of Venetian paintings (1957) as by Giorgione, or as he put it, by "Giorgione (Virgin and Landscape probably finished by Titian)." Had he agreed to this attribution twenty years earlier, Duveen doubtless would have continued his large annual payments.

B. B.'s earliest books, four on the principal schools of Renaissance

painting in Italy, offered a new approach to pictures and have remained
the best introduction to the study of Italian painting ever written. We,
B. B.'s pupils, used to call them, jokingly and lovingly, the Four
Gospels. They were followed eventually by the book to which I have
referred, an invaluable reference listing, with attributions to individual
artists, all the significant pictures painted in Italy during the Renais-
sance. This volume we called the Book of Revelation. These revelations
were based on endless research and comparison and on the continual
tracing of panels and canvases from one collection to another. B. B.,
during his years of pure scholarship, mapped a continent of artistic
achievement, gave us a basic guide, where scientific charting was sorely
needed. But as the Four Gospels had proven, he was too great a genius
to be a mere cartographer of art.

In his conversation with his friends, as we roamed the Tuscan
countryside, or sat in the loggia of I Tatti, or warmed ourselves before
the bright fire in the library, he used to point out how the effect of
beauty comprised physical sensations, as well as abstract ideas. His
belief in the sensuous nature of aesthetic experience was fundamental.
When he walked in his garden every day he used "to taste the air, to
listen to the sounds of birds and streams, to admire the flowers and the
trees." He noted at the same time the beauty of lichen, "as gorgeous as
an Aztec or Maya mosaic," or of moss, "of a soft emerald that beds your
eye as reposefully as the greens in a Giorgione or a Bonifazio."

In these words one senses B. B.'s great gift, his power to sink his
identity in the work of art or in the effect of nature, and his ability to
analyze at the same time his response as the perceiving subject. But for
years his thoughts about the values of art and nature vanished in
conversation. B. B. was gradually becoming a modern Goethe, but none
of his friends proved to be an Eckermann. From 1907, almost until the
Second World War, B. B. wrote only specialized and scholarly criti-
cism. There were two reasons, I believe, for this limited, this archaeo-
logical nature of his books. One reason was that his living depended
upon the flotsam and jetsam of Italian paintings constantly brought to
his attention, works of art, some major, some minor, in which he
became absorbed in analysis and identification. The other was that
Mary Berenson and her brother, Logan Pearsall Smith, persuaded him
he could not write decent English. He told me of a whole book in
manuscript which Mary had criticized so severely that he threw it in the
fire. It was tragic that his wife and brother-in-law, who, in their many
books, handled conventional English prose with great skill, were unable

to recognize that B. B., with a different heritage, wrote in a style that was more intricately involved, more highly ornamented, though in its way every bit as admirable. They might have thought of Joseph Conrad, to whom English was also a second language.

But the break with Duveen, the isolation of the war, and Mary Berenson's withdrawal into her long illness gave B. B. leisure and confidence. The "modern Goethe" in whom his Boston friends had so rashly invested, matured when B. B. was over seventy. It was at this advanced age that he wrote *Aesthetics and History in the Visual Arts, Sketch for a Self-Portrait, Rumor and Reflection, Seeing and Knowing, The Passionate Sightseer*, and *A Year's Reading for Fun*. All these books appeared in print between B. B.'s eightieth year and his death at ninety-four. In my opinion they are among the most stimulating and important books which have been published in this century.

They were written under desperate circumstances. With the war upon him B. B. faced a terrifying future. In time of crisis some people go to church, some take to drink, others simply run away. B. B. turned to his library.

It is a fascinating image one glimpses from his diaries, a human being of immense culture caught in a "manquake," as B. B. calls it, an irrational upheaval of passionate hatred. By reading he tries to find the explanation, the causes of this tragedy; he searches among the German Romantics for the genesis of modern Germany; he studies the personalities involved in the Treaty of Versailles for the more immediate causes; he turns to Herodotus for the effect of chance on history. His library is his fortress, and it is filled with the smoke of the battle raging outside.

But the war eventually drove B. B., who was nearly eighty, from his fortress, compelled him to leave his library. He had to take refuge with a friend who happened to be the minister to the Vatican from the Republic of San Marino, and therefore had a tenuous, diplomatic immunity which the Germans recognized.

After the war I went to see the villa near Florence where B. B. had stayed. He showed me where he had sought shelter during the bombardment. He spent weeks in what really amounted to a small closet. One night after a heavy shelling, when the Allies were very close, he got in touch with a friend in the Italian underground and asked him to see whether he couldn't get to the American battery, which was firing at the villa, and tell the commanding officer that Bernard Berenson was under bombardment from his unit. The Italian carried the message at

great risk, only to have the young American reply, "Nuts! Who's Berenson?" And that night they practically blew the villa to pieces. B. B., however, survived and went on with his writing under the worst shellfire. He eventually returned to his own villa, which miraculously escaped. But during all his trials and dangers he never lost his wonderful sense of humor, even when his countrymen showered him with shells.

The real miracle, however, was that Berenson had ahead of him fifteen years of tranquil work in the library he loved so much. During these years his philosophical attitude developed and deepened. B. B. had a speculative, even a devotional, interest in religion. But he had an equal hatred of dialectics and of metaphysics. Thomism was anathema. All his life he was in search of an antimetaphysical metaphysics. He had no talent for abstract thought. His gifts were different. They were principally a wonderful machinery of observation, an ability to look so intensely that he could become, as he said, "merely a perceiving subject," completely detached from himself.

All the great religions preach the renunciation of self, the absorption of the ego in something transcendent. B. B. achieved this identification with the non-self through his absorption in beauty, whether of art or of nature. Did he then have any need of institutional religion? Perhaps not, but he felt, nevertheless, a warm affection for the Catholic Church as an institution.

I remember his often saying to me that the Catholic Church is the greatest achievement of the human spirit, the sublimest expression of human genius. But he would add, "If it is supernaturally ordained, then man can take no credit for his noblest creation." B. B., the humanist, was fiercely proud of humanity. Man might be no more than an earth bubble, but he was a marvelous phenomenon, capable of exquisite feelings and of high attainment. Divine inspiration only lessened his stature.

Like many people of intellectual integrity, B. B. was too honest to be always consistent. On the first page of *Rumor and Reflection* he wrote, "Here I am, a rational being, convinced that within the universe, as we know it, there is no force outside ourselves that we can appeal to with prayer or compel with magic, no conceivable intelligence aware of our existence, ready to marshal the stars in their courses to serve our individual, momentary need." "Yet," he continues, "when I come up against people with no feeling for the numinous, no awe before the universe, no ever-present sense of the precariousness of human life,

. . . I feel almost as remote from them as I do from the pre-scientific mind of the Mediterranean lower classes."

Here are the two sides of his mind: a rationalism, matter-of-fact and skeptical; an intuitionism, mystical and believing. This dichotomy, so far as I could tell, he never completely resolved. But I felt, after he passed his ninetieth year, that the intuitive, mystical side of his nature had gained the upper hand. He faced death with more faith and less skepticism.

Not that B. B. feared death. He had, as he told me, his bag packed and was like a voyager waiting on the station platform. But until his final illness in his ninety-fourth year, he was reluctant to have the train arrive. His joy in life had grown more and more intense.

My last visits to him, except the year he died, were passed at his summer place near Vallombrosa. There he had a house which had once been a hunting lodge. It was in the mountains high above Florence. Every afternoon we would walk to a terrace overlooking the loveliest of all valleys, that magical landscape carved by the Arno. The river glimmered far below, winding its way to Pisa and the sea. We would watch the sunsets, great conflagrations burning in the western sky, and B. B. would quote almost ritualistically *Flammantia Moenia Mundi;* the flaming ramparts of the world. And then would occur what Iris Origo has so well described as "those times of total abstraction which we all sometimes witnessed in his last years, that disconcerting fall of a shutter, almost in the midst of a sentence." B. B. would totally withdraw, not only from me, but almost, it would seem, from himself. And then he would say after a long pause, "The mystery grows denser and denser." These were the moments of struggle, the conflict between the two parts of his mind, his rationalism and his intuitionism, his skepticism and his mysticism. He was, in his last years, obsessed by transience, and he felt the passage of time visually at sunset, as at no other period of the day. For it is characteristic that he could apprehend the fugitive nature of existence better with his eyes than with his reason. He would stay on and on until the damp shadows of evening made one fear for his health. He used to seem almost hypnotized by the transitory light, vanishing slowly away.

I do not know whether those ecstasies he treasured, moods fugitive as shimmer of light on water, had brought him intuitions, like reflections seen in a pool, of something more real and more permanent. Watching those unforgettable sunsets, it seemed impossible to ask this question

which I longed to have answered; but I learned without surprise that in his last hours he had indicated his willingness to receive the sacraments and that he was buried as a Catholic.

On our walks together we often spoke of the future of his villa and his estate. The bequest of I Tatti to Harvard, planned as early as 1909, was the lodestar which determined the direction of much of B. B.'s life. He considered the repellent association with Duveen partially justified by the resources that accrued from it. He wanted as much money as possible for the endowment of the future institution. I once heard Mary Berenson trying to cheer B. B. up about his commercial life. She said Joe Duveen was, after all, stimulating. He was, she said, like champagne. "More like gin," B. B. glumly remarked. And for the sake of I Tatti he found that he had become a gin drinker. When he broke with Duveen, he had earned more money than he could possibly spend for the rest of his life, as I pointed out to him repeatedly. Yet, always thinking of I Tatti, he consented to continue in the jungle and to advise George Wildenstein under circumstances similar to his arrangement with Duveen.

But curiously enough, B. B. had very little sense of the value of money. For example, after spending a winter in an apartment lent by a friend in New York, he told his wife to give the lender a little present as a token of gratitude. She selected a panel by Domenico Veneziano, now in the Kress Collection. In 1939 the friend came to see me and offered to sell the painting to the National Gallery for $750,000. I do not know what the Kress Foundation finally paid, certainly not that much, but enough to have bought B. B. at least one large house in New York.

His collection was bought when pictures could be picked up for next to nothing, especially in Florence. The story his brother-in-law, Logan Pearsall Smith, used to tell is that B. B. saved his greatest work of art, a large altarpiece by Sassetta, from being used as a tabletop. In those days even the name of Sassetta had been forgotten. It was B. B.'s beautiful essay on "A Painter of the Franciscan Legend" which brought him again to notice. His rise to fame, however, has been so great that the "tabletop" today would fetch at least a million dollars. When B. B. was in one of his periodic panics that he would not leave enough money as endowment for I Tatti and Harvard would refuse to accept his legacy, I suggested he might sell the Sassetta to the National Gallery of Art, or if not that painting, then some other part of his collection, for he had the right to export those works of art he had bought outside of Italy. In our

friendship of nearly thirty years, it was the only time I experienced the lash of his anger. *Nothing* from his collection was ever to be sold, he said. How could I even make such a suggestion?

Nicky Mariano relates how on one occasion she was looking at the collection of Charles Loeser, a neighbor and old friend of B. B.'s, and she missed a particular picture which used to hang in one of the rooms of his house. She asked where it had gone, and Loeser said he had used it to play a game he loved, as do most collectors. He had exchanged it for something better. He was sure, he added, that B. B. had often enjoyed the same pleasure. Nicky thought for a moment and replied that in the ten years she had been at I Tatti not a single object had ever been exchanged or even moved. During the next thirty years, until B. B.'s death, this remained true.

The first picture he ever bought was, ironically, a forgery. I have studied it often. It was by the great Tuscan forger of the beginning of the twentieth century, Joñi. B. B. owned a second work by this extraordinary falsifier, a Madonna and Child in the manner of Botticelli, which continued to hang in his study. Both were important instructors in connoisseurship.

Having made his fortune attributing works of art, the attribution of paintings in his own collection did not interest him. For many years he continued to call the supremely beautiful *Madonna Panciatichi* a Baldovinetti, while all other experts recognized in it the hand of Domenico Veneziano, an artist of equal rarity and genius. Had the picture been in the Uffizi, B. B. would have been the first to ascribe it correctly. For him attribution, unlike charity, did not begin at home.

How angry he used to get when visitors to Florence, usually Americans, staying only a few days, would write for permission to come to I Tatti to see the Berenson Collection. "Idiots," he would say. "With the indescribable treasures to be seen in Florence, they want to come here only because it is a place not open to the public. Such imbeciles are not worth answering." But now that he is dead the "imbeciles" still come to I Tatti — or try to.

Possessions meant nothing to him. In his diary of May 30, 1947, he wrote, "Walked in my garden. 'My own' — what am I saying; I have little if any sense of my own, and least of all with regard to what I own here . . . fields, houses, pictures, books — yes, I enjoy them as what cannot be immediately snatched away from me, but which are but temporarily mine . . . Perhaps if I had inherited my possessions I might feel differently, but twice uprooted, first to U.S.A. and thence to

Italy, how can I feel the fixity of possessions? Perhaps if I had heirs of my body."

He had no "heirs of his body," it is true, but he had his university, Harvard, which he never ceased to criticize but which he loved passionately. The legacy of I Tatti was his repayment for all the learning and the intellectual stimulus he had received so generously three-quarters of a century earlier in Cambridge, Massachusetts.

He knew exactly what he wanted his institute to be, when after his death, it was to become a part of Harvard. "Our present Western world is harassed, hustled and driven," he wrote in an unpublished memorandum. "It excludes leisure, tranquillity, permits no unexciting pursuits, no contemplation, no slow maturing of ideas, no perfectioning of individual style. Therefore my first and foremost wish is to establish fellowships that will provide leisure and tranquillity . . . to promising students. . . . I would like the Fellows at I Tatti to continue what all my life long I have been trying to do but have only faintly succeeded in doing. I would like them to take as models Goethe and Winckelman, Ruskin and Pater, Burckhardt and Wölfflin, rather than mere antiquarians or mere attributors of the type of Cavalcaselle, Bodmer and their like. I would like them to write about the way artists and their works have been appreciated through the ages rather than to concentrate on the material history or the provenance of a given work of art. In short, I want this Institute to promote aesthetical and humanistic, rather than philological and antiquarian interests."

The miracle is that I Tatti, as a branch of Harvard, has become almost exactly what B. B. wished. In his library, which was the center of his existence, and under the cypresses and the olive trees of his garden, which gave him such delight, his dream is being fulfilled. It was a dream held passionately throughout his life. Its realization gives his friends a sense of great happiness.

6

The Collector
Who Founded a Museum:
Andrew W. Mellon

It is surprising that Pittsburgh should have produced two of the greatest collectors in history: Andrew Mellon and Henry Clay Frick. Both were businessmen, and in their early days the business community in Pittsburgh regarded collecting with suspicion if not with distaste. There is a revealing report handed in to Andrew Mellon's father, Judge Thomas Mellon, who had sent an agent from his bank to investigate Frick as a credit risk and was told: "Lands good, ovens well built, manager on job all day, keeps books evenings, may be a little too enthusiastic about pictures but not enough to hurt."

On further acquaintance, Judge Mellon must have come to like the young and enterprising coke manufacturer, who became one of his son's closest friends. Frick was five years older than Andrew Mellon, and thus somewhat more sophisticated. He acted as mentor when in their twenties, in 1880, the two traveled to Europe for the first time. Mellon returned bringing with him a painting for which he had paid a thou-

sand dollars, and businessmen who had admired his sagacity began to question their judgment.

Through Frick, Andrew Mellon met a partner in Knoedler and Company, Charles S. Carstairs, a man of considerable social charm who was far more influential in the formation of American collections than is generally known. From 1899 until the twenties, virtually every picture Mellon bought came from Knoedler's. The monopoly which that firm exerted for so many years was finally brought to an end by Joseph Duveen. The elaborate arrangements made by Duveen to meet a new client are delightfully described in S. N. Behrman's book, *Duveen.*

In 1921, Mellon, visiting London, occupied a suite on the third floor of Claridge's. Duveen had a permanent suite on the fourth floor of Claridge's. Stirred suddenly by premonitions of intimacy, he had himself moved to the floor below Mellon. Duveen's valet was, inevitably, a friend of Mellon's; the two valets seem to have wished the contagion of their friendship to spread to their masters. One afternoon, Duveen was apprised by his valet that Mellon's valet was helping Mellon on with his overcoat and was about to start down the corridor with him to ring for the lift. Duveen's valet hastily performed the same services for Duveen. The timing of the valets was so exquisite that Duveen stepped into the descending lift that contained Mellon. Duveen was not only surprised, he was charmed. "How do you do, Mr. Mellon?" he said, and introduced himself, adding, as he later recalled, "I am on my way to the National Gallery to look at some pictures. My great refreshment is to look at pictures." Taken unawares, Mellon admitted that he, too, was in need of a little refreshment. They went to the National Gallery together, and after they had been refreshed, Mellon discovered that Duveen had an inventory of Old Masters of his own that, although smaller than the museum's, was, Duveen thought, comparable in quality.

Though I have no doubt the valets cooperated for the benefit of Duveen, this was not the first meeting between the aloof patron and the contriving dealer. On June 24, 1919, two years earlier, Mellon had noted laconically in his diary, "Breakfasted with H. C. McEldowney. We then go to Frick. See Duveen there." When Frick introduced the two he said, "This man [Mellon] will some day be a great collector." I

feel sure Andrew Mellon's valet was particularly helpful to Duveen; and later, after his employer's death, while working for the National Gallery of Art, he may have continued to be useful to the firm; or so I concluded from the knowledge of callers to the Gallery and other matters, which Duveen's successors, much to my surprise, always seemed to possess.

Though Mellon met Duveen during the twenties, he continued to buy chiefly from Knoedler's. It was only at the end of his life that he made important purchases from the rival firm. With one exception, when he negotiated for a picture directly with the owner, everything of significance he acquired came either from Knoedler's or Duveen.

In 1900 Andrew Mellon was married. He brought his bride from a beautiful country house in England to an ugly, and for a Pittsburgher already rich, rather modest residence on Forbes Street, a part of the East End of Pittsburgh which remains strikingly unattractive. Paul Mellon, his son, has said of his first home: "The halls were dark, the walls were dark, and outside Pittsburgh itself was very dark." Perhaps in an effort to mitigate the bleakness of these surroundings, the inventory of Knoedler's showed that in 1899 Andrew Mellon spent over $20,000 on pictures. He bought, however, paintings which can only be described as mediocre and which have all mercifully disappeared. For Troyon's *Cows in a Meadow,* the most expensive canvas that year, he paid $17,000; for Cazin's *Moonlight Effects,* $3,000; and for van Boskerck's *Sunset, Pulborough, Sussex,* perhaps to make his wife less homesick, $750. Many years later he asked Roland Knoedler: "When I first started buying pictures why didn't you offer me Gainsboroughs, Rembrandts, Frans Hals, et cetera?" To which the dealer replied: "Because you would not have bought them." One wonders whether this is quite true.

During six years, through 1905, Andrew Mellon spent on paintings over $400,000, a sum equal to several million dollars today, without buying a single picture which he ultimately considered worthy of the National Gallery of Art. Thus his education as a collector was expensive and wasteful; and when one considers that during the same period Frick had bought twenty-eight pictures all up to the high standard of the Frick Gallery, including works by Titian, El Greco, Rembrandt, Vermeer, Hobbema, Cuyp, Gainsborough, Romney, Raeburn, Lawrence, Turner and others, it is little wonder Andrew Mellon queried Roland Knoedler about the paintings he had been offered.

Perhaps the statement of the head of Knoedler's was correct. Sophis-

tication of taste may have come slowly to Andrew Mellon. He was not a born collector as was Frick, his somewhat older friend, who even in his youth had been "a little too enthusiastic about pictures," at least by Pittsburgh standards. But when Mr. Mellon learned to discriminate, probably from looking at English collections during his long summers abroad, he bought only the best. By the time he established the National Gallery his feeling for quality was instinctive. The masterpieces he assembled were equaled in this country only by those of Frick and Widener. There was a great difference, however, in the nature of the three collections. The ideal of Frick and Widener was the Wallace Collection, whereas Andrew Mellon's objective was to rival the National Gallery in London. This shift of focus reflects the emphasis given paintings over the decorative arts during the twenties and thirties when Andrew Mellon was making his great purchases, a change in taste which has become increasingly pronounced.

The evolution of Andrew Mellon as a collector, up to about 1928, seemed to have passed through three phases: the first was his rather naïve acquisition of overvalued Barbizon painters and their entourage — pictures intended to be hung in his first house. Clanging streetcars and dusty traffic, however, must have made his life on Forbes Street grim. In 1916 he bought a more suitable residence on Woodland Road, one of the few pleasant and restricted streets in the East End of Pittsburgh. The house, built by Alexander Laughlin, a partner in the steel firm of Jones and Laughlin, was vaguely Jacobean in style. It was surrounded by attractive gardens, and it managed to suggest, even in the smoky atmosphere of Pittsburgh, the civilized charm of an English country house. This must have pleased Andrew Mellon, who had long since fallen under the spell of England, a country he visited repeatedly, spending many of his happiest days there. It was this Anglophilia which, outside his business, molded his life; and it was the National Gallery in Trafalgar Square which always remained for him the ideal museum and the model for the institution he was to establish in Washington.

In the daytime the house on Woodland Road was as full of sunshine as the smoke of Pittsburgh's blast furnaces and steel mills permitted; but at night one had a general sense of gloom, the darkness broken by patches of light where reflectors on paintings illumined the muted colors of English and Dutch portraits and landscapes. I remember on one occasion seeing emerge from the shadows a frail, fastidiously dressed man with high cheekbones, silver hair, and a carefully trimmed

moustache. He was most impressive in an aristocratic, patrician way. I found him, however, exceptionally silent, as I tried my best to convey my admiration for his collection. He was inarticulate on the subject of art. Even the names of the artists whose works he owned occasionally escaped him. But from the way he looked at his paintings, from the sheer intensity of his scrutiny, I knew that he had a deep feeling for what he collected, a relationship to his pictures which I have rarely found in the many collectors I have known.

The canvases in the house on Woodland Road introduced the second phase of Andrew Mellon's collecting. They were all of excellent quality, and many of them are now in the National Gallery of Art.

When he became Secretary of the Treasury in 1921, he rented an apartment at 1785 Massachusetts Avenue. More masterpieces arrived to decorate his new residence. His taste was still personal, not institutional. As he wrote the Duchess of Rutland in 1926, "I have no gallery with paintings or tapestries. I have only those paintings and a few tapestries which I have acquired from time to time when I had suitable places in my residence. I have not had occasion to consider acquisition of such for public purposes."

He seems to have wanted paintings which would offer him an escape into an ideal world filled with civilized human beings, often portrayed in the midst of beautiful scenery. Passing much of his life in Washington among uninspired bureaucrats and in Pittsburgh where day after day he faced the smoke and dirty fog which produced his wealth, he wished to dream of a pleasanter environment. His portraits of George IV and the Duchess of Devonshire by Gainsborough, of Miss Urquhart by Raeburn, of Lady Caroline Howard by Reynolds, offered imaginary companionship with people whose personalities did not jar and whose presence did not in any way affect his reticence. Similarly, his views of the flat terrain of Holland bathed in crystalline air, and his scenes of English country life illumined by the dappled sunshine falling through fleecy clouds, gave him glimpses of landscape which obliterated for a moment the constantly settling soot outside his office windows.

He did not want to look at faces which reminded him of the politicians who were his enforced associates. Duveen once sent him Raphael's *Portrait of Giuliano de' Medici*, ultimately acquired by Jules Bache. It was returned and Andrew Mellon wrote Helen Frick, who must have subsequently contemplated its purchase, "It seemed to me a strong work but not particularly attractive for a private living room." Was there also some intuitive doubt about the picture's attribution, a position

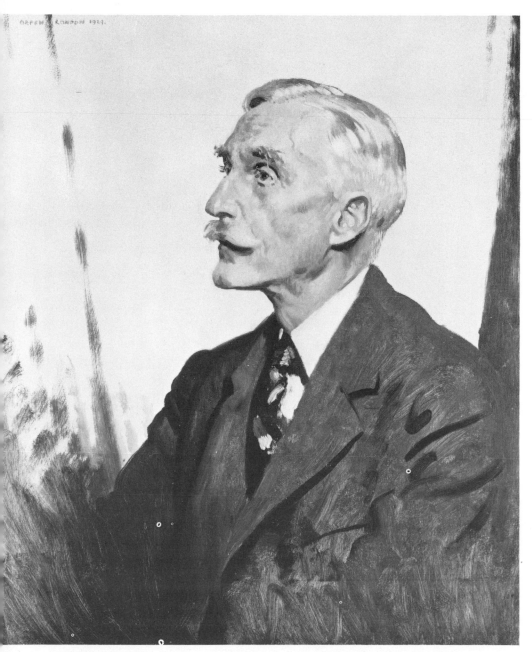

Sir William Orpen, *Portrait of Andrew W. Mellon*, 1924. A frail, fastidiously dressed man with high cheekbones, silver hair and a carefully trimmed moustache. From the collection of Mr. and Mrs. Paul Mellon.

taken by a number of recent scholars? The painting is now admittedly a copy after Raphael and will be so catalogued by the Metropolitan Museum of Art, to which the Bache Collection was donated.

But more probably it was, as he said, the personality of the sitter which he found distasteful. During this second phase of his collecting, he also avoided religious pictures. This meant that for the time being very few Italian pictures entered his collection. Crucifixions were particularly distasteful to him. When he finally acquired a Crucifixion by Perugino it was a scene of sublime tranquillity without a suggestion of suffering. Nudes too were anathema. The partially undraped *Venus with a Mirror* by Titian is the closest to a nude in his collection. These were Andrew Mellon's prejudices and preferences as a collector. But when he decided to establish the National Gallery he put aside his aversion to religious art, though not to nudes.

The exact date of his decision to make his collection the nucleus of a new museum, which marks the third phase of his collecting, is difficult to place. Duveen, during Andrew Mellon's tax trial, said they had discussed the formation of the Gallery as early as 1923, but a few random remarks could easily have been considered a discussion by a witness anxious to show an intimate friendship which was largely nonexistent. The letter to the Duchess of Rutland written in 1926 can, I believe, be taken at its face value. He was still not buying "for public purposes."

But in the latter part of 1927 he seems to have made up his mind. He discussed the museum he proposed to build with David Finley, his personal assistant at the Treasury, and with his usual flair for the right person for the job, said that he wanted Finley to be the first director. In 1928 in his diary he noted: "Ailsa [his daughter] telephoned in morning from No. 1 Sutton Place. Has just arrived from Boston. Asks if I have given art gallery to the Government." This is the first documented mention of his intentions. From then on there are frequent references to his search for a suitable site for the new building.

The nature of his collecting also changed, and by a fortunate coincidence, two years later he was given the greatest opportunity that has occurred in the twentieth century to form the nucleus of a collection for a great National Gallery. Paintings from the Hermitage Gallery in Leningrad had come on the market.

The history of these Russian sales is enormously complex. In the late nineteen-twenties the USSR was swarming with hopeful art dealers like bees buzzing around sugar. But the Hermitage, a mountain of sweets in itself, seems to have remained relatively inaccessible. Early in 1928

Armand Hammer, whose career is discussed in a later chapter, made the first significant attempt to gather some honey. Shortly thereafter, Calouste Gulbenkian, having successfully advised the Russians on how to dump their oil in the world market, found himself exceptionally popular with the commissars — a popularity which helped him buy for his own collection the first of the Hermitage paintings and sculpture to be sold. But one particular dealer, Zatzenstein, he told me, gave him a great deal of trouble, and to keep prices down and avoid competition, he tried to use the Matthiesen Gallery in Berlin, Zatzenstein's firm, as his agent. In the chapter on Gulbenkian I have described his dealings with Zatzenstein in more detail.

Zatzenstein decided, when he learned that many of the masterpieces from the Hermitage Collection were really for sale, that it would be more profitable to buy on his own. But this reasonable conclusion presupposed capital, and he had little or none. He asked help from Colnaghi's, the oldest dealer in London. They suffered from the same debility. They had, however, joined with Knoedler's in many enterprises, and Knoedler's had an asset beyond all price: a client named Andrew Mellon. Consequently a triangular partnership was worked out between Knoedler's, Colnaghi's, and the Matthiesen Gallery.

When it became evident that the Matthiesen Gallery and Colnaghi's really had the means of procuring pictures from the Hermitage, Charles Henschel, the president of Knoedler and Company, on January 15, 1930, wrote his European representative George Davey the following letter.

Dear George:

As you know, there has been a lot of talk for the last year of some of the Hermitage pictures being sold. This now seems to have come to a definite head. I had a cable from Gutekunst saying that they had a specific price of £80,000 [$400,000] on the Rubens 'Portrait of Helena Fourment,' and £50,000 [$250,000] on the 'Titus,' Rembrandt, Bode 447. [Both were subsequently bought by Gulbenkian.] He wanted an immediate answer as to whether or not we would definitely buy these pictures. I telephoned him to London yesterday morning and told him that we could not conclude a matter of this kind in such a hurry. Further, I told him that we were prepared to buy a number of these pictures for a good round sum, provided we got the pictures that we wanted and not necessarily the pictures that they wanted to sell. My idea was that

if we purchased about £500,000 [$2,500,000] worth, it would tempt them, and we could then get some other pictures on consignment from them. Zatzenstein has apparently put this matter up to Gutekunst. I, on the other hand, have been working this through another source. I am perfectly willing, however, to cooperate with Zatzenstein and Gutekunst in the matter, and told this to Gutekunst. . . . I thought the best way to handle this would be for you to get the particulars from Gutekunst and then make arrangements with Zatzenstein to see the pictures.

In selecting the pictures, we want to bear in mind the attractiveness of the subject and the size and condition. For instance, the Rubens that Gutekunst cabled about is doubtless a very fine picture, but it is a full-length and a bad shape; consequently it is not the sort of picture we would be willing to put much money into, — certainly not any such sum as £80,000 [$400,000]. It may be worth this sum to some people, but not to us.

Regarding the Titus Rembrandt, I can only judge from what is said in the books and from the size. Based on the fine self-portrait [see page 124] we bought a year ago, this picture would not be worth more than approximately half, or around £25,000 [$125,-000], possibly a shade more.

To understand fully Henschel's letter one needs to know something of the cast of characters involved. Gutekunst was the head of Colnaghi's, and his partner, Gus Mayer, played a leading role in all the Russian transactions. The source of the information that purchases from the Hermitage were possible was, of course, the Matthiesen Gallery, which made their contact with Knoedler's through Colnaghi's. The Matthiesen Gallery was headed by Zatzenstein, whose assistant, Mansfeld, seems to have been their "man in Moscow." To complicate matters further, at some point Zatzenstein, born Katzenstein, changed his name to that of the company he headed, and in later life when I knew him was called Matthiesen.

Carman Messmore, another Knoedler partner, got in touch with his client Andrew Mellon and proposed an ingenious arrangement. In a letter of April 24, 1930, recapitulating a verbal agreement, he wrote:

Dear Mr. Mellon,
 . . . It is understood that you have authorized us to purchase for you certain paintings from the Hermitage Collection in Petro-

grad, and that if you decide to retain them you will pay us a
commission of 25% of the cost price. In the event you do not wish
to keep any of them, it is understood that we will sell them for
your account, and pay 25% of the profit on the price we receive for
them.

We have shown you reproductions of the paintings which we
decided to purchase from the above Collection, and it is understood
that we will acquire them at a price at which we consider they can
be disposed of, should you not care to retain them, of approxi-
mately 50% profit.

Meanwhile, in March, as an earnest of the Soviets' commitment to
sell, one picture, *Lord Philip Wharton* by van Dyck, had arrived in
New York and been bought by Mr. Mellon for $250,000. In April a
Frans Hals and two Rembrandts were added at a cost of $575,000, a
very reasonable sum even in 1930.

It is apparent from the correspondence that Charles Henschel was
only reluctantly enthusiastic about dealing with the Soviets and he was
determined to get the Russian paintings at the lowest possible price.
If Mellon did not take them, he would have to sell them at a 50 per-
cent profit and pay out 25 percent to his client. There was also the
liquidity squeeze brought on by the Depression. In 1932, when the
Mellon Russian purchases were over, the situation was so serious that
Charles Henschel had to write Andrew Mellon, then ambassador in
London, asking for financial assistance. Knoedler's normally had a line
of credit with New York banks amounting to more than a million
dollars, but this had been cut in half when the banks began reducing
their loans. Doubtless Mellon assisted Knoedler's, just as the Mellon
bank helped Duveen in similar circumstances. But throughout the
Knoedler correspondence the endless efforts to get the Soviets to reduce
prices put a severe strain on Knoedler's relations with Matthiesen and
Colnaghi's.

In this connection Charles Henschel received a significant wireless
from Gus Mayer of Colnaghi's.

GULBENKIAN IS BUYER OF TITUS [by Rembrandt] AND FOURMENT
[by Rubens] WHEN OFFERS ARE NOW MADE HE AND OTHERS ARE
GIVEN OPPORTUNITY TO OUTBID HAVE TOLD MANSFELD TO TRY TO
REVERSE THIS POSITION IN OUR FAVOUR . . . JOE [Duveen] DEVEL-
OPING FRANTIC ACTIVITY AND TALKS OF GOING EAST HIMSELF

(SIGNED) GUS

It seems likely that this wireless was sent on February 25, 1930, when Henschel was returning to New York after his trip to London of February 7, referred to in his letter to Davey.

The three firms, Knoedler's, Colnaghi's, and the Matthiesen Gallery, seem to have been suspicious of each other. Davey was not permitted to make the trip to Leningrad suggested by Henschel. He did not get there until early in April, and then he wrote a letter to Henschel critical of the sales possibilities and of his London and Berlin partners.

> Dear Carl,
> [the more intimate first name used by his friends]
> . . . From what I could see and learn, I do not think they [the Soviets] have the intention of selling any of the best pictures. They seem to be pretty well posted as to what they have. . . . Zatzenstein did not help in any way: in fact I felt that he was not pleased at all on my going to Russia and seemed frightened lest I should see any of the authorities. I am sorry now that I have followed his advice as I had only to ask a friend of mine to give me a card for the Head of the Hermitage who would have shown me everything and I could have made then a better report. Still, if something turns up very seriously, it is easy for me to run there. Through my friend, I could have got all the pictures I wanted by simply giving him a commission of 10% or even 5% at a pinch.

It is interesting to note that both Henschel and Davey felt they could buy from the Hermitage without going through Colnaghi's and Matthiesen. But the fact remains that the Hammer brothers failed, Duveen failed, Wildenstein, apart from what assistance he may have given Gulbenkian, failed. To none of their firms would the Soviets part with their Hermitage masterpieces, though Armand Hammer and his brother Victor felt that they could have made a deal had their mysterious client, discussed in chapter 10, been less parsimonious. Zatzenstein, perhaps because he was thought sympathetic to Communism, had the confidence of the commissars, as did Calouste Gulbenkian among private collectors.

Davey's suggestion that he had a friend who would give him a card to the head of the Hermitage and that he could have got all the pictures he wanted by paying 5 or 10 percent commission is particularly naïve. Joseph Alsop talked to Saemy Rosenberg, who had succeeded in buying furniture and other examples of the decorative arts in Russia, and in a

fascinating book on collecting to be published shortly, he recounts how Rosenberg, in an effort to expedite his purchases, had once invited Dr. von Schmidt, the Director of the Hermitage, to tea at his hotel. "It was a mistake," Rosenberg told Joseph Alsop, "although it was a good thing to do, too. The poor man must have been near to real starvation; for he stuffed himself so, during a whole half hour, and just on tea and cakes, that he nearly choked in the end. I was really worried about him. Furthermore the police knew about his visit, of course, and it made things harder instead of easier."

Zatzenstein was smarter. He dealt only with *Antiquariat*, the official organization for the sale of Russian art, and he paid cash for each transaction. He knew the Hermitage officials were opposed to the sales, but he also knew that they were powerless. The Treasury wanted money, and its executives were the final authority.

It is, at first, surprising that Duveen was frustrated in his dealings with the Soviets. It was the outstanding failure of his career. In his testimony at Mr. Mellon's tax trial he gave an explanation of his frustration. He said the Soviets would not do business with him because he was buying for his own account. "They gave me to understand," he said, "as a matter of fact they made the statement: 'If we were to sell these things to a dealer and he were to make a large profit on them, our heads would be cut off.' He pointed his finger up to his throat . . . and I thought, well, maybe you ought not to sell them out of the country." Assuming that Duveen told the truth, it is fortunate the Soviets did not know of Mr. Henschel's arrangements with Mr. Mellon to sell anything rejected for a 50 percent profit. Luckily for the commissars, Mr. Mellon took everything.

But Duveen's explanation, though plausible, is dubious. Knoedler's bought French paintings from the Soviets through the Matthiesen Gallery in 1932 and sold them to private collectors. Saemy Rosenberg also made purchases of furniture and objects of the decorative arts in the 1920s, and the Hammer brothers filled their gallery with Soviet art, which they sold all over the United States at a large profit. It seems more likely that Duveen was *persona non grata* to the Soviets for some other reason. Perhaps they feared his characteristic love of publicity, whereas in dealing with the triple partnership of Matthiesen, Colnaghi's, and Knoedler's, they could count on discretion. They knew their sales would be kept in confidence.

In spite of the discouraging letter of April 15 from Davey, Charles Henschel was so pleased by his sale of the first four pictures from the

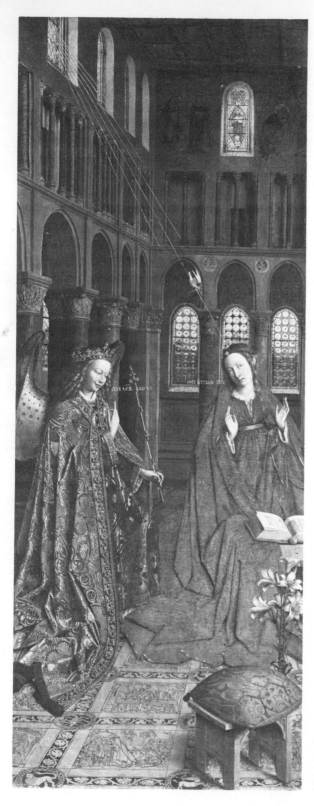

Jan van Eyck, *The Annunciation*, Flemish, 15th Century. This is the picture that Andrew Mellon particularly wanted from the Hermitage. National Gallery of Art, Andrew W. Mellon Collection.

Hermitage to Andrew Mellon that he decided to visit Russia himself. He departed in the first days of May 1930. The picture that Mr. Mellon particularly wanted was the van Eyck *Annunciation*, but the negotiations between the Matthiesen Gallery and the Soviets had dragged on unsuccessfully for some time. One day while at sea crossing to England, Henschel was called to the telephone. (The *Olympic* had one of the first telephones to be installed on a transatlantic steamship.) It was Mansfeld, who said, "The Russian Ilyn is in Berlin and says they will sell the van Eyck if they get $500,000 for it." Henschel then telephoned Carman Messmore in New York; Messmore took a train to Washington and telephoned back, "Mr. Mellon says to go ahead and buy the picture as cheaply as you can and he will send the money to our account in the Guaranty Trust Company in London." A few days later in Berlin Ilyn, who as general manager of *Antiquariat* acted for the Soviets, received his check and delivered the painting. Nothing from Russia was ever fully paid for until delivered, though there was often a 10 percent payment on reaching an agreement.

Henschel's trip to Russia was productive, though apparently the negotiators, Henschel and his nephew Balay from Knoedler's, and Gus Mayer from Colnaghi's, hated every minute of their stay. None of them spoke Russian except Mansfeld, the Matthiesen Gallery's agent, and all they could find to eat was sturgeon, caviar and vodka. Henschel offered a cigarette to one of the officials at the Hermitage. It was wistfully refused with the remark that unless Henschel was prepared to give a cigarette to everyone at the Hermitage, including laborers and guards, the acceptance of such a gift by the official in question might very well cost him his job.

The dealers were delighted to leave the USSR, but they were also overjoyed at the progress they had made. Between June 1930 and April 1931 the following paintings were delivered to Mr. Mellon:

Botticelli	*Adoration of the Magi*
Raphael	*Alba Madonna*
Raphael	*St. George and the Dragon*
Perugino	*Crucifixion*
Titian	*Venus with a Mirror*
Veronese	*The Finding of Moses*
Van Eyck	*The Annunciation*
Rubens	*Isabella Brandt*
Van Dyck	*Suzanna Fourment and her Daughter*

Van Dyck	*William II of Nassau and Orange*
Hals	*Portrait of an Officer*
Rembrandt	*A Woman Holding a Pink*
Rembrandt	*Joseph Accused by Potiphar's Wife*
Velázquez	*Pope Innocent X*
Chardin	*The House of Cards*
Rembrandt	*A Turk*
Van Dyck	*Portrait of a Flemish Lady*

Some of these were received in Berlin at the Matthiesen Gallery and some were brought to New York. The last two to arrive were the *Alba Madonna* by Raphael and the *Venus with a Mirror* by Titian. These were brought by hand by Boris Kraevsky, member of the Collegium of the Commissariat for Foreign Trade, and Nicolas Ilyn. As good Communists they came to America steerage and stayed in a second-class hotel, but exhilarated by the sums of money involved (the payment for the two paintings was $1,355,200) they shortly afterwards moved to the Biltmore and returned home first-class.

It is difficult to comprehend why the few million dollars realized from the sale of works of art seemed so important to the Soviets. The partners of Matthiesen and Company were puzzled at the time. As Zatzenstein in his gloriously erratic English wrote Henschel on January 14, 1931, in the midst of negotiations, "Personally I never can understand why the Eastern people do sell — by their tremendous dumping on every market they get amounts of money so much more important than these comparatively poor sums, worked out of art-business, that I do not believe they are really forced sellers."

Despite the flow of foreign currency which he says the Soviets are realizing, Zatzenstein continues, "After concluding a deal the Russians instantly want money. To solve this difficult question we arranged with our bank a blocked account. This is to make it possible for the Russians to get immediately a credit on the money which is owed to them, for the time until the delivery of the pictures."

The letter was continued on February 9, as Zatzenstein had been ill. He goes on to say that Mansfeld was happily successful in getting "the Botticelli and the Rembrandt" and that he has received Henschel's confirmation of the purchase of the "Hanneman and Veronese." He has started, he adds, to refurbish the reputation of the Hanneman, a portrait of William II of Orange, "which always used to be considered a masterwork by van Dyck." To do this he has had to offer Burckhardt and

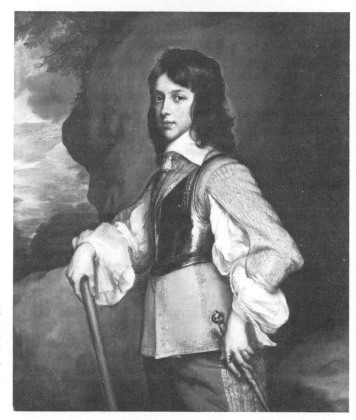

Raphael, *The Alba Madonna*, Umbrian, 15th Century. Known as "the million-dollar picture," it was up to 1930 the most expensive ever purchased. In terms of the value of money it probably still is! National Gallery of Art, Andrew W. Mellon Collection.

Sir Anthony van Dyck, *William II of Nassau and Orange*, Flemish, 17th Century. An expensive Hanneman but a cheap van Dyck. National Gallery of Art, Andrew W. Mellon Collection.

Glück (the foremost authorities on Flemish painting) 20,000 marks. He encloses letters from both ascribing the portrait, which is now in the National Gallery of Art, to van Dyck, and he points out that for a Hanneman the £15,000 [$75,000] they had paid was very dear, but for a van Dyck they had a bargain. (The picture, though possibly of William II, is certainly not by van Dyck.)

He admits that Knoedler's has paid out "a tremendous sum . . . but you must not forget that you would have lost this business entirely . . . and you do not give care enough to the fact . . . that we are more or less a branch of Knoedler's, eagerly proceeding in the art to perform and exquisitely display how to be successful in social communication with Bolsheviki." This last clause ranks high in the history of letter writing!

He continues,

> What you write about Sir Joe [Duveen] was exact at the time when you sent me your letter. Meanwhile he got back a good part of his activity and I am afraid, trusting you are quite alone in the buying field, you will have some bad surprises. . . . After so much publicity, of course, things could not remain in secret, as it used to be, and besides the Russian people changed a good deal of their tactics, trying to come in touch with private people and museums. In fact they succeeded to sell a good deal of pictures between £1,000 and £20,000 [$5,000 and $100,000], as smaller examples by the French and Dutch Masters, but also pictures by Terborch, Metsu, Rembrandt, Rubens, van Dyck, Raphael, and so on, at astonishing prices. . . . Recently Duveen renewed important offers for some of the finest pictures . . .
>
> In ordinary business, time works for you to get pictures cheaper. In this business the competition becomes wider and I am afraid we are going to loose [sic] one picture after another.
>
> All the time I was following your instructions, but as you ask my personal judgement, I must tell you, that I am convinced that your way to work was a mistake, as every picture could have been bought much cheaper half a year ago. . . .
>
> We all here are under the impression that you do not much believe in our ability of negotiating and that you therefore recently have the tactic not to give us your real price-ideas, to prevent us offering too much at the start. I very often explained you, that our counteragents are well informed and even too well informed what

concerns top-prices, and that there is only a very small chance to buy cheap by making discoveries. To buy reasonable we did our best and used all the tactics possible, and developed to be fit for the diplomatic service.

It is apparent from this anguished plea for understanding from Knoedler's German partner that Charles Henschel was trying to drive hard bargains to force the Russians to sell well below their estimates. With the benefit of hindsight it is all too evident that Zatzenstein was right. It is axiomatic that for priceless works of art it is folly to haggle over price. Was Andrew Mellon at fault? It was the beginning of the Depression and the prices of all commodities were falling. Many works of art also could be bought at bargain rates. But it seems probable that Mr. Mellon did not fully realize that he was negotiating for paintings which could not be matched in the stock of Duveen, Wildenstein, or any other dealer in the world. He finally acquired twenty-one paintings of unique beauty and significance for $6,654,000. It seemed a tremendous sum at the time, yet a single painting, the Radnor Velázquez, in 1970 brought almost as much as the entire twenty-one masterpieces. One wishes the enthusiasm of Mr. Mellon and Mr. Henschel, faced with the greatest opportunity in the history of collecting, had been a little less reluctant!

With the delivery by Ilyn and Kraevsky of the last two pictures agreed upon, the Soviet representatives seem to have discussed with Henschel further acquisitions. For on April 11, 1931, Messmore wrote Andrew Mellon the most fascinating letter of all.

Dear Mr. Mellon:

I am enclosing all the facts we have been able to secure regarding the Giorgione and the two Leonardo da Vincis.

They have given us a price of 700 [thousand pounds] [$3,500,-000] for these three pictures, and a price of 500 [thousand pounds] [$2,500,000] for the Giorgione and the "Benois" Leonardo.

They wish to include in this transaction at least three of the pictures on which they had previously given us the prices first mentioned below.

19	Simone Martini	£15,000 [$ 75,000]	£12,000 [$ 60,000]
96	Murillo	40,000 [$200,000]	30,000 [$150,000]

| 163 | de Hoogh | 40,000 [$200,000] | 35,000 [$175,000] |
| 40 | Cima | 56,000 [$280,000] | 48,000 [$240,000] |

They have now named as the lowest prices they will take on these pictures the figures in the second column.

Please think over if you would like to offer them the following price for six pictures, — namely:

42	Giorgione	£170,000	[$850,000]
30	Leonardo	120,000	[$600,000]
31	Leonardo	100,000	[$500,000]
163	de Hoogh	30,000	[$150,000]
96	Murillo	10,000	[$50,000]
19	Simone Martini	10,000	[$50,000]
		£450,000	[$2,250,000]

I have not included the Cima #40 for which their lowest price is £48,000 [$240,000], as we do not consider it worth more than about £25,000 [$125,000].

If we can conclude this deal advantageously, we will have secured all of the greatest pictures in the entire collection. As a matter of fact, the only three outstanding pictures which are left are the Giorgione and the two Leonardos. Later on, if we could secure the early Velázquez and the Filippino Lippi #20 at a low price, it might be wise to do so.

Messmore must have received some encouragement from his client, for a month later Henschel was in London negotiating with a representative of the USSR. On May 12, 1931, he wrote Messmore:

Dear Carman:

I told our Russian friend this morning that we would definitely not be interested in buying the Giorgione at the price that he wanted; he said this was perfectly all right and that he knew he could sell the picture to Joe [Duveen] and therefore we need not worry further about it. I told him at the same time that the price for the de Hoogh was considerably exaggerated and that £25,000 [$125,-000] would be the top price for this picture and that I even doubted that it could be sold for this amount. He said that it was perfectly all right as far as he was concerned; that they did not have to sell

any of the pictures and would not do so unless they got what they considered good prices.

If Joe should buy the Giorgione and announce it to the press, I think we ought to come out with a good strong article telling of our purchases and making an interesting story out of it. Naturally we would not in any circumstances mention A. W. M.'s name, but on the other hand, the Press might put it in on their own account. You might talk to A. W. about this so that we can be prepared in the event of the matter getting into the newspapers.

The letter does not mention the two paintings by Leonardo da Vinci, and nothing more is recorded of the proposed deal. It is heartbreaking, for if it had been consummated, the National Gallery of Art today would have two undoubted paintings by Leonardo, and two possibly by him, and three by Giorgione — a record that only the Louvre could equal. Saddest of all, the prices quoted by Messmore seem in line with what Mr. Mellon had been paying. If these figures can be relied on, it would seem as though the Russians had reduced the price of the Benois Madonna from $2,600,000 in 1928, to $2,500,000 for it and the Giorgione *Judith*, in 1931. Deflation as a consequence of the Great Depression had finally reached Russia.

Why further bargaining was necessary is hard to understand. It is ironical to note that though the National Gallery of Art has never revealed the purchase price of the portrait of Ginevra de' Benci by Leonardo da Vinci, I can say that it was far more than the Soviet government asked for a Leonardo, a possible Leonardo, and a Giorgione. Duveen testified on the witness stand, though he later changed his testimony, that the certain Leonardo, the Benois Madonna, was bought by the Czar in 1913 for $1,500,000. Even if Duveen's testimony cannot always be relied on, surely the purchase of this painting and Giorgione's *Judith* for $2,500,000 would have been a bargain by any standards.

After the collapse of negotiations for these three supreme treasures, Henschel turned to French Impressionist and Post-Impressionist paintings, though as late as March 3, 1933, in the last letter I have seen to Mansfeld, he says,

Mr. Mellon will probably be back here shortly and I am hoping to be able to induce him to make some kind of a deal on the

Giorgione. In the event of his being willing to buy this picture, I feel sure that he would want to give back the van Dyck woman or the Rembrandt Turk, or possibly both. What I will try to do is to get a group of some of the French pictures mentioned above, the van Eyck [now in the Metropolitan Museum], and the Giorgione, and make some kind of a proposition for the whole lot. This would involve more money, and perhaps would appeal more to Ilyn.

Nothing came of that proposal. But Mr. Mellon bought other important pictures from Knoedler's apart from those I have mentioned. The first really expensive picture he acquired was the *Portrait of Edward VI as a Child* by Holbein, for which he paid in 1925 $437,000. There is an amusing telegram in the Knoedler archive which gives one a glimpse of the competition between the big dealers to acquire supreme works of art for Mr. Mellon. It was sent in the autumn of 1924 to Charles Henschel by his agent, another dealer, Carl Drey. He had gone to see the director of the Provincial Museum at Hanover to buy the *Portrait of Edward VI*, Holbein's New Year's Day gift to Henry VIII. He had expected a private appointment, but the astute director had arranged for Schaefer, who in turn seems to have been acting for Duveen, to be present at the same time. For five hours the two dealers fought, argued, and bid against each other, as the text of the telegram indicates:

MEETING LASTED FIVE HOURS WITH SCHAEFER PROBABLY FOR DUVEEN AS COMPETITOR PRESENT HE OFFERED TWO MILLIONS TWO HUNDRED STOP HOPING YOU AGREE I ACCEPTED PRICE TWO MILLION TWO HUNDRED FIFTY THOUSAND STOP BUT SCHAFER OVERBIDDING AGAIN I FINALLY CONCLUDED FOLLOWING WRITTEN CONTRACT MUSEUM ASKS TWO MILLION SIX HUNDRED THOUSAND AND GIVES ME OPTION UNTIL WEDNESDAY FIVE OCLOCK AFTERNOON STOP ON THE OTHER HAND I OBLIGED MYSELF TO UPKEEP MY OFFER OF TWO MILLION TWO HUNDRED FIFTY THOUSAND STOP OPTION AS WELL AS OFFER ARE SUBJECT TO CONDITION THAT GOVERNMENT AND PARLIAMENT DECIDE UNTIL NOVEMBER FIRST STOP SITUATION WAS VERY DIFFICULT BUT HOPE THAT I FOLLOWED YOUR INTENTIONS CABLE OR PHONE IMMEDIATELY PARKHOTEL PHONE 5276 WILL REMAIN HERE UNTIL WEDNESDAY EVENING DREY [The currency involved seems to have been inflated German marks. Drey is talking in terms of $200,000 to $250,000.]

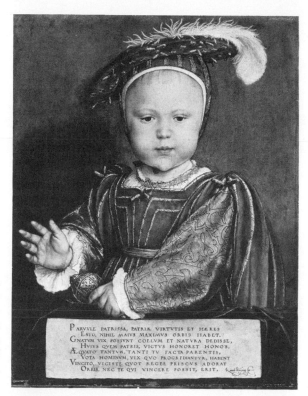

Hans Holbein the Younger, *Edward VI as a Child*, German, 16th Century. Historically one of the most important Holbeins in the world. National Gallery of Art, Andrew W. Mellon Collection.

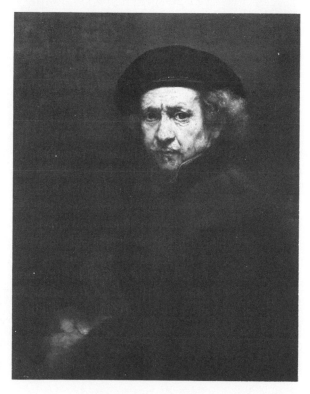

Rembrandt van Ryn, *Self-Portrait*, Dutch, 17th Century. A painting that paid for itself. National Gallery of Art, Andrew W. Mellon Collection.

It is apparent from the above that Schaefer at last collapsed and Drey, who had taken a chance and gone beyond the amount authorized, received an option binding him but subject to approval of the government and parliament. All went well and Mr. Mellon finally got the painting, historically one of the most important Holbeins in the world.

Andrew Mellon was always prepared to pay high prices, but he was anxious that the dealers should not receive exorbitant profits. The Rembrandt *Self-Portrait* from the Duke of Buccleuch's collection is a case in point. It is one of the most profound examples of visual self-analysis in existence and thus represented an acquisition of supreme value. Carman Messmore asked $600,000. Mr. Mellon looked at the painting and inquired how much Knoedler's had paid the Duke. Messmore admitted it had cost his firm only $250,000. This seemed a shocking profit, and the painting went back to New York. Months passed without Knoedler's most important client making any further purchases. Then Carman Messmore in considerable anxiety took the portrait to Washington, and while Mr. Mellon was out of his apartment, hung it on the principal wall of the dining room. He waited nervously for the return of the Secretary of the Treasury, who invited him for lunch. During the meal Mr. Mellon did not once mention the unexpected intruder hanging opposite him. When Messmore left, the painting remained in the dining room, and some weeks later he asked whether it should be removed. Andrew Mellon replied that he had decided to buy the picture but not at the price asked. He added, "You will have to make a considerable reduction." More time passed without concession on either side. Finally Mr. Mellon made a proposal, for the *Self-Portrait* was a painting he had come to love dearly. He had a Pieter de Hooch he didn't like. He offered to trade it in, and if Knoedler would also take a 10 percent reduction, he would buy the Rembrandt. The deal was immediately concluded.

This particular painting has in a curious way paid for itself. Dr. Adolph Miller, at one time the chairman of the Federal Reserve Board, used to come regularly to the National Gallery, and I would often see him sitting on a couch in front of Rembrandt's *Self-Portrait*. One day he asked me to sit beside him and told me that he had finally come to the conclusion that he would leave his entire collection and a property worth a large sum of money to the National Gallery of Art. "John," he said, "I want you to know that I am not doing this because of you or anyone else. I am doing it because of what I have been taught by the extraordinary insight of Rembrandt's self-analysis. I have studied the

picture for years, and it has given me a deeper understanding of life."

Mr. Mellon never bid at auction, and apart from a few American paintings and *Lady Broughton* by Romney, I know of only one other occasion when he bought directly from a private person. In the case of this particular painting, *The Marquesa de Pontejos* by Goya, Knoedler's had asked whether he would be interested in its acquisition if it were for sale. The answer was affirmative, but as the deal hung fire, he decided impatiently that it could be expedited. He authorized David Finley to negotiate through the American embassy in Madrid with the owners, who had been reluctant to come to terms with Knoedler's. When the purchase was made, however, Andrew Mellon found that he still had to depend on Knoedler's for the Spanish export permit. This required months of negotiations and certain payments over and beyond export taxes — delicate deals, for which the word "bribe" might seem too brutally descriptive. Such "reimbursements" only an experienced intermediary could possibly arrange. In the end the commission Mellon paid, somewhat peevishly, was what he would have been charged had he not intervened. After this purchase he seems to have been reluctant to try direct negotiations with private owners.

Shortly after the great coup of the Hermitage acquisitions Andrew Mellon left Washington and the Treasury to become ambassador to the Court of St. James's. In London from 1932 to 1933 he spent one of the happiest years of his life. The English sojourn gave him the opportunity to pass many hours in the National Gallery in Trafalgar Square. Everything there appealed to him: the size, the installation, the high level of quality. He grew increasingly determined that the museum in Washington which he planned to establish should rival the one he loved in London.

It was during this period that his contacts with Duveen increased. Knoedler's influence after the conclusion of the Russian deals waned, but a majority of the greatest acquisitions can be traced to Carl Henschel and Carman Messmore of Knoedler's. The Duveen paintings, though they included many masterpieces, were less impressive, and until 1936 not numerous.

Having decided to establish the National Gallery of Art, however, and realizing that his works of art might seem inadequate as the nucleus of the great national collection he envisaged, Andrew Mellon, the year before he died, turned to Duveen and made his largest single purchase. He had never been enthusiastic about Italian paintings, and this section of his collection was weak in numbers though not in qual-

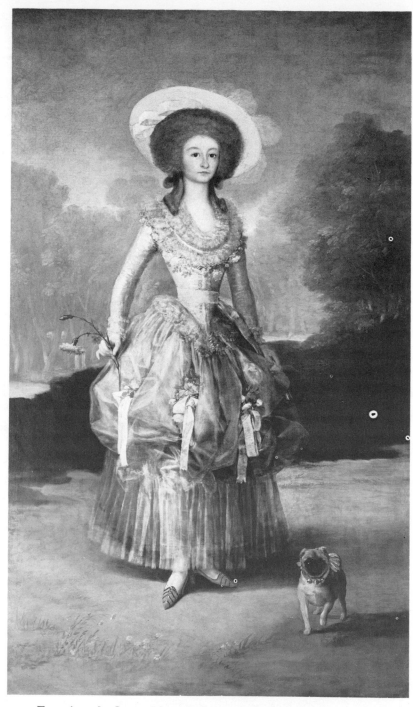

Francisco de Goya, *The Marquesa de Pontejos*, Spanish, 18th Century. One of the rare paintings that Mr. Mellon bought privately. National Gallery of Art, Andrew W. Mellon Collection.

ity. In 1936 when he was in London he saw Joseph Duveen, who said to him, "I am going to retire from business. You are ready to give your collection for a national gallery. This is a combination of circumstances that can never happen again." He urged Mr. Mellon on his return to America to make a selection from his stock, and presumably offered some reduction in price, though considering what was finally paid, any reduction seems to have been illusory.

When Andrew Mellon arrived back in Washington it was evident that he had greatly aged. Feeling too weak to go to New York himself, he asked David Finley to pay a visit to Duveen Brothers and send to Washington any pictures he felt might be worthy of the new gallery. Finley then chose thirty paintings, of which twenty-four were retained. Most were Italian and included masterpieces by Duccio, Botticelli, Filippino Lippi, Giovanni Bellini, and others. It was an extraordinary group, which at that time could have been purchased nowhere else.

Among the paintings selected was the *Madonna of Humility* by Masaccio. Shortly before Duveen's death in 1939 I saw him in London and he asked me what I thought of this extraordinary panel. I praised it, and he told me that he was delighted and surprised. He was convinced at one time, he said, that he would never be able to sell it. He had bought it on the advice of Bernard Berenson, and it had remained for years in his stock. Finally he became so infuriated with this reminder of what he considered to be his folly that he told his assistant, Bertram Boggis, he wanted to chop it up. (He probably also wanted to impress me with his disregard of the wares he was selling, for this in some way seems to have pleased his tremendous egotism.) However, Boggis reminded him that Berenson considered it a great masterpiece and begged him to have patience. His patience was unexpectedly rewarded, for David Finley was an enthusiast for Italian painting who also had read Berenson, and it was he who induced a somewhat reluctant Andrew Mellon to buy the *Madonna of Humility*. Meanwhile Duveen, instead of destroying the picture completely, decided to destroy it partially by having it repainted to make it prettier. There are demonstrable differences between the panel as it appears now, and as it was reproduced in an article by Berenson, who first published it; but though in a ruined state, it remains, in my opinion, a significant echo of the work of the rarest and greatest genius of the early fifteenth century. The anecdote throws an interesting light on two aspects of Duveen's personality: his mercenary side — his anger at having bought an unsalable picture, for he could not foresee that an admirer of Berenson, who also had a con-

Joseph Duveen, 1929. (United Press International Photo)

siderable knowledge and love of the history of Italian art, would fortuitously arrive and persuade his principal client to buy a picture so often rejected; and his disarming frankness — a willingness to reveal his almost embarrassing foibles, among them his desire to give the impression of reckless impetuosity.

Duveen not only wanted to sell Andrew Mellon paintings, but he wished to interest him in the plastic arts as well, for he owned the Dreyfus Collection of sculpture. It was important, therefore, that Mr. Mellon should abandon his original idea of modeling the National Gallery in Washington on that in London, thus restricting the collection to pictures. A supersalesman, Lord Duveen persuaded his client that the design of the building, which John Russell Pope had drawn up, required some monumental statues for the halls leading to the garden courts, and since these pieces were obviously a necessity, a representation of Italian sculpture would be desirable. Some of the Dreyfus Collection was already sold, and Mr. Mellon was not interested in the medals, plaquettes and small bronzes, which Dreyfus himself loved so fondly, but the greater part of the pieces that remained — marbles, terra-cottas, wood carvings — were brought to Washington and seventeen ultimately acquired.

When all the paintings and sculpture were ready to be moved from New York to the capital, Duveen played his masterstroke, one characteristic of his genius. He rented an apartment at 1785 Massachusetts Avenue on the floor below Mr. Mellon, and in these rooms beautifully installed his works of art. They remained there for several months, and Andrew Mellon alone or with friends would spend hours contemplating his prospective purchases. Lord Duveen himself came occasionally to apply his salesmanship. One day he called Mr. Mellon's attention to the *Portrait of the Marchesa Balbi* by van Dyck, suddenly illumined by a ray of sunshine. "Look at that picture, Mr. Mellon," he said, "with that light upon it. Have you ever seen anything so marvelous?" "My pictures, Duveen," Mr. Mellon replied, with the trace of a smile, as though acknowledging the dealer's cosmic partnership, "never look so well as they do when you are here."

The influence of Joseph Duveen on Andrew Mellon, however, has come to be greatly overstated. The explanation of this exaggeration goes back to the politically motivated tax trial imposed on the ex-Secretary of the Treasury by a vindictive President, a trial which Mellon subsequently won. One of the facts at issue was the National Gallery of Art. It had not been established, and the government claimed Mr. Mellon

had no intention of founding such an institution. It was therefore important to produce people with whom he had discussed the future gallery, and it was decided Duveen would be a useful witness. The lawyers for the defense wished him to state in the fewest possible words that he knew Mr. Mellon had had in mind for several years building and endowing a national gallery in Washington. Lord Duveen accomplished his mission but under cross-examination, not in the fewest possible words. Instead he gave the impression that Mr. Mellon was virtually his puppet. He claimed or implied that he, Duveen, chose the location of the future gallery, selected its architect, John Russell Pope, decided that marble should be used for its construction, and advised more or less on the collection it should house.

A few years ago I asked Donald Shepard, who was one of Mr. Mellon's principal lawyers and also his executor, about the Duveen statements. He said he would never forget the amazement and anger of himself and his associates in the case when Duveen began his testimony. This part of the trial departed entirely from the scenario; but it is a rule of law that one cannot impeach one's own witness. The Mellon lawyers were powerless to stop Duveen's boasting. It was his shining hour and he made the most of it.

In fairness to Mr. Mellon it seems important to set the record straight. First, regarding the location, Lord Duveen mentions in the picturesque language of his testimony, "By the obelisk, near the pond." As S. N. Behrman has written in his biography of Duveen, this transposition of "the Washington Monument to the Sahara and its reflecting pool to some English county," caused the spectators to howl with laughter. But what Duveen was describing was a location which had been proposed by the head of the Fine Arts Commission some time before and rejected by Mr. Mellon.

Second, the architect, John Russell Pope. Years before when Secretary of the Treasury, Andrew Mellon had chosen Pope to be the architect of the National Archives Building. Pope and Cass Gilbert were the two architects seriously considered for the new gallery. When Gilbert died, Pope, who would probably have been selected in any event, was chosen. The selection had nothing to do with Duveen, nor is there any evidence that he introduced John Russell Pope to Andrew Mellon, as he claimed.

Third, the material. Mr. Mellon himself chose Tennessee rose marble for the external walls. He had seen several New York buildings of this

material which he liked, and he was determined to use it regardless of cost.

Fourth, the collection. Duveen's influence, apart from the works of art which he offered for sale, was limited to the inclusion of sculpture. All the paintings and sculpture, however, were chosen by Mr. Mellon, whose personal taste can be seen in the rejection of the *Giuliano de' Medici* attributed to Raphael and the return of many of the pictures from Duveen's stock brought by David Finley to Washington.

Mr. Mellon bought fifty-five Old Masters from Duveen Brothers. He bought 129 from Knoedler's. Moreover, the number of paintings he acquired from Duveen's rival was further increased by his acquisition of the entire Thomas B. Clarke Collection of 175 American portraits. The most important of these have come to the National Gallery; others of historical interest have been given to the National Portrait Gallery, and a third group falsely attributed and spuriously identified have been stored away. Mr. Mellon realized that this third group existed, but such masterpieces as *Mrs. Yates* by Gilbert Stuart and many other portraits by the same artist, and *The Washington Family* by Savage, one of the most famous of American icons, more than justify the purchase.

The Mellon Collection which was shown to the public when the Gallery opened was distilled from 369 pictures to 125. Of these more than 95 percent have stood more than thirty years of the most critical scrutiny and have proved to be masterpieces of the highest quality, an amazing feat of connoisseurship. The sculpture, numbering only 23 examples, was bought en bloc and the percentage of masterpieces is somewhat less. Three pieces had ultimately to be stored or returned to Duveen Brothers.

But the record remains astonishing, especially for an amateur, self-trained and involved all his life in business and governmental responsibilities. A friend once asked Mr. Mellon whether his business experience had been of any help in buying works of art. "Decidedly so," he replied. He used in the acquisition of his collection, he explained, the same methods successful in his banking activities: careful investigation, obtaining the opinions of others, weighing in his own mind the pros and cons. But above all taking plenty of time, in many cases living with the paintings before buying them. Never enter on any enterprise in a hurry, he would say; examine it from all possible points of view and decide only after thorough deliberation. A Gulf Oil associate once brought to Andrew Mellon's attention what he regarded as a splendid

opportunity. "But we must accept by five this afternoon," he said. "In that case," Mr. Mellon replied, "the answer is 'no.' Never decide at the point of a gun." And this is how he handled dealers and to some extent why he selected their wares so successfully. It is a lesson many collectors should learn.

At times Andrew Mellon would talk about his collection as an investment. He learned from the follies of his early purchases that it was important to buy only the greatest works of art by the greatest artists. Their values showed a steady progress through the centuries, never a regression. But when he mentioned the monetary appreciation of the masterpieces he had assembled, it was only a form of self-justification, a rationalization of his indulgence in collecting. He loved his works of art for themselves. Their value in dollars and cents was of no significance.

Dr. John G. Bowman, the chancellor of the University of Pittsburgh, an old friend, once asked Mr. Mellon a question every collector must have asked himself, the motivation which led to his collecting. "He looked straight at me for a rather long pause," Dr. Bowman has written in a memorandum for an unpublished life of Mr. Mellon. " 'Every man,' he said slowly, 'wants to connect his life with something he thinks eternal. If you turn that over in your mind you will find the answer to your question' "—a telling statement from the taciturn Andrew Mellon.

7

Two Unwary Collectors:
Samuel and Rush H. Kress

The motivation of collectors varies enormously, but boredom is often an important factor. The problem of leisure is as serious for the rich as it is for others. Samuel H. Kress, one of the hardest-working men I have ever known, found that his health demanded vacations. These, which he customarily took in Europe, bored him. He was restless, and not knowing what to do with his time, he began to assemble one of the largest and most important private art collections ever to be formed in the United States.

There was nothing in his background to indicate that this would happen. He began life as a schoolteacher in northern Pennsylvania. He saved his small salary until he had accumulated enough capital to buy a stationery and novelty store. His hard work and his flair made it an immediate success, and he expanded his business.

This expansion was the outcome of a simple but revolutionary idea. To use Kenneth Galbraith's terms, Kress put his money on "consumer sovereignty." In less academic language, his competitors around 1900

bought for their stores what the manufacturers offered. Samuel Kress spent his time finding out what his customers wanted and then made the manufacturers design their goods in accordance with the wishes of his clients. This may seem an obvious policy, but Galbraith claims that in spite of merchants like Samuel Kress, the producer is still sovereign, even more today than in 1900, and imposes his will on the rest of us. If he is right, Kress's fight for the consumer was a failure, but at least it proved to be immensely profitable. Choosing with wisdom the South and West as the sections of the United States which would expand the most rapidly, he built up a chain of stores which competed successfully with Woolworth, Penney, Kresge and others, and in the end gained him a great fortune.

But to return to the effect of boredom on his becoming a collector, he had never married and his European trips were made with a friend, a very clever and attractive lady who soon recognized that she would have to find an antidote for his ennui or be poisoned with it herself. It was all too evident that Europe was affecting them both malignantly.

The remedy was obvious: to discover an interest for Sam Kress (as his intimate friends called him). This his companion brilliantly devised. She put him in touch with a recently ennobled Florentine, Count Contini-Bonacossi. He was a collector-dealer — always a dangerous source for purchases — and a remarkably attractive human being. A biography of this extraordinary man should be written. In his activities he was, on a reduced scale, a modern Cagliostro; but in his good looks, his tall slender figure, his spacious forehead and air of breeding and authority, he might have had the successes of a Casanova. Influential in the highest Fascist circles, he was made a senator by Mussolini and given his title by the king. He lived in a magnificent villa in a large park in the center of Florence, where he was attended by a retinue of liveried servants. To Sam Kress he seemed the very essence of European nobility. Kress always referred to him deferentially and affectionately as "The Count."

It is rumored that "The Count" began life quite humbly, working in a Spanish household. It is more certain that he became a stamp dealer in Milan. Fortune favored him as a philatelist, and with the money he made he began collecting Italian works of art, trading in a market where values were constantly rising. When Sam Kress was introduced to him in the 1920s, he had formed a notable private collection, and he had in storage the residuum of the paintings and sculpture from which it had been distilled. These were for sale; and once Sam Kress's com-

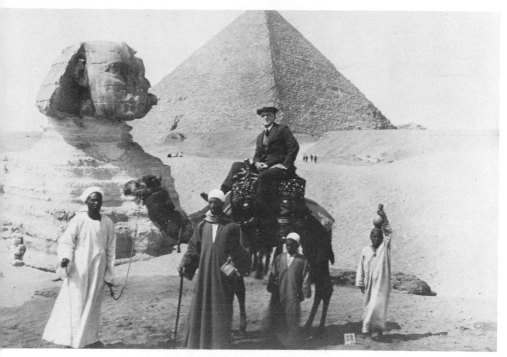

Sam Kress in Egypt. His health demanded vacations but these bored him.
(Photo Courtesy of the Kress Foundation)

panion had brought him and the count together, the ownership of the remainder of the Contini Collection was assured.

As Contini was unwilling to sell his masterpieces, it was necessary to find a raison d'être for parting with indifferent examples. His experience as a stamp collector offered the solution. Why shouldn't Sam Kress assemble a representation of every artist of the Italian Renaissance, major and minor, sometimes represented by mediocre and sometimes by good examples, just as a philatelist will fill his albums with every stamp issued in a particular place at a particular time, some damaged, some well-preserved?

But there is an important difference between collecting stamps and collecting paintings. The information about the stamp, and its value, are printed on its face. Early Italian pictures are almost never signed and even their place of origin is often in doubt. Moreover, Sam Kress, if he were a philatelist, could look up his purchases in a published catalogue. The problem was to find the equivalent of such a catalogue for the paintings Contini expected to sell. The nearest thing to a stamp catalogue for his wares was Berenson's *Italian Paintings of the Renais-*

sance, but B. B. refused to list works of art which were for sale, and, as Contini was a dealer, his stock was not described. "The Count," faced with this dilemma, hit upon an ingenious solution. He employed half a dozen experts in Italian art — Longhi, Fiocco, Venturi, Van Marle, Suida, and Perkins — to write certificates for all the pictures he intended to dispose of. These "expertises" spelled out in unequivocal terms the name of the artist, the date of his work, and by implication its great importance. Sam Kress was delighted. Contini saw to it that there was just enough disagreement among the experts to enhance the apparent veracity of their prepaid opinions.

But Kress was not entirely gullible. He noted that one expert was missing, Bernard Berenson, about whom he had heard in some mysterious way. He wrote himself to B. B. and asked whether he would be willing to look at photographs of his collection. The reply was affirmative and the photographs duly arived at I Tatti. Berenson scrutinized them carefully and freely gave his ascription to each picture. These attributions were more disinterested than those previously written and would have been a shock to a collector less naïve than Sam Kress. He, however, decided that if Longhi, Fiocco, Venturi, Van Marle, Perkins, and Suida said he owned a Botticelli and only Berenson said he owned a work of the School of Botticelli, the vote was six to one, and Botticelli was elected, not unanimously as he would have wished, but substantially, which was all that mattered. It seems never to have occurred to him that these experts, except for Berenson, were subsidized by the vendor whose wares they were appraising.

Thus, the opinions of B. B. were largely ignored by Kress. But the arrival of the Kress Collection photographs at I Tatti had important consequences for me. I had been appointed chief curator of the National Gallery of Art in 1938 and had spent that summer working on the plans of the new building, but I was still under contract to the American Academy in Rome. During the autumn, after I had returned to Italy, David Finley, the recently appointed director of the Gallery, had seen Sam Kress and had persuaded him to give some consideration to the gift of his works of art to the National Gallery, instead of building his own museum or donating his collection to the Metropolitan Museum, the two alternatives he had in mind. Interesting Kress in the Gallery was a remarkable achievement, but David Finley's feeling of euphoria was not shared by his board of trustees. They had heard rumors that the Kress Collection did not meet the high standard insisted on by Andrew Mellon. They therefore asked me to take a leave of absence from the

Academy, return to America, and advise them on what they considered to be a somewhat questionable offer, if and when it was made. The situation was delicate. Kress himself was as doubtful that he wanted the collection in Washington as were the trustees that they would accept it.

I agreed to come to New York and to interject myself into these complicated negotiations. Before sailing I went to Florence for a few days to say goodbye to B. B. As soon as I told him the purpose of my American trip he exclaimed that by the most extraordinary coincidence he had just received photographs of all the Kress paintings and sculpture and that he was at that very moment writing his opinion on each print. We looked at the photographs together and chuckled over some of the attributions of the Contini experts. My recollection is that there were almost a thousand prints, and on the back of each was written the opinions of the six scholars Contini was paying.

Never in my life have I worked as hard as I did those few days I stayed at I Tatti. I memorized the attribution given by each expert to every painting and sculpture. Before I left for America I was letter-perfect.

As soon as I disembarked I was taken to 1020 Fifth Avenue where I met Sam Kress for the first time. I remember his small blue eyes, as hard and piercing as any I have ever seen. His head, which seemed rather large for his stocky body, suggested one of those portraits of Roman emperors of the second century; and like the late rulers of Rome, his expression was one of innate suspicion. I felt as though I was being appraised and at first certainly found wanting.

The apartment, a two-story penthouse, was expensively decorated in what might be termed New York Renaissance. The stairs and floors were marble or tile and the trim a dark oak. Heavy tables and elaborately carved *cassoni* supported a plethora of majolica, plaques, and small bronzes, and the Savonarola stools and Medici chairs on which we uncomfortably sat were upholstered in stamped leather, or red velvet. There was not a photograph, a magazine, or a book to be seen, except the leather-bound sets of standard authors barely visible in the "library" behind the leaded glass doors of the low bookcases. Mr. Kress must have been as depressed as I was by these surroundings, for he spent most of his time in the "solarium" on the second floor, though his living quarters there were as impersonal as the rest of the flat.

Italian paintings, lighted with reflectors, were hung from dado to ceiling in every room. Each panel or canvas was in a shadowbox lined with old velvet; red, green, and sometimes gray. These packaged primi-

tives, heavily varnished and cradled, bore witness to a storekeeper's sense of order and to his conviction that merchandise should be well lighted and attractively presented.

There was, however, one important dissimilarity to the Kress stores — nothing was labeled. But Mr. Kress had a small black book which listed the works of art in each room, and as he and I walked from picture to picture he would say, "Mr. Walker, who do you think painted that Madonna?" I would study the picture for a moment and answer with some hesitation, "I believe, Mr. Kress, Berenson would attribute it to so-and-so. However, I don't doubt that Van Marle would disagree and ascribe it to such and such. Probably Longhi and Perkins would go along with Van Marle." Mr. Kress would refer to his notes and say, "Very remarkable, Mr. Walker, that is exactly the case." We continued in this way around the whole apartment, and Mr. Kress at the end of the day conceded that the new chief curator of the National Gallery knew something about Italian art. He was particularly impressed, as he felt the curator of the Metropolitan had flunked the same impossible examination. I remember later discussing the collection with my curatorial colleague whose museum was across the street, and he spoke very disparagingly of everything he had seen; but the low opinion he held of the Kress works of art, though justified to some extent, was, I felt, exaggerated by his unfortunate visit. I never mentioned my lucky trip to I Tatti.

The next day I was taken to Mr. Kress's office downtown. Again I was shown hundreds of Italian Primitives, all in their shadowboxes, some in racks, some hung, some stacked against the walls. These "items," as their owner designated them, were carefully inventoried, as though they were spools of thread, but they were never catalogued except for the sheaf of expert opinions on each.

The same procedure was followed as on the previous day. But our inspection was somewhat retarded, for Mr. Kress, being deathly afraid of catching cold and perspiring easily, was constantly putting on and taking off his jacket, as I discovered he was in the habit of doing everywhere. I was questioned about attributions and dates, and I recited my conjectures as to the opinions of the Contini experts. I also added my guess as to Berenson's probable ascriptions, which Mr. Kress had just received. His astonished pleasure at my accuracy increased with each bull's-eye. His curator, a former opera singer Contini had sent to America to keep an eye on his client and theoretically to catalogue the

collection, was equally pleased, for he was worried that I might ascribe the paintings to artists different from those selected by his employer's experts. I was also introduced to Stephen Pichetto, the Kress restorer, who was later to have a tremendous role in the development of the National Gallery. Before the day was over it was evident that Sam Kress had become less dubious about the collection going to Washington, though as we left David Finley whispered to me that he had the look of a man who had just married off his daughters but was still somewhat doubtful about his new sons-in-law. Perhaps he suspected I was cheating in some way he couldn't quite understand.

When we got back to Washington, David Bruce, Paul Mellon, and Donald Shepard, the three trustees of the A. W. Mellon Educational and Charitable Trust, who were also trustees of the new Gallery, were skeptical about David Finley's and my enthusiasm. They pointed out emphatically that Mr. Mellon had insisted a clause be inserted into the Act of Congress establishing the Gallery which stated that "No work of art shall be included in the Permanent Collection . . . unless it be of similar high standard of quality to those in the collection acquired from the donor." Was it true that the collection offered by Mr. Kress met the intention of Mr. Mellon as expressed in this clause? The truth was that it did not! But this I could not admit. David Finley had been able to negotiate an arrangement whereby a segment of the proposed gift was constituted a Study Collection, but this was a small part of nearly four hundred works of art Sam Kress insisted the National Gallery accept, most of which were to be shown as part of the Permanent Collection; and these paintings and sculpture, though authentic and on the whole in good condition, included little of world renown, whereas most of the Mellon works of art were masterpieces. Andrew Mellon's collection was comparable to those of Frick and Widener, to name the two greatest in America, and the Kress Collection was not at that level. Certainly to accept the donation proposed by Mr. Kress was to ignore the clear intention of the founder of the Gallery.

I was in a dilemma. Mr. Mellon had donated only 125 paintings and twenty-three pieces of sculpture. We were about to open a vast building, designed to provide well over a hundred galleries, with 148 "items," to use Mr. Kress's term. That was all we had. No one else had given anything. The Mellon works of art, I thought, would seem as scattered as sheep on a Scotch moor. Imagine Congress being asked to provide funds for one work of art per room! Politicians, like nature, abhor a

vacuum. I had a vision of the Gallery being used to show the work of local artists from every state in the Union. Moreover, I was convinced that Sam Kress had every intention of improving his collection. He had the means to do so, and I could tell that he had become a collecting addict. He was hooked!

Never have I been so perplexed. David Finley and I had pleaded with Sam Kress for fewer paintings and sculpture to keep the level of quality as high as possible. But he had no intention of modifying his terms. He held all the cards, and we knew it. We accepted what he wanted to send to Washington, or his collection remained in New York. I really had no choice. I had to lie.

There was, however, a Jesuitical justification for my lie, on which I relied. Andrew Mellon had acquired two or three weak paintings, which were as undistinguished as anything in the Kress Collection. Couldn't one argue, bearing these Mellon duds in mind, that the Kress works of art were of a similar high standard of quality to (*some of*) "those in the collection acquired from the donor"? With this rationalization, which still makes me shudder, I signed the affidavit and put myself on record that the Kress gift met Andrew Mellon's stipulations.

How I hated to do it! It was twenty years before I felt myself entirely justified. But these figures, I believe, are my justification. Of the 393 paintings and sculpture in the first Kress gift only 131 are now shown. Two hundred and sixty-two works of art have been weeded out and replaced by the greatest masterpieces which came on the market during the 1940s and 1950s, the last two decades when acquisitions on this scale and of this quality were possible. At last I can truthfully say that Mr. Mellon's stipulation has been met in every way, and my sense of guilt is gone. The Gallery was saved from the effects of my duplicity, as I shall point out, by Rush Kress, Sam's younger brother, a much greater collector, who raised the Samuel H. Kress Collection to its present eminence, or I might even say pre-eminence, for in quality and number of works of art it is difficult to find its equal among donations to any American museum.

Though Rush Kress deserves the credit for the transformation of the Samuel H. Kress Collection, the improvement began almost as soon as it was accepted by the National Gallery. Sam Kress had never bought anything from the large dealers while Andrew Mellon was alive. He was convinced that Mr. Mellon was being offered first choice, and that he would be given only the leftovers. The situation changed in 1937 with Andrew Mellon's death. Gradually Sam Kress overcame his suspi-

Rush Kress before a portrait of his brother. He was the loving surrogate of a ghost. (Photo: Volpe Studios, Courtesy of the Kress Foundation)

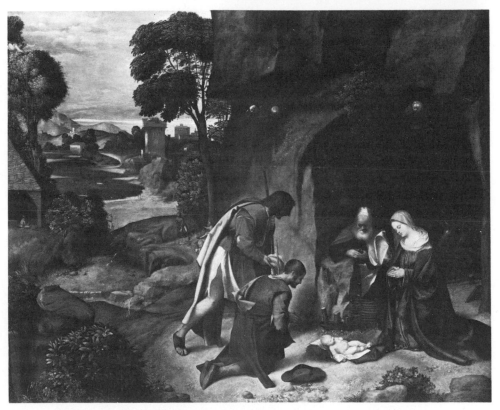

Giorgione, *The Adoration of the Shepherds*, Venetian, 16th Century. This is the painting which caused the break between B. B. and Duveen. National Gallery of Art, Samuel H. Kress Collection.

cions and began to frequent Duveen, Knoedler, and eventually Wilden-
stein. The quality of the wares these dealers submitted was far above
the Contini standards.

The first really important picture Sam Kress acquired, ironically for
a Berenson disciple, was the Allendale *Nativity*, which had caused the
break between B. B. and Duveen. With its presentation to the Gallery
went the stipulation that it should be attributed to Giorgione, an ascrip-
tion I had to accept. When we were told of its acquisition David Finley
and I were sworn to absolute secrecy. We presumed that Mr. Kress
wished his greatest masterpiece to be a surprise to celebrate the opening
of the National Gallery. We were wrong. Its debut was in the window
of the Kress store on Fifth Avenue to celebrate Christmas.

Stephen Pichetto was instrumental in raising the standards of the
Kress Collection. Our relations were complex and delicate. He was
gradually edging out "The Count" as Sam Kress's principal advisor,
and he did not wish me to edge him out in turn. Therefore he subtly
disparaged my judgment and disinterestedness and persuaded Mr. Kress
that I was more loyal to Andrew Mellon's collection than to his. He
stressed my friendship with Paul Mellon, and he managed to make my
actions and advice seem suspect.

I had learned a good deal from Berenson about the deviousness of the
art trade, and being young I foolishly tried to convey my knowledge to
Mr. Kress. Shrewd as he was in buying for his stores, in buying works
of art his innocence remained astounding. But how irksome I must have
seemed to Pichetto! My business, as he saw it, was to applaud important
Kress acquisitions, not to arouse Sam Kress's skepticism about their
cost, their attribution, their condition. No wonder he did all he could to
arouse Mr. Kress's skepticism about me.

I see more clearly now than I did then that Pichetto's interests and
mine were closely associated. It was to our interest to have the Kress
purchases made from the large dealers in New York rather than from
one collector-dealer who would never sell his best works. We both
wanted major masterpieces, not minor examples. I should have aided
him more than I did. He only asked that all the works of art offered to
Mr. Kress pass through his shop to be examined and restored. This was
at considerable cost to the vendor; and later, back came the same paint-
ings and sculpture for further restoration and care, this time at con-
siderable cost to the purchaser. It was an excellent arrangement, and
Stephen Pichetto died worth a great deal of money. But in the process of

acquiring his wealth he helped the National Gallery far more than I realized.

We worked together, however, cordially. I spent many hours in his studio in the Squibb Building on Fifth Avenue, where he occupied an entire floor. When I arrived he was always seated at his desk. He looked like a large, well-fed bullfrog, perfectly tranquil but ready to snap at any insect which might fly by. He had a cigar lighted or unlighted always in his enormous mouth. He would get up, invariably with an amiable smile, and take me through room after room where his assistants were cleaning, inpainting, relining, or cradling, to point out some new Kress acquisition. Occasionally he would wipe a dirty painting with turpentine to show me how brilliant it would become when its restoration was finished. His studio was like a well-run factory. It was Pichetto's efficiency and businesslike methods that appealed so strongly to Sam Kress.

Was his restoration good or bad, I have often asked myself. It was certainly mass-produced, but I am convinced it was not deleterious. He often repeated his First Commandment, "Never do unto a work of art what cannot be undone." It was a commandment he did not always observe. For he often planed down panels to make his cradling more effective, and he was responsible for many irreversible transfers. But on the whole the Kress Collection was well taken care of. If there was more inpainting than seemed necessary, it has proved easy to remove, and if the damar varnish was applied a little thickly, its yellowing has protected the colors from fading.

The National Gallery owes a great debt to Stephen Pichetto, who was, I discovered, a man of considerable intelligence and connoisseurship. It was fortunate for us that he had come to detest the Metropolitan Museum, where his role as a consultant restorer had been inexplicably terminated. His determination to create a rival institution in Washington, which would make the trustees and director of the Metropolitan regret that they had lost his services, was of immense help at a time when assistance was badly needed. That he hindered my friendship with Sam Kress is understandable and unimportant. Moreover, it had little effect on me, for nothing could really diminish my affection for this lonely collector, who was never quite sure why he was collecting.

Two or three times a month I would go to New York alone or with David Finley and lunch or dine in the Kress apartment. Afterward Sam Kress and I would walk back and forth on the penthouse terrace, and I

would tell him how much the public was enjoying his collection. He was always most interested in the attendance figures, which during the war were enormous, as though in the nebulous world of art into which he had accidentally blundered, these figures offered tangible proof that he had not wasted his time and money.

In 1946 he had his first stroke. For the next nine years he was unable to speak and barely able to move. He was president of the Gallery, and the trustees, I am glad to say, maintained him in that office. I would go to New York as often as possible and sit beside his bed and tell him once more how many people had come to the Gallery that week, largely, I would add, to see his works of art. It was heartbreaking to be with him as I spoke my repeated message. He would always make an effort to move his bandaged arms and to speak. He failed always, but his eyes, those hard, piercing eyes, seemed somehow pleased.

<center>ii</center>

When Sam Kress was stricken, his responsibilities devolved on his younger brother, Rush Kress. Whereas Sam had a sagacious, appraising look, Rush's was open, even ingenuous. Rush was many years younger and much the handsomer of the two. He reminded one less of a shopkeeper than of a business executive who had inherited the firm. He did, in fact, become president of the company and president of the foundation when his brother fell ill. With his ascendancy, the really great acquisitions for the Kress Collection began. Between 1946 and 1956, virtually every important painting and sculpture was offered to the Kress Foundation, and in those two decades Rush Kress spent approximately $25 million buying for the National Gallery. The same paintings and sculpture, if they could be bought today, would cost over $100 million. He also broadened the Kress acquisitions from an overwhelming concentration on Italian painting and sculpture to include Flemish, Spanish, French, Dutch and German art.

The first purchase that Rush carried out was also the first acquisition made on my initiative. Heretofore all the works of art in the Kress Collection had been chosen by Contini or Pichetto. The picture in question, *The Laocoön* by El Greco, ranks among the half dozen greatest masterpieces in the National Gallery of Art. It belonged to a friend of mine, Prince Paul of Yugoslavia, who had lent it to the National Gallery in London, but when World War Two was declared had

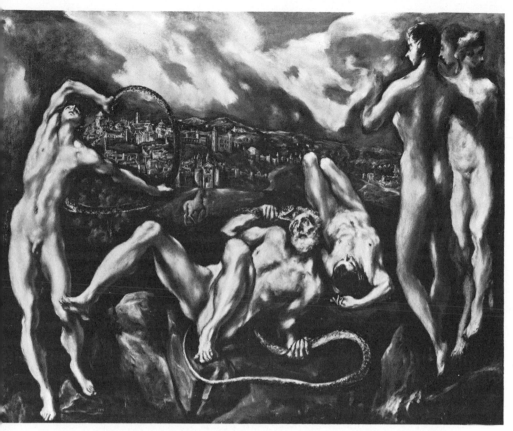

El Greco, *Laocoön*, Spanish, 17th Century. The first important purchase made by Rush Kress. National Gallery of Art, Samuel H. Kress Collection.

sent it to Washington in my care for safekeeping. Soon after the war I learned that Prince Paul was in South Africa, a prisoner of the British. I thought he might welcome an opportunity to liquidate at least one of his assets, and I told Rush Kress that this was a unique opportunity, a chance to acquire one of the greatest masterpieces in the world. He agreed, but the difficulty was to get in touch with Prince Paul.

David Finley had a secretary whose father was in O.S.S. and who was going on a mission to South Africa. We decided to entrust him with a secret message to the imprisoned prince. When he got back he told us that Prince Paul was being held incommunicado and he implied that he almost had to swallow our letter to keep it from being perused by the British.

This method of communication seemed to me at the time a little too romantic. I was going to London, and I said I would see what I could do.

Remembering that European royalty often had accounts at Coutts, I went to see the bank manager and asked whether he knew Prince Paul of Yugoslavia. He said of course, and added that it was dreadful for His Royal Highness to have his account blocked, something which should never happen to Royalty. I told him my problem, and he offered at once to cable and ask Prince Paul whether he wished to sell his El Greco. By the next day I had an affirmative answer and a price. I wired Rush Kress the offer and added that I hoped he agreed bargaining with a man in jail was a little unfair. He cabled back to buy the picture at the prince's valuation. I have always found that, with the British, straightforward action is best.

Rush Kress, like his brother, became one of my warmest friends and greatest supporters. On two occasions with remarkable generosity he forgave my errors: once when my staff work was poor and once when Bernard Berenson changed his mind.

The director's job, and in the case of the National Gallery the chief curator's as well, is to find donors to buy what the curators recommend. Their research in turn is supposed to protect him against mis-attribution and frauds. I was told a painting by Goya of a bullfight was considered by all authorities a major work and that we should have it. I persuaded Rush Kress to buy it on behalf of the Kress Foundation. Unfortunately the Gallery's investigation had failed to disclose that in a recent book the painting had been published as a work by Lucas, a minor contemporary of Goya. I was dismayed when I learned of our oversight, but Rush Kress consoled me and said it did not matter as he would return the picture and be reimbursed. When I next saw him he was in a rage. The dealer, contrary to a standing agreement, refused to take the picture back. He had sold it on commission, he said, and the owner, Arthur Sachs, would not agree to its return. Rush Kress was about to sue, and I saw my career in shambles. I asked for time to see what I could work out.

I appealed to Arthur Sachs, a very distinguished connoisseur, and explained my apprehension over a lawsuit. He was understanding but adamant. He said he absolutely believed the painting to be by Goya, and by doubting its attribution Rush Kress had cast aspersions on his ability as a collector. However, he said he was willing to submit the painting to the director of the Prado, Sanchez Canton, and if there was any doubt about its ascription, he agreed to return the money.

My problem was to persuade Sanchez Canton to look at the controversial canvas. The director of the Prado had no need or wish to involve

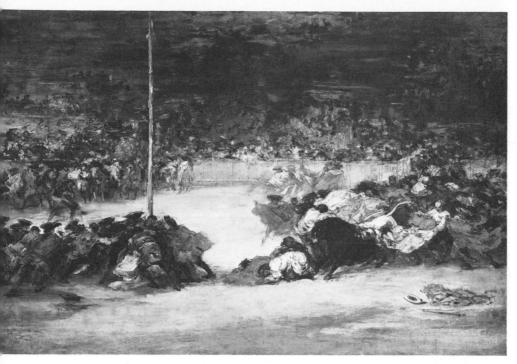

Francisco de Goya, attributed to, *The Bullfight*. A close shave with ignominy! National Gallery of Art, gift of Arthur Sachs.

himself in the dispute, but he agreed to give his opinion, for which I shall always be grateful. This kind of solidarity among museum colleagues is one of the attractive aspects of the profession. The painting was taken to Madrid by a curator of the National Gallery, studied at length in the Prado, and finally reported on by Sanchez Canton. It was not, he said, by Lucas, nor was it by Goya. It belonged to a group of pictures all painted with a palette knife by a contemporary of Goya about whom little is known. The money was refunded to the Kress Foundation; I was saved from potential disgrace; and to my astonishment Arthur Sachs then donated the painting to the National Gallery, where it now hangs with the label "Attributed to Goya." I continue to consider it one of the most fascinating and beautiful pictures of its period, an opinion I find shared by many artists.

Attributions, of course, do not affect the beauty of works of art, but they do affect collectors and consequently values. They should be merely a convenient way of categorizing, but instead they often set up irrational standards of quality.

My effort to persuade Rush Kress to acquire the Cook *Adoration of*

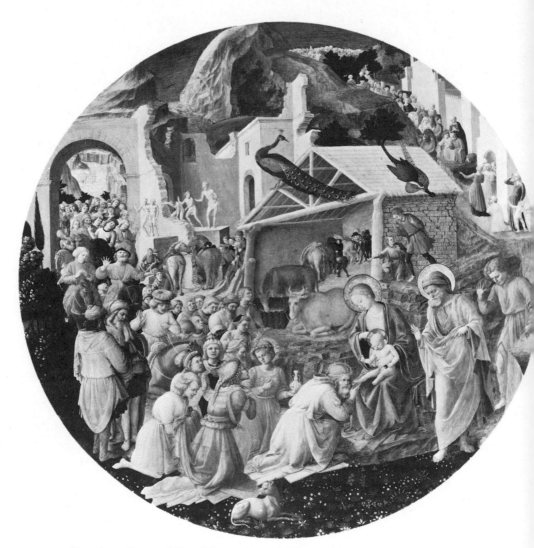

Fra Angelico and Fra Filippo Lippi, *The Adoration of the Magi*, Florentine, 15th Century. Berenson's disastrous change of mind. National Gallery of Art, Samuel H. Kress Collection.

the Magi, the most important Italian painting of the first half of the fifteenth century to come to America, is a case in point. It was sent here during World War II as a refugee. I desperately wanted Rush Kress to buy it. For once the price staggered him and he refused.

It was at a warehouse being packed for return to England, and I begged him to look at it once more. He agreed, and it was removed from its crate. There was a label on the frame saying "Fra Filippo Lippi," the usual ascription; but I pointed out that when I was a student with Berenson I had helped gather the material for an article proving this attribution erroneous and demonstrating that the painting was by Fra Filippo's master, Fra Angelico. Rush Kress was impressed. If the painting was not by Fra Filippo Lippi, but was instead by Fra Angelico, a name with which he was more familiar, perhaps it was worth the price being asked. He hung fire. I was in anguish. Then he said the Kress Foundation would buy this newly baptized masterpiece by Fra Angelico, and he inquired about Berenson's article. I explained that it had been published in Italian fifteen years ago and was no longer readily available. Would it be possible to reprint the article in English with superb color reproductions, Rush Kress asked? I was on my way to Europe, and I said I knew Berenson would be delighted and that I could arrange everything.

Ten days later I arrived in Florence and went immediately to I Tatti. I told Berenson about the Gallery's good fortune, and he congratulated me. I related the story, and then said Rush Kress wished to reprint his article attributing the Cook tondo to Fra Angelico. I remember as though it were yesterday. We were sitting in his study under his entrancing Madonna by Domenico Veneziano, surrounded by books and photographs. He held his bald head in his beautiful, sensitive hands, shaking it slowly and sadly. "I know now I was wrong," he declared solemnly. "The painting is not by Fra Angelico. It is really by Fra Filippo Lippi!"

It was my most melancholy moment. I rushed to the library and got out all the material for his article. We studied photographs — overall, detail, and microphotographs — and then ultraviolet, infrared, and x rays. After a long time, stroking his beard, B. B. looked up and with a conciliatory smile said, "Johnnie, I do think just before he died Fra Angelico may have painted one or two of the figures. Looking at the photographs again I can just barely discern his touch." Ever since that memorable day the tondo has borne the label "Fra Angelico and Fra Filippo Lippi."

Rush Kress, who was happily married, was a devoted family man, and he welcomed marital bliss in others. There was a small New York dealer from whom he bought rather more than I thought altogether judicious. I was puzzled by his enthusiasm for this particular shop until he explained to me one day that he got great pleasure from watching a husband and wife who worked together so harmoniously. The way the two grappled with large and weighty paintings without the help of laborers fascinated him, and he told me that seeing such devotion to their job and to each other gave him a satisfaction he had never experienced in buying works of art elsewhere.

At the time we were negotiating for some pictures in Switzerland, and the same dealer was the intermediary in the transaction. When we met in Zurich he introduced to me a beautiful girl, much younger than himself, as his wife. I was astounded! The lady in New York, I learned later, was a previous wife who owned a half interest in the firm and, suspicious of her husband, refused to allow divorce to part her from her possessions! I never disillusioned Rush Kress.

There was another dealer who also charmed him, in this case by his stories of purchases made by P. A. B. Widener, Frick, Huntington, and others of an earlier generation. These tales went on for hours, and believing them to be largely fictitious, I was often bored. The major painting this dealer still possessed, and which he had been unable to sell these giants of collecting, was a large and very darkened panel of uncertain authorship for which he wanted half a million dollars. I thought the price ridiculous and the panel, an Assumption of the Virgin, not particularly desirable; but Rush Kress loved bargaining with his friend, always beginning his negotiations with the phrase "You'll have to sharpen your pencil." How sharp the pencil became in the case of this particular painting I do not know, but it was acquired against my advice and contrary to my best judgment.

When it was cleaned, however, I recognized that I was entirely wrong. It proved to be in miraculous condition. Although its authorship remains uncertain, it is generally considered to be by the Master of the Saint Lucy Legend, whoever he is, but I ruefully admit it is one of the most beautiful Flemish pictures in the entire National Gallery. Rush Kress in his characteristic way said he had finally bought the painting because he was so anxious that I should not make a mistake, which I would afterward regret. I say characteristic, because he was one of the most considerate men I have ever known, and his statement was perfectly sincere, and as events showed, perfectly right.

Master of the Saint Lucy Legend, *Mary, Queen of Heaven*, Flemish, 15th
Century. One of the most beautiful Flemish pictures in the entire gallery,
which I did not want Rush Kress to buy. National Gallery of Art,
Samuel H. Kress Collection.

He was also very imaginative. He "analyzed," a word he was fond of using, the Kress Collection at the National Gallery of Art and decided that the Study Collection and certain paintings in the Permanent Collection could be used more advantageously elsewhere. He concluded that if these pictures and others he intended to buy were given to twenty regional museums from Miami to Honolulu, their effectiveness would be increased, especially in cities where there was a dearth of works of art. It was an idea opposed by several scholars he consulted and by some of the most influential members of the Samuel H. Kress Foundation. I thought from the first he was right, and a quarter of a century later I am more than ever convinced.

But the program caused one of our few serious disagreements. Pichetto had died, and Contini saw a fresh opportunity to reassert his influence, an influence I thought calamitous. He arrived in New York with scores of paintings, none positively bad, but none of outstanding quality. The prices seemed to me extravagantly high, but in view of the market today, nothing in the past can be said to have been high. Rush Kress wanted to buy everything immediately. I did what I could to stop him, until at last Contini took me aside and said menacingly that I ought to know that if it hadn't been for him there would be no Kress Collection, an assertion that was certainly true. Nevertheless, I continued to do everything in my power to frustrate him. I failed, and for a time my relations with Rush Kress were, as a result, strained.

That I would be unable to stop these purchases should have been obvious to me. Guy Emerson, the able and dedicated director of the Samuel H. Kress Foundation, who was untiring in his efforts to build up the collection, Mario Modestini, the brilliant restorer who succeeded Stephen Pichetto, and William Suida, the curator of research of the foundation, whose scholarship was remarkable, were all against me. I tried to argue the merit of the single masterpiece, but they were enthusiastic about mass purchases. They were in my opinion unduly acquiescent in Count Contini's high valuation of his minor Italian pictures. I was unhappy at what seemed to me their subservience to this supersalesman, who was, I admit, very impressive in the lofty way he showed his wares. Although I was puzzled by their complaisance, I recognized that what they wanted agreed with what Rush Kress had come to want, for Contini's influence on him seemed almost hypnotic. Masterpieces would eventually be added to the regional gallery gifts, they said, and they were right; but meanwhile it was essential to have enough works of art to fill the rooms reserved for the Kress Collection.

There were two Contini visitations, and also one by a satellite of the count, which took place after his death. The total number of pictures acquired by the Samuel H. Kress Foundation on these three occasions was one hundred and sixty-two, of which I found only seventeen up to the standard of the distilled Kress Collection at the National Gallery of Art. But many years later I have often wondered whether it was right to struggle so hard to spoil these sales. Following auctions as closely as I do, I must admit that if I bought all the Italian pictures coming on the market, paintings no better in quality than Contini's stock, I would find it difficult to put together the collection Rush Kress acquired in these three deals. So, as in the case of the Master of the Saint Lucy Legend, perhaps I was wrong. Certainly I was foolish to oppose Contini. He was Sam Kress's friend, and to make Rush Kress question the integrity of someone Sam had considered worthy of his friendship was impossible.

The devotion of Rush Kress to his brother and to his memory is difficult to describe. The collection was always referred to as his brother's collection, and he said repeatedly that his interest in art was due only to his desire to carry out his brother's wishes. He wanted to make the Samuel H. Kress Collection an enduring monument to Sam's memory, and in the end he created a more impressive monument than Sam would ever have erected himself. Having made the money, the older brother was a little parsimonious in parting with it. But Rush Kress had only one objective, and he never worried about expense in its attainment. He wanted his brother's collection to be the greatest in America. The catalogue now being published by the Samuel H. Kress Foundation in nine volumes is evidence that he came close to achieving his goal.

Sam's lingering illness was to Rush a constant torture. Whenever we met he told me exactly how many days his brother had lain in bed, one thousand, then two thousand, and finally more than three thousand days. Except when business required him to travel, Rush sat at his brother's bedside a part of every one of those days. When death finally came he was shattered. For many years as head of the business and head of the foundation he had felt his responsibilities an intolerable burden. But the power he grasped so tenaciously he looked on as an inherited duty, which he could not relinquish. It had been thrust upon him by his brother and was therefore inviolable. He was always, as he would have been the first to say, the surrogate of a ghost.

8

The Most Unlikely Collector: Chester Dale

I find it difficult to write about Chester Dale. The recent and overused word "ambivalent" might have been coined to describe our relations. When I think of him I have so many blocks I need a psychiatrist. This chapter should be spoken from a couch, not written at a desk.

I was fond of Chester, and presumably he liked me, for when he died, to my stunned surprise, he left me a considerable sum of money. Yet we often fought; and when the second director of the National Gallery of Art was to be chosen, though I was the chief curator and in direct line for the directorship, he wished the job to go to another. Because of his strong personality, joined to persuasive assets, I was very nearly passed over. If he had had his way my life would have been entirely different, and I would have become an expatriate living in Italy.

When, in spite of Chester's opposition, I became director, I found myself bound by the tentacles of Long Distance to his apartment in the Plaza. Day after day we talked endlessly. I developed bursitis from holding the telephone during these interminable conversations. He once

said to me, "You know, John, what I like about you is that you aren't a 'yes-man.'" I thanked him for the compliment and added: "Chester, I have been saying 'yes' to you for the last half hour, but you won't take 'yes' for an answer!"

Chester Dale looked like a middleweight prizefighter, and he had once boxed professionally. His temperament was as fiery as his red hair; his vitality infectious. His language was idiosyncratic, racy and contagious. He was fond of aphorisms, which recur to one's mind involuntarily.

"Never stick your neck out because there's always a guy with an axe to fit it. They're all out to get you."

"A shroud has no pockets."

"I want a twenty-four-foot ring in life. Room to turn around. Get it."

I did "get it," and I can hear his husky, gravelly voice saying, "John, I've got news for you! Stop horsing around and get down to business."

The business is not easy. To describe Chester Dale's involvement in the arts, which represents the maximum of improbability, is a formidable task. How could a tough, matter-of-fact businessman, for many years never far from the stock ticker, respond with sensitivity to works of beauty? Yet he did. Their value in dollars and cents was always in his mind; but he was able at the same time to judge their aesthetic quality, to feel emotions of deep pleasure — especially when their ownership was his or the National Gallery's.

I hoped the clue to this phenomenon of a hard-boiled stockbroker metamorphosed into an adventurous connoisseur, for he was among the first in America to buy works by painters of the School of Paris — Modigliani, Matisse, Picasso, Braque and the others — would be found in his autobiography, which at the end of his life he started to dictate but never finished. It opens promisingly. "The beginning of my collection began with the Windsor Hotel fire in March 17th, 1898." I read on with fascination and frustration. For thousands of words there is no further mention of the collection. I suppose he meant that the fire of 1898 caused his family to move to the suburbs and to bring him back from the Peekskill Military Academy, to which institution of learning he refused to return. Instead, with some difficulty, he persuaded his father to allow him to get a job on Wall Street. Thus the fire started him on his way to his fortune, which in turn enabled him to collect.

This unpublished and uncorrected autobiography is a minor masterpiece. It is pure "stream of consciousness." Thinking aloud, Chester Dale dictated into a tape recorder with uninhibited spontaneity. The

Diego Rivera, *Portrait of Chester Dale*. I can close my eyes and see him still, much as he appeared in this portrait. National Gallery of Art, Chester Dale Collection.

choice of words and their cadences are so peculiarly his that in transcribing them he comes alive for me, and I am intensely aware how much I miss him.

His first job was with the American Express Company at five dollars a week. The work hours were intolerable. Chester Dale decided that

if you come down town at eight o'clock in the morning and work till all hours of the night and no one ever told you to go home, there must be some other job around that wouldn't be any worse anyway. So when the week was up I got my five dollars and told the man who seemed to be in charge that I didn't think I was fitted for that kind of a job and I wouldn't be back. But that night when I got home I told father what had happened and he said, well, he said, I don't think that was the right thing to do.

Chester went looking for a new job. He knew a friend who was employed by a firm named Douglas, but he could not remember the last name.

So Monday I hied me down to Wall Street. So I stopped a number of people on the street that were busy running around and asked them if they ever heard of a brokerage firm named Douglas and something. They were very sorry they couldn't help me out. I thought an American District Telegraph messenger ought to know more than some of these people I had stopped and asked before. So they were running all over the place, and so I picked out one and said, "Say kid, like to speak to you a few minutes," and he wanted to know what I wanted, and I said, "Well now I am not very familiar with this part of the city and I am looking for a friend of mine that's employed by a firm named Douglas and something but I can't remember the last name." With a sneer he turned around and called me a hick. Well I was plenty of things but I wasn't a hick. That made me a little sore and I took a swing at him. Well by that time it was about twelve o'clock when a lot of people went to lunch. By the time the cops had separated us there was a large crowd and who should I see in the front of the crowd but my friend John. I told him I was looking for him but I couldn't remember the last name of his firm. He told me it was Jones, Douglas, and Jones. He said "I will take you in and introduce you to the manager and I think maybe you can get a job!"

Chester became a "runner," delivering securities with

a good big wallet with a chain around my waist. I ran my feet off pretty nearly but I didn't have to get down until nine in the morning and at least it was exceptional when we didn't get out around five o'clock. After having read the Alger books and all that sort of business why I thought don't you know when you got a job you just had to work as hard as you knew how and the very best you could.

Chester, however, found that the admonitions of Horatio Alger meant doing the work of three kids for the wages of one, five dollars a week. His feet were giving out and he decided Horatio Alger's advice might

make more sense to someone less ambulatory. He asked for another job, one preferably of a static nature. He was told to go to work posting quotations on the Board. He started with help

> but all of a sudden I found I was on the Board alone where I was working just as hard as I was working as a runner. I decided I wasn't going to learn very much up there and I better get out.

He then decided to apply for a job with F. J. Lisman, "the dominant investment house in the Street in railroads." He was an immediate success and was soon making twenty-five dollars a week.

> And if you don't believe it that was an awful lot of money in those days plus what we used to call "cakes" that meant the trading for your own account and picking up eighths and quarters here and there. Also losing a few now and then. But if you were active and on the job on the law of averages you were ahead of the racket.

He became "curb representative."

> I was doing awful well. I saw some awful stuff going on the curb there. You could get away with murder. You know in those days you didn't pay money to go on the Curb. You just walked in there and traded and if you were a very active crowd and bought some stock or something you'd have to be damn quick to look up and see whether you wanted to take the name or not, cause it might be that somebody from the Bowery or God knows where that just horned in and you could easily get hooked and badly that way. That was one reason why the boys that graduated from the Curb that went over to the Stock Exchange later well they just went to town over there cause they had experience that the boys that bought seats on the Stock Exchange just didn't have.

The Lisman firm, however, broke up, and Chester Dale was out of a job again. F. J. Lisman decided to specialize in bonds instead of stock, and Chester came back to work for him as office boy, once more at five dollars a week. But he had a chance to watch Lisman's activities. He noted that his employer would buy

a block, ten, fifteen, twentyfive thousand dollars worth of bonds at say fortyfive. He'd sell them at fifty, sixty, sixtyfive with a letter describing where the railroad was and how much it was mortgaged per mile and what they had earned and all this and that and the other. It was all Greek to me in the beginning. Then I began to get wise and I said to myself if you could ever learn this stuff it is a natural. In other words you'd have to make a study of values which a lot of people wouldn't take the trouble to do. Mr. Lisman knowing values he'd put a price on some bonds dependent on how stupid the people were who sold and what he thought he ought to get for them without being too much of a robber. So I said to myself Um, then I had to find out how you learned. I heard of White and Kemble's *Atlas and Digest of Railroads* with these maps, showed you the position of the various mortgages, most of the important things, all in concrete form. Well I got so intensely interested in all that that I couldn't even sleep nights. I continued my study and never gave it up until I got to a point where I was a very fresh kid some of the houses didn't like to see coming in. But I would make a boast that you can't name a railroad mortgage in the U.S. that I don't know.

Chester Dale was ready to make his fortune. His opportunity came soon. "It was rather late in the afternoon," to continue to quote from his autobiography,

and I was kinda tired of running around the street on my feet all day trying to pick up a few dollars and I was sitting up there between George Washington legs on the SubTreasury building opposite Morgan and Co. when I saw Mr. Harriman walking rather jauntily into Morgan and Co., wearing his specs and looking very serious and all of a sudden it occurred to me that there were five million Erie notes coming due in the morning. I said there's something stirring. Well it wasn't too long before Mr. Harriman came out and looked to me as he had a kind of smile, a little bit like the cat that swallowed the canary. I said that smart guy beat Morgan and Hill and got the Erie. Whereupon I beat it over to Kissel, Kinnicut and bought a half a million notes. Imagine me buying half a million notes. Supposing they'd gone off a couple of points where would I have been? I'd been washed up in Wall Street. Well I didn't think of that. I just thought I was right.

He *was* right, and this gave Chester Dale his real start. A year or two later a friend, Bill Langley, asked him to start a bond department in his new brokerage firm. He was soon a general partner. To his delight there was enough capital to provide a private office for himself and his partner, Langley.

I'll admit it was a little small with not much more than room for a desk and ourselves but it was a private office and we had graduated up to that. Well we were sitting in there one morning just before lunch minding our own business when two gentlemen were announced. We had a receptionist at the desk. We had reached a point where we just didn't see everybody. Well these were two gentlemen from Canada. Neither Bill nor myself ever heard of them before. But they came in or were sent in by Mr. Frank Potter, one of our very old friends of a firm we did a lot of business with. So of course we had to see them. Well they were two big men. One of them was the biggest I ever saw and believe it or not he had two guns on his belt. We could hardly make room for Bill and myself and these two fellows. We asked 'em what we could do for them. They explained that Mr. Potter told 'em he was quite sure that we were just the kind of people that they wanted to meet. That didn't sound just exactly right to me because Frank Potter wasn't sending up everybody that was going to do business that could possibly do it with him. But it's always a good idea to explore a situation, so we asked 'em what everything was all about etc. One of them said he was the chairman of the school board of Calgary in Western Canada and he had come to New York to sell seven hundred and fifty thousand school bonds. Well I had never even heard of Calgary. Sounded to me more like a cemetery than a town. So I asked these fellows so many questions that Bill gets a little bored and went out of the room. Left me alone with 'em. I asked them why they didn't go to the Bank of Montreal or the Royal Bank of Canada with their securities. They didn't have to tell me the answer. They couldn't do any business up there or they wouldn't have been down here. So I got as much detail out of them as I possibly could and excused myself by saying I regretted I couldn't take them to lunch, that I had a luncheon engagement and if they'd come back after lunch I'd be glad to discuss the matter further with them. Course what I wanted to do was to get rid of them and try to find out whether there was a town named Calgary and where it

was. Of course the first thing I did was to go to the Atlas and look through every place I could find in Canada. I didn't see Calgary anywhere there. Then I got out the Financial Chronicle and I looked all through that to see if there was any reference to Calgary. No Calgary. No matter where I looked or who I enquired of no one ever heard of Calgary. I had just about made up my mind that it was a cemetery and these boys were pulling a fast one on me with the aid of Frank Potter. Well they came back after lunch and I said where is this place, this Calgary? How big a town is it? They told me the place was sixty thousand people, one of the fastest growing cities in Western Canada. All of a sudden it struck my stupid mind that that must be the place where Jack Johnson fought Tommy Burns. No white man could fight a colored man at that time anywhere in the U.S. So I doped that out and why they went to Canada and maybe this is a town and maybe it's all right.

The bonds were all right. Chester Dale went out and bought a better atlas and W. C. Langley and Co. ended up financing Moose Jaw, Medicine Hat, Saskatoon, Regina and other Canadian towns before Wall Street woke up to the profit to be had in Canadian municipal bonds. "Later on," Chester Dale has said in an interview, "Sydney Mitchell of Electric Bond and Share began forming these public-utility holding companies, and I was very active in them." From companies like Electric Bond and Share and especially American Waterworks and Electric, Chester Dale made a great fortune, much of which melted away during the Depression.

One reason for his losses does him much credit. He owned huge blocks of certain stocks which he had recommended to friends, especially shares of American Waterworks and Electric, and though the market was falling calamitously, he held on to these until the other smaller holders were able to liquidate. In this one stock he lost over $25,000,000. But had he dumped his shares on the market the collapse would have been hastened, and his friends, for whom he felt responsible, would have been ruined.

He had, however, used a small amount of his profits to buy paintings. He once told me that his assets before 1929 were approximately sixty million dollars. When he died they had shrunk to under ten million. But the pictures and sculpture for which he had paid less than two million dollars, according to his confidential secretary, Louise Marock, who knew more about his affairs than he did himself, were appraised in

1962 at the time of his death at over fifty million dollars. Today, of course, the collection would be worth much more. Thus his shrewdness in selecting works of art made up for his generosity in not getting out of the stock market in time.

How did he become artistically so astute? The explanation, Chester would readily admit, was his first wife, Maud Dale. He once said, "Maud was like Lisman. She taught me values. Maud didn't care who owned a picture. She loved the paintings. I did all the buying."

Maud Dale was a painter and had studied at the Art Students League under Carroll Beckwith and with Steinlen in Paris. Unlike her husband she was not possessive. I became very fond of her. It was delightfully rare and refreshing to find a collector interested in works of art belonging to someone else. Maud Dale's values were never distorted by ownership.

It was through having his portrait painted that she first interested Chester in art. Robert Reid posed him in a fur-lined red tweed coat, standing beside his red Airedale. Maud always referred to it as "the red-headed man, the red-headed dog, and the red-headed coat."

The Dales had made some friends who were cartoonists and illustrators: Rube Goldberg, Herb Roth, James Montgomery Flagg among others. At that time the only significant artist of their acquaintance was George Bellows, who painted both the Dales, Maud twice, and who had considerable influence on their taste. Chester enjoyed posing. Besides Reid and Bellows, he was to be painted by Lurçat, Rivera, and Dali. He had his share of human vanity, but I found his egotism very endearing.

The Dales began to spend their Saturday afternoons in the art galleries. "By this time," Chester has said, "I began to like the art business and to enjoy art talk. I began by asking my wife a few questions, and I ended by asking them by the thousands."

The beginning of their collection was modest. Their first purchase was a small painting entitled *The Politician* by Guy Pène du Bois, whom Chester always considered a "sleeper," meaning that his work was slower to increase in value than he had anticipated. Perhaps time will prove him right, but Guy Pené du Bois' paintings, which Chester bought by the dozen, remain in my opinion minor league stuff. (The contagion of Chester's vocabulary is incurable!)

In those days, just before World War One, Chester was living on West Ninth Street. Two doors away he had a musical friend, Joe Hewitt. He asked his help in the selection of a piano. Joe was surprised and asked, "What's the idea?" "Well, I don't know," Chester replied. "But there

doesn't seem to be much difference between art and music, and I am just beginning to get intrigued with art." They bought the piano, which Chester took with him wherever he lived, and together they went to hear many singers: Galli-Curci, Tito Ruffo, Mary Garden, and others when they were in their prime. "I never realized," Chester observed in his autobiography, "that music in my strange way was a dish that just seemed to fit me."

Again a horrible fire next door changed Chester's life. He developed a trauma. "Every time I'd hear a fire engine I woke up whatever time of the night it was with a flashlight in one hand and a gun in the other." He never explained what the gun was for. In the end he found a cure for his psychosis by becoming a fire buff. The East Fiftieth Street firehouse made him an honorary member and gave him a special gold badge. He would leave anything he was doing to go to a fire. There is a story that one evening after attending a banquet, he was seen on a ladder truck in full flying tails. On another occasion he stayed on at the firehouse talking to the boys, forgetting that he was due at an important dinner. He got there on time. He was taken where he was going on a fire engine. The excuse of the firemen was that there might be a fire nearby.

When in 1929 he moved to the penthouse on the thirty-fifth floor of the Carlyle, he wondered what would happen if the hotel caught fire.

So I took my old friend John Ryan, who was the chief of the Hook and Ladder No. 2, and I said "John I'm kind of high. Suppose there is a fire in an elevator or something, what do I do?" "Oh!" he said, "Just grab an umbrella and jump and pray." "Well," I said, "John that's not so hot." "Well," he said, "that's the best you're going to do. You'll be gone before we ever get up here."

As Chester nevertheless lived at the Carlyle for some years one must suppose that his trauma was cured by the fires he had seen.

By the time he had left Ninth Street he realized that "the picture collecting business was getting under my skin. I found that when I was at work downtown my mind was still on pictures. I wanted more and more pictures and you can't buy pictures with hay. So I worked harder than ever to get money to buy them."

But the taste of the Dales was still uncertain. Zuloaga, for example, seemed a master, and they bought several of his pictures. They then began to go to the auctions at the American Art Association. They

George Bellows, *Mrs. Chester Dale*. Her values were never distorted by ownership — she loved paintings. National Gallery of Art, Chester Dale Collection.

Jean-Baptiste-Camille Corot, *Agostina*, French, 19th Century. The Corot glimpsed behind the door. National Gallery of Art, Chester Dale Collection.

bought a number of American pictures, some incorrectly attributed, some by artists who are now forgotten, and some, but very few, like the Liston portraits by Gilbert Stuart, masterpieces.

About 1925 Maud Dale, realizing that the virus of collecting had entered her husband's blood, decided their desultory collecting should have some rationale.

"From my point of view," she said, "if you want to collect seriously, why don't you pick a school? Then pick a period in the school. I think you might like the French School."

"What do you mean by the French School?" Chester asked.

Thereupon he got a lecture particularly about the French painters of the nineteenth century, what great masters they were and what they had done.

"That is all right by me," Chester responded. "I don't know much about the French School, but let's look them over and see what happens."

The Dales set out for Paris and their self-education. Maud had a first-rate mind and a discerning eye. She took Chester at once to the Louvre, and tried to interest him in the eighteenth century. No success. But when he wandered into the Camondo Collection, he found the artists that appealed to him. One reason was that the little bonnets worn by Renoir's models reminded him of his mother. He felt at home among the Impressionists.

Nevertheless, as collectors they were still timid, and on this trip they bought only a few pictures, the most important being two oils and a watercolor by Forain. But as Chester remarked, "There I was! They had me on the hook!" A few months later they were back in Paris. They found an easy transition, the first but expensive step in their collecting of French painting. They moved from Forain to Toulouse-Lautrec. Chester with Maud's approval bought *Jane Avril*. He also saw coming up at auction two other Lautrecs he coveted, *Alfred La Guigne* and *La Goulue and Her Sister*. Unable to speak French, he paid a dealer to accompany him to the auction and act as his agent. He specified the amount he would bid for both pictures and asked to be informed when his limit was reached. As both Lautrecs went for less than he was prepared to pay, he assumed both had been knocked down to him. Instead he found that he had acquired only one, the less important. He was furious, and Chester's anger could be monumental. He threatened a lawsuit, hurled a few anathemas, and the terrified dealer delivered both pictures. Afterward Chester learned that the price being low, his agent

had decided to go fifty-fifty with another dealer and buy the better Lautrec for their stock.

Chester then realized that the art market was as much a jungle as the Curb had been when he began trading a quarter of a century earlier. In both places "you could get away with murder." Meanwhile Maud Dale was learning to spot important paintings, and Chester's problem was how to buy them. He analyzed the situation and found a solution few collectors have employed. He discovered that the common stock of the Gallerie Georges Petit, one of the best firms in Paris, was on sale on the Bourse. He bought sufficient shares to be able to demand a place on the board. He was then on the inside looking out, a position he liked. When there was a "ring," and there usually was, he benefited; when bargains turned up, he had to be informed; when dealers formed their secret and ephemeral partnerships he was among the first to know. He joined the Sporting Club, where the dealers lunched and planned their *coups*. He learned to trust no one. "They're all out to get you" was as true of the art market as it had been of the stock market. But it was a game. It was a challenge. Chester, in an interview with Geoffrey Hellman, spoke of his overwhelming desire always to win, whether on the Market, at picture auctions, in sailboat races, at golf. "I'm not a good golfer," he admitted, "but I'll take anybody on. You win at golf on the putting green. I got so I could putt into the hole from anywhere on the green because that's the payoff." In collecting pictures he found the "payoff" consisted in finding the masterpiece and buying it at a fair price. Chester was never a bargain hunter, but he drove hard bargains.

One of his favorite methods was to make an offer for a limited time. Maud Dale spotted Corot's *Agostina* in the home of the Bernheim Jeunes, where they were dining, and after they had returned to their hotel she said with awe to Chester, "Did you see the Corot behind the door?" Chester had missed it. If she thought it was the greatest figure by Corot she had seen, Chester said he wanted to buy it. Maud protested, saying he couldn't go to a private house and offer to buy a picture hanging on the wall. Chester said nonsense, but when he went to his agent the next day and said he was prepared to offer a substantial sum for the painting, the agent said it was part of the Bernheim Jeunes' private collection and it would be rude to try to buy it. Chester again said to stop the nonsense about rudeness, make the offer, or no further business. Moreover, he said he would meet his agent next day at a certain café at six o'clock. "And I will not be there at ten minutes after

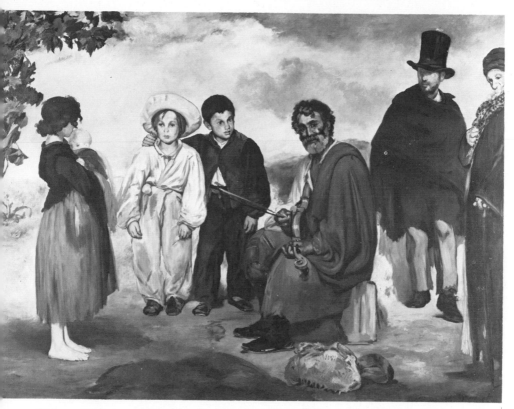

Edouard Manet, *The Old Musician*, French, 19th Century. When Chester was told the asking price, $250,000, he said, "I had to brace myself to keep from fainting." Today, it would be worth ten times that amount. National Gallery of Art, Chester Dale Collection.

six," he added. He got the picture. Chester knew the Bernheim Jeunes would not mind that kind of bad manners.

On another occasion he wanted the Modigliani *Gypsy*. The dealer refused to sell, saying it was part of *his* private collection. As Chester was about to sail for New York, he dropped in on the dealer again. His secretary said her employer was out. Chester told her to go into the office "and tell your boss that Chester Dale was there and had no time to lose." The dealer emerged and said he was sorry, but he was late for an appointment already. Chester took out his checkbook and said, "You are busy and late for an appointment. I am late for an appointment, too. So let's get together and do business. What do you want for the *Gypsy*?" The dealer named what he considered a prohibitive price. Chester wanted the *Gypsy* and he also wanted a rare example of Modigliani's

sculpture. "Throw in the stone head and I'll give you cash," he said. The dealer, wishing that he had asked for still more, said he insisted that he be paid in dollars. (Those were the days!) Chester told him he could go to the Guaranty Trust Company and get any kind of money his heart desired — Chinese if that's what he wanted. And walked out owning the two Modiglianis.

Sometimes Chester, in spite of his usual impatience, waited months and even years to buy an important painting. He was shown the Manet *Old Musician* by a well-known French dealer, C. C. Hodebert. The price asked, $250,000, seems derisory today, but Chester was stunned, and as he said, "I had to brace myself to keep from fainting." The Dales left the gallery without making a purchase. Two years later Chester asked: "Maud, what's so great about that Manet?" She didn't know what he was talking about. He explained, "The big Manet that Hodebert has." She asked, "Whatever made you think of it?" "Never mind," Chester replied. "Just how good is it, how important?" Maud's answer was that it was "a world picture, one of the two greatest Manet masterpieces."

Chester telephoned Etienne Bignou, his agent in Paris, and made an offer which the French dealer thought ridiculously low. Chester said no bid in six figures was low, particularly after the stock market crash. "Get busy," he told Bignou. "And the offer stands only until six o'clock tomorrow evening, understand?" Bignou got the message. It so happened that the owner had just had a stroke and was also in financial trouble. He accepted Chester's low bid reluctantly, but revealed that he only owned three-quarters of the painting. Finally the other owners agreed to the offer, but the trouble had only begun. The French owners who had bought the painting from the Imperial Museum in Vienna, fearful that the authorities in their own country would ban its export from France, had lent it to the Munich Museum.

Chester's agent went to Munich and with great difficulty received the release of the picture. It was boxed for shipment to America and placed on the S.S. *American Farmer* in Rotterdam. The ship ran into a storm so severe that it had to shelter in the nearest harbor. Fortunately this was British and not French, or the French government would have seized the painting and banned its export. When after all the trouble it finally arrived in New York, it was too large to get through the doors of Chester's apartment and he had to lend it to the Metropolitan Museum.

In 1931 Chester bought another picture whose size caused him difficulties. He was shown a photograph of Picasso's *Saltimbanques* by

Val Dudensing, who stated correctly that it was one of the greatest masterpieces of the twentieth century. The price was $100,000, and it was held by a Swiss bank as collateral for a loan which was in default. Chester concluded that the money owed was probably considerably less than $100,000 and that the bank would be glad to settle for the amount of the loan, regardless of the feelings of their client. He cabled a bid well under the offering price, and it was accepted at once. The picture arrived in New York, and Dudensing was told to have it delivered immediately. After several days Frank McCarthy, an old friend and an important Customs official, called Chester and said something funny was going on and that he had better send a check for the picture at once. He did and it was released by the Customs. He then discovered that several French dealers had been negotiating for the *Saltimbanques* at a still lower figure and had not expected any competition. To their surprise they learned that the painting had been sold, but to their relief they also found that it had not been paid for. They told their American representative to say that the deal with Dale was off, and to have the picture reloaded and returned to France, whence they could continue their negotiations.

Once Chester had the picture, as in the case of the Manet, he could not get it into his apartment. He decided to have it delivered to Val Dudensing. Henry McBride, the art critic, describes walking along Fifty-seventh Street at twilight on a snowy afternoon. He looked up and to his astonishment saw a huge Picasso silhouetted against the wintry sky, swinging in the air, as it was lifted by a derrick high above the watching crowd. An open window in the building housing the Dudensing Gallery seemed its destination, and he rushed upstairs and met Chester Dale, who was seeing for the first time Picasso's masterpiece. Like the Manet, the picture had to be lent to a museum until Chester had a place to live with doors large enough to allow the entrance of his oversized purchase.

It was rare for Chester to buy a painting from a photograph. It was still rarer for him to buy a painting he had never seen even in a photograph. I was with him when this happened. We were looking at a Rubens I thought might be purchased for the National Gallery. It was disappointing, and we were very pressed for time. As Chester and I hurriedly left, his eye caught sight of a tall picture standing against the wall and covering a second painting. It was a St. Sebastian by Odilon Redon. He asked the dealer about it and was told it was one of a pair and the price was so much for the two pictures. While the elevator was

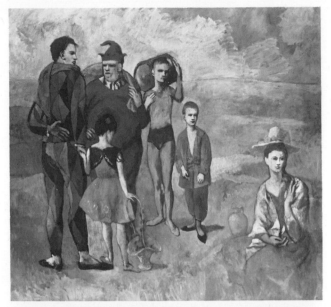

Pablo Picasso, *Family of Saltimbanques*. One snowy afternoon in New York the art critic Henry McBride incredulously watched this painting swinging in the air, silhouetted against the wintry sky. National Gallery of Art, Chester Dale Collection.

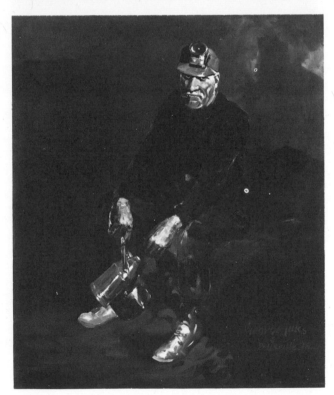

George Luks, *The Miner*. It cost the author an unforgettable kick on the shin! National Gallery of Art, gift of Chester Dale.

coming, Chester said he would buy them. The dealer was amazed and asked whether he didn't want to see the pendant. Chester said no. He was in a hurry and he had been willing to pay the amount asked for a single picture and so he had nothing to lose getting both.

Pictures poured into the Dale apartment at the Carlyle. They couldn't use all the bathrooms "so we put boards over the bathtubs and put racks there for the pictures." But even this expedient left them with problems of storage. Finally Chester decided to buy a house at 20 East Seventy-ninth Street and construct a gallery for his collection. "Somebody told me," Chester once said, "that after we got a few hundred pictures and had to have places to hang them, I would find I had a bear by the tail with no way to let go. He was right."

It was in this new house that I resumed after many years my acquaintance with Maud and Chester Dale. When as an undergraduate at Harvard I was helping to run the Harvard Society for Contemporary Art, I went to see them at their apartment at the Carlyle to request the loan of some modern paintings of the School of Paris. The Dales were sympathetic to our enterprise and very generous. After graduating from Harvard in 1930 I went abroad and did not see the Dales again until the autumn of 1940. The meeting at 20 East Seventy-ninth Street was arranged for David Finley and myself by Stephen Pichetto, the restorer of the National Gallery, whose influence on Samuel Kress I have mentioned.

When we told the Dales about the new National Gallery of Art still under construction, they were enthusiastic. The vast areas of unoccupied space impressed and attracted them. It was, however, too close to the opening to install a number of rooms devoted to the Chester Dale Collection. Nevertheless, they sent seven American pictures on indefinite loan to bolster this weak section of the Gallery. A few months later twenty-five French nineteenth-century paintings arrived and were given this same status. These were our first examples of Impressionism and Post-Impressionism. In 1942 more were added, and in 1951 and 1952 the School of Paris canvases previously on loan to Chicago and Philadelphia were brought to Washington. All these paintings were only on loan, though we were told by the Dales to give the impression that they had been donated.

It has been said that Chester was unable to distinguish between the words "gift" and "loan," that he used these terms interchangeably, that like Humpty Dumpty in *Alice in Wonderland* words meant what he wanted them to mean. There is truth in this, and his autocratic attitude

toward semantics turned my hair gray and caused considerable anguish to my colleagues in Chicago and Philadelphia. As long as Chester was alive, the Chester Dale Collection was never committed to any institution; but as hope springs eternal in museum breasts, there were several directors who felt at one time or another that they were destined to be the "Proud Possessors." They too thought, as did Chester himself occasionally, that "permanent loan" meant "irrevocable gift."

The first of these was Mr. Bedard, director of the Museum of French Art in New York. Chester was a trustee and had paid to convert two apartments owned by the museum into a gallery. Maud was the chairman of the Exhibitions Committee. During three years she arranged six exhibitions: Portraits of Women; Romanticism to Surrealism; Picasso, Braque, Léger; Renoir and His Tradition; Fantin-Latour; Derain and Vlaminck. There is general agreement that these shows were distinguished, the catalogues admirably compiled, and the introductions by Maud Dale remarkably informative. The Dales bore all expenses.

Chester had made a condition that "the pictures of no one picture dealer or collector who is known to deal in pictures may be shown exclusively." The trustees of the museum decided to show the collection of prints owned by Mrs. George Davidson, contrary to Chester's wishes. Maud claimed that this violated the stipulation, but in her letter of resignation she did not say that Mrs. Davidson dealt in pictures. In a somewhat acrimonious correspondence Mrs. Davidson's status as a dealer remains obscure. But in any case the Dales withdrew permanently from the Museum of French Art.

For a time Chester was a trustee of the Museum of Modern Art and that institution benefited by some thirty loans. But again for reasons too complicated to explain Chester fell out with the board and resigned. His feelings for the Metropolitan Museum also varied; they remained favorable once Roland Redmond had become president and Chester had become a close friend of Theodore Rousseau, at that time curator of paintings, and James Rorimer, the director. In the end he left the Metropolitan Museum half a million dollars and also gave a few of his paintings.

The Chicago Art Institute and the Philadelphia Museum had large Dale loan collections, and Chester was made a trustee of both. But they were less fortunate. As Geoffrey Hellman, in a *New Yorker* "Profile" of Chester, wrote:

The ninety-four Chicago and Philadelphia Dales had graced those cities on the firm stipulation by their owner that the galleries housing them should not be tampered with in any way — no switches, no removals, no additions from other collections. Their wholesale exodus at a period when local art lovers, lulled by eight or nine years of fancied security, had come to take their presence for granted was perhaps not envisaged . . .

But in fairness to Chester it must be stressed that he had made no commitment to either institution, nor had he promised that his pictures would remain in Washington. I was scarcely more secure than my Chicago and Philadelphia colleagues. In some ways my position was worse. For the Samuel H. Kress Foundation was acquiring and sending to Washington supreme masterpieces of earlier painting and sculpture. But Rush Kress, recognizing that his influence in the affairs of the Gallery would be negligible if the Kress Collection were donated while the Dale Collection remained uncommitted, refused to make any gifts unless Chester reciprocated. Reciprocity was not Chester's intention. Consequently the Gallery concealed as best it could the fact that almost half the works of art on display in the late 1950s might be whisked away by two potential donors, whose fervent dislike of one another was all too evident to all of us on the staff. There were times when it seemed impossible that the National Gallery of Art would end up with the Dale Collection and most of the major works of art in the Kress Collection or with either. As the newly appointed director, the nervous strain I felt is indescribable. To lose either collection so long associated with Washington would have been a scandal, for which I would have felt responsible. In 1961 Rush Kress was finally persuaded to transform his loans into gifts, but the Dale loans only became donations at his death in 1962, when he bequeathed 252 paintings and sculptures. He also made a large donation for purchase and for fellowships. At long last my constant apprehension ended and I have slept better ever since.

Chester was difficult. Attached as I became to him, I must say he was not the easiest of trustees. He was critical, less of me than of his colleagues on the board. Whenever things at the National Gallery were not going to his liking, and this was often, he would say that the only place his collection would be properly appreciated was Paris. My heart would sink, and I would remember that Georges Salles, then director of the Louvre, had told him that his was the greatest private collection of nineteenth- and twentieth-century French paintings in existence. These

were heady words to Chester, and the thought of an *enfillade* of rooms in the Louvre was a strong magnet. I never took the acquisition of the Dale Collection for granted, and when toward the end of his life he repeatedly read me his will, I knew that at any moment it might be altered. I was fortunate that our friendship, our very real and deep affection for each other, was undiminished at his death.

I can close my eyes and see him still, much as he appears in the portrait by Rivera. He is surrounded by objects which suggest the range and variety of his tastes. Behind him in the portrait are two fine pieces of pre-Columbian sculpture, a mask and a seated figure. On the table is his catalogue of his French paintings. To the left of the catalogue a book is opened at one of these paintings, a *Self-Portrait* by van Gogh. Chester has laid aside his glasses and seems rapt in thought. Perhaps he is absorbed in the problem presented by van Gogh's life. How did it happen that Vincent managed to sell just one painting for which he realized about $80.00? What failure of connoisseurship explains this tragedy? Would a collector today miss so obvious a talent? It is always difficult to evaluate the artists of one's own time, but Chester showed great perspicacity.

Behind the desk at which he always sat when I visited him at the Plaza were two paintings by van Gogh. Often he seemed infected by van Gogh's sense of despair. It was then that he would fall into that familiar pose, leaning on his desk, one hand on his cheek, which Rivera caught so well. His face was lined and troubled, like one of those portrait busts done at the end of the Roman empire when the news arrived that the barbarians had just chopped up the last of the Praetorian Guard.

When we moved into the next room for cocktails it was a different matter. After the first martini Chester would say ritualistically, "A bird can't fly on one wing," and we would have a second. He should have said, "A seraph can't fly on five wings," for our martinis sometimes reached six. Gradually the world would seem brighter; perhaps in the end the Praetorian Guard had won out; perhaps the barbarians would be held at bay; and perhaps the Republican party might even win the next election. Then he would tell me that I was a great museum director, and I would reply that I wouldn't seem like one if his pictures went to the Louvre. He would roar with laughter and say nothing was further from his mind, though a few hours earlier he had quoted Georges Salles once more and said he was the only person who knew the

importance of the collection and that perhaps he should have it in his museum.

After we had had several drinks, Mary, his second wife, would join us, and we would go somewhere for a gay dinner. Chester's desire for companionship was insatiable. He would have been intolerably lonely had he not been fortunate enough to marry again when he was seventy-one years old. Mary Dale was for him the perfect companion. For years she had been the curator of the Chester Dale Collection and, living with these works of art, had, like Chester, developed taste and discrimination. Maud Dale until her death had constantly guided her husband, and without her stimulus one might have supposed his collecting would end. This was not the case. In a market immeasurably more competitive than it was in the twenties and thirties, Chester and Mary made some of the most important additions to the Dale Collection, paintings like Toulouse-Lautrec's *A Corner of the Moulin de la Galette*, van Gogh's *Girl in White*, Picasso's *Pedro Mañach* among others.

Chester was also active in advising the Gallery on its purchases. We went to a number of auctions together. Usually we were a good team, Chester making the bids, and I keeping my eye out for the opposition and advising him. Once, however, I had a painful experience. There was a painting by George Luks we both wanted for the Gallery, which was coming up for sale at Parke-Bernet. In those days auctions were not run with the smooth efficiency Peter Wilson of Sotheby's has subsequently introduced. On this particular evening there was a good deal of confusion, with bids coming from all over the room. Chester, seated beside me, was acting for the Gallery, while I was trying to spot who was against us. Finally there was a pause and the auctioneer said, "Going, going," and Chester to my horror remained motionless. We greatly needed the painting and the price was still low. Before the auctioneer said "Gone," I held up my hand. The kick on my shin was unforgettable! The last bid had been Chester's, and I was bidding against him! This so confused the auctioneer and the dealers that there were no further bids, and at a ridiculous price the picture was knocked down to me. Nevertheless it was a mistake I did not make again.

Chester Dale taught me a great deal. His knowledge of the history of art might be minimal, but his knowledge of the world of art was prodigious. He knew what was going on behind the scenes, and he was familiar with all the tricks of the trade. He operated his own Central Intelligence Agency, which gathered information from dealers in New

York, London, and Paris. How often after his death I have thought of him and wished I had his advice!

He was someone who longed for friendship and affection. His friends meant everything to him. Outwardly aggressive and tough, he was inwardly sensitive and emotional. In his autobiography he describes an evening with George Gershwin, which gives a rare insight into his personality and is worth quoting at some length.

> I bumped into George somewhere I can't remember now. He said "Oh! Chester," he said, "I understand you got a lot of swell pictures. I'd like to see them." I said it's O.K. with me George. Come over anytime it's convenient to you. So by that time we were pretty well settled and established of course with the piano. So George, and I think his brother and somebody else, I don't remember, came in for cocktails. Just where we were in the morning room there happened to be a Cézanne, right near the door called "Estaque." Well there were a lot of other good pictures, but George said, "My God Chester that's a wonderful picture!" I said what the hell do you know about pictures? "Well," he said, "it's a Cézanne isn't it?" I said sure it's a Cézanne. And I said George are you interested in art outside of your great art? He said, "Yes, Chester, I'm crazy about pictures." I said well George I don't know much about pictures but I happen to like 'em. Music and pictures aren't they more or less the same? He looked at me and he said "Yeah," and he began to tell me some things about Cézanne that I didn't even know. Well I said now look George if you feel like that why don't you go and play me a Cézanne. He said, "Sure I will," so he went to the piano that my old pal Hewitt played on down on Ninth Street. I haven't got any more idea than the man in the moon what he played but emotionally there was Cézanne to the both of us. I was thinking over what George had said and to this day I still don't believe there's a hell of a lot of difference between music and art. They are the same thing. To people that love either one of them what is the difference? They are both emotional. We came back, had another drink, and I was humming and happy as a lark.

If Maud Dale had not interested Chester in art, one wonders how he would have expressed this emotional side of his nature. Perhaps it might have been repressed with distressing consequences. But luck was with him, and he was unbelievably fortunate in both his marriages.

Certainly in Mary Dale he found the affection, understanding, and companionship he desperately wanted.

He also found in a little black poodle called Coco the adoration his ego needed. He doted on Coco. It was his love for this poodle which to some extent brought about his death. For many years he and Mary had stayed with their little dog at the Everglades Club in Palm Beach. They were very happy until the directors decided that in the future dogs would be banned. When Chester learned that Coco had been black-balled, he went South to find an apartment for the winter, so the poodle could be with him. He was far from well when he left, and the trip proved too much. When he returned he had only a short time to live. Just before he died he said he hoped I would retire and succeed him as president of the National Gallery, an unimaginable proposal which I told him neither I nor anyone else would agree to.

9

The Second Generation:
Paul Mellon
and Ailsa Mellon Bruce

Paul Mellon, the son of Andrew Mellon, is a passionate collector, a collector of art, of books, of horses. He and his sister Ailsa are exceptional, for in America one rarely finds two generations of collectors in the same family. I can think only of the Wideners, the Havemeyers, and the Mellons.

In the case of the Mellons, the collections formed by father and son are totally different. The Andrew Mellon Collection is a group of masterworks by artists of all schools; the collection of his son falls instead into two sections: there is a systematic assemblage of British art and there is a collection of Impressionist and Post-Impressionist masterpieces with a scattering of American paintings and some examples of contemporary art. The British section will occupy a gallery Paul is building at Yale, which will be known as The Yale Center for British Art and British Studies. The oils in this part of his collection are comparable to those in the collection of the Tate Gallery and the watercolors and drawings to those in the British Museum and the Victoria

Andrew W. Mellon, with Ailsa and Paul. 1912. It is rare to find two generations of collectors in the same family. (Courtesy of Paul Mellon. Photo: Johnston Studios)

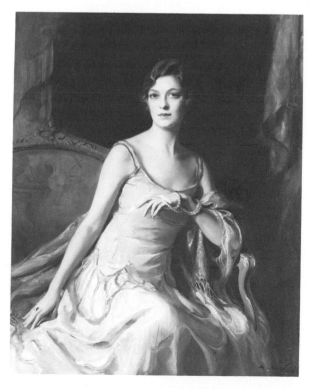

Philip de Lazlo, *Ailsa Mellon Bruce*. (Photograph courtesy of the National Gallery of Art)

and Albert. Thus, in its field, an American private collection ranks with the three greatest public collections in England. But still more remarkable is the fact that nearly all these British works of art have been acquired since 1961.

Though Paul became an art collector relatively late in life, his father, sensing his interest, made him one of the three trustees responsible for the construction of the National Gallery. Except for the war years, he has been instrumental in determining its policies, its acquisitions, and its management. He was president from 1938 to 1939, and he again became president in 1963, but during the presidencies of his predecessors, Sam Kress and Chester Dale, he was always among the most influential members of the board.

It is usual for museum officials to have difficulties with the president; the pattern is monotonously repeated. But Paul has always seemed to me the ideal trustee. He has firm and sensible beliefs about policy, which he expresses clearly; these beliefs are not inflexible and he gives full weight to the ideas of the professional staff. Once a policy is determined, however, he does not interfere in its execution. As chief curator and subsequently director I found his understanding, sympathy and advice invaluable. Our relations were always felicitous.

I started with a great advantage. In Pittsburgh we grew up together. We had the same friends, male and female, and we were amused by the same things. We enjoyed games, especially poker. Andrew Mellon had the reputation of being a superb poker player. Paul was not. The stakes we played for were low, but even so Paul started at an early age sharing his wealth.

We lived a happy life in Pittsburgh. The twenties, when we were growing up, was the period of Prohibition. As we ceased to be adolescent, this presented a problem. The Mellons, however, had owned a distillery which manufactured a superb rye, known as Old Overholt. The stock in the Mellon cellars, bottled before Prohibition, was so enormous that Paul still has a large supply. "Grandfather's Coca-Cola," we called it, but as a drink how infinitely more rewarding! We were indeed grateful to Grandfather Mellon for adding the liquor business to his other profitable enterprises.

After college Paul went to England and I to Italy. Marriage dissolved our group of friends, but I remember one of our last parties. A particularly close companion was being married in Canada, where, as I have said, Grandfather Walker had his summer home. Grandmother by that time was a widow, or I would never have been allowed to give the

bachelor dinner. As the party became more boisterous, with all of us proposing what we considered hilarious toasts, we were suddenly startled to hear a cascade of water falling from all sides of the house. We ran out of doors, and there were our boatmen and gardeners with huge fire hoses spraying the roof, which like the rest of the house was shingled. Grandmother didn't want to interrupt the party, but she was sure we would set fire to something, and she wanted to take what precautions she could.

Paul's years in England were perhaps the happiest he has known. From childhood he had loved everything English. Before the First World War his father and mother always took a house near Windsor for the summer. Of those distant summer holidays he has written feelingly: "I remember huge dark trees in rolling parks, herds of small friendly deer, flotillas of white swans on the Thames, dappled tan cows in soft green fields, the grey mass of Windsor Castle towering in the distance against a background of huge golden summer clouds; soldiers in scarlet and bright metal, drums and bugles, troops of grey horses; laughing ladies in white with gay parasols, men in impeccable white flannels and striped blazers, and always behind them and behind everything the grass was green, green, green . . . somehow at this great distance it all melts into a sunny and imperturbable English summer landscape. There seemed to be a tranquillity in those days that has never again been found, and a quietness as detached from life as the memory itself." How this description fits hundreds of the English watercolors he was later to collect!

The enchantment of England cast a spell over his youth. At Yale in the late twenties the spell deepened under the influence of such brilliant professors as Chauncey Tinker, Billy Phelps, and Bob French. He became in his own words "a galloping Anglophile," with the emphasis on galloping, for he was and is a passionate foxhunter. Riding is how he keeps himself in condition, and his tanned face and lithe body (for he watches his weight carefully) witness how much out-of-door exercise he takes.

If one were to speculate on the period in which he would have chosen to live, I think one would select the time between the ministry of Sir Robert Walpole and that of Lord Melbourne. Paul would have been at home with those urbane, cultivated gentlemen, living in their Georgian town houses or on their country estates. We see them in pictures by Stubbs, Zoffany, Devis, Marshall, and others, painters who convey the charm of the country: the exhilaration of foxhunting, the excitement of

Grandfather Walker's house at Beaumaris. Grandmother was sure we would set fire to the house which she had built herself without an architect or a contractor.

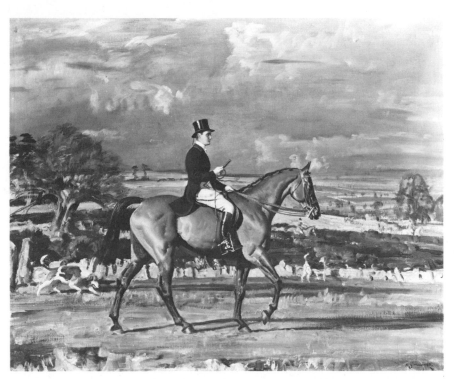

Sir Alfred Munnings, *Portrait of Paul Mellon on "Dublin."* In Paul Mellon's life the *deus ex machina* for sorrow and joy has been the horse. From the collection of Mr. and Mrs. Paul Mellon.

shooting driven birds, the satisfaction of catching a salmon, and always as a recurring theme, the delight of seeing beautifully groomed horses in their cool paddocks. Little wonder that these gentlemen of Georgian England are so often portrayed walking with obvious self-satisfaction across the velvety lawns of their lovely country houses. Their way of life, as mirrored in English painting, must have exerted a strong attraction for Paul long before he became a collector.

But Tuesday to Friday his is a different existence. Had he lived in the eighteenth century he might have squandered his vast wealth gambling. Today there is the risk of dissipation through eleemosynary gifts. One method of wasting money can be as bad as the other. Paul once said, "Giving money away is a soul-searching problem. You can cause as much damage with it as you can good." At least three days a week he devotes to The Andrew W. Mellon Foundation, one of the largest in the world, and to his other duties deriving from his enormous wealth. How fortunate were the Georgian aristocrats whose major anxieties were limited to gambling debts! Today for the really rich the obligations of charity and the Bureau of Internal Revenue are more boring, more complicated, and more time-consuming.

After I started to work at the American Academy in Rome I saw Paul rarely. We both married at about the same time. When one summer I returned to Pittsburgh for a vacation bringing my wife with me, we met Mary Conover, Paul's first wife. The two women liked each other at once. Mary had worked for a time with an art dealer in New York. She had been part of a society whose members were less parochial and more bohemian than most of Paul's Pittsburgh friends; and, as my wife had grown up in diplomacy, they were brought together by a greater cosmopolitanism and also by a slight feeling of estrangement in their new environment. In the case of my wife all sense of alienation in Pittsburgh vanished quickly, but Mary remained a somewhat exotic though beautiful figure.

Unfortunately she suffered from a common form of asthma, an allergy related to horses. She was convinced that her affliction was largely psychological and not purely physical. She was hopeful that analysis might help, and therefore she and Paul went to Zurich to become patients of Dr. Jung.

The result of Jung's treatment, which lasted more than a year, was certainly beneficial, and Mary seemed so cured of her asthma that she was able to share Paul's passion for riding. He in turn, perhaps as a result of Jung's analytical psychology, became one of the best balanced

and, as far as an outsider can ever know, one of the happiest of human beings. One might sum up his character by saying that he likes to see others equally happy but with a minimum of personal involvement. He has immense charm and has always been able to make devoted friends. He attracts people, but he is fundamentally a "loner."

The war came, and Paul served first in the cavalry and later in O.S.S., rising from private to major. But when he came home to his house in Virginia and resumed the equine life he had always loved, Mary found that her asthma had returned. The attacks were so severe that they strained her heart, and she was told by her doctor that she must never again go near a horse. It was characteristic that she rejected this diagnosis, refusing to be separated from Paul's greatest pleasure. She went riding once more and suffered a fatal heart attack.

In Paul's life one might say the *deus ex machina* for sorrow and joy has been the horse. Fifteen years after Mary's death in 1946, an exhibition entitled *Sport and the Horse* was to turn him into one of the most remarkable collectors of our time. For many years he had been a trustee of the Virginia Museum in Richmond. George Cole Scott, a fellow trustee, and Leslie Cheek, the director, thought that a show of sporting pictures would appeal to Virginia's foxhunting community; and when an exhibition glorifying horses, hunting, and racing, three of Paul's major interests, was proposed, he felt he could not refuse to head the selection committee. It was from his involvement in this exhibition that his passion for British art was born.

He has always been extremely modest, but when he told the trustees of the Virginia Museum that he knew virtually nothing about British art, apart from living with his father's paintings and owning a few sporting pictures himself, he was not overstating his ignorance. He was, however, a friend of many of the owners of English collections, and he felt that his companions from Cambridge University, the hunting field, and the racetrack might be willing to lend at his request certain works which would not otherwise be available. But he pointed out that he had no idea what should be borrowed. He required, he said, someone familiar with British painting to guide him. Leslie Cheek arranged for Basil Taylor, then at the Royal College of Art, to take a leave of absence and help make the selection. This was the beginning of the remarkable and fruitful association between Paul and Basil.

The exhibition they mounted in Richmond in 1961 proved to be as important for the appreciation of British painting in this country as was the Armory Show in 1913 for Post-Impressionism. After the Virginia

Museum exhibition, American collectors had a new respect for the creativity of British artists. Foremost among these converts was Paul himself.

His conversion resulted in a crusading zeal. He was determined to create a new and more intelligent appreciation of British art. Within two years, with the help of Basil Taylor, he was able to arrange, again in Richmond, an exhibition of his own paintings (he had bought over four hundred during this period) which ranked with the show he had helped to borrow from museums and private collections all over England. It was an extraordinary achievement. It also showed the amazing supply of British paintings available for purchase. This could never happen again.

As he could not spend much time out of America, for he had many responsibilities thousands of miles from English dealers and auctions, the sources of the pictures he wanted to buy, Basil Taylor came to represent him. Basil is an admirable connoisseur. An authority on Stubbs, he has a discerning eye and long experience in the English art market. His untiring search for the kind of paintings Paul wanted revitalized the trade in British painting. Dealers were spellbound by the magnitude of the orders they received. Photographs, transparencies, drawings, paintings arrived in America by the plane-load. The available supply of British art, accumulated over a long period of disregard, was so great that prices for a surprising time remained at the same low level.

The opportunity to do some business in this neglected field was a heady experience for most of Bond Street. One dealer, who owned race-horses, aware of the fame of the Rokeby Stables, which in recent years have won the most important races in America, England, and France, offered to trade some of his best English pictures for an opportunity to obtain one of Paul's best-bred mares. In a short time the art dealers became so hypnotized by the name "Paul Mellon" that the few amateurs interested in British painting, to their intense irritation, found virtually everything in the market reserved for him, though sometimes without his knowledge or that of Basil Taylor.

The extraordinary disdain of British art, especially among the young aesthetes who grew up in the twenties and thirties (I was not immune myself), has several explanations. There was the influence of Berenson with his emphasis on the connoisseurship of Italian painting; there was the contemptuous attitude of Roger Fry, whose lectures at the Royal Academy were intended to promote the British School but ended by

patronizing it; and there was the salesmanship of Joe Duveen, who inundated the houses of American millionaires with ridiculously over-valued eighteenth-century portraits, some brilliant like *The Blue Boy, Pinkie, Mrs. Sheridan,* but for the most part mechanical, repetitious, and often greatly repainted.

The enchanting painters of genre and conversation pieces, Zoffany, Devis, Morland, and the rest, though not unknown in this country, were rarely to be found. I remember being deeply impressed seeing paintings by Stubbs, one of the great masters of the eighteenth century, in the James C. Brady Collection, for nowhere else in this country had I seen his works. Wright of Derby, another genius, was a name unfamiliar to American collectors. Even Richard Wilson was scarcely to be seen. Mr. Morgan and Mr. Frick each owned one picture by Hogarth, but where else were his really important works to be found on this side of the Atlantic? The best collection of British painting in America was in Pasadena, but the Huntington Collection was formed by Duveen and reflected his taste for a few of the well-known and expensive eighteenth-century English masters.

The continent was even less interested than America in British art. At the beginning of the nineteenth century it was fashionable to own English mezzotints, especially after Morland, and the larger museums could boast a Reynolds, a Gainsborough, and occasionally a Romney. But they were about all among eighteenth-century artists. Among nine-teenth-century painters, pictures by Constable, Turner, and Bonington, who was considered French, were to be found, but usually, except for Bonington, in poor examples. Though British art had a strong influence on continental painters, it was only on those who came to England or who were fortunate enough to see the Constable exhibition in Paris in 1824.

The rehabilitation of British painting begun by Paul Mellon has not yet extended to the Continent, though recently a picture by William Beechey was stopped by the French authorities from being exported. But in America and England undue neglect has changed to an almost exaggerated esteem. Ultimately the effect of Paul's buying was like repeated shots of Vitamin B, to which the English market finally re-sponded. The staggering rise in prices in the end reduced the rate of his acquisitions, not for lack of funds, but because he refused to pay what he believes to be ridiculous prices. For example, a fair painting by Stubbs only a few years ago would sell for about ten thousand dollars, a great work by him for about thirty. Now the figures have increased at least a

thousand percent, and a run-of-the-mill canvas would bring roughly a hundred thousand dollars, whereas a superb work was sold recently for $550,000. This particular picture, incidentally, *The Cheetah with Two Indians,* was bought by a British gallery, and much as he wanted it, Paul did not bid. He has made it a matter of principle never to try to acquire works of art which he knows the British consider national heirlooms.

After the Virginia Museum exhibition of his collection, however, Paul for a time continued to buy even more extensively. An enlarged Paul Mellon Collection of British painting was shown at the Winter Exhibition of the Royal Academy in 1964 and at Yale the following spring. These were the only public exhibitions of the Mellon British oil paintings except the one-man shows at the National Gallery of Art of Constable, Turner, Stubbs, Hogarth and other major English painters borrowed exclusively from his collection.

The whole collection has still to be exhibited for it is in a state of growth, slower than formerly, but far from static. Basil Taylor has ceased to advise, and his place has been taken by Dudley Snelgrove, John Baskett, and John Harris in London.

I played a minor if ineffective part in some of these purchases. One involved Turner's masterpiece, the *Dort.* In my continuing search for pictures for the National Gallery of Art I was touring Yorkshire and decided to visit Farnley, a house belonging to the Horton-Fawkes family, where Turner had once stayed and painted. We were lost, and at last after seeing no one to direct us we came on some children aged eight to ten playing near a gatehouse. I asked how to find the Horton-Fawkeses. The eldest of the children got off his tricycle and proudly said, "*We* are the Horton-Fawkeses." I followed their tricycles up a long drive and was finally greeted by their mother. She showed us the superb Turner watercolors and one magnificent canvas, *The Dort Packetboat from Rotterdam Becalmed.* As we left, Mrs. Horton-Fawkes confided in me that her father-in-law might have to sell this picture, which Constable described as "the most complete work of genius I ever saw." I asked her to let me know the price and in due course a letter came from her, saying 120,000. In front of the numerals was a figure I took to be a dollar sign, which did not surprise me as Mrs. Horton-Fawkes is an American. I told Paul, who immediately confirmed his willingness to buy the painting for $120,000, which seemed at the time a remarkable but not impossible bargain. His offer was disdainfully refused. The symbol was a £, not a $, which made the amount almost

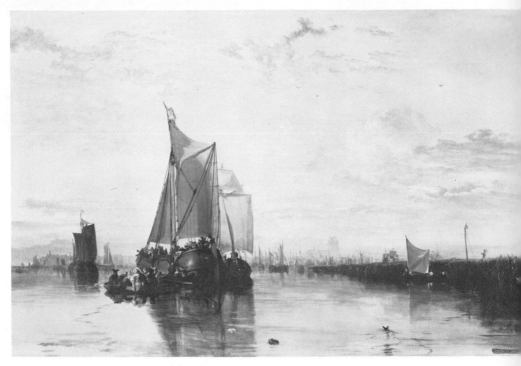

Joseph Mallord William Turner, *Dort or Dordrecht: The Dort Packet-Boat from Rotterdam Becalmed, 1818*. A bargain in dollars, but not in pounds! From the collection of Mr. and Mrs. Paul Mellon.

three times greater! It took time to recover, but Paul did and finally paid in pounds.

The Turner *Dort* in my opinion is one of the two greatest English landscapes in his collection. The other is Constable's *Hadleigh Castle*. Again I was involved, but no more effectively. The painting belonged to Countess Széchenyi, who was born a Vanderbilt and who lived a block away from Paul's Washington house. I used to call on her frequently and talk about the tax advantages of gifts and bequests to museums. I thought there was no question but that she had agreed to leave the supreme landscape of Constable's last years to the National Gallery of Art. I failed to tell Paul of my efforts with his neighbor. The next I knew he showed me with justifiable pride his latest acquisition, *Hadleigh Castle*. To my astonishment and distress I discovered that Countess Szechenyi had sold it to Geoffrey Agnew, the London dealer. The picture had gone across the ocean and returned to within five hundred

feet of its previous location. Its journey, however, was immensely expensive for Paul and of no advantage to Countess Széchenyi. How easily might I have benefited them both had the Countess only confided in me!

But confidences collectors rarely share. They often disregard their own interests in some inexplicable desire for secrecy. I have described our purchase of El Greco's *Laöcoon* from Prince Paul of Yugoslavia (pages 144–146). He had several other masterpieces he had managed to bring to London, in particular a very valuable and beautiful Mantegna. He never told me he had been able to remove this marvelous panel from Belgrade, although he must have known the Gallery would eagerly have bought it. To my amazement it was offered to the Kress Foundation by Wildenstein's. The price asked I judged to be at least twice the amount paid to my friend. In the end it was sold to M. Assis Chateaubriand of Brazil.

Dealers are used to doubling or even trebling prices. A staggering increase occurred in connection with one of Paul Mellon's pictures, in this case I suppose due to my folly. The values involved were not large, but my annoyance was. When I submitted a portrait of Audubon painted by his son to our Acquisitions Committee, Paul asked me if it didn't look familiar. I said it did, oddly enough. He pointed out that it had once hung over the mantelpiece in his living room in New York, a house it is true I rarely visited. He had bought it from his bookseller for a modest price, but having grown bored with the picture he asked for his money back. It was returned with delight; and several years later our expert in Americana, the assistant director, Macgill James, came across the portrait at a better-known dealer's. Paul's modest purchase price had advanced by arithmetic progression, but Macgill insisted that the painting was of great historic value and the Gallery should acquire it. Paul said he had never thought it worthy of the Gallery or he would have given it gladly. Now, he admitted, it was a little painful to have to buy it back for many times what he had received; but he acquiesced, partly I think for the pleasure of teasing me.

To return, however, to Paul's efforts to rehabilitate the British School. He established the Paul Mellon Foundation for British Art in London with Basil Taylor as its director. An English board of trustees was formed and funds were provided by the Old Dominion Foundation, which Paul had created. British art studies, which had withered away, parched so long for lack of money, sprouted and grew with a rapidity

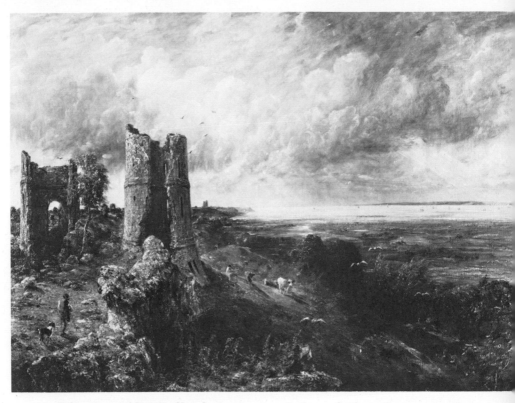

John Constable, *Hadleigh Castle*. A painting which took an expensive journey, before returning to within five hundred yards of its previous location. From the collection of Mr. and Mrs. Paul Mellon.

that became alarming. A Dictionary of English Artists in not one, but *twenty* volumes, was begun. Numerous books were commissioned and a variety of scholarly undertakings were subsidized, but the results were not in proportion to the amount of time needed simply to coordinate the program and to arrange for financing the foundation. For this reason and because of Basil Taylor's expressed wish to retire, Paul decided to endow the foundation with a reasonable amount of money and to join it to the Yale Center for British Art and British Studies.

That the Paul Mellon British Collection should eventually go to Yale was, of course, a disappointment to me. Selfishly, I should have liked it under the aegis of the National Gallery of Art. But its very magnitude — over sixteen hundred oils, and over five thousand watercolors and drawings — would have required another building. Paul discussed with me on many occasions the future disposition of this enormous

assemblage of British art, the most massive example of selective buying, so far as I know, in the history of collecting. Although I argued loyally for Washington, I basically agreed with him that the nature of the collection called for its use by scholars absorbed in the study of English history and culture. In such studies Yale is paramount among American universities. Washington, on the other hand, is a tourist city, and the National Gallery of Art a tourist museum. Only certain masterpieces Paul has acquired would be of significance to most of the Gallery's visitors; whereas the completeness of the collection has made it a teaching instrument. It belongs in a great university, and in selecting Yale I am convinced Paul has chosen wisely.

There is compensation, however, for the loss of the British Collection. There are the other paintings and sculpture Paul and Rachel Lambert, his second wife, known to her friends as Bunny, have acquired. These in all probability will ultimately rest in the National Gallery of Art. In forming this part of their collection, Chester Dale for a short time played an important role. He encouraged Paul to continue his collection of French paintings and often brought to his attention such masterpieces as van Gogh's *Green Wheat Fields, Auvers;* and Degas' *Race Course: Before the Start.* Chester was delighted to feel that he was molding a new and vastly important collector. He came to look on Paul as a son. But, as so often happens, the nominal son never looked on him as a father.

With his many responsibilities and interests it was difficult for Paul to take part in the endless conferences at the Plaza which Chester requested. Huntington Cairns, Secretary of the Gallery, and I were poor substitutes. Consequently a predictable coolness developed in their relations. This added to my anxiety over the future of the Dale Collection; and it was with relief that I watched Paul form his own collection which would make the Gallery less dependent on Chester's moods. Little did I realize that this second collection would become, in my opinion, the most important in its field still privately owned.

In its formation Bunny Mellon was soon far more influential than Chester. She is a very remarkable woman, a brilliant horticulturist and landscape gardener, the equal of any professional, and also an amateur architect. The church she built in Upperville, working with Page Cross, who was the professional architect employed, is one of the most beautiful modern churches I know.

At the beginning the pictures the Mellons acquired were intended

only for the decoration of their houses. Their taste is very personal. Windmills they can't abide and they are prejudiced against cows. As Paul has said, "Three are enough in a painting." But pictures of sea and sky and windswept meadows recall their youth in Easthampton and Southampton. Such paintings are their particular delight, whether by American artists like Winslow Homer or by one of the masters of Impressionism.

In an article Paul wrote for the *Washington Post* at the time of a large exhibition held to commemorate the twenty-fifth anniversary of the National Gallery, he said, speaking of the paintings in his houses, "Our pictures . . . are lived with, constantly looked at, and loved. They are more than decorative, or merely attributes of the general style and atmosphere of each house. They have become companions and friends, and are part of the life lived in the house, part of our own lives. . . . I have never bought pictures as an investment, except as an investment in pleasure, as treasures to the eye."

This should be the creed of all collectors. Love is vital in making a collection. How many have I seen filled with masterpieces unlovingly assembled. A lack of love somehow tarnishes the works of art. One respects, admires, but seldom enjoys them. What Paul and Bunny have brought together reflects instead the glow of their affection. This enhances the intrinsic beauty of all they have collected.

But what is at the root of their predilections, what causes their instinctive selection of one painting rather than another? From many conversations with Paul I think it is often, as with myself, empathy, an imaginative identification with the subject represented. The picture thus becomes a stimulus to remembrance, an inducement to recollection, an evocation of some former experience. The Mellons, for example, have the largest collection of beach scenes by Boudin I have seen anywhere. Sand, sea, sky, as he painted them, aren't these the elements of their childhood experiences, reminders of the happiness of their youth? Or Degas horses and their jockeys pirouetting like ballerinas, how magically they evoke the excitement of the racetrack! Art as the embodiment of memory, not the remembrance of actuality, but of the ideal shaped by the imagination, this I think is at the base of their aesthetic response.

From his parents Paul inherited, in his words, "a desire to own, to enjoy, to savour, and to conserve rare and beautiful things, a desire which must infuse all collectors." This instinctive feeling "begins in childhood," and he thinks it is there perhaps even at birth. "It is the

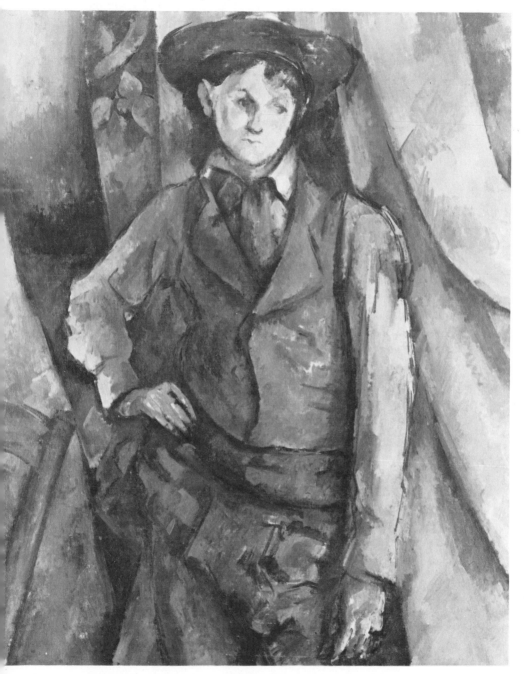

Paul Cézanne, *Boy in a Red Waistcoat*. Paul's pictures have become his companions and friends. From the collection of Mr. and Mrs. Paul Mellon.

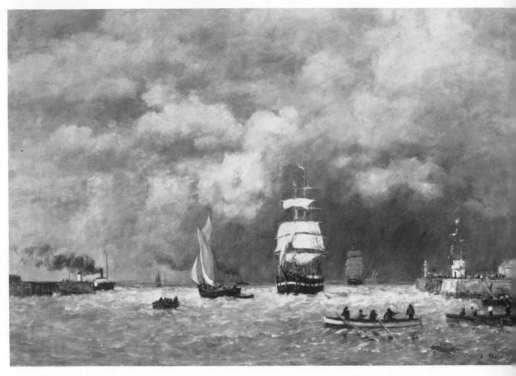

Eugene Boudin, *The Outer Harbor of Le Havre, 1888*. Of his numerous paintings by Boudin, this is Paul Mellon's favorite. From the collection of Mr. and Mrs. Paul Mellon.

childish pleasure of searching for rare and beautiful shells on a beach, the immediate and delighted relationship between the shell lying in the afternoon sun in the wet sand and the clear, unclouded vision of the child . . . it is an attempt to preserve timelessly the bright vision of an instant, and to transform the object into part of one's self."

Anyone who has felt the impulse to "conserve rare and beautiful things" has been infected by the virus of collecting. He is the victim of a distemper of the mind, for which we should all be grateful. The symptoms of this benevolent disease are an insatiable acquisitiveness. The true collector is an addict. The number of works of art he owns is meaningless. There are over ten thousand paintings, drawings, prints and sculptures in the collection of the Mellons; yet it continues to grow. There is always to be found a shell gilded by the evening sun, which is irresistibly attractive. This is one reason the world has its great museums.

ii

If about Paul there is an aura of happiness, about his sister, Ailsa, there was always one of sadness. It was as though a wicked fairy had appeared at her christening, waved a wand, and blighted all future enjoyment of her wealth and beauty. Yet those of us lucky enough to have penetrated her shyness knew a woman who could be as gay and amusing as her brother. But we also realized that for years she was in constant pain from a form of arthritis, and that in her personal life there were repeated tragedies.

When we were children I did not know her as I did Paul. She was a few years older, and in adolescence a difference in age often means total separation. Early in life she married David Bruce, who was beginning his career in the Foreign Service. They were divorced during World War Two, and thus she never shared with him his triumphs as one of the outstanding ambassadors the United States has produced. They remained, however, close friends; and David, who was himself a passionate collector, may have set her an example.

But Ailsa always denied that she was a collector. Nevertheless she provided collections of great importance for the National Gallery of Art, the Carnegie Art Museum in Pittsburgh, and the Virginia Museum of Fine Arts in Richmond. As a noncollector, she resembled Bernard Berenson, for both bought works of art only for the use and decoration of their houses. Neither had that irresistible desire for acquisition for its own sake which marks the true collector.

Berenson, however, owned only one house, I Tatti, whereas Ailsa Mellon Bruce at one time owned three apartments in New York, two houses in Greenwich, one in Syosset, and one in Palm Beach. When she died she was considering a place in Ireland. She also helped the National Trust for Historic Preservation and the Park Service acquire a number of historic mansions. One might say that if she was a collector at all, she was a collector of houses.

She was deeply interested in interior decoration, especially the furnishing of her apartment at 960 Fifth Avenue, which she bought a few years before her death. At the time she was living in a much smaller flat. There she surrounded herself with crates, boxes, samples of textiles, pictures on tables and on the floor, *objets de vertu* half unpacked, a medley of works of art, each to decorate her new home when she moved.

I never knew how she could live in such chaos. Neat and stylish in appearance, she seemed out of place in the midst of such disorder, which looked as though she were moving the next day. I can see her now seated on one of the two chairs still available in her living room as she served tea, doing it as she did everything, with an air of distinction, always, even in her late sixties, looking very beautiful, with her father's high cheekbones, slender figure, and long tapering fingers.

If she was surrounded by miscellaneous furnishings strewn around in utter confusion, she knew, nevertheless, where each piece was ultimately to be placed. They were the material out of which she intended to achieve her dream, to decorate an apartment which was to be the most beautiful in New York. Much of her time was spent discussing colors, curtains, rugs, boiserie, appliqués, chandeliers, with decorators from New York and Paris. She often maddened them with her indecision. One told me how for two years Ailsa had carried around a sample of chintz, holding it up in her apartment repeatedly, never able to make up her mind. At last she decided it would do, but by that time it was out of stock and no longer manufactured. She had the greatest difficulty over small decisions. Another decorator who was also a close friend described being called urgently to the telephone while she was lunching. Ailsa said she was thinking of going abroad and could not decide about the color of the band she wanted painted to identify her luggage. What did the decorator recommend? These were her eccentricities, but all those who worked for her loved her. In her combination of sensitivity and diffidence there was something deeply appealing.

In spite of her reticence, going far beyond her father's, she was very competitive. She wanted her surroundings to be unparalleled among her friends. She always had in mind, as a standard of comparison, the apartment of Charles and Jayne Wrightsman; and she would ask me whether what she had brought together and arranged could be compared with what they had assembled. I assured her it could. Her apartment in my opinion ended by being the most beautiful I knew in America or Europe.

In the summer of 1969 it was finally finished. When she was at last ready to move in, after four years of preparation, she was told that she ought to go to the hospital for a minor operation. She never left her hospital bed, never slept in her new apartment. Except for two small dinners, the only time those rooms she had so carefully painted and repainted, arranged and rearranged, in which we had hung and rehung

her collection of paintings, were seen by a few of the people she had hoped would admire them was at her funeral. When her body was carried away, it was necessary in accordance with the terms of her will to dismantle everything immediately, thus obliterating the only work of art she had ever created. That the apartment was never photographed is an oversight her brother now deeply regrets. It would seem as though the spell cast by the wicked fairy had remained to the end.

At Paul's suggestion most of the furnishings Ailsa had collected were given by her executors to the Carnegie Institute Museum of Art in Pittsburgh, where they now form an important and distinguished Department of Decorative Arts. Her donation was badly needed. Previously what one could see of the decorative arts in the Carnegie Museum was negligible. I am sure she would have been pleased by the ultimate repository of her beloved treasures which had been so discerningly assembled. She was always troubled that her father had taken his own collection away from the city which had been the source of his fortune. Her furniture, silver, porcelains, rugs, *objets d'art* are some compensation for this loss.

Charles Carstairs of Knoedler's, as I have said, strongly influenced Andrew Mellon as a collector of paintings. His son Carrol played the same role with Ailsa. They were close friends. He sold her a few pictures of places which she liked, a Derain which reminded her of the south of France, a Renoir garden scene which recalled her own garden at Syosset. But in 1950 Carrol Carstairs died, and her desultory collecting languished. She had enough paintings given by her father or from his estate to decorate her place on Long Island, her house in Florida, and the only apartment she had at that time in New York.

Among these pictures was a sketch by Manet, *A Boy with a Sword*, a study for the Havemeyer picture in the Metropolitan Museum. She kept it in Palm Beach, but when she returned there one winter it had disappeared. It was the only picture in a collection of over two hundred she had lost, but because it had belonged to her father she was particularly unhappy. She showed me a photograph, and for several years I continued at her constant urging a spasmodic search, going through photographic archives of paintings, asking dealers, looking at auction catalogues, consulting new books on Manet. My investigation was complicated by the fact that many of her pictures were stored with various dealers, hung in her different houses, and used to decorate her foundation. Nevertheless, I finally came on a clue. A friend told me he

had seen a canvas of a boy with a sword in the Santa Barbara Museum. On my next trip to California I took along my photograph, and there I found the missing painting proudly exhibited.

The story was easy to reconstruct. While repairs were being made to the Palm Beach house the picture had been stolen; and, after passing through the hands of various dealers, was, in all innocence, purchased by a neighbor. She in turn had lent it to Santa Barbara.

I reported my success as a detective and asked Ailsa whether I should consult her lawyer about steps to regain her picture. She said as the painting was on exhibition in a museum, why not leave it just where it was? The owner would in all probability eventually give the picture to the public, and after all her own collection was going some day to a museum.

But *one* of her father's pictures which ended in a museum broke her heart. It is the portrait of Lady Caroline Howard by Reynolds. She had fallen in love with this painting of a little girl, and it had always hung in her bedroom. She was sure her father would leave it to her. But unfortunately he did not know how much she wanted the painting and it was among those he had deeded over to his foundation. When he learned of her disappointment there was nothing he could do, but he told David Finley in any case he felt the picture too important to remain in a private collection. Consequently *Lady Caroline Howard* now belongs to the nation. Ailsa spoke to me about it often. Was there any way she could buy it and have it during her lifetime, or exchange it for some other work of art, which she would purchase at any price? If I could have found a way to satisfy her, some means that would not have led to endless publicity, which she dreaded above everything, I would have asked the trustees of the Gallery to agree to an exchange. I wanted desperately to have *Lady Caroline Howard* go to her for the few years she was to live. But I never worked out a solution, and if I had, she might in the end have rejected it. When we bought with her money another picture which she also loved, *La Liseuse* by Fragonard, as I have said, she insisted it go immediately to the Gallery.

Paintings of young people appealed to her. Her brother had a portrait of a girl by Sargent which she loved almost as much as the other two, but it was one of his favorites and he would not part with it. Once more she felt frustrated. Finally she purchased Goya's portrait of the young Infanta, known as the *Chinchon*. This painting of a little girl, enchanting as it is, she never considered a real substitute for the other three. For a time she lent it to the National Gallery, but it finally became

Sir Joshua Reynolds, *Lady Caroline Howard*, British, 18th Century. A painting Ailsa wanted to keep. National Gallery of Art, Andrew W. Mellon Collection.

Francisco de Goya, *Condesa de Chinchon*. A poor substitute for Lady Caroline Howard. National Gallery of Art, Ailsa Mellon Bruce Collection.

Auguste Renoir, *Pont-Neuf, Paris,* French, 19th Century. Impressionist paintings, with their bright colors and warm sunshine, seemed to alleviate Ailsa Mellon's pain. National Gallery of Art, Ailsa Mellon Bruce Collection.

migratory between her house at Syosset and her apartment in New York.

Next to pictures of children, she loved landscapes by the Impressionists and Post-Impressionists, such as the *Pont Neuf* by Renoir, *The Artist's Garden at Vétheuil* by Monet, and the many Bonnards she owned. These seemed, with their bright colors and warm sunshine, to alleviate her pain. They were to some extent antidotes against suffering.

The Molyneux Collection gave her particular satisfaction. Captain Edward Molyneux, the famous dress designer, had for many years been buying with great discernment intimate works by the masters of Impressionism and Post-Impressionism. Ailsa knew the collection, which she had often seen in Paris. Almost all his pictures were small, and Ailsa loved little paintings, which she could group on walls and place on tables. She

was delighted when she learned Molyneux had decided to sell everything *en bloc,* and to begin a new collection of the work of young and unknown artists. There were over ninety examples in his collection, for which in 1951 she paid under a million dollars, or roughly ten thousand dollars apiece. It has been some time since even a few brush strokes by an Impressionist have sold for as little as ten thousand dollars. The Molyneux purchase was an incredible bargain. It was also the beginning of her serious collecting.

Ailsa was never a bargain hunter, but in spite of her immense wealth, she liked to negotiate. I became her principal negotiator. Like her father, she wanted the pictures she was considering to hang on approval in her apartment. This used to make the dealers frantic. Once after she had returned several paintings, a dealer said to me in his engagingly broken English, "Mrs. Bruce play with me Ping-Pong. I go ping. She go pong. And all my pictures are back."

Ailsa would often remark sorrowfully, "I don't think so-and-so among the dealers likes me. I am sure he has wonderful pictures he isn't showing." Then we would go to see so-and-so, and with the incredible charm she could exert, she would extract from the back room the masterpiece he was reserving for another client. Ailsa then would say with her wistful half smile, "I don't suppose you will let me see it in my apartment, but I don't know what to do. Before I decide I must know how it looks hanging on my wall." The dealer would melt, and the Ping-Pong would recommence. One dealer said to me despairingly, "Mrs. Bruce doesn't realize that she doesn't buy as much as her brother. She doesn't know that she costs me a lot of money." I would try to console him, and when Ailsa would reappear at his gallery and look at him appealingly for a few minutes, he was again putty in her hands and out would come his latest treasure.

These expeditions to dealers were for many years one of my principal delights. But there were occasions when they caused me some alarm. The library in the new apartment Ailsa was decorating needed five paintings. She had two fine canvases by Bonnard, and she decided that three more would be very suitable for the room. We went together to a dealer. He produced a number of works by Bonnard. whose death was recent. The New York art market, it seemed to me, was glutted with his pictures, all apparently produced in the last years of his life. At this time the book by Clifford Irving on fakes appeared. Bonnard was a master of color but not of form. Of all the School of Paris painters he would be, in my opinion, the easiest to forge. Were the pictures Ailsa

and I were looking at genuine? In making purchases I am very cautious. I like to take my time, to give each possible acquisition a long scrutiny and devote to it considerable thought. Ailsa, however, was in a hurry. The apartment was almost finished, and she wanted the pictures at once. I took a deep breath and advised her to get them. They seemed genuine to me, and I thought if they aren't right, it is doubtful whether anyone coming to see Ailsa will be in a position to challenge them. Little did I realize that in a few months Ailsa would be dead and her whole collection would be left to the National Gallery. So far as I know all is well, and I hope and pray that my intuition that the pictures are authentic holds up. But they are now open to a critical scrutiny I did not expect for many years!

Devoted as she was to the National Gallery, I never thought Ailsa would leave it every painting she owned. Her will astonished me. In respect to her collection it did not represent what she told me she had planned. When her only child, a daughter whom she adored, disappeared in a flight over the Caribbean, she took an even greater interest in her grandchildren; and they, though very young, Ailsa thought had a strong feeling for works of art. She wanted each of them to have a choice of one or more of her pictures. I remember her saying, "You know, John, you mustn't think you are going to get everything I have for the National Gallery. My grandchildren are to have some of the collection." Yet to my amazement the National Gallery did get everything. I was distressed. I have often urged collectors not to overlook their children. It is vital to interest the next generation in collecting, and bequests of loved works of art can do exactly that. I have always thought museum directors should practice *enlightened* selfishness, not just selfishness.

Ailsa's generosity to the Gallery cannot be exaggerated. She gave many millions of dollars for purchases. The majority of the greatest acquisitions the Gallery has made with its own funds came from the immense resources she provided. For some of the paintings and sculpture she felt excited enthusiasm, for others personal indifference; but as long as I assured her that the works of art were needed, she urged me to go ahead.

When we bought Leonardo's portrait of Ginevra de' Benci, she would not allow her name to be mentioned. Because of speculation in the newspapers as to the picture's cost, she felt that to be identified as its donor would be ostentatious. After more than a year, however, she

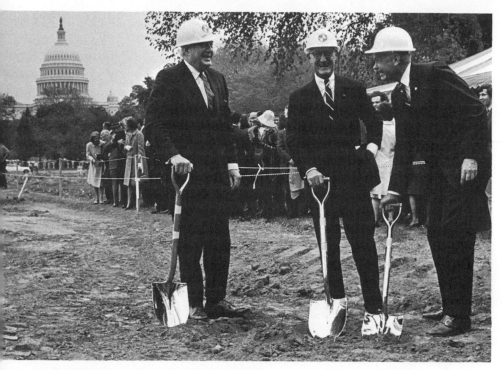

To fulfill a dream I needed the backing of both Mellons, especially Paul. Here the gallery's President, Paul Mellon, breaks ground for the new Center for Advanced Study, with Chief Justice Warren Burger, ex-officio Chairman of the Board of the National Gallery of Art, on his left, and Slater Davidson of the Charles H. Tompkins Construction Company on his right.

finally agreed to have her name on the label. Such reticence I have rarely found among museum benefactors.

Ailsa's support enheartened us all. But though her fervor for the Gallery and confidence in its administration were evident, when it came to important decisions, she depended very much on her brother's judgment. Therefore, to fulfill a dream I had held for many years, I needed the backing of both Mellons, especially Paul, the Gallery's president. It was really Berenson's dream, imparted to me thirty years earlier. He had said, when I was appointed chief curator, that he knew the new museum would have superb works of art, but he was less interested in them than in the thought that here was an opportunity to establish an institution the like of which had not been seen since the ancient library at Alexandria was burnt in 391 A.D. He wanted Washington to be a center of scholarship for our age such as Alexandria had been for Hellenistic times. He pointed out that the National Gallery could pro-

vide the same environment — a marvelous collection of works of art, a magnificent library adjacent, and a group of scholars to work in both.

I told Ailsa that I had discussed with her brother this concept of a great museum joined to a great center of scholarship, and that after giving the matter careful study, he had enthusiastically approved, and had urged me to try to gain her support. I said that I envisaged a building erected on a site reserved by Congress at her father's request, for an addition to the Gallery. It would contain, besides exhibition space and a large library, offices for scholars and their secretaries, and a common room and a dining room where they could meet. Such a Center for Advanced Study in the History of Art would offer scholars from universities and museums an opportunity to do uninterrupted research and writing without financial anxiety, and would also provide a chance for younger students, while doing their own work, to benefit from contacts with their more experienced colleagues. A knowledge of American collections, which are now so vast, I added, has become essential for European scholars, and the center I proposed would be a base from which they could travel to study the immense treasures of art in America.

She was delighted with the idea and offered immediately to give ten million dollars. It was her intention, she told me, to add further funds each year. This, alas, was not to be. Her prodigious gifts came abruptly to an end. Her sudden death was the severest blow the National Gallery will probably ever receive.

The Center for Advanced Studies is being built. Washington will one day become a great center for art historical scholarship. It is sad that Ailsa will never see this come about. But never to see the fruition of her plans seems to have been the pattern of her life. Hidden in the myth of the wicked fairy is a dreadful truth.

Ailsa's sudden death shocked her friends. They were never numerous for she formed friendships slowly, but to those of us fortunate enough to know her, to those few with whom she did not feel shy, her loss was a tragedy. It has left an emptiness which cannot be filled.

10

Collecting as a Business: Armand Hammer

My friendship with Armand Hammer came about accidentally. I knew him as a fellow trustee of the Los Angeles County Museum of Art, but I had seen him only once or twice. I had learned when I was in California that he had given two million dollars to the County Museum but that there had been a contretemps. The director had endorsed an exhibition of his collection with an understandable but unwarranted enthusiasm. Later, having appraised the pictures more justly, he had withdrawn his previous commendations. There was a problem of reprinting the original introduction for further exhibitions. The controversy reached its climax when the show was scheduled for Washington.

I had just retired from the National Gallery of Art, but while I was director I had never approached Armand Hammer for loans. I was told his collection was not distinguished. Nevertheless, when I heard that his paintings were to be shown in the Smithsonian Museum of Natural History I was surprised. The galleries there are obsolete, and I could not

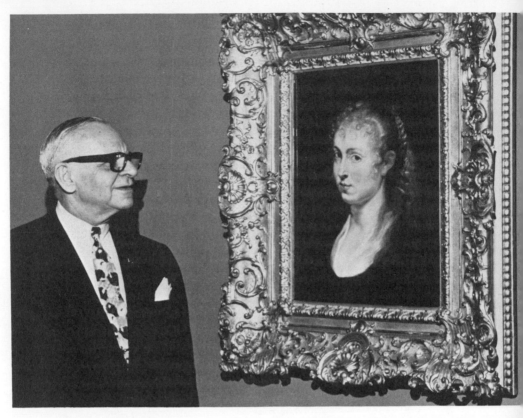

Armand Hammer, a rare collector who delights in the quest, not the ownership. Here he is looking at *Young Woman with Curly Hair*, by Rubens. (Courtesy of Armand Hammer)

imagine why he had agreed to exhibit his pictures in such an unfavorable environment. I was still, however, recovering from thirty years of pursuing private collectors, and I did not bother to go to the opening. I put Hammer and the collection out of my mind.

One day a close friend, Sir John Foster, who happened to be at the time Armand Hammer's English lawyer, was lunching with me. He asked whether I had seen the reviews in the Washington papers of the Hammer Collection. I said I had, and they were so derogatory I hadn't bothered to go to see the paintings themselves. He suggested we walk through the exhibition together on his way to his train.

As soon as I saw the show I realized that about half the pictures were mediocre, a few unauthentic, but a number of acceptable quality with a scattering of masterpieces. I very hastily sorted out the sheep and the goats for John, and he asked whether I would do the same for Armand

Hammer. I said I had spent thirty years trying to avoid having to tell private collectors about their poor judgment, and I wasn't going to begin now.

The next day Armand Hammer telephoned from New York and said he had spoken to John. He begged me to tell him which of his paintings I thought worthy of a good museum. I refused. Then Armand flew to Washington and repeated his plea, saying that, after all, the collection was destined for a museum, and that I could be of help to him and to its future recipients. I agreed reluctantly. I said I would write a serious report on the whole collection, which would take some time; and when he had read it, he was, of course, at liberty to take my advice or not, but I wanted him to know that I would probably recommend discarding at least half of what I had seen.

The report was finally finished, and he did accept my judgments, not 100 percent as he is fond of saying, but about 90 percent. When the collection was at last shown at the Los Angeles County Museum of Art in 1971, I had weeded out much of what I thought at my first inspection was mediocre, and Armand on my recommendation had acquired and added a number of extraordinary masterpieces.

Working with him was a great pleasure. I have known very few collectors as willing to recognize mistakes. With his brilliant mind he quickly grasped why he had erred. It was very simple. He had been a colossal bargain hunter! There is no better way to be an unsuccessful collector.

Armand Hammer himself proved to have a fascinating personality. I became absorbed in knowing all about him. From his own autobiography, published many years ago and long out of print, and from many conversations, I have been able to reconstruct something of his career. Of all the collectors in this book his life has been, in my opinion, the most astounding. For example, few young men can claim to have made a million dollars while earning a degree in college, and fewer still can claim to have made a fortune out of Communism. But Armand Hammer did both. His first million invested in the Soviet Union was the initial step toward his great wealth, later to be vastly augmented by his involvement in the Occidental Petroleum Company, of which he was president and is now chairman. His close contacts with Russian leaders, made while he was in his twenties, have remained, and they explain in part Occidental's recently signed contracts with the USSR, vast deals greatly envied by competing firms.

In 1923, when Armand was in Moscow, Trotsky asked how the

financial circles of the United States regarded Russia as a field for
investment. When his reply was hesitant, Trotsky advanced a startling
argument. He pointed out that since Russia had had its revolution,
capital was really safer there than elsewhere, because, of course, what-
ever should happen abroad, the Soviet Union would adhere to any
agreement it might make. "Suppose," he added, "one of your Americans
invests money in Russia, when the revolution comes in America, his
property will, of course, be nationalized, but his agreement with us will
hold good, and he will thus be in a much more favorable position than
the rest of his fellow capitalists." Armand Hammer may not have
agreed with Trotsky's reasoning, but he has made many profitable
investments in Russia. It is to Trotsky's colleague, Lenin, that he owes
the beginning of his real affluence. These two unlikely acquaintances
became warm friends — a bizarre friendship as I shall describe, which
resulted from a chance act of philanthropy, one of many in his unpre-
dictable and varied life.

A doctor of medicine, Armand Hammer is probably the richest
medical doctor in the world today. Although his wealth has had little to
do with his training as a physician, the story of his spectacular finan-
cial successes begins with medicine, with a pharmaceutical company in
New York. His father, who was brought to this country from Russia at
the age of one, was also a doctor, the type of physician who, when he
treated people too poor to pay, gave them money to buy medicine. The
family had once been rich, with great shipbuilding interests in Russia.
But when their wealth, invested in salt ponds on the shores of the
Caspian Sea, was wiped out by a tidal wave, they emigrated to America.
Now, two generations later, the family faced another liquidation prob-
lem. Armand Hammer's father had put all his savings into a company
manufacturing drugs. His partner, he felt, had not run the company
properly, and he decided to buy him out. This worsened the situation,
and as he could not sell his drugs, he faced bankruptcy. One day he
came to see Armand, who was studying medicine in Columbia Univer-
sity, and told him the family's small fortune was lost: a heart attack had
made him unable to continue to practice medicine and they were
destitute.

Armand saw that it was his duty to try to salvage something from the
company. He decided he would do what his father had done — work in
the daytime and study at night. By the time he had graduated from
medical school in 1921, the pharmaceutical business had grown so
successfully that at twenty-three Armand was worth more than a

million dollars. He sold his interests to his employees and determined to devote his life to medicine. Like his father, he was an idealist, and he believed that to be a doctor was a means of doing good for people.

He received an appointment as an intern in the Bellevue Hospital, but as it did not begin until the following year, and as he did not want to stay in business, he decided he would spend the intervening months in Russia, where typhus had broken out. In this way he hoped to be both helpful and at the same time to learn more about immunology, his special field of study, in which members of the Columbia faculty thought he had a brilliant future. Knowing that the Russians did not welcome foreigners, he decided to arrive with a desirable gift — an entire field hospital fully equipped.

To get a visa to enter the USSR in 1921 was a formidable task, but Armand Hammer is adept at surmounting difficulties. In a way which was to become characteristic, he managed to exert influence on the Soviet Foreign Office, and received a wire in record time: VISA GRANTED LITVINOV, which staggered the Soviet bureaucracy, who had expected him to wait in Berlin for months. But in Moscow he was less successful, and there were endless delays. He became ill in a hotel of indescribable squalor; and when he had almost decided that as it seemed impossible ever to operate his field hospital, he might as well return to America, an official in the Foreign Office offered him a place on a special train which was leaving for the Ural Mountains on an inspection trip. This, he realized, would give him an opportunity to investigate conditions in the famine area while his own plans materialized. He expected to be back in America within six months. He was to stay in Russia for nine years.

When his train arrived at its destination, what he saw staggered him. As he wrote in an autobiography published in 1936, "I had imagined that my professional training as a physician had steeled me against human suffering, but the first vision in Ekaterinburg . . . struck me cold with horror." One train, for example, which had started out carrying a thousand people, arrived with only two hundred alive. The unburied dead were everywhere. Disease and famine were ubiquitous, but so were tremendous factories and mines, stocks of platinum, mineral products, Ural emeralds, and semiprecious stones. In the shadow of these vast resources human beings were dying of starvation. Production had ceased and there seemed no way to provide food which would keep the population alive till new crops could be harvested.

Young Hammer decided that something must be done. He asked that

the local Soviet be assembled and he addressed the leaders in Russian, which he had been studying for some time. He said that he was prepared to buy a million bushels of wheat, which would feed the entire population of the Urals until next year's crops could be harvested. He proposed that each boat which he would load with grain in the United States should take back goods he could sell at home. Through this barter system there would be a continual replenishment of supplies. When he stopped talking there was wild applause, and in the babble of voices he could make out one Russian word everyone seemed to be shouting. He asked what it meant. He was told they were saying, "Translate!" His audience thought he was speaking English. When his speech had been translated he became at twenty-three the hero of the Urals.

News of his proposal reached Moscow, and when the special train returned, Hammer was requested to see Lenin at once. He found the ruler of the Soviet Union smaller than he expected, a stocky little man about five feet three with a large domed head and brown eyes. They spoke in English. Armand explained that he was still learning Russian, trying to master a hundred words a day, but that his experience in Ekaterinburg was a bit depressing. "I used the same method myself when I was in London," Lenin said. "Then I used to visit the library and read books to see how much I could remember. At first it is not so bad, but the more you learn, the more difficult it is to retain."

Their friendship was immediate and lasting. Lenin pointed out that Russia and America were complementary, that Russia was a backward land with immense resources and that what it lacked was American capital. He said, "We don't need doctors as much as we need businessmen, people who can do things such as you have done." He was eager to grant concessions, and he urged Dr. Hammer to take one at once. He offered every possible cooperation, and every promise he made was fulfilled. Even when mortally ill he said to Professor Foerster, his doctor, "Tell young Hammer I have not forgotten him and wish him well. If he has difficulties tell him to be sure and let me know."

On his trip to the Urals Armand Hammer had seen an asbestos mine, which an engineer on the train had said could easily be put in operation and would prove profitable. Though he knew nothing about mining, he made a quick decision and asked for an asbestos concession. It was granted immediately, but for once he told me he had miscalculated. After World War One the price of asbestos slumped badly, and it was several years before his concession began to show even a small profit.

But at the same time he wisely asked for a second concession, one for

foreign trade, so that his barter deal in grain could be developed into an import-export business. To his delight this too was granted, and he now knew that he was in a position to benefit the Russians and himself far more spectacularly than by mining asbestos. What was needed in the Soviet Union, he decided, was American machinery which would make possible the mechanization of agriculture. From his uncle, who had once been the agent for Ford in southern Russia, he received a letter introducing him to Henry Ford. On a return visit to the States, friendship was quickly established as it had been with Lenin. Much of Armand Hammer's success is due to a genius for such intimacy. It is one of his most remarkable characteristics.

The upshot of the visit to Henry Ford was that the young doctor never again thought of practicing medicine. Instead he took back to Moscow a number of models of the Ford car and the Ford tractor. He was now the agent for all Ford products in the Soviet Union. Orders for tractors poured in. During November 1922, the first Fordsons arrived, and Armand Hammer met them at Novorossisk and drove the whole fleet to Rostov, a distance of about one hundred miles. The excitement on the way was fantastic. The only limitation on sales was the availability of foreign currency. Other companies asked him to represent them — thirty-seven in all — such companies as Allis-Chalmers, U.S. Rubber, Underwood Typewriters, Parker Pen. Armand's younger brother, Victor, once said that in those days for a Russian to wear a large, red Parker pen in his jacket pocket was the equivalent of the Legion of Honor. When he finally began purchasing works of art from the Russian government he distributed his Legion of Honor lavishly.

For a time most of the trade between the United States and Russia passed through the Hammer Trading Company. Credit was no problem, for Armand was exporting as much as he was importing, and the currency of payment was dollars. He opened branches all over Russia, especially in fur-trading stations. But he even shipped caviar, the first sent from Russia since the revolution. For each product he was exporting he worked out a joint venture with the best company abroad. Thus he knew that in buying for export he was in the hands of experts. The business grew so big that he opened offices in London, Paris, and Berlin, as well as New York. Salesmanship was unnecessary. Demand always exceeded supply.

Armand Hammer rented a palatial house in Moscow, which had belonged to a textile king. It was unfurnished, and decorating his new residence gave him, he explained, his first interest in art. Victor, who

had come to Russia to help him, had studied the history of art at Princeton. He became Armand's tutor. Together they bought for a song everything which made the life of a Russian noble the most luxurious in Europe. Furniture, tapestries, silver, porcelains, furs, and jewels were then sold in commission stores in Moscow, where they were brought by the impoverished aristocracy. There were at the time so few foreigners in Moscow that except for some competition from the French and German ambassadors, the Hammer brothers had the field to themselves.

However, the success of private enterprise in a socialist state *is* precarious. One day the commissar in charge of the Foreign Trade Monopoly explained cordially but firmly that the Soviets had their own organizations for trade abroad, ARCOS and AMTORG, and that henceforth they would not share with foreigners an export-import monopoly. He added, however, that his government was not ungrateful for the contribution Armand Hammer had made at a critical time in the history of the Soviet Union and that he hoped he would find other and not less profitable fields of enterprise in Russia. He suggested choosing another concession.

Armand Hammer thought awhile. He wanted a concession with more immediate profits than asbestos. He asked the commissar whether the government did not intend to teach every single Russian to read and write. The reply was, "Of course, that is the major objective of the Soviet Union." "Then," Armand Hammer said, "I want the lead pencil concession." He had found an industry with a guaranteed future.

He had no idea how a lead pencil was made, but he had inquired and learned there was an immense shortage and that every pencil in the Soviet Union was being imported from Germany. Having decided what he wanted, he went to the Central Concessions Committee, and offered to pledge fifty thousand dollars that he could set up a pencil factory within twelve months of the signing of the concession and that he would do at least a million dollars worth of business in the first year. The Soviets had been trying unsuccessfully to manufacture pencils for some time and they thought him mad. However, in October 1925, the concession agreement was signed.

Armand was committed to produce pencils. All that remained was to learn how to make them. The process was a closely guarded secret known to only a few manufacturers, among whom the most important was the Faber family in Nuremberg. After a frustrating week trying to penetrate the Faber works, he became so discouraged that he would have abandoned his concession if he had been able to. When he was

most despondent he met a young, disgruntled engineer, an employee of Eberhard Faber, who was willing to help him enter the pencil fortress. Once inside, he found many of its closely guarded inmates encouragingly disloyal. Promising he would provide homes with gardens, schools for their children, all the amenities of German life including beer, he enticed a number to come with him to Russia. In England, in Birmingham, the center of the pen industry, he found much the same situation, and again induced many of the younger men to emigrate to the Soviet Union.

As soon as he got back to Moscow, he began to build his factory, install machinery, and create the village he had promised his workers. Six months later the first pencils were produced, half a year earlier than his agreement; and instead of a million dollars gross, which he had promised, in the first year he did two and a half million dollars worth of business. The retail price of pencils was reduced from fifty cents to five cents, and in a short time the factory was producing annually countless millions of pencils and pens. These Russia was exporting instead of importing. By the end of 1929 the pencil factory had become five factories and was manufacturing various metal articles, celluloid and allied products.

This was one of the most profitable business ventures of Armand Hammer's life. But the more money he earned the less he could take out. Currency had become a problem. It was evident that Stalin was hostile to foreign concessions. In America the Depression of 1930 had begun, and foreign financing had grown difficult, which hampered expansion. For these and other reasons, though the concession still had five years to run, Armand Hammer decided to sell out to the Russian government. A committee of four was formed to evaluate the property and a fair price decided on. He was reimbursed in dollars, partly in cash and the balance in notes spread over several years. These notes were all fully paid. One of the conditions of the contract, and in many ways the most important, was the right to take out of Russia all personal belongings, which included the treasures Victor had purchased.

Two years earlier the Hammer brothers had begun to deal in works of art. Their stock consisted of eighteenth-century furniture, tapestries, rugs, silver, service after service of Sèvres china and Meissen porcelain, jewels, especially the Easter eggs made by Fabergé of precious stones and exchanged by the aristocracy at Easter time, icons and church vestments.

They had also met a New York art dealer who had come to Moscow

on a visit. He was fascinated by the bargains the Hammers had found. For example, Victor on one occasion heard that all the vestments from the royal chapels in Leningrad were being disposed of. When he arrived to check up on the rumor, he found these priceless textiles piled in one room of a palace almost to the ceiling. As most were woven with threads of pure gold and silver, the officials in charge were about to burn them for the metal which would remain, just as so many of the earlier tapestries in France were burned for the same reason during the French Revolution. Victor asked the value of the gold and silver they expected to realize, and found that it was a comparatively small amount. He offered double and bought the whole lot. These textiles were then cut up and made into piano throws and table covers, which sold in America for large sums.

As their friend, the New York dealer, had been unsuccessful in doing business with the Soviet government, he was anxious to enter into partnership with the Hammer brothers, who were permitted to export works of art, after paying a tax, so long as the objects were not wanted by the Russian museums. Victor joined his firm, but only for a year. Heavy speculation in 1929 bankrupted their partner and Armand bought him out and put Victor in charge of a new company, the Hammer Galleries. Stocking the new gallery was no problem. When the Hammer brothers were ready to leave Russia their rubles had been converted into several warehouses full of art, and these "household effects and other treasures" left with them.

Armand's nine-year sojourn in Russia was over. But he continued to make his faith in the Soviet Union pay dividends. In 1930 he went to Paris to live, and then decided to go into the private banking business discounting Russian notes. These three-year notes could be bought at a discount of 72 percent off from face value. Yet at the end of three years they were paid in full. Skepticism about Soviet finances caused several well-known American businessmen to present him with handsome profits, one of the few ways of making money in the Depression.

His contacts with Russia continued, and many years later President Kennedy, knowing his intimacy with the Soviet leaders, asked him to revisit Moscow and see if he could improve trade relations. Realizing that he would have to brush up on his Russian, he went to several Russian movies and found that he could again speak fluently.

The embassy in Moscow had a list of people for him to meet, but he recognized that they were too far down the hierarchy to be of any use.

He said instead he wanted to see only Khrushchev or Mikoyan. He was told they were not receiving anyone from America. Mikoyan had once been a friend, and so Armand explained to the acting ambassador that he would write his old acquaintance a personal note. Within an hour there was a car waiting to take him to the Kremlin. He spent a long time with Mikoyan reminiscing about their early days together. Finally the commissar put his arm around him and said, "Just think, we were both young men when you came to Russia and we are now old men." As secretary of the Southeast Communist party stationed at Rostov, Mikoyan had been Armand's first customer when he arrived with his fleet of Fordson tractors. Their pictures were taken together when the tractors were plowing up a public park in Rostov, and when he was showing the Soviet engineers how the tractors worked, how they could be used to saw wood, pump water, as well as plow the fields.

The next day the acting United States ambassador excitedly told Dr. Hammer that Khrushchev had phoned and wanted to see him. They had a two-and-a-half-hour conversation together. He asked Khrushchev, "What is the one most important thing that would improve relations between our two countries?" The answer was surprising. Khrushchev said, "It is the small things that irritate us. Take crabmeat. You will not allow us to send you Russian crabmeat because you claim we prepare it with slave labor. Your government knows that since Stalin died there have been no slave labor camps in Russia. I have abolished them — your intelligence department knows that. The Japanese are catching crabs right next to where we are. They know we don't employ slave labor. Besides, we eat that crabmeat ourselves. We have our own canning factories. It is made with care."

When Armand Hammer returned, he reported to the Secretary of Commerce, Luther Hodges, his conversation. The information was passed on to President Kennedy, who asked, "Is it true that our Intelligence knows there is no slave labor?" The answer was affirmative. The President said, "Take off the ban on crabmeat immediately." The Russians were immensely pleased and Armand received a number of presents from Khrushchev: magnificent examples of Russian handcraft, paintings by Russian artists, a transcript of conversations with the cosmonauts, caviar, vodka, and similar gifts.

He returned to Russia a few months later and saw Khrushchev again. Armand was by then president of Occidental Petroleum. This was the most spectacular of all his business enterprises, and to understand his

subsequent Russian deals, something should be said about the company
he created. His involvement in oil came late in life, and like his other
ventures was somewhat fortuitous. He had retired and was living rest-
lessly in Los Angeles. An acquaintance came to see him one day and
told him of a small oil company which needed a loan of fifty thousand
dollars to avoid bankruptcy. Its principal assets were two drillable oil
leases which looked interesting. The stock had fallen from fourteen
dollars a share to eighteen cents, and for less than one hundred thou-
sand dollars it would have been possible to purchase all the shares in
the hands of the public. Armand agreed to speculate and to put up
enough money to drill two wells. Both hit oil and the stock jumped to
over a dollar and a half a share. He bought more and more stock and
pushed for further explorations. Other fields came in and he became the
largest stockholder and president of the company. He diversified: oil
tankers, chemical plants, construction companies, coal — Occidental is
now the third largest coal company in the United States. The most
profitable single development was thought to be the oil concession in
Libya, which Armand Hammer negotiated with two governments, the
old monarchy and the young revolutionaries. But Libyan nationalism
has made Occidental's position vulnerable, and the stock having once
reached sixty dollars a share has declined to about ten dollars.

But Occidental Petroleum was also in the fertilizer business, and
Russian agriculture was badly in need of fertilizers. Khrushchev offered
Armand a deal. He said, "I want to give you an order for one billion
dollars to build fertilizer plants in Russia." Mikoyan was there and
remarked, "You heard the boss. You've got the order." Unfortunately,
by the time Armand Hammer had arranged the credit in England with
a consortium of British manufacturers, Khrushchev was out. It was
distressing. The whole project immediately fell apart. Had it gone
through, the profit for the consortium, Armand Hammer estimated,
would have been over one hundred million dollars.

This, however, was only the prologue to a dazzling series of contracts
and arrangements made more recently with the Soviet Union. In 1972
the deputy chairman for science and technology presented Armand
with the draft of a trade agreement. It was written in Russian. Hammer
read it through and in his words, "It sounded fine to me. I took out my
pen . . . crossed out the word 'Draft,' and I signed it. I handed it back
to Mr. Gvishiani and he was taken aback and said 'Don't you want to
show it to your lawyer?' I said, we don't have to show it to my lawyer. I

read it. It is satisfactory. . . . I handed him the pen to sign. He hesitated for a few minutes; he had a little quick consultation with his men, and he came back and he said, 'All right, we will sign it. You haven't changed a word.' "

The deal involved $40 million for nickel finishing for cars; $200 million for fertilizers in exchange for $200 million of ammonia and urea; a trade center to cost $110 million; and largest of all, a scheme to purchase Russian liquified natural gas over a period of twenty-five years which may reach a figure of $10 billion.

But to return to my main interest in Armand Hammer, his adventures as a collector and dealer — he found in 1930 that the Depression was ruining the Hammer Galleries. When the stock market collapsed, the art market disintegrated. With much of his fortune tied up in Russian art, which seemed impossible to sell, a great deal of his capital was frozen tight. As his brothers in New York despairingly pointed out, their Fabergé Easter eggs were beautiful but not edible. They begged Armand to return from Paris. They needed his genius to prevent a third family disaster.

People were selling apples on every street corner, and Victor had nightmares of himself selling icons the same way. But not Armand. Undismayed, he decided that something spectacular was needed to move his stock. He wrote a dozen of the leading department stores in various cities asking for an entire floor to exhibit his unique collection of what he claimed to be the greatest works of art ever to leave Russia. He offered a share of the profits. Only one favorable reply was received, a wire saying COME IMMEDIATELY from the Scruggs Vandervoort department store in St. Louis.

He and Victor quickly set out to find containers in which to pack their collection. They discovered that a bankrupt theatrical troupe had sold all their trunks to a dealer on Sixth Avenue. They bought a dozen of these huge receptacles, took them back, and packed them with their works of art. They then took a train to St. Louis, checking the trunks in the baggage compartment.

Armand had photographs of all his treasures, and he asked the head of the department store to arrange for him to meet members of the press the next day. He went to each newspaper with his collection of photographs, his stories about his adventures in Russia, and the history of the works of art, which he stressed were closely associated with the royal family. The title of his autobiography, which he was to write in con-

nection with these sales, was *The Quest of the Romanoff Treasure*, and this was the theme that he stressed in his talk with reporters. He made the Hammer Collection news.

He and Victor beautifully installed the works of art in the department store, working day and night, and the next morning all the St. Louis newspapers carried photographs with the caption "Million-dollar art collection goes on exhibition and sale today." When the exhibition opened there were a thousand people waiting to get in. The police were called to keep them in line. The sale was so successful that before the day was over Armand had to phone another brother in New York to go back and buy more trunks and come with them on the night train.

Marshall Field and Company heard about what was happening in St. Louis and sent a vice president to persuade the Hammers to have their next exhibition at their store in Chicago. That was an even greater triumph. Armand Hammer was asked to lecture, and every afternoon he told his experiences in Russia in assembling his collection. The exhibition was supposed to last three weeks. It lasted three years.

The success of the Hammer brothers was so spectacular that they decided to add a traveling exhibition. For this they needed publicity, and fortunately Victor had made a useful friend many years before. One day when he was looking for purchases in the basement of the Winter Palace in Leningrad he saw two men arguing, one speaking Russian, the other English. They were obviously at an impasse and he went over to see if he could be of assistance. The English speaker asked whether he understood "this god-damned language." Victor said he did and immediately started to interpret. The man was Carl Bickel, president of the United Press. He was so grateful, that he said to call on him any time Victor needed help. Help the Hammers now needed, and Bickel fulfilled his promise. He gave them a letter to his Western representative, Charles McCabe, and through him they received so much national publicity that every department store in the United States wanted their exhibition. With two shows going simultaneously, their routine was to stay two weeks in one place, and Saturday evening to pack what was unsold. Then the trucks would travel all night; Sunday they would unpack, Monday they would have a preview, and Tuesday they were in business again. After exhibitions in the principal cities of the United States, they wound up at Lord and Taylor's in New York, where they had their greatest triumph of all.

In the midst of the Depression Armand Hammer had sold art worth many millions of dollars. Liquidity proceeded so rapidly that Victor

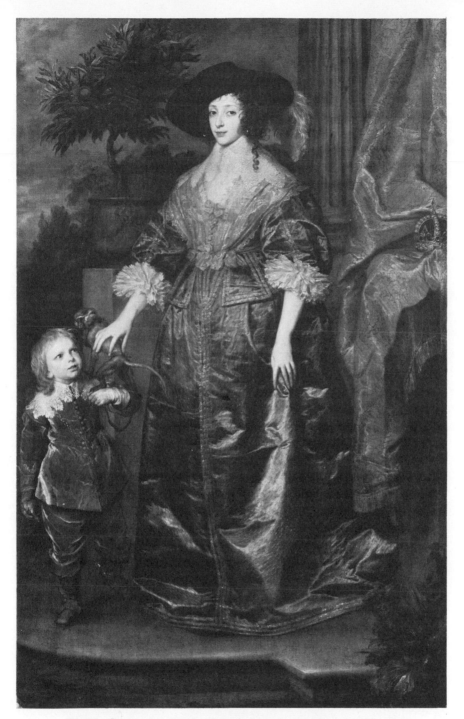

Sir Anthony van Dyck, *Queen Henrietta Maria with Her
Dwarf*, Flemish, 16th Century. Bought by Hearst in the
twenties for $375,000; sold by the Hammers in 1941 for
$124,998; bought by the Kress Foundation in 1952 for
$82,500; today worth? National Gallery of Art, Samuel H.
Kress Collection.

had to return to Russia for more stock. Armand had created a market which was exhausted only when he ran out of material to sell. These Russian works of art might be said to constitute the first Hammer Collection, but it has been entirely dispersed. It existed only to convert rubles into dollars.

I once asked Victor whether he had encountered any anti-Communist feeling on his tour, or whether Russian emigrés had presented difficulties. No, he assured me, the only protest came from a group of Orthodox Russians in California who objected to church vestments, which they considered sacred, being cut up and made into table covers. Clients of the Hammer Galleries, important collectors like Mrs. Marjorie Post, who had been married to our ambassador to Moscow, Joseph Davies, did not hesitate to buy treasures which they knew had been largely confiscated. But bitterness did exist among the exiles, as I learned from a descendant of the Romanoffs. With them the Hammer brothers were far from popular.

Charles McCabe, by then the publisher of the *Daily Mirror*, was so impressed by what he had seen the Hammers accomplish that he urged Armand to come to the rescue of another collector, his employer, William Randolph Hearst. He said the banks were about to foreclose on all the Hearst papers. The only assets his business associates thought were liquid were the works of art, but they had been bitterly disappointed. After two years the Hearst International Studio Corporation, which they had organized, had grossed only three hundred thousand dollars. This did not even cover corporate expenses.

In their desperation, the executives of the Hearst company were only too happy to turn to the Hammer brothers, and after brief negotiations an agreement was signed, giving the Hammer Galleries a 10 percent commission. Armand went at once to see an old friend, Beardsly Ruml, chairman of the board of Macy's. Never one to undervalue his projects, Armand began by saying, "I think I have the greatest merchandising promotion any department store ever had — the sale of a fifty-million-dollar art collection in a department store. Nothing like this has ever been attempted before."

This statement was no exaggeration. The catalogue of the Hearst Collection when finally printed ran to 334 pages. The list of arms and armor, for example, takes up nine pages of small print in two columns and contains everything from arquebuses to war hammers. There were tapestries, paintings, sculpture, furniture, stained glass, gold and silver services, pottery, china, and glassware, even lighting fixtures and

wearing apparel from the Middle Ages on. There were also mysterious objects like two "Chopes," one dated 1666, as well as several "Schnelles" and one "Krug," all of the sixteenth century. There were whole rooms, such as a Venetian frescoed council chamber of the sixteenth century, French boiserie from the fifteenth to the eighteenth centuries, and Gothic, Jacobean, and Georgian interiors. There was the famous twelfth-century Cistercian Monastery from Spain in 10,500 packing cases, each stone wrapped in straw, which the United States Customs insisted had to be unpacked and rewrapped because of the possibility that the straw might carry hoof and mouth disease. In this connection, as an example of the Hammers' salesmanship, they eventually managed to place the monastery with an undertaker, to be used as a funeral parlor, only to have Hearst refuse to accept the sale. It was finally re-erected in Miami and is once more occupied by monks. But recently it was just saved from the bulldozer by a devout Catholic who contributed $400,000 for its preservation.

The monastery was probably the bulkiest single item, but the whole collection filled a number of warehouses. Ruml was staggered by the magnitude of what the Hammers were offering and arranged at once for a meeting with his partners. After considerable legal maneuvering, a contract was tentatively drawn up in which Macy's insisted on the right to approve the selling price on each article. When Armand Hammer realized the department store officials had no idea of values and had priced a pair of Hawthorne vases, which Victor valued at nine thousand dollars, at twenty-nine dollars, he withdrew his offer.

Meanwhile, Fred Gimbel, who had heard of the proposed deal with Macy's, came to see Armand and suggested the sale be held at Gimbel's instead. He agreed to let Victor decide on values and to give the Hammers complete control. He offered a whole floor of his department store, the size of a city block, and one hundred thousand dollars for expenses. The Hammers proposed that experts from Hollywood be brought to New York to dramatize the installation and that Gimbel's advertise for former museum curators to act as salesmen. At this juncture, Armand told me he suddenly realized that he might have made an appalling mistake. He said to Fred Gimbel, "You know everybody talks about Gimbel's basement, and I know exactly what the Hearst people are going to say. 'My God, Macy's was bad enough, but Gimbel's basement! What the devil is going to happen to the great Hearst art collection if it winds up in Gimbel's basement?' But," he added, "you own Saks. Why don't we combine Saks Fifth Avenue and Gimbel's?" Fred Gimbel re-

plied that there was no room at Saks. Armand's solution was to have the major part of the sale at Gimbel's and a small but very distinguished collection at Saks. There was a further difficulty. Gimbel's did not advertise that it owned Saks, and this would be the first time the two names would be linked together. Armand insisted that the linkup would increase the prestige of Gimbel's, and Fred Gimbel agreed to try to sell the idea to his brother, Bernard, and to Robert Lehman, a director of Gimbel's. Lehman, an art collector himself, knew the Hearst collection and thought it was a splendid opportunity, and Bernard Gimbel went along.

The only room available at Saks was on the floor where dresses were sold, and Armand had to settle for a small space beside the elevator where he could install a few of the finest objects with a sign saying that the rest of the collection could be seen on the fifth floor at Gimbel's. One hundred thousand customers with charge accounts at Saks were invited to a formal opening and twenty thousand accepted. The first day the Hammers sold five hundred thousand dollars worth of works of art. Within a few months they had sold enough to pay off eleven million dollars in Hearst bank loans, and they would have liquidated the whole collection had Hearst not decided to stop the sales. From then on the Hammers were besieged by executors of estates asking their help.

The prices the Hammer Galleries received for some items are revealing. There was a Childe Hassam entitled *Le Crepuscule* which they could not sell in 1941 for $675. It recently brought $150,000. On the other hand, a picture now in the National Gallery of Art, *Queen Henrietta Maria with Her Dwarf*, by van Dyck, was bought by Hearst for $375,000 and sold by the Hammers for $124,998. In 1952 the Kress Foundation bought the same picture from Knoedler's for $82,500. Its present value would probably be once more about what Hearst paid originally. Thus the price of an acknowledged masterpiece by an artist no longer in vogue has fluctuated widely over the years but has risen scarcely at all; whereas a work by a minor American painter now much in fashion has appreciated staggeringly. To buy for profit, the lesson is, choose whatever will become the mode. Art dealers have a saying that if you can't sell a fashionable item, mark it up — but I might add, if you buy it, realize your profit quickly.

Armand Hammer had an office at Gimbel's, and one day Fred Gimbel said to him, "I am going to give you a tip. American Distilling Company stock is a good thing." The war was on, and whiskey was very scarce. It was difficult for Gimbel's to supply their own retail

department. But American Distillers had announced that each share-holder would receive one barrel of whiskey as a dividend for each share of stock. Fred Gimbel explained that his store could not purchase the stock because under the law a retailer cannot own any part of a distillery. But if Armand Hammer went into the whiskey business, Gimbel's would be his distributor.

He quickly bought 5,500 shares and put them in one of his small companies, called Hammer Cooperage. This was a manufacturer of wooden barrels and barrel staves, which were imported from Russia when white-oak staves were unprocurable in America. As most of the companies manufacturing beer barrels had been bankrupt by Prohibition, he had for a short time a monopoly and large profits. Hammer Cooperage, in a few months after the dividend was received, bottled, labeled, and sold most profitably 2,500 of the 5,500 barrels of whiskey Armand Hammer owned. It looked as though his entire stock would soon be exhausted. This time what he had bought was all too liquid.

In his life the right person has always turned up at the opportune moment. One day a chemist whom he had befriended in Russia came to see him, and they discussed the liquor business. Armand Hammer explained his problem: rapidly diminishing supply, and because of the embargo on grain, no foreseeable replenishment. The chemist said, "You can take whiskey and stretch it with alcohol made out of potatoes."

The chemist and Armand Hammer left at once for Maine, where surplus potatoes purchased by the government to aid the farmers were rotting in warehouses. They found an abandoned rum distillery in New Hampshire, near the Maine border, which could be bought from the Reconstruction Finance Corporation and could easily be converted into an alcohol distillery. The War Production Board in Washington quickly approved the project, since the disposal of the rotting potatoes was becoming a political scandal. The law permitted 80 percent alcohol and 20 percent straight whiskey to be called *blended* whiskey. Thus, overnight, instead of three thousand barrels of straight whiskey, Armand Hammer had fifteen thousand barrels of blended whiskey. It was perfectly potable. In those parched days blended bourbon, whether or not the alcohol was made from grain, was a godsend.

There was, however, a hitch. The government made Armand put on his label what went into his whiskey, and people had an inexplicable aversion to anything called "potato alcohol." He went to Washington, saw the appropriate officials, and asked for a dispensation from using the word "potato." The government was adamant. He pointed out that

"grain alcohol" was an acceptable term and that it was made from a mixture of several grains which were not specified. Why couldn't he call his alcohol "vegetable alcohol," which would seem less unpalatable? The government's position was that as he only used potatoes the designation "potato alcohol" would have to stand. Supposing, Armand said, his alcohol were made of several vegetables, would the term "vegetable alcohol" be permitted? The answer was yes, and Armand was delighted. Thereafter a bushel of carrots was always added to every carload of potatoes.

In the thirsty days of the war his whiskey, in spite of its vegetable alcohol, sold magnificently. Armand Hammer had a surplus of alcohol, and he would say to another distiller, "I'll give you three barrels of vegetable alcohol, if you'll give me one barrel of aged whiskey." Whiskey had to be at least four years old to be sold under that designation, and he hadn't been in business four years. Thus, bartering his potato spirits for aged whiskey, he was able to keep replenishing his stock.

Then one day the government declared a grain holiday, and gave the distillers a right to go back and produce grain alcohol. When this was available no one would touch "vegetable alcohol." Armand Hammer had a warehouse piled to the roof with potatoes and no customers, but he went ahead and kept on piling up the alcohol in inventory. Luckily for him, at the end of the month the holiday was over and restrictions were reimposed. Potato alcohol was once more in demand, but he had learned his lesson. To stay in business he would have to own some grain distilleries. He then bought J. W. Dant and several other companies in Kentucky. But it was a nerve-racking business, and he was delighted to sell his whiskey empire to Schenley Distilleries.

Meanwhile his involvement in the Hammer Galleries continued. But here he was confronted with the same problem of replenishment of stock. It was impossible to import works of art from Russia, as they had done originally. Therefore a change in the character of the galleries was imperative, and Armand and his brother decided to focus on Impressionism. This was a significant departure. Previously the only pictures they had sold were anecdotal paintings and icons brought from Russia.

At the beginning of their career as collectors they had tried buying Old Masters, but they had had an unfortunate experience. In Moscow they had purchased a painting attributed to Rembrandt for the modest sum of twenty-five thousand dollars. It was recommended to them by a leading Russian restorer from the Hermitage Gallery. Armand, how-

ever, was suspicious and decided he wanted the authenticity confirmed by the best available expert. Victor therefore took the Rembrandt to Friedländer, the director of the Kaiser Friedrich Museum in Berlin. At first Friedländer seemed favorably impressed, but he asked his assistant to test the pigment with a weak solution of acetone. It dissolved at once, which proved that the paint had been recently applied. The Rembrandt was a forgery.

When the Hammer brothers confronted the restorer with Friedländer's opinion, he confessed. He admitted that the picture had been painted by a friend, the director of an important museum in Moscow, who had swindled a number of well-known collectors and museums. Armand threatened, unless his money was returned, to denounce them both to the Soviet authorities. Facing a cold, Siberian future, they readily agreed to give back all they could. It turned out, however, that the forger's wife was a professional pianist, and he had spent part of the money buying her a piano. Consequently he was somewhat short of rubles. Delighted to get most of his money back, Armand gladly donated the piano to the musical wife and expressed the hope that concerts instead of forgeries would provide the family income.

Their unsatisfactory experience with the Old Masters made the Hammer Brothers cautious. They restricted their purchases to minor works by seventeenth-century Dutch painters. Victor took particular delight in watching these blackened panels being cleaned. They became attached to such pictures, the staple of Russian collecting, and they never offered them for sale.

Thus, because of their misadventure with their only important painting, they hesitated to participate in the greatest of all art deals, the sale of pictures from the Hermitage Gallery in Leningrad. Victor realized that with his lack of knowledge it would be folly to commit vast sums for works of art he was too inexperienced to appraise, and Armand's connoisseurship at the time was nonexistent. Moreover, the Russians wanted to receive dollars, whereas the Hammer brothers wanted to convert rubles. For these reasons the purchase of major paintings was for them difficult or impossible.

But Armand and Victor were aware, probably before anyone else, that the Hermitage paintings were for sale. In the winter of 1928 they received a cable from their brother Harry in New York saying that a syndicate of American dealers knew the Soviet Union needed money and that they were interested in buying pictures from the Hermitage. They offered a 10 percent commission on whatever they acquired, and

they asked the Hammers to find out whether anything could be bought.

With this telegram in hand, which they surmised the Soviet officials had already read, they went to see the head of *Antiquariat*, the organization in charge of the sale of all works of art. The director, a man named Shapiro, was enraged at the mere thought of such a proposal. "What!" he said to Victor. "Sell treasures from our great Hermitage — ridiculous!" But he added after a long, well-timed pause, "If your friends in America want to make offers we are obligated to submit them to the proper authorities, and then whatever happens, happens."

The Hammers cabled America and two days later received a reply listing forty masterpieces which included works by Leonardo da Vinci, Raphael, van Eyck, Rubens, and other supremely great artists. For these forty pictures they offered a flat sum of five million dollars. This, as Victor has said, was like offering ten dollars for a Rembrandt. Nevertheless he and his brother went back with the cable. The commissar reacted furiously, "What do they think we are? Children? Don't they realize we know what is being sold in Paris, London, and New York? If they want to deal with us seriously, let them make serious offers." He banged his hand on the catalogue of the Hermitage and pointed to the Benois Madonna by Leonardo and said, "This picture alone is worth five million gold rubles [$2,600,000]."

Then the Hammer brothers realized that, in spite of his first protestations of outrage, the Hermitage paintings were really for sale. They cabled New York accordingly and received a reply signed by Max Steuer, a New York lawyer they knew, saying, CONCRETE OFFER ON LEONARDO DA VINCI $2,000,000. IF OFFER ACCEPTED WILL ARRANGE IRREVOCABLE LETTER OF CREDIT AND ASK BERNARD BERENSON TO GO TO LENINGRAD TO SEAL UP PICTURE.

Now the Hammers had a definite offer within range of the asking price, and they were already beginning to spend their 10 percent. Armand went at once to Mikoyan, who was a close friend. He was well received, and Mikoyan said, "We are serious. We do need money." And then he jokingly added, "Of course one day you'll have a revolution in your country, and we'll take the picture back, so we're really only lending it to you!" But as regards the price, he did not joke. He repeated the offer, five million gold rubles, and nothing less. In 1913, if Duveen can be relied on, the czar had paid $1,500,000 for the picture, and so a price of $2,600,000 was not unreasonable. The Hammers spent hundreds of dollars cabling back and forth to New York, but Steuer would not come up and the Soviets would not come down. Victor even re-

turned to America to see what he could do, but the trip was a failure. The Hammers never knew who was behind the offer, but since Berenson was involved, they surmised that it was Duveen.

When this deal fell through, Armand decided that, even assuming the best possible expertise were available, his capital in foreign currency was not great enough to compete for sales from the Hermitage Gallery with Calouste Gulbenkian and Andrew Mellon, who began buying a year or two later. This was thirty years before he was to develop the Occidental Petroleum Company, when the situation might have been different.

Armand's holdings in Occidental Petroleum made possible the third Hammer Collection, for there was a second Hammer Collection of minor Old Masters, mostly the Dutch paintings from Russia, to which I have referred. This he gave in 1965 to the University of Southern California. Although it does not contain any masterpieces, it is useful for study purposes in a university museum. But subsequently he began a more ambitious collection with a particular emphasis on the Barbizon painters, the Impressionists and the Post-Impressionists. These were the pictures I saw at the Smithsonian Institution in 1970.

The most important works exhibited had been bought by the Los Angeles County Museum of Art with funds provided by Armand: two splendid seventeenth-century panels, Rembrandt's *Portrait of a Man of the Raman Family* and Rubens' *Israelites Gathering Manna in the Desert*, and one painting of the School of Paris, Modigliani's *Woman of the People*. But there were also a number of excellent paintings from Hammer's own collection: another Rubens of a young woman, a few fine Corots and Fantin-Latours, and numerous Vuillards. But these were exceptions, and his great purchases were all made after 1970. He then acquired several of the finest canvases sold by Norton Simon, among them van Gogh's *Hospital at Saint-Rémy*, Pissarro's *Boulevard Montmartre*, and Bonnard's *Nude Against the Light*. Victor also began searching out really distinguished paintings for his brother. On his advice and mine Armand bought one of the most beautiful Monets painted on the Riviera, the *View of Bordighera* from the Hersloff Collection, and two superb works, *King David* and *Salome* by Gustave Moreau, an artist just coming into his own.

He also acquired during those two years I was advising him a series of masterpieces of American painting. The first of these, Thomas Eakins' portrait of Cardinal Martinelli, represented the only conflict of interest I have ever had. It belonged to Catholic University, of which I

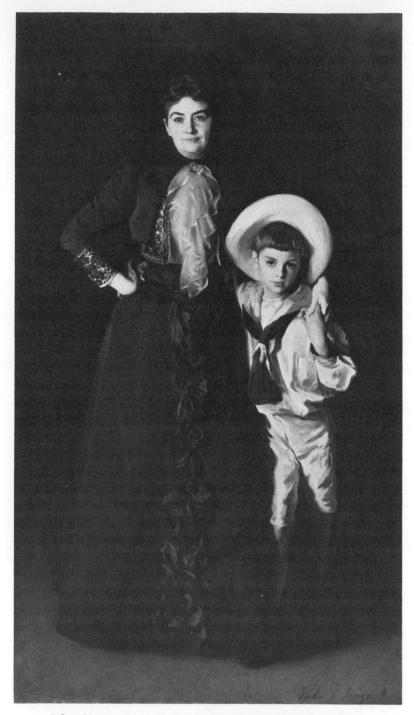

John Singer Sargent, *Portrait of Mrs. Edward L. Davis and Her Son, Livingston Davis.* In Sargent's day American society had learned to look fashionable but usually failed to look chic. Los Angeles County Museum of Art, Frances and Armand Hammer Purchase Fund.

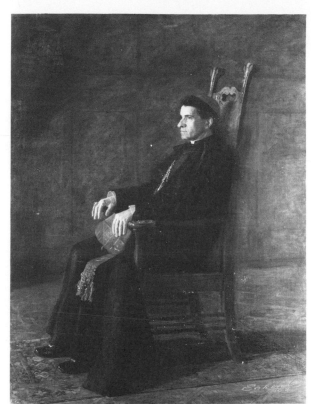

Thomas Eakins, *Portrait of His Eminence Sebastiano Cardinal Martinelli*. Purchased by Armand Hammer from Catholic University — the only conflict of interest I ever had! (Courtesy of Armand Hammer)

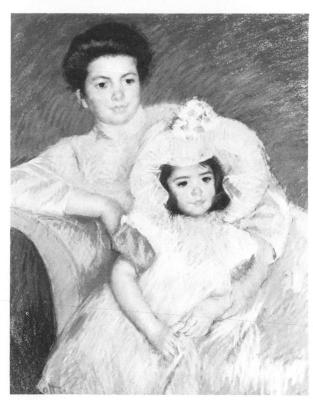

Mary Cassatt, *Madame Lefebvre and Margot*. A superb Cassatt, her most brilliant pastel done after 1900. (Courtesy of Armand Hammer)

was a trustee. For financial reasons the picture had to be sold, and I recommended auctioning it at Parke-Bernet. A reserve of $125,000 was suggested, and on my advice this was raised to $150,000 just before the bidding began. A reserve, for those unfamiliar with auctions, is the lowest amount acceptable to the seller, and naturally this is a figure of the utmost secrecy. Our expectations were that the portrait would certainly bring more than $250,000. I was told after the auction by a dealer in American paintings that a ring had been formed and that this consortium had a spy who had leaked to them the amount of the earlier reserve. They thought by keeping others out, and by bidding the exact amount of the reserve, the usual stratagem, they would get the portrait. Their spy did not know that at the last minute the reserve had been changed and they were stunned when after their bid of $125,000 the painting was withdrawn.

As soon as I had this information, just before leaving for Europe, I wrote the treasurer of Catholic University and said to take the picture back immediately, for I had been assured by the same dealer that he would guarantee a price of over $200,000, and probably he would get $250,000 or more. When I returned to America I found that Armand, whom I had urged to bid on the picture in the first place, had offered Catholic University $150,000, the final reserve figure, and it had been accepted contrary to my advice. I was pleased that Armand had bought what one critic refers to as "the most powerful portrait of its kind ever painted in America," but I still lament the folly of Catholic University, for which I somehow feel responsible.

I recommended the purchase of many of his other American paintings, but fortunately without the distress of a personal involvement. They form an impressive group. His Harnett *Still Life* is one of the few pictures from this country ever shown in the Members Exhibition of the Royal Academy in London; his Prendergast *On the Beach* was considered by the artist one of his greatest masterpieces; his two Cassatts are superb, one, *Summertime*, a rare landscape, and the other, *Madame Lefèbvre and Margot*, the most brilliant pastel done after 1900; and his two early Sargent portraits, the highly dramatic *Dr. Pozzi* and the double portrait of *Mrs. Edward Davis and Her Son* are among that painter's finest works. The latter, which was bought with Armand's funds for the Los Angeles County Museum of Art, is especially telling, revealing as it does the essence of upper-class America, a society that has learned to be fashionable without learning to be chic.

For a museum, the Hammer collection of drawings is the most

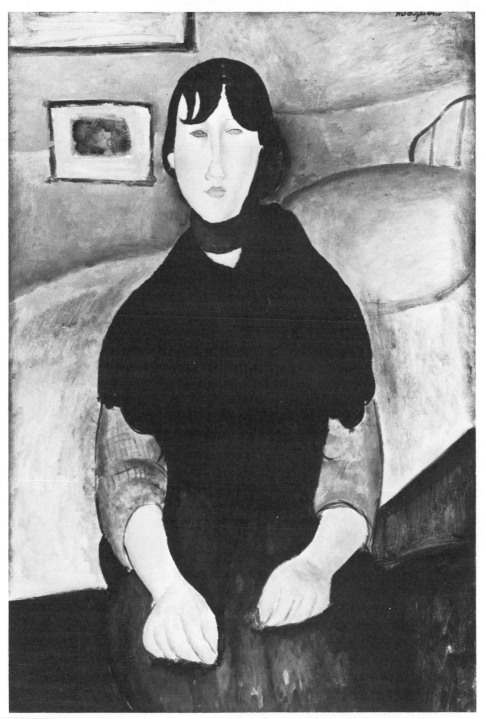

Amedeo Modigliani, *Young Woman of the People*. A copy of this painting done by Mrs. Hammer is the principal decoration of their living room. Los Angeles County Museum of Art, gift of Dr. and Mrs. Hammer.

desirable still in private possession. In this section the curators of the National Gallery of Art have been most helpful, though it was I who encouraged his first important purchases, principally from the Irma N. Straus Collection, at whose sale Armand bought the exquisite Watteau *Couple Seated on a Bank*, a series of glorious Fragonards, and the superb Ingres of Mrs. Badham; and later, from the Goldschmidt Collection, one of Daumier's masterpieces, *The Pleading Lawyer*. But this was only the beginning. He afterwards added drawings by Dürer, Leonardo, Correggio, Raphael, Rembrandt and others.

When Armand entreated me to weed out the mistakes in his collection and to advise him on further purchases I was, as I said, dubious. Before making up my mind I thought I would ask him why he collected, for I was puzzled by what I considered a lack of discrimination, an insensitivity to quality, which might make my task impossible. His answer, sincere and simple, delighted me. "Because it's fun!" he explained. "It's a hunt. I get a certain joy out of finding rare works, out of learning the stories attached to them. I've always liked to collect. I used to collect stamps. My father had a great stamp collection. But pictures are something more than just collecting. You are connecting yourself with something that really is immortal, something that has survived all these centuries. You are preserving something for posterity." With such an answer I could not help but wish to be of assistance.

Armand has given up bargain hunting, and his real joy is in the excitement of negotiating for great works of art. In today's tight market his purchases in the two years, between 1970 and 1972, when I was his advisor were as thrilling as those of Rush Kress a decade earlier. Improving his collection has cost him a great deal of money but, distilled and richly supplemented by these acquisitions, it has been shown with outstanding success at the Royal Academy in London, the National Gallery in Dublin, the Hermitage in Leningrad, and the Museum of Western Art in Moscow. Doubtless it will travel farther, for Armand wishes his paintings and drawings to be seen as widely as possible.

As I came to know him better I realized that he was different from most collectors I had collected. For his delight is in acquisition, not possession, in the quest, not the ownership. Unlike the houses and apartments of other collectors, his home contains no significant works of art. He is satisfied to have the principal decoration of his living room in his modest Los Angeles house a copy by his wife of the Modigliani he gave the Los Angeles County Museum of Art. He is like a fisherman who throws back everything he catches, and museums are the lucky

recipients. For instance, the last picture about which he asked my advice was a magnificent Goya, which he gave the Hermitage Gallery in Leningrad, because the Russians had no example of the work of this revolutionary artist. He has stated that it is his intention to leave all his paintings to the Los Angeles County Museum of Art and his drawings to the National Gallery of Art. With my deep interest in both institutions, nothing could delight me more. I like to think I helped him reach this decision.

After two years, however, I decided he no longer needed my advice, for his collection had begun to rank with the most important in the country. Moreover, he had started to curtail his own private collecting, and had further complicated his position as an amateur by purchasing the oldest firm dealing in art in the United States, Knoedler and Company. I thought it was time for me to bow out in the friendliest manner. His ownership of the Hammer Galleries was from my point of view questionable enough, but his deeper involvement in dealing made my position as a former museum director even less tenable.

But my close friendship has continued, and it has been in itself a most rewarding experience. Armand Hammer is a fantastic human being, one of the most interesting and delightful men I have known. When he was young he was a hero to the starving peasants in the Urals. In old age he has become a hero to the covetous museum directors in the United States. His early life was spent converting rubles into dollars. His later life has been spent converting the profits which accrued into a collection every American museum would like to have.

11

The Collector Who Got Away:
Calouste Gulbenkian

The Gulbenkian Collection, the greatest in breadth and standard of quality assembled by one person in our time, has recently become public property. In Lisbon a new building was erected in 1969, both as a museum and also as offices for the Gulbenkian Foundation, a trust for charitable, educational and artistic purposes with an income close to that of the Ford Foundation. Collection and foundation are presided over by José de Azeredo Perdigão, a brilliant and dedicated lawyer, to whom Calouste Gulbenkian entrusted the drafting of his will and whom he appointed one of his testamentary executors. More than anyone else, Perdigão was responsible for the works of art coming to Lisbon and, as I shall explain, for my personal frustration. The Portuguese are fortunate. The collection is already a pilgrimage site for lovers of art, the foundation for petitioners for grants. Thus the genius of a little-known Armenian has restored to Lisbon an élan missing since the Second World War.

Although Calouste Gulbenkian might not have approved the spare,

modern architecture of the building erected by his foundation, he would have loved the seventeen acres of garden surrounding it. For the contemplation of natural beauty was his greatest delight, and every day for months on end he passed halcyon hours in the parks of Lisbon, sitting on a camp chair, meditating and dictating to his secretary. His only problem, he once told me, was that he soon became an object of curiosity to the urchins of the town, who to his consternation surrounded him, stared, jabbered, and interrupted his work.

For Gulbenkian to be confronted with a problem was to find a solution. Each day he selected the oldest and strongest boy, made him managing director of the group, and offered him a modest sum of money to be distributed to the others provided they played elsewhere. When the chairman of the company, Gulbenkian, was undisturbed, dividends were paid, but if he had been annoyed, the dividend was passed. It worked, and he was left in peace.

When I attended the opening of his museum, I wondered whether it would have pleased him. I was not, however, sufficiently disinterested to make a fair judgment. A personal failure was involved. For ten years, from 1947 to 1957, I bent every effort to acquire for the United States both the collection and the foundation. In the midst of my final negotiations with Calouste Gulbenkian, death touched this extraordinary Armenian, surprising him as much as the skeleton in Holbein's *Dance of Death* surprises its victims. True, he was eighty-six, but he expected a span of life longer than his grandfather, who died at the age of a hundred and five.

Before we met, I had heard a good deal about Calouste Gulbenkian. I knew that among other assets he owned 5 percent of all the oil in Iraq; that though he was Armenian by birth, and thus a subject of the Ottoman Empire, he had become a British citizen, while at the same time he held an Iranian diplomatic passport; and that, obsessed with privacy, he avoided interviews and photographs. Thus, in our publicity-ridden age, as someone said, "He had become the most mysterious man of our era."

Thirty-one of his paintings had been lent to the National Gallery in London in the 1930s, and a part of his Egyptian collection was on loan to the British Museum. These works of art I had seen, and they were staggeringly beautiful: pictures such as Rembrandt's *Pallas Athene*, Fragonard's *A Fête at Rambouillet*, Rubens' *Helena Fourment*, and Egyptian pieces like the supremely beautiful obsidian head of Amenemhet III. Museum directors are predators by nature; no prey seemed as

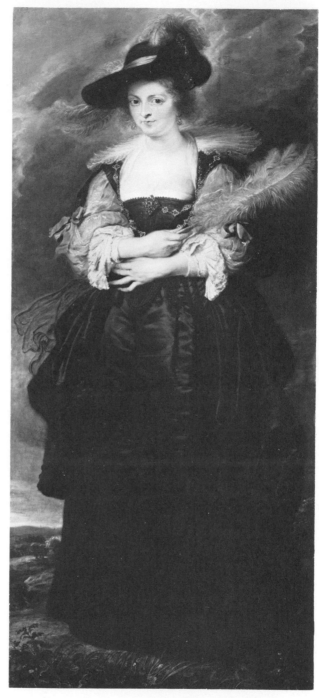

Peter Paul Rubens, *Helena Fourment*.
One of Gulbenkian's great purchases from
the Hermitage. (Courtesy of Calouste
Gulbenkian Foundation)

tempting as the Gulbenkian Collection, no prize as desirable as some future Gulbenkian Foundation. I was determined to get both.

But first I had to meet the owner of these irresistibly magnetic possessions. I knew he lived in Lisbon and had very few friends, but among them was the American ambassador, Dr. Herman Baruch. Through a mutual acquaintance I arranged for the ambassador to show Gulbenkian a colored film of the National Gallery of Art. Shortly thereafter, to my delighted surprise, I received an invitation to be his guest at the Aviz (a Lisbon hotel no longer in existence, but once the best in the world) where he occupied an entire floor. He met me at the airport with the stately and elaborate courtesy of an Eastern potentate. His appearance reminded me at once of a fierce bird. Stocky, bald, he walked at a hopping trot. His deep-set, unblinking eyes were surmounted by exceptionally bushy brows. His aquiline nose increased this hawklike appearance, a resemblance he must have recognized, as he once had himself photographed under a sculptured Horus, the legendary hawk of Egypt.

For the next two weeks we met every evening. In his sparsely furnished and dimly lighted sitting room, where his hat, cane, and gloves were always laid out as though he were ready at any moment to depart or flee, we talked until one or two each morning, our conversations occasionally interrupted when he showed me a new rug he had acquired or some coins he had recently purchased. Then began my attachment to this financial genius and fanatic of art. I was to see him many times over the next six years, and as our friendship grew, I was sad that my affection would always seem to him clouded with ulterior motives. Actually I had ceased to be a predatory museum director and had become a devoted friend.

What charmed me about Calouste Gulbenkian was his entire devotion to aesthetic values. He had amassed hundreds of millions of dollars, but he seemed desperately anxious to explain to me that this vast sum of money held no basic interest for him. It was the organization he had created — the beautiful structure, the balance of interests, the harmony of economic forces — that gave him joy and satisfaction. His masterpiece was the Iraq Petroleum Company. It was as architecturally designed, as faultless in its composition, he felt, as Raphael's painting *The School of Athens*. If he compared himself to Raphael, he compared his partners, especially two of them, the Standard Oil Company of New Jersey and Socony Vacuum, to Girolamo Genga. It was delightful to hear him find analogies between the activities of these oil companies and the work of an obscure, mediocre follower of the Renaissance

masters. Through their selfishness the oil companies were always trying to destroy his beautiful work of art. It was this he fought to preserve. His money was secondary. His interest was in the structure that yielded it.

He told me the history of the Iraq Petroleum Company. He explained its origins in early struggles for oil in the Near East. His family, distinguished members of the Armenian community in Constantinople, had been for years in the business of importing and exporting oil. Like so many of their compatriots they endured the ambivalence of their Turkish rulers. For Turkish policy was either to place Armenians in high posts, as had the Byzantine emperors in the past, or to starve, rob, and massacre them. Sultan Abdul Hamid (Abdul the Damned) followed this traditional procedure of consult or kill. He concealed his intellectual deficiency under the brains of the Gulbenkian family while murdering their near and distant relatives.

Of all his Armenian advisors the sultan was particularly indebted to the youthful and brilliant Calouste Gulbenkian, a recent graduate of London University. It was his report on Mesopotamian oil that made Hagop Pasha, director of the sultan's privy purse, realize that, apart from the estimated thirty thousand women in his harem, the sultan's major asset was this vast reserve of petroleum. In gratitude Hagop Pasha told young Gulbenkian, "My boy, you ought to be very proud because you served the Treasury of His Majesty, and to serve His Majesty's Treasury is to serve your conscience." There was no other compensation, not even one concubine, which the sultan, one would have thought, might have been able to spare.

But Calouste Gulbenkian was a man of infinite patience. He foresaw the revolt in 1909 that put the Young Turks in power. Although he had become a British subject, he continued to ingratiate himself with the Turkish government. As its principal financial advisor, he helped both Turkey and Great Britain. In 1910 he was instrumental in setting up the National Bank of Turkey, which was in fact a British front for obtaining concessions for the exploitation of Mesopotamian oil.

Meanwhile the Germans, using the leverage of the Berlin-Baghdad railway, were getting oil concessions for themselves. Calouste Gulbenkian was at his best when reconciling divergent interests; and after long negotiations the National Bank of Turkey underwent a metamorphosis and became what Gulbenkian always intended it to be, the Turkish Petroleum Company. The Germans were bought off with a 25 percent interest, the British took 35 for themselves, and Gulbenkian was al-

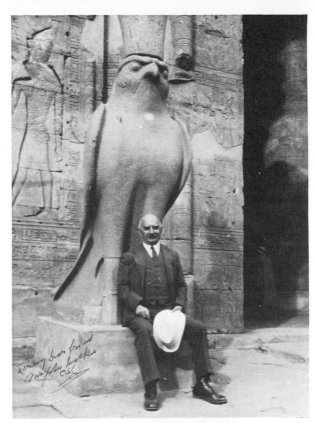

Calouste Gulbenkian must
have himself recognized his
resemblance to a fierce bird,
as he had himself photo-
graphed under the legend-
ary hawk of Egypt.

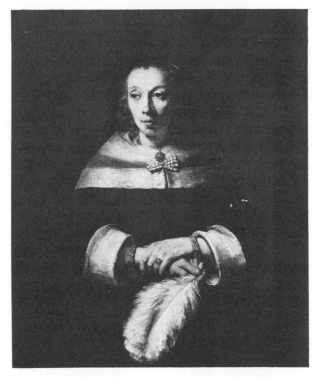

Rembrandt van Ryn, *Por-
trait of a Lady with an
Ostrich-Feather Fan*, Dutch,
17th Century. A famous
court battle brought this
painting finally to the Na-
tional Gallery, Widener
Collection.

lowed to distribute the remaining 40 percent. This he did by giving 25 percent to the Royal Dutch Shell Company, a merger he had previously helped to arrange, and by retaining 15 percent for himself.

But just as the new company was preparing to drill, Gulbenkian's partners, England and Germany, began their mutual slaughter. The belligerents were too engulfed in a sea of blood to exploit their pool of oil. Calouste Gulbenkian had to wait.

He was already a rich man. As marriage broker to Royal Dutch Shell, he had received immense benefits, and there were many other successful deals that added their millions. But he continued to concentrate on what he knew to be the great bonanza, the Turkish Petroleum Company. The end of the war revived his hopes. His first step was to urge the transfer of the German 25 percent interest to the French. When the Americans complained that under the "open door" policy of the United States, they too should be admitted to the Turkish petroleum syndicate, he recognized the wisdom of including these powerful interests. For a time, however, the Turkish Petroleum Company was a football kicked back and forth by Lloyd George and Clemenceau, with Gulbenkian darting in and out, a desperate and frustrated referee. His share in the company shrank from 15 percent to 5 percent, but in 1925 he finally got the settlement he had designed with the partners he wanted. The new arrangement was that the Anglo-Persian Oil Company, the Royal Dutch Shell group, the French participation, and the American interests would each have 23¾ percent of the stock. This left Gulbenkian with 5 percent, but with a balance of power he rightly felt would protect him. He was satisfied to have earned the nickname Mr. Five-Percent.

In reality, however, his partners each had 23¾ percent and he had 5 percent of nothing. For the Turkish Petroleum Company had never produced oil, and it had no valid concessions to drill. The land it intended to develop was no longer a part of Turkey and the drilling rights previously granted, if not obsolete, were at least obsolescent. Calouste Gulbenkian had to begin all over. To make the situation more difficult, he had at first to negotiate with a nonexistent government, until after long delays the state of Iraq was established in Mesopotamia. When it finally came into being in 1925 the Gulbenkian syndicate was, as might be expected, the oil concessionaire. A few years later the company was tactfully rechristened the Iraq Petroleum Company, and the enormous oil pool of Mesopotamia was tapped.

He was always convinced, he told me, that the oil resources of the

Near East extended into Saudi Arabia. For many years the geologists employed by his partners insisted he was wrong. If he was right and oil was found, he wanted to be sure he received his share. Thus in every contract he insisted on what came to be known as a "self-denying" clause. To do this he had to persuade each partner in turn that the others were untrustworthy — something each believed in any case. Mutually suspicious, the partners realized that their self-interest required that new discoveries be shared. Therefore, urged on by Gulbenkian, they made a pact, known as the Red Line Agreement, that provided for mutual exploitation of all oil found within the boundaries of the old Ottoman Empire.

Some years later when, as Gulbenkian had predicted, oil was discovered on this vast piece of real estate, the discoverers, among them Standard Oil of New Jersey and Socony Vacuum, found the Red Line Agreement a nuisance and wished to abrogate it. They had the courtesy to buy off their major partners in the Iraq Petroleum Company, but Mr. Five-Percent seemed too insignificant for their attention.

He was, he said, like an artist who had painted a great picture. It had been bought, and now the new owners were ignoring its creator. They did not realize that he was an artist who would fight with every drop of his blood to keep his work of art from being defaced. I was with him often during this struggle with the world's leading oil companies. His power of concentration amazed me. He ground away at his problem, returning again and again to the subject, asking repeatedly whether someone else did not have a solution to suggest, and ultimately by sheer inhuman tenacity discovering the solution himself. In this case by brilliantly playing off one partner against another, the balance of power he had so carefully arranged won him a fair settlement, and as a consequence many additional hundreds of millions of dollars. Henceforth he would often be referred to as the "mystery billionaire."

This tremendous effort made by a man of seventy-nine was from my point of view a disaster. If it had not been for the lawsuit over the Red Line Agreement, which absorbed the best years of his old age, he would, he assured me, have made his first trip to America. This in turn would have immensely increased the chances of the Gulbenkian Museum being erected in Washington instead of in Lisbon.

Long before Baruch showed him our film, Gulbenkian knew all about the National Gallery of Art. To my surprise, one of the first things he pointed out was how much the Gallery, of which I was then chief curator, had benefited from his activities. True, his assistance had been

inadvertent, and from his point of view, highly regrettable. Nevertheless, credit must go to him for having made possible the greatest single acquisition by an American collector, Andrew Mellon's purchases from the Hermitage Gallery in Leningrad, which I have described in the chapter on Mr. Mellon. Had it not been for Calouste Gulbenkian, these sales might never have occurred. They resulted from his usefulness to the Soviet government in dumping Russian petroleum for desperately needed foreign exchange. This was one of his most successful enterprises. He killed two birds with one stone: his advice netted the money the Soviets required, while the dumped oil ultimately depressed the value of Royal Dutch Shell stock, with whose management Gulbenkian was having one of his periodic quarrels. But best of all, to his delighted surprise, a third bird lay at his feet. The commissars asked what he would like in return for his help, and delightedly accepted his recommendation that their holdings of foreign exchange be further improved by converting some of their works of art into gold. Armand Hammer's proposals had been turned down, but Gulbenkian was more successful. Because of his popularity with the government he broke the ice, and he found himself being offered many of the supremely beautiful treasures from the Hermitage now in his museum at Lisbon, among others the marble of Diana by Houdon, the fascinating studies of the gardens of Versailles by Hubert Robert, and much of the fantastic French silver collected by Catherine the Great.

The prices were not unreasonable, although higher than those proposed by . Armand Hammer, and everyone was happy, except the curators of the Hermitage. They let it be known that in their opinion the commissars were as naïve about the sale of oil on canvas as they were about the sale of oil from the ground. Stung by this criticism, the commissars turned to the young Berlin art dealer, Zatzenstein, whom we have already met in the chapter on Andrew Mellon. He was asked to come secretly to Leningrad, look at the collection, and tell them something about values. They emphasized, however, that under no circumstances would anything ever be sold. Zatzenstein gave them the information they wanted and returned to Berlin.

Some months later, Gulbenkian summoned him to Paris and immediately inquired about his Russian trip. Zatzenstein, conscious of the secrecy of his mission, denied having been in Russia. Gulbenkian called him a liar, took him into the next room, and showed him the works of art from the Hermitage which had just been purchased at Zatzenstein's greatly increased valuation. Zatzenstein was staggered. He could not

believe the Soviet commissars would sell the very paintings he had told them were the most irreplaceable of all.

Gulbenkian then proposed a deal. He would pay Zatzenstein to be his Russian agent. But Zatzenstein, aware that he had stumbled on invaluable information, decided quickly that he could make more money elsewhere. He refused the offer.

There followed one of those thunderous and terrifying rages Calouste Gulbenkian could not control. Years later Zatzenstein, by then known as Matthiesen, still remembered his fright. He was thrown out of the house, and Gulbenkian swore he would never buy another work of art from the Soviets. This was a decision he regretted the rest of his life. "But worse still," he told me, "I, who have always been discreet, had disclosed a vital secret. I knew the information would be used to my regret."

He was right. As I have explained in greater detail in chapter 6, Zatzenstein, armed with his new knowledge, hastened to London and there negotiated a partnership with the dealer who had Andrew Mellon as a client, Knoedler's. Shortly thereafter, twenty-one masterpieces from the Hermitage were on their way from Leningrad to Washington. Thus the National Gallery is indirectly indebted to Calouste Gulbenkian for these stupendous works of art, but this was not a debt which gave him any pleasure!

He received still less pleasure from another incident that affected the Gallery. With uncharacteristic gullibility, he placed confidence in a somewhat unreliable advisor, Lord Duveen of Millbank, to whom I have referred so often. Prince Felix Yussupov, Duveen said, had just arrived in London with two canvases by Rembrandt which were generally accepted as among the greatest of all portraits. Unfortunately Joseph E. Widener had seen the prince first, and the paintings had been sold, but their sale was not necessarily final. Duveen told Gulbenkian that Joseph Widener's father had gone to Russia before the First World War to buy these paintings, but at that time the Yussupovs were so much richer than any American millionaire that he was unceremoniously shown the door of their palace. The revolution had come, and the scion of the Yussupovs, Rasputin's murderer, was penniless. His only assets were some jewels and the two paintings which he had managed to smuggle out of Russia.

The paintings had already been shipped to Philadelphia, Duveen explained, but there was a clause in the deed of sale which would enable Yussupov to retrieve his pictures. Originally he had wished to use

them as collateral for a loan, but Widener, with the same lack of cere-
mony shown his father, told the prince he was not a pawnbroker.
Finally it was agreed that Widener could buy the portraits for $500,000,
but that if Yussupov were ever able to resume his former way of
life, he could redeem them.

Thus all Gulbenkian needed to do, according to Duveen, was to help
the prince resume his former way of life. This could be done by advanc-
ing some money to be deducted from the ultimate price of the portraits,
which were worth, Duveen said, at least $500,000 apiece (a figure far
below their market value today). Gulbenkian agreed, and next to the
Zatzenstein disaster, it was admittedly the greatest folly of his career as
a collector.

With an enormous advance for expenses and a check for $500,000 to
recover the paintings, Yussupov set about taking up his former way
of life. His New York spree left Gulbenkian far from happy, but worst
of all, Widener refused to allow the portraits to be redeemed. He
pointed out that Russia was still Communist and that there was some-
thing suspicious in this resumption by the prince of his former ex-
travagances.

A famous court battle followed, and the outcome depended upon the
telegram from Yussupov accepting Widener's offer. The Widener
lawyers searched Lynnewood Hall, his home, from top to bottom, but
they could not find the cable. With a brilliance that made legal history,
they convinced the jury of the existence of the telegram without being
able to produce it, and Yussupov lost his case. Years later, when I
was packing the Widener Collection for shipment to the National
Gallery, the missing cable fell out of an old studbook Joseph Widener
must have been reading when it arrived. I told Gulbenkian the final
denouement, but it did not lift the gloom into which he was plunged
when he thought of the money he had spent helping Yussupov enjoy
his former way of life, principally in New York City nightclubs.

It was part of Gulbenkian's attractiveness that he was detached and
humble about his mistakes and about himself. But his charm in turn
was lessened by his ineluctable suspicion, his feeling of constant be-
trayal, which increased his isolation and his loneliness. When he finally
concluded that a person was trustworthy, he was enchanted and could
be himself enchanting. But he was by nature a recluse. As his close
friend Lord Radcliffe has written, "If he had to go into a public room he
preferred to charge head down, thus to minimize the chance of catching

anyone's eye." People, he felt, diminished his vitality, lessened his capacity for work, and wasted his intellectual force.

Walking in the parks of Lisbon, talking late into the night, eating at odd hours, for he lunched at four and dined at eleven, I passed fascinating and happy days. But there was no discussion of the purpose of my visit, which I tried repeatedly and unsuccessfully to introduce into our conversations. He knew that I wanted to borrow his works of art, but he was in no hurry "to give me satisfaction," to use one of his favorite idiosyncrasies of speech, which I always thought would apply more idiomatically to a duelist. Had I known his eagerness to get his paintings and sculpture out of England, my worries would have ceased. I should have realized his intense anxiety over British export restrictions. When he told me of a recent trivial and irritating frustration, I understood why I had been so unexpectedly invited to Lisbon.

Although his artistic discernment was extraordinary and impressed me deeply, my invitation to visit him in Portugal was indirectly connected with one of his few errors in taste. He had once bought, and for a time admired, the most celebrated of all examples of calendar art, *September Morn*. For years he had been teased about this vulgar canvas. But one day, he told me, a banking friend from New York, having been shown his Rembrandts, his Rubenses, his van Dycks and his other masterpieces, expressed a preference for *September Morn*. Gulbenkian's joy at this surprising choice was indescribable. At last he saw himself free of his albatross. He would give it to its new admirer. Before the banker could change his mind, *September Morn* was his.

During the Second World War, however, the painting had become separated from its frame, which had remained in England. Gulbenkian instructed his London office to send the frame to the new owner in New York. A few days later he was told that the British Board of Trade was making difficulties about the export. He was stunned. If there were impediments to the shipment of a gold frame, what of the paintings and other works of art in London that he had lent to the National Gallery and the British Museum? Fate and bureaucratic stupidity were on my side! I knew that as far as he was concerned, I would get all the loans I wanted.

This left me with two problems. I had to negotiate with the British authorities to release the works of art, and I had to try eventually to transform these loans into gifts. Following the shrewd and tactful procedure laid down by Gulbenkian, I managed to disentangle the English

loans from the restrictions of the British Board of Trade and get them to America without a commitment for their return. Gulbenkian was delighted with my success.

The second problem, however, was far more difficult. Its solution depended on arousing his sympathetic interest in the new National Gallery and then in persuading him that his works of art would be cared for, beautifully installed, and appreciated in Washington. As soon as everything had arrived, I had colored photographs taken of the rooms showing the installation. Gulbenkian was enthusiastic about the setting. He was also pleased with the care I had shown "his children," as he called his works of art. I seemed to him a satisfactory guardian for his artistic offspring, and I was constituted forthwith their "nanny," as his real children used to call me.

It was an arduous job that aged me greatly. No father has ever been more preoccupied with the care, reception, and future of his progeny than Gulbenkian was with his works of art. For six years I received almost daily letters from him, and if I did not reply by return post, a cable would follow asking what was wrong.

As an example of his concern and of the aging process I underwent as custodian of his so-called children, here is a sample of one of many dialogues between Gulbenkian and myself. It involved the shipment of a portrait of Duval de l'Epinoy by Maurice Quentin de La Tour, probably the most important pastel in the world.

Gulbenkian: Tell me, Mr. Walker, is there danger in shipping a pastel?
Walker: In some cases there is. For instance I would advise you to leave the pastel of Duval de l'Epinoy in London unless it is to remain in America.
Gulbenkian: To have it left behind would be lamentable. Consult Sir Philip Hendy [The Director of the London National Gallery].
Walker: I have consulted Sir Philip. He concurs that the pastel should travel as little as possible.
Gulbenkian: Without the pastel my exhibition will be a failure. We might as well call the whole thing off.
Walker: Since you are so anxious for the pastel to be in the exhibition, we shall move it as carefully as is humanly possible.
(*Later. The pictures are now on the* Queen Elizabeth *which will sail in a few minutes. A telephone call from Paris.*)
Gulbenkian: I hope you were right, Mr. Walker, to persuade me to lend you the portrait of Duval de l'Epinoy. Your responsibility is very

great. You know, of course, that when the Rothschilds owned the pastel, they built a special room to protect it from the vibration of traffic.

I thought of the *Queen Elizabeth*'s turbines vibrating across the Atlantic. The painting was boxed and in the strongroom. I couldn't even look at it. The agony of that trip remains unforgettable. The picture arrived safely and is still in perfect condition. I am not! I developed nervous indigestion and ever since have taken what I call my Gulbenkian pills.

It was soon evident that Gulbenkian wanted all his works of art in America. When those in England had been extricated, he brought up the subject of the removal of a large part of the immense treasure in his Paris house. While my eagerness was beyond description, I recognized the new complications. The National Gallery of Art was intended by its founder, Andrew Mellon, to be limited to European and American paintings and sculpture. When the Widener Collection was offered, a condition was the acceptance of those examples of the decorative arts collected by P. A. B. and Joseph Widener. Reluctantly the trustees agreed, but voted not to increase this part of the Gallery holding. Now Gulbenkian was discussing a huge donation of the most varied works of art. Though all were superb, to accept them would be totally at variance with the Gallery's policy. Furthermore, Gulbenkian wished his gift kept together, something which had not been done for any other donor.

I could think of only one solution: an additional building. To my delight the idea appealed to Gulbenkian. The necessary real estate was available. When Andrew Mellon offered funds to erect the National Gallery of Art, a stipulation was the reservation of an adjacent plot of federally owned ground for future expansion. As I explained in chapter 9, the Gallery is presently erecting an addition on this tract of land; but it was then available for a Gulbenkian museum.

He had once seriously considered building such an annex to the National Gallery in London, as I have discussed in chapter 13. Delano and Aldrich, an American architectural firm, had been commissioned to draw up plans. These he now sent to Washington so that we could clearly understand his wishes. He requested estimates for the erection of a similar building, and indicated he might contribute funds to build it.

He told me he had a great regard for America. The United States, he said, had behaved admirably in two world wars and twice had come to

Maurice Quentin de La Tour, *Duval de l'Epinoy*. I developed nervous indigestion crossing the Atlantic with this fragile picture, probably the most important pastel in the world. (Courtesy of Calouste Gulbenkian Foundation)

the rescue of Europe. He wished to show his appreciation, something few Europeans had done. But what impressed him most about the United States was the treatment of his cousin. He explained that though he himself had become a British subject as a very young man, in the eyes of the English he remained an Armenian; whereas his cousin, who managed his estate at Deauville, had taken out American citizenship and was as American as anyone else.

He proposed that after his death his house at Fifty-four Avenue d'Iéna, one of the most beautiful in Paris, become the residence in perpetuity of the American ambassador to France, and he asked me to determine whether such a proposal would be well received by the Department of State. Needless to say, I discussed this enthusiastically with two close friends, David Bruce, then ambassador, and his successor, Douglas Dillon. Both were favorably disposed.

Next he brought up the question of the foundation he wished to establish. Would it be possible for the Chief Justice of the United States to be chairman of the board, ex officio? We inquired and found no obstacle. There was even a precedent. Chief Justice Stone, ex-officio chairman of the board of the National Gallery of Art, had also served as a trustee of the Samuel H. Kress Foundation, the Gallery's principal source of support.

I was playing for high stakes — the collection, the foundation, and even the house in Paris — and I seemed to be winning. Then came two reverses. The Office of Foreign Buildings, which manages United States embassy property, made difficulties. The chief of this division of the State Department pointed out that it would be impossible to guarantee that the Gulbenkian house would be the American ambassador's residence in perpetuity. He admired the great beauty of the house, he said, but he insisted structural alterations would have to be made. This setback was followed by a real catastrophe. A new law, the McCarran Act, was passed, requiring that American citizens of foreign birth reside in the United States if they wished to retain their citizenship. The Armenian cousin, who had been so touchingly taken to the bosom of the United States, was managing the Gulbenkian estate in Deauville. If he remained abroad, he lost his citizenship; domiciled in America, he was of no use to his employer. Gulbenkian was furious and told me in no uncertain terms that he had misjudged the United States. His cousin was after all a second-class citizen, worse off than any British subject. Stormy letters followed. I must have the law changed, or an exception made. I struggled with every branch of the government, used all the

influence I possessed, tried unceasingly to rectify the situation, but in the end I failed. I felt like Cardinal Wolsey when he had to tell Henry VIII that the pope would not grant his divorce.

Fortunately Gulbenkian was more understanding than the cardinal's frustrated lover. We still discussed the American future for the collection and the foundation and I felt we were closer than ever to a solution. Our last talks took place in Deauville just before his long, fatal illness. We motored from the hotel each day to his estate nearby. It was a vast park, its only architectural feature a balustrade, as in a painting by Hubert Robert. Flowering meadows planted with fruit trees reached to the distant low hills. He had never built a house because no architect was able to suggest anything beautiful enough to be worthy of this enchanting garden.

We sat on camp chairs. I was used to this, for in Lisbon all our daytime conversations took place out-of-doors in those solitary places he had discovered which had the loveliest views. On this last occasion he told me he had finally made a will. However, he emphasized that he intended to amplify it on his return to Lisbon. To my surprise he told me that for tax reasons he was establishing his foundation in Portugal; but, he said, there was an important provision that would enable his trustees to remove the foundation to any other country if this proved advisable. The funds were to be used internationally, and he hoped they would be devoted to art, literature, the humanities, subjects which interested him. Medicine, hospitals, science he felt received enough from other foundations. He added that he would instruct his trustees about the disposition of his collection, and that Washington was still very much in his mind.

We parted; he returned shortly afterward to Lisbon, fell ill, and I was never to see him again. But I like to think of him as he was during those last days in Deauville, sitting on his camp chair contemplating the beauty of nature, reminding me of a Zen sage. Then he was tranquil, detached, in harmony with his environment. He was always happiest out-of-doors. It was in a park or a garden that he liked to sit, dictating, meditating, talking to an occasional friend; and it is out-of-doors that I remember him, rather than in the stuffy sitting rooms of the Aviz in Lisbon, the Ritz in Paris, the Hotel de Normandy in Deauville, or even his own house in the Avenue d'Iéna where he almost never slept, preferring to go to bed in his suite at the Ritz.

After Gulbenkian's death no instructions about the collection were found. My years of effort were wasted, my mission a failure. Apart

from a generous contribution to music from the Calouste Gulbenkian Foundation, whose trustees with one exception are now Portuguese, the National Gallery of Art has not benefited. From all those trips by sea, by rail, by air, from that immense correspondence stretching over a decade, what had I to show? Only my friendship with a remarkable human being. Calouste Gulbenkian was a man who had striven all his life to make his every activity a work of art. Often he had succeeded; sometimes he had failed. To have enjoyed his friendship was my only reward, but it has always seemed to me sufficient.

12

Collecting in Partnership: Charles and Jayne Wrightsman

C harles Wrightsman is fond of saying that I made him and his wife collectors. This is an exaggeration, but I certainly made them my very close friends. If I made them collectors, however, my efforts were to prove disinterested, for their collection seems now in all probability destined for the Metropolitan Museum, the National Gallery's greatest rival.

What the Wrightsmans have assembled is small. They own fewer than forty Old Masters, several Impressionists, and ten or twelve drawings. But the quality is so high that if one excludes the Norton Simon Collection, which is no longer privately owned, and the Paul Mellon Collection, which is unique but essentially limited to British and French painting, Charles and Jayne Wrightsman possess the most important private collection left in this country. Paintings and drawings are only part of what they have collected. Their furniture, rugs, porcelains, *objets d'art*, everything included under the heading "Decorative Arts," are unsurpassed this side of the Atlantic. The Wrightsman rooms at the

Charles and Jayne Wrightsman in their New York apartment. I may have made them collectors; I certainly made them my very close friends. (Photograph by Cecil Beaton)

Louis XV red lacquer writing table. One of the most valuable examples of French furniture still preserved. The Metropolitan Museum of Art. Gift — Mr. Charles Wrightsman

Metropolitan Museum are, in the opinion of many curators, the finest eighteenth-century French rooms to be seen in any museum, not excluding the Louvre.

I first encountered Jayne and Charles in Venice in 1951. They had arrived on their yacht, which I remember being told was too large to anchor off the Dogana, the usual anchorage, and had to be moored near the Biennale. It was July and the annual regatta was taking place. I had been invited to the palazzo of the Brandolinis, and on a balcony overlooking the Grand Canal I was introduced to Mr. and Mrs. Wrightsman. At first I thought Charles was someone Gulbenkian had mentioned when I had visited him a few days earlier, a European important in his petroleum investments. But though my hostess had whispered that her guest had made a large fortune in oil, his American accent told me at once that I was wrong and that he was a compatriot.

When the regatta was over Charles invited all the Brandolini party for a cocktail on his yacht. I had noticed that he had a very attractive wife, slim, chic, and with beautiful eyes. In the press of the cocktail party I found myself not inadvertently seated beside her on the aft deck. Seeking a subject for conversation I began talking about collectors, and I described Gulbenkian as the most magnetic and astute I had met. This interested her, and with her extraordinary gift for drawing people out I found myself indulging in a brief autobiography. Of the friends I mentioned, the one who interested her most was Bernard Berenson. She asked me if she might meet him, and I said it could easily be arranged. During our talk I watched with fascination her large, gray-blue eyes. It seemed to me, as I described the world of experts and collectors, that some thought irradiated them. I had an intuition then that though she knew almost nothing about works of art, some day she would know a great deal. She questioned me about museum work and my training for it. I still remember her responsiveness to everything I said. Such absorption had only one explanation. She foresaw an involvement for herself and Charles in collecting and museums.

In age they were separated by many years. Charles had reached a time of life when he needed some new interests. Jayne recognized that his oil business could be managed without drudgery, that he was too old for sport, that gambling did not interest him, that yachting could never be a full-time occupation. What should she do to help him avoid his major problem, boredom? Why not dedicate themselves to art, to learning about it, to seeing it, to collecting it? This might be a way of life,

Jayne thought, free of ennui and at the same time potentially of public benefit.

She herself was artistically unsophisticated, though her father had been responsible for the decoration of many government buildings. But she had in her a spark ready to burst into flame, an instinctive love of beauty, an innate good taste. Charles, on the other hand, was a more problematical art lover. He had been a connoisseur of polo ponies, a discerning collector of skillful polo players, but that was all. His team won the English cup in 1938, but with the advent of World War Two he gave up polo.

Jayne's experience in artistic matters, on the other hand, was not altogether negligible. She and Charles had settled in Palm Beach and had bought the Harrison Williams house. The furnishings which they also acquired reflected the taste of Mona Williams and her decorator, Syrie Maughn, who was then at the height of her fashion. The chairs, tables, sofas were designed by Chippendale or Hepplewhite, though to Charles's consternation and surprise fabricated much more recently, and the walls were either paneled or covered with Chinese paper. The house was much publicized and greatly admired. When the Wrightsmans acquired a French commode and diffidently tried it out in the living room, their friends were shocked and disapproving. Mona's decor was in perfect taste, they said. What right had anyone to alter it?

But the Wrightsmans were undeterred. They compared the furniture of English cabinetmakers with contemporary work in France, and concluded that, in the eighteenth century, craftsmanship was more skillful and design more refined on the other side of the Channel. This was heresy at the time. The vogue for Louis Quinze and Louis Seize furniture was still a decade away. Collectors like Elie de Talleyrand were still finding on Third Avenue at ludicrous prices superb examples. The influence of the Rothschild exiles, who created the American rage for French interiors, was still to be felt. Monsieur Boudin of Jansen's had not yet become the most fashionable decorator on this side-of the Atlantic.

It was the Wrightsmans who contributed greatly to Boudin's American triumph. Once they had decided that they wanted to transform the Palm Beach house from the style of the Georges to the style of *les Louis*, from the taste of Syrie Maughn to the taste of Jansen, Boudin took over. He was a magnificent teacher, and Jayne a devoted pupil. Her enthusiasm for the *ancien régime* was contagious and infected many of her

friends, including Mrs. Onassis, then Mrs. Kennedy, and Mrs. Dean Johnson, then Mrs. Henry Ford, whose collection of French decorative arts was sold at auction recently for two million two hundred thousand dollars, breaking all records.

It is amusing to watch the dissemination of a fashion. For many years during the popularity of English interiors, French furniture in this country was a drug on the market, as Elie de Talleyrand proved. But in the nineteen-fifties a change occurred, at first slowly and then, backed by the Wrightsmans, rapidly. Influential in this new vogue, which Berenson designated "the Louis, Louis craze," were two Europeans, Rénée de Becker, born Lambert of the Belgian branch of the Rothschilds, and her close friend, Erich Goldschmidt-Rothschild. Rénée de Becker had a superb collection of rococo art, which she managed to bring to New York before the Nazis could confiscate it. She and Erich Goldschmidt became involved in the firm of Rosenberg and Stiebel, with whom the Rothschilds had dealt for many years in France and Germany. It was logical that their New York branch should be chosen to sell the Rothschilds' collection when their owners had fled to America. Rénée de Becker and Erich Goldschmidt knew all the right people, including the Wrightsmans, who might become clients of Rosenberg and Stiebel. Helped by them, business in the firm became brisk, especially in French furniture and *objets d'art.*

Meanwhile President Kennedy had been elected and Mrs. Kennedy had decided that the White House was badly in need of refurbishing. Jayne introduced her to Boudin, and she too fell under his spell. To raise funds for acquisition and to avoid criticism she decided to form an advisory committee, and as chairman she appointed the most distinguished connoisseur of Americana, Henry du Pont, the founder of Winterthur. She and Jayne longed for a French decor, at least in some rooms; but the chairman, even though Monroe had filled the White House with pieces purchased in Paris, felt that to suggest the taste of the kings of France would be in some way unsuitable for the home of the President. Mrs. Kennedy, however, though undeviating in her respect and admiration for Mr. du Pont, did not wish to ignore the judgment of Monsieur Boudin. It was, she felt, important to have his advice as well. She and Jayne would summon him to their assistance, but because the thought of a Frenchman doing over the White House might possibly cause some question among 100 percent Americans, still as suspicious of French furniture as they had been when Presidents Monroe and Jackson made their much-criticized foreign purchases, his visits were

never publicized. It is not true, as Washington gossip related, that he was carried into the White House wrapped in a rug, like Cleopatra when she visited Caesar; but his influence was certainly not widely known. When he arrived, he and Mrs. Kennedy would sometimes re-arrange furniture, which had been previously placed by Mr. du Pont, Then the chairman of the advisory committee would appear, see what had happened, call for porters, and put the furniture in its original location. If even one ornament had been changed, Harry du Pont would notice and replace it. Mrs. Kennedy's tact on these occasions aroused my deepest admiration.

The only area in which Boudin was granted a free hand was the Blue Room, the oval reception room facing the entrance. Charles and Jayne paid for its redecoration, and they saw to it that no one interfered with their chosen decorator. For this most difficult space Boudin, I thought, created a beautiful interior. Although it retained evidence of its original color, which explains its traditional name, white became more evident, and after its redecoration a more descriptive title would have been "The Blue and White Room," for a two-toned white striped satin on the walls reduced considerably the blue effect. The Wrightsman decor survived the Johnson Administration, for Mrs. Johnson was determined not to disturb anything Mrs. Kennedy had done, but the Nixons have changed a great deal, and the Blue Room is once more azure. No matter how well-decorated, it is the fate of the White House to be in a state of constant flux.

Jayne's apprenticeship under Boudin ended with the decoration of the White House. Her graduate work in the decorative arts was done with still more eminent connoisseurs, Pierre Verlet of the Louvre and Francis Watson of the Wallace Collection. In the end she became an authority in her own right. Meanwhile, her tutelage gave Charles the confidence in collecting which he had lost. In his youth he had been badly cheated, over a Dutch painting, by the leading New York picture dealer of the time. He had also in subsequent years bought porcelains which turned out to be inferior. These mistakes for a time inhibited him as a collector.

But one day he and Jayne wandered into the Metropolitan Museum to see an exhibition of porcelains lent largely by Judge Untermyer. Charles was astute enough to recognize a true connoisseur when he saw one. He did not know Judge Untermyer, but he was determined to meet him. He immediately phoned the firm which handled his legal business and said that he assumed one of the partners must know anyone called

"Judge." He was right and his lawyers arranged a meeting. Judge Untermyer became a close friend. Friendship with the Wrightsmans, when they wish, is irresistible, and in a short time the judge and his two neophytes were visiting all the porcelain dealers on both sides of the Atlantic. In London the judge arranged a special preview of the antique dealers' annual fair. After that initiation Charles was "blooded" as a collector. Guided by Judge Untermyer, their collection of porcelains soon became spectacular.

Joseph Widener once said to me that no collector ought any longer to make mistakes. There are so many experts available to advise him. He left out, however, a proviso: that the expert must not be financially linked to the vendor, which is all too often the case. Where then does one find disinterested advice? Although the answer has escaped many collectors, it did not escape Charles. Realizing that private collectors as unselfish as Judge Untermyer are too rare to count on, he turned instead to museum curators and directors. He discovered that if they were persuaded either that their institutions might some day benefit, or that they might look forward to the emoluments of cataloguing the collection, they were only too eager to help. For many years the purchases of Charles and Jayne Wrightsman in the decorative arts were made on the advice of Pierre Verlet, the *conservateur des arts decoratifs* at the Louvre, and Francis Watson, the director of the Wallace Collection, and in pictures, for a time, on my recommendation. We could not afford to let them make an error. Our reputations were at stake. Francis Watson and Pierre Verlet worked on the Wrightsman catalogue. My compensation, apart from friendship which was sufficient in itself, was my hope for the bequest of the Wrightsman paintings to the National Gallery of Art. But my advice ceased over twenty years ago. Since then Jayne has proved that self-education in connoisseurship, regardless of the number of advisors one may have, is the only education worthwhile. It requires determination and dedication, and she has given both to her studies.

In my files there is a letter from Jayne written in 1957. The University of Chicago was offering a correspondence course in French art of the eighteenth century and she wanted to know whether she should subscribe. I looked over the material and found that she could have written the syllabus herself. Francis Watson once described sitting beside her in Palm Beach and showing her the pulls of two hundred and forty illustrations of a book he was writing on furniture of the period of Louis XVI. They were not captioned. To his amazement Jayne knew the name of the *ébéniste* responsible for making the piece and in most

cases the present owner, the sale at which it was purchased, and the price paid.

Not only is her knowledge of the decorative arts of eighteenth-century France remarkable, but she has become very expert about paintings. Her training was unusual. As I said, she was fascinated by all I told her about Bernard Berenson. I once mentioned to Charles and Jayne that one of my deepest disappointments was that B. B. was too old to come to America to see the National Gallery of Art, which was so much a part of myself. They had just returned from flying around Asia in their private plane, and Jayne on the trip had taken superb stereo-photographs. Charles at once proposed that they photograph the whole National Gallery and send the slides to B. B. This would give him some idea of what the Gallery was like.

When he is embarked on a project Charles never delays, and they soon arrived with their equipment. I laid on laborers, stepladders, and lights. Evening after evening when the Gallery was closed they would appear. Charles would scramble up the ladders so as to hold the light at the precise angle Jayne wanted, and she would snap away. In the end they made several thousand slides of the architecture, the installation, and every work of art. But this was only the beginning. Jayne pored over her negatives, selecting the best, identifying the works of art, in a way cataloguing the collection. Her eye was trained by this arduous photographic project. She learned to see quality, to discern, to discriminate. Charles's impulsive decision to send a set of stereo-photographs to B. B. made both of them look very hard at a great collection. Connoisseurship can be developed only in this way: by an intensive scrutiny of masterpieces.

When they arrived at I Tatti in 1954 with their photographs, B. B. was overjoyed. Their friendship was an example of spontaneous combustion, especially in the case of Jayne. When they separated after a few days they continued to correspond (Jayne is a brilliant letter writer), and a deep attachment sprang up between a very old man and a very young woman. In 1955 when B. B. was ninety Jayne wrote me, "I hear all the time from B. B. One letter he sounds on the top of the world and the next not so well. He is a darling and loving friend that I worry about all the time. I do not know whether I am happy or sad that you brought him into my life, but I am deeply touched and grateful for his friendship."

Later Charles was to help me realize B. B.'s dream: that I Tatti should become a part of Harvard dedicated to the study of Italian cul-

ture. As I have said, B. B. was always apprehensive that his estate might not provide sufficient endowment and that his bequest would be rejected by Harvard. When I discussed the future of I Tatti with President Pusey he repeatedly pointed out that two million dollars of capital must be raised. The chance of Harvard's acceptance seemed to me more and more remote.

While staying with the Wrightsmans in New York, I told Charles that the crucial meeting with the President of Harvard and a member of the Corporation of Harvard was to take place that afternoon, and that I was convinced from what I had been told that I Tatti would be refused. He asked me what the other executor and I would then do. I explained that under the will we had the right to designate another university as the recipient, but that I knew B. B.'s heart had been set on having I Tatti run by his alma mater. I was very depressed.

Charles retired to his room and returned with a letter. "I want to give you some cards to play, a couple of aces," he said. "Read Pusey this, and my guess is he will accept I Tatti."

I went to the meeting, and after listening to the impossibility of Harvard's operating I Tatti on an endowment of two and a half million dollars, the value of B. B.'s residuary estate, I finally said, "Gentlemen, I see your difficulties clearly. If Harvard rejects the bequest the executors will have to choose another university. I have a letter here from Charles Wrightsman to the effect that if we select New York University he will provide as endowment for Mr. Berenson's project the additional two million dollars which you say are required." The atmosphere totally changed. Harvard, the President replied, had raised funds for worthy undertakings in the past, and it could do so again. There was no further question about the future of I Tatti. Charles has only now permitted me to mention his gesture, which I am convinced made possible the realization of B. B.'s wishes.

To return, however, to the Wrightsmans as collectors. In recent years Jayne and I have reversed roles, and I have often asked her opinion about paintings. I have invariably found her perceptive and astute. Perhaps I am prejudiced because our reactions are always so similar. But this congruity of taste has also had awkward consequences, as I shall explain. As a rival collector Jayne has often been much too discerning.

But when the Wrightsmans were beginning to collect paintings they were very dependent on me. I brought to their attention the first significant picture they acquired, a Monet of a Lady Seated in a Garden. It

was so cheap I might have bought it myself, something between ten and twenty thousand dollars. It hangs in their New York apartment beside the bedroom I occupy when I stay with them. I always glance at this entrancing scene, marveling at the beauty of its dappled sunshine, a little wistfully, a little sadly.

My sacrifice, however, had important consequences. Buying this jewel of a painting also helped to give Charles back the confidence his worthless Dutch picture had destroyed. Shortly after their return to Palm Beach I had a letter from Jayne saying Charles had bought her "a very stylish Pissarro for Christmas." When later in the winter I went South to stay with them I realized that Charles had the virus of collecting in his veins. Possessing two beautiful paintings, he was himself possessed, like the other collectors I have written about. He had become an addict. Could I help him satisfy his craving? I said I would do what I could.

After my return from Palm Beach I learned that the beautiful *Girl with a Cat* by Renoir, lent to the Gallery by the Whittemore family, had to be sold. My first duty, of course, was to try to find a donor who would give it immediately to the National Gallery. I tried Chester Dale and others, for at that time we had virtually no funds for purchase. My most likely prospect turned out to be a cat hater. I failed everywhere. As no one would buy the picture for us, I decided it should go into a collection which I felt would ultimately come to Washington. I telephoned Charles. He knew the painting, having seen it in the Gallery, and he said at once that he would buy it.

The market in those days favored the buyer, and it was usual to bargain. I suggested Charles might wish to make a lower offer. He refused and insisted he would buy the picture at Mr. Whittemore's price. It was a relief not to have to make a counteroffer. The picture is now worth ten times its purchase price, but most collectors, even in a rising market, Arab-like, feel bargaining is part of the fun of the transaction.

My belief that Charles's pictures would come to the National Gallery of Art, however, caused me to lose a masterpiece I deeply regret. Several years earlier Rush Kress thought he had bought the portrait of the Princesse de Broglie by Ingres, but Wildenstein had for various reasons been unable to deliver it. When the picture finally arrived from France it was offered at once to the Kress Foundation. In spite of my pleas the offer was rejected, on the grounds that in the meantime a similar full-length by Ingres had been bought. I was staying in New York with

Charles and Jayne, and I told them that Wildenstein had just received the finest portrait of a woman ever painted by Ingres. We looked at the picture together, and though they liked it immensely, they thought the price too high. I then turned to Ailsa Mellon Bruce, who was just beginning to take an interest in the Gallery. I made an appointment for her to see the painting at her first opportunity, two days later. It was love at first sight, but to my horror I found the picture was by then under option. Charles had told the curator of painting at the Metropolitan Museum, in strictest confidence, that he had seen the most marvelous Ingres. The curator had telephoned Robert Lehman, who immediately reserved the portrait and subsequently bought it.

This was the saddest failure of my career. The Wrightsmans were distressed at what they had done; and perhaps it was my fault and I should have reserved the picture even though I did not have a buyer. But in fairness to the dealers I have tried never to reserve a work of art unless I was virtually certain it would be purchased.

I was pleased when the Wrightsmans stopped buying Impressionists and decided to go further afield. The rich in this country have bought so many Monets, Sisleys, Pissarros, Renoirs, et cetera, that their apartments, along with wall-to-wall carpeting, often seem to have wall-to-wall Impressionism. It was delightful to know that Charles and Jayne wanted something else.

They told me that they had decided to hang above their commodes and fauteuils some *dix-huitième* paintings. Did I know of any? There were two lovely paintings by de Troy I had seen on Fifty-seventh Street, and I had pleaded with Rush Kress to buy them for the Gallery. He thought them too suggestive, though the impropriety went no further than a gentleman adjusting a lady's garter. I told Charles of their rejection and my dejection. He bought them immediately and acquired two of the most ravishing glimpses of the *ancien régime* I know. I next called his attention to a much more important painting, *The Portrait of a Girl* by Jan Vermeer from the collection of the Duc d'Arenberg. As soon as I learned it was in New York I again begged Rush Kress to buy it. If only it had been owned by Contini I would have had no trouble; but this was a masterpiece in quality far beyond the range of the count's acquisitions, though its price was no higher than some of the pictures he was selling the Kress Foundation.

Heartbroken by the failure of my interview with Rush Kress, I went out to lunch with the Wrightsmans; and Jayne, with her usual sensitivity to the moods of her guests, asked me why I was so depressed. I told

Jean-François de Troy, *The Garter*. A ravishing glimpse of the *ancien régime*, although Rush Kress thought it too suggestive! Collection Mr. and Mrs. Charles Wrightsman.

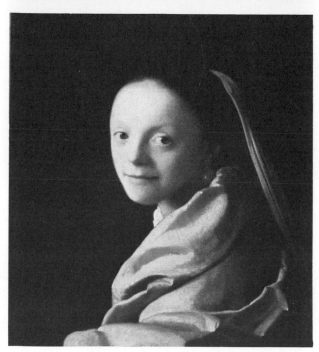

Jan Vermeer, *Portrait of a Young Woman*. The most important painting I helped the Wrightsmans to get. Collection Mr. and Mrs. Charles Wrightsman.

her the story and added that Germain Seligman, the agent (Germain
Seligman had dropped the final *n* of his father's well-known name),
had left that day for Europe and had arranged for the Vermeer to be
returned to its owner in Belgium.

Charles at once wanted to see the picture. I rang up the Seligmann
Gallery and spoke to a secretary. She said the picture was in a vault
awaiting the packers, and she had been instructed to show it to no one. I
behaved inexcusably. I threatened never to buy another work of art
from her employer unless she produced the Vermeer at once. The
National Gallery was an important customer and the poor woman was
in a dilemma. She decided that it was better to violate her orders than to
offend a valuable client, and she agreed to show the painting if we came
immediately.

When we arrived she was ashen, but the picture was on an easel.
Jayne when confronted by a masterpiece usually displays a warm
enthusiasm. She was silent and Charles looked at the picture coldly. My
heart went out to the secretary, and I felt an abominable cad.

Charles and Jayne left soon after for Paris, and I tried to put the
unpleasant incident out of my mind. One day I received a cable saying
the Vermeer would remain in America, as I had wished; and would I
like it on loan at the National Gallery with the compliments of Charles
and Jayne Wrightsman. I sincerely hope Seligman gave his secretary a
large bonus.

On another occasion I was involved with the Wrightsmans in the
purchase of a picture which in the long run turned out to be possibly
the most costly painting in history. We were in London together, and
Jayne saw the portrait of the Duke of Wellington by Goya, which was
to be auctioned at Sotheby's. She coveted the painting passionately.
Realizing that the bidding would be high, Charles decided to go way
beyond the highest price ever paid for a Goya at auction. With alarm-
ing rapidity he found himself bidding above his top figure. Rather
breathlessly he whispered to me, "What shall I do?" Jayne whispered
in my other ear, "Tell him to go on!" At an auction decisions have to be
made in seconds, and Charles bravely continued till the picture was
knocked down to him at $392,000.

When the newspapers learned that the portrait of England's hero had
been bought by an American there was an uproar. Export was tempo-
rarily blocked, and everyone turned to the National Gallery in London
to exert its right of pre-emption and prevent this intolerable loss to the
British people. Sir Philip Hendy, the director of the National Gallery,

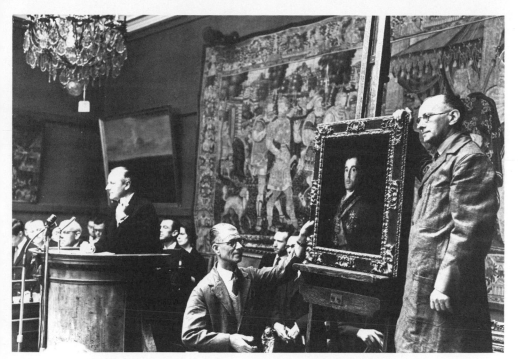

Sotheby's June 14, 1961. The auctioneer's hammer comes down on the bid of £140,000 for *The Portrait of the Iron Duke* by Goya. (Photo by The Sport and General Press Agency, Courtesy of Sotheby's)

Francesco Guardi, *View of the Villa Loredan near Paese*. Outwitted by Jayne Wrightsman! Collection Mr. and Mrs. Charles Wrightsman.

did not particularly want the painting, which he thought should be the responsibility of the National Portrait Gallery, nor did he have the money to buy it back from the Wrightsmans. He tried to get an appropriation from the British Treasury and failed. He turned to all the rich Englishmen he knew, except X, without success. Finally, the president of the board of trustees told him that he must go to X and ask his help. Sir Philip demurred and pointed out that X was considering a gift of several million pounds to the National Gallery for the purchase of French Impressionist and Post-Impressionist paintings, which the gallery badly lacked. Therefore he was unwilling, he said, to request this relatively small sum while negotiations were in progress. The president, however, insisted, and Sir Philip reluctantly went to X. He received an unenthusiastic donation.

Charles's money was refunded, and the portrait was sent to the National Gallery. Almost on delivery it was stolen. X was shocked and decided he would prefer to give his money elsewhere. Thus Wellington's portrait cost the National Gallery a vast amount, far beyond the few hundred thousand dollars repaid to the Wrightsmans. Its recovery after many months scarcely lessened the director's sense of deprivation. He still thinks wistfully of the endowment he might have had.

Charles and I were not always on the same side at auctions. At the sale of *La Liseuse*, which I have described in the second chapter, we were bitter antagonists. How I wished then that I had never interested him in painting! How I wished Jayne's taste had never improved! *La Liseuse*, I am delighted to say, is not in the Wrightsman Collection.

For by the time *La Liseuse* was sold, Charles had told me that he had changed his will and that his paintings were no longer destined for the National Gallery of Art. He was living in New York, near the Metropolitan Museum, of which he had become a trustee and an important member of the executive committee and the purchasing committee. I understood his reasons for this change, and the loss to the National Gallery of Art, though personally heartbreaking, has not affected our friendship.

Had I known from the beginning that the Wrightsman Collection in all probability was going to the Metropolitan Museum, would I have acted the same way? The answer I think is yes. I wanted more and better collections for America, and I considered it part of my job to try to bring this about. To focus all my attention on the National Gallery of Art would have been too parochial. One had to hope for the best, and if the collection went elsewhere then some other museum would be the

gainer. In any event the public would be the ultimate beneficiary. This was and still is my philosophy.

The Wrightsmans and I were now rivals, and our new relationship was exciting and sometimes entertaining. Once, cruising on Charles's yacht, we stopped in Venice to see the definitive show held that summer of the work of Francesco Guardi. Jayne and I were fascinated by one landscape of exceptional beauty and of an unhackneyed subject, the Villa Loredan in the Veneto. I looked it up in the catalogue and to my delight saw that it was lent anonymously, which probably meant that it had been lent by a dealer. (Museums do not like to advertise pictures that are for sale.) A little ungraciously, as Jayne wanted the picture and I was her guest, I sneaked away to the office of the director, whom I knew, and asked the lender's name. He *was* a dealer, and I rushed to London, saw him, but found he wouldn't sell the painting, which was part of his private collection. Jayne is the fairest of competitors. She did not resent my getting to the dealer first. She simply discovered there was a companion piece of greater beauty and bought it.

Her judgment about works of art is quick, precise, and determined. Given the similarity of our tastes, when I was buying for the Gallery I generally avoided going to dealers with her; but one day we were at Knoedler's together, and we were shown a transparency of a painting by Gian Domenico Tiepolo, which had been in an exhibition in Venice we had seen several years before. Jayne's memory is remarkable, and the moment she saw the reproduction she remembered the original, which depicted with glowing color Venetians in carnival attire embarking in a gondola. I was about to say, "Reserve it for the National Gallery," but she was quicker with, "I'll buy it." The dealer was overjoyed. Private collectors have a big advantage over museum directors. A reserved picture is in limbo, sometimes for months, until a meeting of the museum's board of trustees. In a seller's market this can represent a considerable loss.

The Wrightsmans have also followed the trail of works of art, which might be for sale, to the homes of many private collectors. I flew in their plane all over Europe: to Holland to see the Van Beuningen Collection, which we mistakenly thought might be bought; to Aschbach to see Baron von Pölnitz, whose *Christ Calling Peter and Andrew* by Pieter Bruegel the Elder was for sale at a price that staggered us and was later to stagger the Canadian government; often to Liechtenstein, where I bagged many trophies; and elsewhere on the Continent. Our pilots were two Texans; and though English is the international lan-

guage of air control towers, how anyone on the ground could under-
stand their heavy Texan accents still baffles me. Once when I was
standing in the cockpit, flying over the Alps from Munich to Florence,
the pilot looked at a town and then consulted his map and asked me
where he was, was he over PadÓVA or VÉRona. I told him he was over
Vicenza. I had recognized the Villa Rotonda. But somehow we always
arrived safely!

Sometimes when the Wrightsmans were pursuing private collectors,
the dealers were pursuing them. Then the hunters were hunted, occa-
sionally with amusing results. A Milanese jeweler was a picture dealer
on the side. He thought Charles collected jewels and wrote constantly
asking to come to see him. Charles always threw away the letters, but
when he learned the jeweler also had four superb Canalettos, he became
more interested. The jeweler, hoping to sell two pink diamonds which
he considered of tremendous value, pressed for a meeting, and Charles
reluctantly agreed.

The jeweler arrived at Cipriani's with his precious stones and his
paintings, which he stacked against the wall. A long discussion followed
about the pink diamonds, their rarity, their beauty, their value. Charles
seemed impressed and hinted that he might buy them and the Cana-
lettos too if the price were right. The dealer offered the diamonds at an
astronomical figure, and to make the deal attractive the Canalettos at a
reasonable price. To his dismay Charles immediately bought the paint-
ings and said he did not want the jewels, rare and beautiful as they
were. Disconsolate, the dealer returned to Milan with his diamonds and
Charles brought home the Canalettos, which when cleaned proved to be
among his most important early works.

These paintings were acquired after I had ceased to advise Charles.
Although Jayne was quite capable of making decisions without profes-
sional counsel, Charles still asked advice of Theodore Rousseau and his
successor, Everett Fahy, formerly curators of painting at the Metropoli-
tan Museum, and Francis Watson, who edited the catalogues of his
collection. Their search for works of art was extraordinarily rewarding.
They bought many paintings I would have loved to have had for the
National Gallery of Art: works by Gerard David, El Greco, Georges de
La Tour, Poussin, Rubens, van Dyck, Gian Battista Tiepolo and others.

These paintings will one day be in a museum; but how well, Charles
wonders, will they be looked after? Aware that there is a scarcity of
qualified museum personnel, it has seemed to him imperative to in-
crease the number and improve the quality of future curators and

museum directors; and to accomplish this he has given time and money to the Institute of Fine Arts of New York University, of which he was the chairman of the board of trustees until recently, when he retired. He has also underwritten the Wrightsman lectures at the Metropolitan Museum, which have been delivered annually by the foremost European and American scholars and subsequently published. All these efforts to stimulate the study of the history of art have their basis in conversations and correspondence with B. B., whose influence has been far more fruitful than he would have believed possible during his lifetime.

All of us are molded by circumstances: in the case of the Wrightsmans it was meeting Judge Untermyer at the Metropolitan, myself on the yacht, B. B. at I Tatti, weaving his magic net of words. These chance encounters drew Charles and Jayne to art, induced them to collect, stimulated their interest in scholarship. The result has been a satisfactory, useful, and exciting way of life. They have known the prestige of a great collection, and they have experienced the power of influencing the activities of a great museum. Yet in the style of life they have so successfully chosen, I feel the most rewarding result has been their friendships with scholars and museum professionals who have shared their interest in the search for works of art.

13

———————

Three English Colleagues:
Francis Watson, John Pope-Hennessy,
Kenneth Clark

Museums in America were originally patterned on those in Europe. In recent years they have diverged from this pattern and the differences are increasing. I have chosen the three most brilliant English museum directors I have known, Francis Watson, John Pope-Hennessy, and Kenneth Clark, to illustrate by their training, their careers, and their philosophies something of this divergence.

But it is disconcerting to recognize at the outset that what these men have given us as scholars, writers, and connoisseurs, cannot in any way be matched by my colleagues at home. What then is the explanation? Early training, allocation of time, problems with trustees, fund raising, donor hunting, social demands? All these are different in America and Europe, and all have their influence. In making a judgment these factors must be taken into consideration. I have tried to do this in what I have briefly written about these three distinguished scholars and museum directors. I hope in their careers and their opinions may be

found some of the answers to what troubles me about my profession in America.

i

Sir Francis Watson, the recently retired director of the Wallace Collection, I have known for many years. Together we have visited most of the Greek islands and much of the coast of Asia Minor. There is no better traveling companion. His gaiety is infectious, his gossip riveting. Of medium height and slender build, his most impressive feature is the bigness of his head. His cranium seems exceptionally large to contain even *his* remarkable brain. In appearance he suggests a somewhat startled cherub, with a halo of frizzly, graying hair.

He is very popular in London, dining out a great deal, particularly now that he is a widower. When his wife, Jane, was alive their social activities were somewhat curtailed. Their time was taken up with her passion for looking after cats. In their house on average they were caring for over fifty, mostly strays that she had picked up. When she died suddenly, Francis discovered that she had placed another fifty in foster homes, and that she had been paying for their pension all over England. Since her death the cat population in the Watson *ménage* has been drastically reduced. But Francis retains a few favorites, and in the preface to the Wrightsman Catalogue he acknowledges "a purely personal debt to my Siamese cat, Miss Wu, who by consistently sitting either on my lap, my manuscript, or my books whilst I was at work taught me much about the importance of concentration."

Whether or not Miss Wu taught Francis concentration, only extraordinary sedulousness can explain his ability to publish so many scholarly books and catalogues, while at the same time meeting the demands of his museum, one of the best-maintained and most rewarding in England.

I have already mentioned the Wallace Collection in the Foreword to this book. To emulate it, as I have said, was the wish of many of the great American collectors. It was the model for the Frick Collection and for Fenway Court, though in size and variety of objects it surpasses both. These two American private museums, however, were created by single individuals, whereas the Wallace Collection was the result of five generations of collectors, four Marquesses of Hertford, and Sir Richard

Francis Watson acknowledges a debt to his Siamese cat, who taught him much about the importance of concentration.

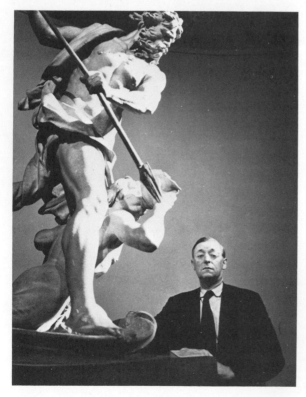

John Pope-Hennessy with the magnificent example of baroque sculpture, Bernini's *Neptune and Triton*, which he acquired for the Victoria and Albert Museum through a brilliant guess and rapid action. (Crown Copyright. Victoria & Albert Museum)

Wallace, an illegitimate son of the last. Though the museum bears Sir Richard's name, it was his father who gave the collection its importance. He was probably the greatest collector of the nineteenth century, and what one sees today represents less than half the works of art he assembled. A fire in 1874 at the Pantechnicon, the fashionable storage warehouse in London, destroyed a great deal, especially armor and enamels; and Sir Richard's wife left his secretary a huge bequest.

If the standards used in America for museum personnel had been applied, Francis would never have become director of the Wallace Collection. It is indeed doubtful that he would have been employed in any capacity whatever, except possibly for administration. For when he began his career he had neither museum experience nor had he studied the history of art. When he went to Cambridge he majored in mathematics, and in *Who's Who* he still describes his recreations as "reading, writing, and arithmetic." At his university there was no one to teach him art history even if he had wished to pursue it. When he graduated he went into the publishing business, and joined the London office of Brentano's. But in 1929 this branch was closed and he found himself jobless. One day a friend told him about the newly organized Courtauld Institute, the branch of the University of London devoted to art historical studies. He said they needed a bursar, a purely administrative and financial officer. Francis got the job and stayed until W. G. Constable, the first director, after an acrimonious dispute with Lord Lee of Fareham, the chairman, indignantly resigned. The deputy director at that time was James Mann. He too resigned in sympathy and was offered a position as head of the Wallace Collection. Francis became assistant to Mann, entering on his new job with, as he says, "no prejudicial training or knowledge," and when Mann died he succeeded him as director.

Mann gave Francis about a fortnight to look around, and then told him to write the catalogue of the furniture. It was a slow business. He worked on it from 1937 to 1956, but the war years of course interrupted his research. In the end he produced a masterpiece of its kind. This responsibility for preparing a catalogue, Francis feels, is the ideal museum education. It is far better, he thinks, than the American system which has been imitated in England: the memorizing of lectures, textbooks, photographs, to the neglect of the study of original works of art.

There is no doubt in his mind, and none in mine, that one learns only by handling, scrutinizing, and cataloguing art objects. My first job at

the National Gallery was to catalogue the Andrew Mellon and Samuel H. Kress collections. Like Francis, I learned as I worked. We both read enormously about our subject and made the work of art the focus of our attention. Charles Bell, who was keeper of the Ashmolean Museum at Oxford and greatly influenced Francis Watson and Kenneth Clark, used to say that if one ever wanted to read a textbook one should write it oneself.

Besides important books on Canaletto, Tiepolo, Fragonard, and many articles, Francis's most significant publication is the catalogue of the collection of Charles and Jayne Wrightsman, in five volumes, some of which he has written and all of which he has edited. For this impressive work, his first assignment, to catalogue the furniture in the Wallace Collection, was the perfect preparation.

As nothing at the Wallace Collection may be added to or taken away, the position of the director affords a good deal of leisure for writing and research. But there is the frustration of being unable to make acquisitions. This defect in Francis's career, however, the Wrightsmans remedied. They gave him the rare experience of helping to form one of the great collections of recent years. He once described to me the excitement of walking around Paris with Charles and Jayne, wandering into *antiquaires* after a delicious lunch, and of then spending seven or eight hundred thousand dollars of their money on furniture before tea. Collecting like this, with Other People's Money, can be extraordinarily exhilarating!

I have had the same emotions myself when I used to go to the New York dealers with Rush Kress. Francis and I have often discussed the intoxicating sense of power combined with a dreadful feeling of responsibility when OPM is burning a hole in one's pocket. We agree that the first reaction to a work of art is what matters. Francis is exceptionally quick and sure in his judgment. I am more cautious in making decisions; and when I have been advising collectors I have done a good deal of research before reaching a conclusion; but I have found that long study and repeated scrutiny almost always confirm my first impression. Research, however, does allay to some extent the butterflies fluttering in one's stomach when one spends a million or more dollars of OPM.

Sometimes research also provides the reason for buying an object. Charles Wrightsman once telephoned Francis from New York to say that he and Jayne had come across a red lacquered writing table at a dealer's, which they rather liked. What should they do? Francis told them to look underneath and see whether there were any marks which

might identify it. Charles called back to say that he had discovered a faint number, 2131, which the dealer seemed to have overlooked. He was told to wait while Francis consulted his library. In an eighteenth-century inventory a red desk which had been in the private study of Louis XV was listed as 2131! Charles bought the desk at once, and it is now in the Metropolitan Museum, one of the most valuable examples of French furniture still preserved.

Francis's knowledge about works of art is not the kind that comes from seminars and lectures which lead to degrees. Luckily he was employed before we became a degree-ridden world. Thomas Hoving, the director of the Metropolitan Museum, says he wants every curator to be a Ph.D. Yet in our time three of the greatest museum directors, who are outstanding scholars as well, Francis Watson, John Pope-Hennessy, and Kenneth Clark, are all self-educated in the history of art. They agree that their most useful assistants have been bright young men and women whom they have trained in the museum itself. Courses in "museology," so popular in American universities, they feel, are a complete waste of time, and a doctorate as a requirement for curatorial work is utter nonsense.

Thus there is a fundamental difference between the British and American ideas of museum training. Is there a difference also in basic philosophy? Francis believes museums exist to give pleasure. What the museum director wants, he says, "are people who come because they like looking at things. Doing so adds a measure of pleasure, of gaiety, of happiness to their lives. And if museums don't accomplish that, they had better be closed. They are also centers for a scholarly study of art. Publishing catalogues, for example, is important. But all this is secondary to giving pleasure to the public."

It is a simple creed, without any of the overtones of social relevance, education, and uplift one finds in America. But there are other differences between American and British museums, especially in the selection of the trustees and the director. The board of every national museum is appointed by the prime minister. It is not self-perpetuating, as it is in the United States. The prime minister is also responsible for the selection of the director, although he always consults and generally follows the advice of the trustees. This may explain why no British director of a national museum has ever been fired! There are no contracts, but for many years there seems to have been an unwritten law that directors have what amounts to tenure. In America the trustees are supposed with a few exceptions to provide or raise most of the money for the museum

budget. Thus they have the power of the purse. In Great Britain these funds are on the whole provided out of taxes. This should make the English board, I observed to Francis, different in character and less autocratic in practice.

It is true now, he agreed, but in the days before the war, after the meetings of the board of trustees of the Wallace Collection, the keeper, as he was then designated, was often in tears and had to be revived with brandy. This was all the more extraordinary as at the Wallace there are really few decisions to be made since nothing can be withdrawn or added. I suppose most of the controversy must have been about the color of the walls or the hanging of the pictures. Nevertheless, Francis says the trustees used to bully the director unmercifully. This was also the case at the National Gallery in Trafalgar Square, until a revolt in the thirties, which ultimately resulted in Kenneth Clark becoming director, overthrew the chairman. He is said to have been so autocratic that, being displeased with the rug in his office, he once compelled the person responsible for its selection to get down on the floor and smell it.

Kenneth Clark, when he was made director of the National Gallery, was instrumental in changing the relations of director and trustee. He was a man of independent means; and he was not intimidated by rich people nor was he hostile to them. Tenure of office, which at that time was on a five-year basis, meant nothing to him. His directorship was the breakthrough. Since the Second World War the character of English trustees has changed and their relations with the staff are now much more felicitous. Everyone agrees that the decline in the power of the aristocracy, from whom so many of the trustees in the past were chosen, is the explanation. There is now less arrogance and less desire for egotistical display. Have American trustees, especially those with great wealth, I sometimes wonder, assumed the posture of the British nobles of fifty years ago?

Perhaps the situation in America is also changing. But in the United States one still encounters the bitterness of the professional staff toward what they consider their overlords, the board of trustees. I never shared this resentment, nor had I any reason to, for my trustees were always amiable toward me though not always toward each other! Doubtless our pleasant relationship explains in part my delight in my job, but I was keenly aware of a different point of view whenever I attended a meeting of the American Association of Museums. I remember hearing a curator bitterly observe, "Bootblacking sandwiches are served in our cafeteria to get us used to the taste of shoe polish." I had an associate

whose wealthy father tried hard to persuade him not to take up a museum career. He had been a trustee himself; and he wished his son, if he had anything to do with museums, to sit with the board, not be subject to their authority. In some museums in recent times the director has been elected a trustee, but events have proved that his position is no better unless the others consider him a part of their peer group.

Francis pointed out to me that British museum directors have one immense advantage over their American colleagues. Most of their donors are underground! If they had to spend the amount of time flattering benefactors required of an American director, they would not be the scholars they are. Americans are far better paid but much more driven. Perhaps this explains why the directors of our museums have produced so few publications of scholarly significance. They are promoters and evangelists, not scholars in the sense that Francis Watson, John Pope-Hennessy, and Kenneth Clark can claim to be.

ii

Although John Pope-Hennessy believes museum directors are not called on to be scholars, he is most certainly one himself. His many books on Italian paintings and sculpture reveal meticulous research expressed with exceptional literary grace. It is difficult to find his peer among European art historians, and impossible among Americans. To publish so extensively and at the same time to run a large museum requires genius. John puts it differently. He says it calls only for a freakish power of concentration and organization. But he acknowledges that many of his publications were written while he was still keeper of architecture and sculpture and earlier when he was assistant in the department of painting in the Victoria and Albert, or V. and A., as it is usually called. When he became director his writing slowed down, and now that he has become the head of a still more complex institution, the British Museum, his leisure for scholarship may diminish further.

I knew him first when he had just begun his career. He arrived at I Tatti with a letter of introduction from Logan Pearsall Smith, B. B.'s brother-in-law. He came under the worst possible auspices. Relations with one's wife's family are often uncertain, but in the case of Logan, B. B. felt no uncertainty. His dislike was positive, its intensity increased by the necessity of concealing it from Mary Berenson. He once told me how maddening he found Logan's incessant frivolity, probably a conse-

quence of manic depression. When Logan arrived in Florence he had always just emerged from the shadows of melancholia, and had reached a stage of repellent cheerfulness, full of chuckles, practical jokes, and endless, rather pointless gossip. B. B. was convinced any protégé of Logan's must be a disaster. It was many years before John's immense ability was recognized at I Tatti — especially as he was preaching in B. B.'s parish, Italian fifteenth-century painting, and the doctrine he taught did not precisely accord with that of the master.

John has never lacked confidence in himself, and B. B.'s hostility probably went unnoticed. He has known from an early age exactly what he intended to do. As a child of twelve, when he was living in Washington, where his father was the military attaché at the British embassy, he bought Crowe and Cavalcaselle's *North Italian Painting*, which he devoured. He decided then and there that he would be an art historian. At Oxford he read history, but his time was devoted to writing the first of his remarkable books. It was on Giovanni di Paolo, a Sienese painter of the Quattrocento. Published shortly after his graduation, it is still a standard reference work.

It was not B. B.'s favorite reading — there were too many implicit criticisms — nor was John's second book, which dealt with Sassetta, a contemporary of Giovanni di Paolo, any more popular at I Tatti. Sassetta was an artist for whose emergence from obscurity several art historians claimed credit, but for his debut as a painter of stature, B. B. felt himself, with reason, solely responsible. John was the younger generation knocking at the door, pushing it open, and entering B. B.'s sanctuary with little if any deference. Later they became attached to one another, but B. B. was always very much on his guard.

I remember John's striking appearance, which in forty years has changed scarcely at all. He is tall and thin, with sharply drawn features, reminding one of a Florentine intellectual of the sixteenth century, the type of noble who might have been painted by Bronzino or Salviati. When he removes his glasses he gives the impression of an almost total lack of vision, but when he puts them on again one is immediately aware of his penetrating sight. He has two of the best-trained eyes in the museum profession. He has kept them in training by constant exercise, scrutinizing day in and day out the most diverse works of art. I remember as though it were yesterday his high-pitched voice and explosive laugh ringing through the library at I Tatti. Since then this unmistakable sound has been heard in the galleries of nearly every museum in Europe and America.

John had no particular wish to work in a museum. When he left Oxford, however, he found that an embryo art historian, coming on the scene before departments in the history of art had been established everywhere, had to turn to a museum for his livelihood. His family knew Sir Eric Maclagen, then the director of the Victoria and Albert, and to apply to him for a job was natural. John was made assistant keeper in the department of painting, the bottom of the ladder. He continued to write while doing his official duties, and produced the best works in English, or probably any language, on Paolo Uccello and on Fra Angelico. He also catalogued the drawings of Domenichino at Windsor Castle. When he subsequently transferred to the department of architecture and sculpture, he covered with equal brilliance an entirely different field of art history. He wrote three definitive works on Italian sculptors during the Gothic, Renaissance and baroque periods. He has also published books on Sienese Quattrocento painting, on Renaissance portraiture, and on Raphael, and he has catalogued the Italian sculpture in the Victoria and Albert, the Frick Collection, and the Renaissance bronzes in the Kress Collection, all model publications of their kind.

On the retirement of Trenchard Cox, John was the obvious choice for director of the Victoria and Albert. It is the most comprehensive museum in Great Britain, and his own knowledge of art is just as all-embracing. Having myself directed a totally different type of museum, one focused on painting and sculpture, I have often argued with him the disadvantages of one person being ultimately responsible for so many different departments. In America, where all the large municipal museums are comprehensive, I have pointed out that the directors and the staff are often at daggers drawn. John says he cannot imagine why. He himself certainly has experienced no hostility. He sees no reason why running a museum is any different from running a university, where there is a still greater diversity of faculties and disciplines. Administration is not a problem as long as the director and keepers or curators agree on what a museum is all about, and on what constitutes a masterpiece; and as long as the director does all in his power to acquire these with an equitable distribution of purchase funds.

The historical background of the Victoria and Albert is unlike any American museum. The founders in 1852 wished to assemble a collection with a utilitarian purpose: to assist manufacturers and artisans in their work. The new museum was the outcome of a Victorian miscalculation, which at the very beginning Palmerston, then prime minister,

recognized. Less blinded by what the Victorians considered Enlighten-
ment, he took one look at a collection just purchased for the museum
and observed realistically, "What use is this rubbish to our manufac-
turers." J. C. Robinson, who was the first director, doubtless agreed. He
was in favor of filling the V. and A. with great works of art of no
utilitarian value whatever, and in accordance with this theory he
bought brilliantly when masterpieces were everywhere available. His
superiors, loyal to the founders' intentions, reprimanded him, relegated
him to an inferior post, and forced him at an early age to retire. Though
he was never fired, he came closer to it than any subsequent English
museum director. But he was right. The effect of the collections of the
V. and A. on English commerce has been minimal but on English
culture immense.

For many years Robinson's misfortunes haunted his successors. The
buying at the V. and A. was "plagued by a kind of contagious timidity,"
to quote John. This is reflected in the minutes of the acquisitions com-
mittee. "Very pretty late seventeenth-century *altorilievo*, French no
doubt. Worth I think ten or fifteen pounds. Very desirable at the former
price." Or of some chessmen offered to the museum, "Good, cheap,
genuine, and full of life and spirits." The "life and spirits" of these
chessmen now languish in storage; the *altorilievo* has vanished!

The problem is common to all museums. "An in-built tendency to
stamp collecting," as John puts it, "to buying for small sums objects
that are of interest solely for the reason that nothing similar exists in
the collection. . . . In the long term . . . major acquisitions are the
only acquisitions that count." How I agree! When I was director of the
National Gallery of Art I refused to indulge my staff in what I call
"curatorial purchases," minor objects solely of art-historical interest or
useful to fill gaps in the collection. Such acquisitions are the plague of
American museums. The risk in buying these inexpensive works of art
is commensurate with their low price, and their significance is in
proportion to both. But their cheapness makes them popular with
trustees, and being objects of curiosity rather than of beauty, they have
a strong curatorial appeal. I was struck visiting the Metropolitan
Museum during World War Two to find that the great treasures given
by private collectors had been sent away for safekeeping, while less valu-
able paintings and sculptures bought by the curators had been brought
out of storage and correctly judged to be expendable. "Curatorial
purchases" are an inexcusable way of spending Other People's Money.

John has concentrated on major acquisitions. These are vital to his

concept that every cultural area must be represented by its own masterpieces, and masterpieces alone will provide the visitor, he feels, with the basic educational experience of moving from one culture to another simply by walking through a door, and of finding in each new room superlative works. This is a goal of all good museum directors, of course, but it is amazing how close John has come to reaching it.

The baroque style, for instance, needed a magnificent example of sculpture which would illustrate its mastery of movement. John found the perfect piece in the group by Bernini representing Neptune and Triton. This masterpiece he saved for England through a brilliant guess and rapid action. A friend, who was a buyer for Wildenstein, the biggest art dealer still left in business, mentioned in a casual conversation that he was off to Lincolnshire for the weekend. John, a little suspicious, wondered why Lincolnshire. When he returned to his office he asked for a map and drew a circle with a diameter of fifty miles and Lincoln as its center. Like a bolt from the blue came the realization that Brocklesby, the estate of the Earl of Yarborough, fell within the circle. Next morning the museum secured an option to buy what is generally considered Bernini's greatest work outside of Italy. It was ornamenting a fountain in the rose garden! They beat the Wildenstein representative by a few hours.

Another splendid acquisition was the monumental sculpture of Samson slaying a Philistine by Giovanni Bologna. In this case a former director of the V. and A. made a discreditable mistake. In the 1950s Francis Taylor, then in charge of the Metropolitan Museum, asked Leigh Ashton, who directed the V. and A., whether there would be any difficulty about the export of this statue. Without consulting his staff, Leigh said there would be absolutely no objection. But when John learned that the most important work of its kind in England was about to be shipped abroad, he went over the head of his superior, and arranged for the export of the statue to be blocked. The V. and A. subsequently purchased the statue. I saw Francis Taylor shortly afterward. He was outraged at what had happened, and I shall never forget his unprintable comments on his English colleagues. His language was always pungent, but it reached new levels of expletives.

But Francis Taylor's frustration illustrates a problem of American museums. Whereas John Pope-Hennessy and other British museum officials have purchased in New York, without restrictions of any kind, outstanding works of art, in Great Britain the law is on their side and they have the right to ask for a delay in the export of similar objects. If

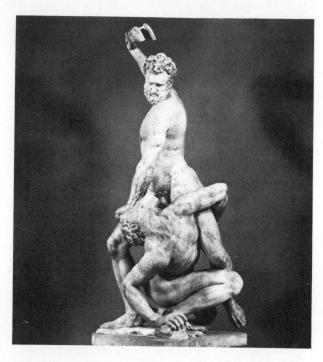

Giovanni Bologna, *Samson Slaying a Philistine*. Francis Taylor reached new levels of expletives when this monumental sculpture eluded his grasp! (Crown Copyright. Victoria & Albert Museum)

Jacopo Alari-Bonacolsi (L'Antico), *Meleager*. John Pope-Hennessy's superlative and touching purchase. (Crown Copyright. Victoria & Albert Museum)

granted, export can be held up for many months, to give a British museum pre-emptive rights at the purchase price. This is certainly not reciprocity. I have always advocated legislation to give our museums a similar right of pre-emption. Why the American Association of Museums or the Association of Art Museum Directors, who have gone on record in favor of supporting the export restrictions of other countries, have not pressed for some similar laws in the United States continues to puzzle me.

The export restrictions in Great Britain, however, are more liberal than those elsewhere. At present Switzerland and the United States are the only completely open markets in works of art. Other countries make their export extremely difficult, and most American museums have consequently acquired objects which have been smuggled. The Italian regulations are the oldest and the most restrictive in Europe. In the nineteenth century even the V. and A. was caught trying to circumvent them. Its smuggling was on a particularly heroic scale, which one cannot help but admire. The huge Malespina Monument, some thirty feet in height, and weighing many tons, was secretly shipped out of Verona. Our American museum directors would have boggled at a surreptitious transaction of such gigantic proportions. The scheme was exposed, but the monument remained in London. Nevertheless, the Italians imposed a large fine on the dealer, which was ultimately paid out of the V. and A. purchase funds.

John, while at the V. and A., made many superlative purchases, which form an impressive array. Not the most important but perhaps the most touching was from a small dealer in the Fulham Road. It resulted from the V. and A.'s policy of permitting the public to bring in works of art every weekday afternoon for the staff to examine. This is a policy I also followed at the National Gallery, but with strong opposition from our legal advisors, who feared we would be sued, though nothing ever materialized. I have always felt it wrong that so many American museums, worried either by the possibility of lawsuits or out of ineptitude and laziness, refuse to help the public in what I consider an essential way.

In the case of John's fortunate acquisition the owner of the sculpture had been a member of a "ring." In this case when the booty was divided up, the unlucky Fulham dealer got only a bronze statue valued at fourteen pounds, which the others left on his hands thinking it part of an Empire clock. John examined it, and told the dealer it was a statue of

Meleager by a famous Renaissance master, Jacopo Alari Bonacolsi, known as L'Antico. He gave the owner some idea of what it was really worth, which was a great many times fourteen pounds, and the delighted dealer departed. Some days later he returned and said that he had taken his bronze to Sotheby's, who told him it might fetch twice as much as John had estimated; but, he added, since he had been treated so decently over an object he considered worthless, he had decided to let the museum have the statuette for the amount they had said it was worth. It is now in a place of honor among the Renaissance bronzes at the V. and A., which are probably the finest in the world.

I once asked John what he thought art museums were all about. He always has a positive and lucid answer. He said they are quite simply places where works of art are put to use. They can be used in a number of different ways simultaneously: for education, for scholarship, as a stimulus to creation, but above all for pleasure. Was there, I inquired, any pressure to change this traditional point of view, to make the museum more "relevant," a word popular with many museum directors in the United States? "Relevance, if it has any application to museums," John replied, "means simply that the collections must be so displayed as to appeal to a large, inquisitive, fairly well-educated public most of whom have no specialized interest in the works of art they are looking at. Only if the display is boring (which certainly does not seem to be the case at the V. and A.) will the works shown appear irrelevant. Otherwise the terms 'relevant' and 'irrelevant,' when applied to museums, are meaningless."

After many years of observation he is convinced that museums need not compromise their standards to justify themselves, that there are enough people of education to enjoy works of art, to learn from them, to be inspired by them, and that these visitors need no stimulus from ballyhoo, promotion, or sensationalism. His point of view is taken for granted in Europe, and it was also once the accepted belief in America. But Populism and the fear of seeming to favor the elite are changing the direction of our museums. Recently, in the United States, there has been an increasing emphasis on publicity, on the monetary value of works of art, on attendance figures, which are often grossly falsified, and on shows that are transparently propaganda. Community relations have been given such importance that the distinction between an art center and an art museum is vanishing. For those who love works of art for their own sake the result is heartbreaking.

iii

In a broadcast, when the camera is focused on him, Kenneth Clark is apt to look a trifle smug; and when one thinks of his career with its astounding success as a collector, museum director, television administrator, actor and above all writer, smugness is certainly justified. But he is really far from complacent. He is, instead, introspective, self-critical, and extremely modest. When one sees him, the impression he makes is of a slender, active man with beautiful hands that gesticulate expressively. His head is rather large, and under his squarish cranium, his alert gray-blue eyes seem when he is broadcasting surprisingly small. His expression on television can sometimes be mistaken for sardonic amusement, but it is really the defensive mask of a diffident, rather apprehensive actor anxious to beguile and charm his viewers, a task at which he invariably succeeds. In real life his face is more relaxed, and without his forced smile his eyes seem to have grown surprisingly larger. Off the television screen he is much handsomer and much more winning. His wit, responsiveness, and intelligence make him one of the most attractive human beings I have known.

The popularity of *Civilisation*, the superb series of broadcasts he made for the BBC, should restore to American museum directors some of their former faith in the taste and appreciation of a large, educated public. In the United States and Canada it has been seen by millions of viewers. In Great Britain the whole series has been presented four times. It has been shown all over Europe, including such Iron Curtain countries as Bulgaria, Rumania, Hungary, Yugoslavia, Poland, and Czechoslovakia. Only in France has it not been seen. The French cannot bear to have anyone who is not French talking about civilization.

Kenneth Clark himself is surprised by the success of this television series. No more surprised, I suppose, than William Paley, chairman of CBS. Charles Wrightsman, when in London one summer, was taken to an advance showing of several of the broadcasts; and when he arrived in Greece for his annual cruise on his yacht, he brought with him all the texts and asked me to read them and tell him whether he was wrong in believing that they were magnificent and would have a tremendous success if shown in America. I agreed wholeheartedly, and as soon as Charles returned to New York he arranged a dinner for the Paleys with

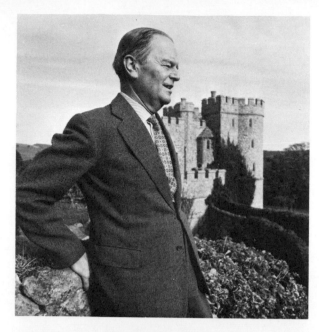

Kenneth Clark with, in the
background, his home, Salt-
wood Castle, from which the
knights of Henry II rode to
Canterbury to murder
Thomas Becket.

Amedeo Modigliani, *The
Little Peasant*. Returning
this painting was one of the
greatest mistakes Kenneth
Clark ever made. The Tate
Gallery, London.

a special showing of a part of *Civilisation*. He was convinced that CBS would immediately negotiate for the rights to televise the program in the United States. Bill Paley spoke to me between two films and asked if I was not bored. I was amazed and said, on the contrary, I was absorbed. He concluded our conversation by saying that CBS would never put on *Civilisation*. It would not interest enough people. Eventually it was broadcast by educational television and its popularity was fantastic. Bill underrated the intelligence of his audience. He was right in deciding *Civilisation* was for a special group, those reasonably educated people anxious for some intellectual challenge; his mistake was in his estimate of their number. In the end, always ready to recognize an error, he changed his opinion, and CBS televised *Civilisation* nationally on Sunday evenings at the best possible time.

Kenneth Clark's audience comprises an underprivileged minority in America, but even so one more numerous than the managers of our mass media calculate. The intelligentsia has classified these seekers for self-improvement as middlebrow, and it is axiomatic to disparage their taste. Due to them, *Civilisation* as a book was on the best-seller list in America for weeks; but so pervasive is this intellectual snobbery that even Kenneth Clark himself wonders whether the picayune criticism of a few dons and professors may not have some validity. He is not sure whether what he has written is a masterpiece of synthesis, as I believe, or a mass of superficialities as some specialists claim.

It is difficult to get an unbiased judgment. Kenneth, or K. as he is known to his friends, has always had a complicated relationship with the intellectual world. He has been a close friend of the greatest art historians of our time, Johannes Wilder, Ernst Gombrich, A. E. Popham, and many others. But there are those who resent his ability to reach a huge popular audience, and at the same time to produce a catalogue like that of the Leonardo drawings at Windsor Castle, which is a model of painstaking scholarship. He has brought more people to an understanding of art than anyone writing in English since Ruskin. But Ruskin never claimed to be a scholar, and today we are astonished by his art-historical errors, which are at times hair-raising. The extraordinary fact about K. Clark is that he combines scholarship of a high order with a remarkable power of generalization expressed in a style lucid and arresting. This is the rarest of combinations among art historians.

Apart from his popularity as a writer he has, from the point of view of the more pedantic and stodgy members of the academic fraternity, two other defects: he is the son of rich parents and he is worldly. I

sympathize, for I too have felt a somewhat similar animus. Our milieus are much the same. We are descended from industrialists who became rich, and our fathers, who combined idleness with speculation, dissipated a good deal of what we hoped to inherit. Each of us was an only child, and we both had devoted nannies (mine saved almost everything she earned and left it to me). When young we both had inordinately large allowances.

K., however, was wiser in the expenditure of his money. When at the age of sixteen he was given a hundred pounds, he spent sixty of it buying the Modigliani *Peasant Boy*, now in the Tate Gallery. Unfortunately, as it did not fit in with his family's collection of Barbizon masters, he returned the painting "with my usual feebleness of character," as he puts it, and got his money back, one of the greatest mistakes he ever made.

But from an early age he had the acquisitive instinct of a true collector. He was encouraged in this by his father, who was delighted by all his artistic inclinations. The elder Clark was a collector too, and covered his walls with paintings now out of fashion, but very beautiful, I am told. Far stronger than his love of art, however, was his love of gambling. He spent much of his life on the French Riviera. He was one of those who literally "broke the bank at Monte Carlo." His luck was incredible. For a time the family fortune, based on great-grandfather Clark's invention of the cotton spool and his profitable thread factory, actually increased. But K.'s father, unlike those austere, industrious Scots who were his ancestors, was a speculator. He found gambling at the roulette table insufficiently lucrative, and he turned to speculative investments. He bought an aluminum company and poured money into it. A large dam in Wales was built to provide the necessary hydroelectricity. K. is prepared to admit that there may have been many people in Great Britain richer than his father, but he insists there were few lazier. Paying no attention to the construction of the dam, the elder Clark allowed the engineers and contractors to make a large profit, but also to provide an inadequate foundation. One evening Mr. Clark came home and showed his family a newspaper headline, "Disaster in Wales." The dam had burst, and swept away a village. The Clark fortune, in great part, was literally down the drain. It is much to the credit of Mr. Clark that he spent over a million pounds of his own money restoring the village. Though K. was preparing himself to be an art historian, he gave up his studies for a time, took a place on the board

of directors of the family firm, helped to reorganize the business, and sold the aluminum company as profitably as possible. He then returned to Italy to continue his art-historical research. Although he is too modest to claim credit, it is probable that without his assistance his father would have been ruined.

As Monte Carlo was no place for a growing boy, K. spent much of his childhood alone with his nurse on the family estate in East Anglia, where his parents came annually for the shooting. He thought in those days that he would be a painter. This was still his ambition when he went up to Oxford, where he designed the costumes and the scenery for Monteverdi's *Orfeo*. But one day he came across a sentence written, he thinks, by Arnold Bennett. It read, "If an Englishman feels he can both write and paint, let him be a writer." This K. took to heart, gave up painting, and began his book on the Gothic Revival.

But to return to his career as a collector, after his youthful purchase of the Modigliani, K. made many astute buys, as well as a few foolish sales. Among the latter there was the outstanding mistake of parting with the Matisse *Studio, Quai St. Michel* in 1940 for a paltry fifteen hundred pounds. It was bought by Duncan Phillips and is generally considered one of the greatest masterpieces in that extraordinary collection. A dealer once told me that he had only two regrets: what he had failed to buy and what he had sold. K. could say the same. But what he did acquire is impressive. For example, one day in 1929 he and his wife Jane wandered in to see Paul Guillaume, just as the Parisian dealer was opening a packet of fifty watercolors, which Cézanne's son had brought in for sale. The Clarks bought the lot for six pounds apiece. A single Cézanne watercolor recently sold for £200,000.

In the twenties and thirties K. was collecting actively. He acquired a number of Cézanne oils from Vollard for between eight hundred and fifteen hundred pounds each. It has always fascinated him that if one were willing to appear at Vollard's apartment, sit and wait for the old gentleman to shuffle in, meanwhile smelling his lunch being cooked in the next room, one could get these incredible bargains; but millionaire collectors preferred instead to go to the dealers in the fashionable part of Paris, where they were flattered, bowed to, sat down, stood up, given a cigar, and after this treatment, which they loved, shown pictures which had come from Vollard a few days earlier and which were offered at ten times the original price. Chester Dale was one of these millionaires. His friends at Georges Petit successfully kept him away from Vollard. But

Chester was probably too truculent a character to get on with this eccentric old man, who had been a friend of so many of the Post-Impressionists.

K. had limited funds and he could not afford the markup of the big dealers. Whenever he was in Paris he regularly visited the less-known galleries, those not yet discovered by Americans like Chester. He bought quickly and without hesitation. His superb Seurat, the *Bec de Hoc,* which he sold to the Tate Gallery, he acquired without seeing the original. He paid £3,500. So delighted was the owner to receive such a large sum that she added a second Seurat, the beautiful *Sous Bois,* which he prefers to "the rather aggressive rock," as he describes the painting he felt compelled to sell.

I once asked K. which he considered the greatest painting he had owned. He said the *Baigneuse Blonde* by Renoir. This cost him more anguish to part with than anything else. But he was in serious financial straits and it was necessary to give up the Renoir or Saltwood Castle in Kent, from which bastion of the Middle Ages the knights of Henry II rode to Canterbury to murder Thomas Becket. He now thinks he made a bad choice. This was before his writings brought him enough money to live on, as they do now.

Although he has collected every type of art, and always with unfailing perspicacity, he is proudest of his patronage of contemporary artists. He has bought works by Henry Moore, Graham Sutherland, Victor Pasmore, John Piper and others when they were virtually unknown, and he has given over a hundred of their drawings, canvases and statues to provincial museums, a generous gesture he sometimes wistfully regrets. When he was the chairman of the British Arts Council from 1953 to 1960, he used his position to make it the outstanding patron of the more advanced painters and sculptors. Much of the renaissance in contemporary English art is owed to his encouragement. Artists have continued to be his closest friends and it is in this milieu that he has been happiest.

It is a milieu that I know less well than he does, much to my regret, but in other respects the similarity of our backgrounds has been a bond between us. I have always felt closer to K. than to anyone else in our profession. I have had perhaps few intimate friends in the museum and art-historical world, but for these few I have felt a deep sympathy. With K., however, I have had a special relationship. I owe him a great deal; among other things there was his strong recommendation to David Bruce, then a trustee of the A. W. Mellon Educational and Charitable

Trust, who consulted him about a chief curator for the future National Gallery of Art, that I was the best bet. I hope it was a bet that paid off.

Nevertheless, my outstanding debt is to his wife, whose contribution to my career was inadvertent. Jane and K. knew each other at Oxford, but they remained merely acquaintances, and she had become engaged to a mutual friend whose family lived in the villa next to I Tatti. When the friend, who was a journalist, found that he had to go to Egypt, he asked K. to take care of his fiancée. In a few weeks he received a cable to the effect that the caretaking had been so enjoyable, both had decided it should continue. It has, with mutual delight, for forty-six years. But the Clark's *coup de foudre* had a decisive effect on me. When their marriage took place, B. B. delivered one of his jeremiads, saying again and again that he had been betrayed, that K. should never have brought a wife to I Tatti. When K. at last felt that he had to depart, his "betrayal" left a vacancy which I filled.

K.'s relations with B. B. were always complex. They met through a mutual acquaintance, Charles Bell. When K. had just graduated from Oxford, Bell took him to Italy. It was the greatest educational experience of his life, he says. The trip began somewhat eccentrically. They did not first go to Florence, the usual stopping place for students, but to Bologna, where they studied the painters admired several generations ago but out of fashion in the twenties, Guido Reni, Domenichino, the Carracci, Guercino and the rest. Bell was always ill, but at last he was well enough to continue on to Florence. While he lay in bed he told K. where to sightsee, and when he returned in the evening, he had to describe what he had seen. After covering the major works of art in Florence, he was sent to Umbria and again had to report on everything he looked at. It was a marvelous training. Like Francis Watson and John Pope-Hennessy, K. has reservations about art history as an academic discipline, at least at the undergraduate level; and the education he received from Charles Bell, which was really self-instruction, was, he feels, incomparably better than any courses which might have led him to some graduate degree.

Finally Bell got himself off his bed of pain to take his pupil to I Tatti. K. was far from charmed by B. B., who was not, as he puts it, at his nicest. After the usual I Tatti lunch and half-an-hour talk in the loggia overlooking the garden, B. B. said goodbye. He was motoring by slow stages to Vienna. K. accompanied him to his car, where Perry was on the box, with Elizabeth, the Berenson's maid-valet, beside him, and

Mary already wrapped in rugs seated in the back. As B. B. was about to step into the ancient Lancia, he turned to K. and said, "My dear boy, I am very impulsive. I would like you to come and live with us and help me with the new edition of my *Florentine Drawings*." K. was stunned, and B. B. drove off.

K.'s family were less than enthusiastic about the venture, and he took several months to come to a decision. Finally he wrote accepting the proposal and received a conclusive reply, not from B. B. but from Mary Berenson, whose role in their strange partnership was usually to manage her husband's human commitments. K. never knew, as B. B. later told me, that during their lunch together he was preoccupied with the decision of whether to select K. or Hyatt Mayor, subsequently curator of prints at the Metropolitan Museum, to be his assistant. Had he chosen Hyatt I probably would never have reached I Tatti.

Hyatt would, I believe, have proved to be the same docile disciple that I was, and he might have remained indefinitely. But K. already knew that he had a career as a writer in front of him, and though he gave B. B. a certain amount of his time, he was anxious to get on with his own books. This B. B. resented; but K.'s brilliance made up for his deficiencies as a devoted apprentice; and when he left, B. B.'s jeremiad came from the heart. Yet, as K. has told me, for many years they were never completely at ease together. It surprises me that these two people with whom I have always been so relaxed and so completely in sympathy were often uncomfortable in each other's company.

B. B.'s attitude has also been for K. a constant puzzlement. I have a letter in which K. writes at some length about their curiously ambivalent relationship. "After 1938 I believed myself to be on comfortable and affectionate terms with B. B., and after the war he behaved to me with the utmost kindness and sympathy. It was only later on that I discovered to my surprise that B. B. did not really like me much. A perceptive friend of mine, who looked up my name in the index of *Sunset and Twilight*, said to me, 'Good heavens! How Mr. Berenson disliked you!' It was a great shock, and it proves how sweet he was, that he never let me feel it when I was in his company."

Once K. was married, life at I Tatti proved impossible, and after a few months he returned to England and settled at Richmond. The Clarks became immediately one of the most popular couples of their generation. At one time they went out so much that Jane is said to have remarked that her tiara was wearing out. She was always beautifully dressed, one of the chicest women in London, and with her black hair

and blue eyes, she was a joy to look at. But even in their most social period, K. was never distracted from his serious scholarship. He took the train each morning to Windsor where he worked happily at his catalogue of Leonardo drawings. When in 1931 he was asked to replace Bell as the director of the Ashmolean Museum at Oxford, he accepted reluctantly and he now thinks foolishly. His acceptance was motivated in part by filial piety. It used to embarrass his mother, he says, when people asked her, "What does your son *do*, Mrs. Clark?" and she would have to reply, "He is a writer," which was almost as shaming as to say, "He is an actor." Much better to be able to describe him as a museum director, a humble occupation but at least a definite job.

K. was always being torn from his real vocation, writing, to positions of administration. After only three years running the Ashmolean Museum, which was not much harder to look after than one's private collection, the trustees of the National Gallery asked him to become director. He should never have accepted the offer, he now thinks. He certainly would not have agreed to take on the job if he had known what an awful turmoil was going on. The directorship of a museum requires less knowledge of art, we both agree, than knowledge of how to deal with human beings. He took on a difficult assignment at the age of thirty, and, without sufficient experience, as he says himself, got into terrible trouble.

The difficulty was with his staff. K., they admitted, was brilliant, but he was very young and they thought unduly arrogant. He lacked in their opinion a certain human worth. He has always found it difficult to put people at their ease, and his subordinates felt he looked down on them. As a matter of fact, this was true. He delegated responsibility reluctantly and when he did, often expressed his disapproval of the result. All this, he acknowledges with humility, was wrong, and in the end aroused the hostility of his staff, who then proceeded to make his life miserable.

They reacted like small children, and as children will do, sent him "to Coventry." They would not listen to him and they would not speak to him. They kept their offices locked and refused to let him enter. They did everything possible to be frustrating. Things got so bad that he called the staff together and asked what they thought the function of the director *was?* Didn't they agree that it was his job to get good pictures? Wasn't that exactly what he had done, and with the most meager assets: £8,000 a year from the government, a small trust fund, and some assistance from the National Arts Collection Fund? With such limited

Peter Paul Rubens, *The Watering Place*. One of the great paintings bought for the British National Gallery by Kenneth Clark with the most meager funds. Reproduced by courtesy of the trustees, The Tate Gallery, London.

resources he had bought the six Mackay Sassettas, the six Morgan Giovanni di Paolos, Ingres' *Mme. Moitessier*, Rubens' *The Watering Place*, and other masterpieces. He had to buy cheaply. One of the most splendid examples of Mannerism, now ascribed to Niccolò dell' Abbate, cost £300.

His colleagues, antagonistic as they were, could not refute him, but they bided their time and waited for his foot to slip. It did when he was tempted by four small panels of the Venetian School. To get help from the National Arts Collection Fund for their purchase, he had to agree to exhibit them as by Giorgione. He did not believe in the attribution himself, but he was enthralled by the poetic beauty of the paintings, and he wanted them for the National Gallery at all costs. It was a dreadful mistake, for he played into the hands of his critics. As soon as the purchase was made, they pointed out that the pictures were certainly not by the master but probably by some minor follower like

Previtali. They are paintings that I find enchanting under any attribution, and that I would love to have for the National Gallery of Art in Washington. The moment K. retired, these jewels of Giorgione's School were relegated to storage and have never been returned to the main galleries. Given the high opinion I have of the pictures, and this is my particular field of study, I feel there is something vindictive in their continued demotion.

The root of K.'s trouble, however, was not his aloofness, but a continuation of the split between trustees and employees. Lord Lee of Fareham, the former chairman, had always treated the staff in an imperious manner, and their enmity had become enormous. Charles Holmes, when director, was their leader and principal advocate. He had fought Lord Lee until ultimately a new chairman was appointed in his place. But Holmes soon resigned, and the prime minister chose as his successor A. M. Daniel, who had himself been a trustee. The breach, however, remained, for by then the staff had come to consider themselves members of a trade union and had begun to look on the board as their oppressive bosses. They became more bitter than ever when the director, their spokesman, was chosen from among their overlords. Daniel lasted only a few years, but he left the gallery in chaos. He was replaced by K. The staff at first were pleased. They were to be run by a professional, and therefore, they thought, someone from the "union." But they soon decided that K., who was rich and a personal friend of the trustees, was after all the board's man, and they concluded they were no better off. Then they vented all their rancor on him. His apostasy, in their opinion, was intolerable.

It is true that K.'s relations with his trustees were excellent. He spoke their language and shared their way of life. Being wealthy, they looked on him as one of themselves. Most of them could be counted on to back his every decision. Nevertheless, there was one trustee who caused some trouble, one solitary dissident, Lord Duveen of Millbank, as he had become. The recently created peer was popular with the other trustees. He amused them, clowned for them, and made them laugh. But he was also very influential, as K. had to recognize. His hold on some of his colleagues was based on more than buffoonery.

I once gained from B. B. an insight into the source of Duveen's influence. I had brought to I Tatti photographs of the Mellon Collection. Among them was an altarpiece by Cima da Conegliano. B. B. pointed out that it was an inferior painting considerably below the high standard of the rest of the Mellon Collection. A mechanical perfor-

Scenes from an eclogue of Tebaldeo, ascribed to Previtali. Kenneth Clark's foot slipped. Reproduced by courtesy of the trustees, The National Gallery, London.

mance, it was also a wreck, as anyone can see today who looks at it in
Washington. He told me how he had tried his best to persuade Duveen
not to buy it, and when the purchase was insisted on, placed a low but
fair value on the picture. To his amazement his valuation was disre-
garded and a much larger sum paid. The owner of the painting was the
Viscount d'Abernon, a life-trustee of the National Gallery in London, a
former ambassador, and in the eyes of the British government a
prestigious personality. At that time Duveen was plain "Sir Joseph." A
peerage was highly desirable.

Duveen's favors to other trustees of the British National Gallery were
extensive, and made him firm friends. There was no harm in these
friendships, but his colleagues must have felt that it was ethically
wrong to have an art dealer on the board deciding on the purchase of
works of art. Conflicts of interest were bound to occur. K. told me for
example about the problem of the acquisition of the Mackay Sassettas.
The National Gallery trustees, at K.'s insistence, decided to make an
offer. A letter conveying the offer was duly sent, but no reply was
received. Knowing that Duveen was acting for Mackay, his colleagues
on the board asked him why there had been no response. He answered
that he considered the offer too low and had not presented it to Mackay.
Eventually the paintings were purchased, but Duveen had a double
conflict of interest, toward the National Gallery and toward his client.

I knew that Neville Chamberlain when prime minister had not
reappointed Duveen a trustee, which was perhaps the saddest disap-
pointment of his life, and I asked K. for the explanation. It involved, he
said, our mutual friend, Calouste Gulbenkian. In 1934 Gulbenkian had
asked K. to see his collection in the Avenue d'Iéna. Shortly after he had
received K.'s appreciative comments, he phoned London and said that if
the National Gallery wanted some of the paintings on loan he would be
delighted to cooperate. Thirty pictures duly arrived, enough to fill a
small room with masterpieces of the highest quality. These were the
pictures I saw, which whetted my appetite to get the collection for
Washington.

During the next two years Calouste Gulbenkian decided that, if the
Ministry of Works would grant the land adjacent to the National
Gallery, which they were prepared to do, he would build a museum for
his whole collection and dedicate a great part of his fortune to the
endowment of his gallery and to other purposes beneficial to Great
Britain.

He made, however, a condition, but one that was reasonable and not

difficult to fulfill. It was that no art dealer should sit on the board of trustees of the National Gallery. K. went to Neville Chamberlain and explained the vast sums of money involved and the great works of art which might come to London. He urged the prime minister not to reappoint Lord Duveen, whose term as a trustee had come to an end. Mr. Chamberlain immediately telephoned New York and broke the news to the dealer — a reverse which rankled during the remaining years of his life.

When K. retired as director, the Gulbenkian donation, which had been interrupted by the war, was still being considered. But for various reasons, some of which I have explained in the chapter on Gulbenkian, and others which cannot be disclosed, the concept of a Gulbenkian Gallery in Trafalgar Square was abandoned. All that came of K.'s activities was Duveen's disappearance from the board.

When the war was over, and the National Gallery reinstalled, K. retired. He wanted to devote himself to writing and to scholarship. Over the years he has produced a number of books which, unlike the ephemeral products of most art historians, will be read for a long time to come. Apart from the catalogue of the Windsor Leonardo drawings which I have mentioned, the most important are: *Leonardo da Vinci*, published in 1939; *Leon Battista Alberti on Painting* in 1944; *Constable's Hay Wain* in 1944; *Landscape into Art*, in 1949; *Piero della Francesca* in 1951; *Moments of Vision*, 1954; *The Nude* in 1955; *Looking* in 1960; *Rembrandt and the Italian Renaissance* in 1966; *Civilisation* in 1969; and most recently *The Romantic Rebellion*.

But he also engaged again in administrative work. He became the first chairman of ITV, the British commercial television system. He imposed standards on independent television in the United Kingdom, which are still observed and which make it, in my opinion, much superior to CBS, NBC, or ABC. When he became chairman of the British Arts Council, besides the patronage he directed toward painters and sculptors, he was instrumental in establishing Covent Garden as a great center of opera.

Because of his professional experience he has also been in many ways the most influential trustee of the British Museum. In this connection I discussed with him the role he felt museums should play in the modern world. I was surprised to find that he divides them into two categories, one epitomized by the British National Gallery and the other by the British Museum. The National Gallery exists to give visual pleasure, he said; the British Museum to give visual documentation of the history of

man. In the National Gallery aesthetic judgment is basic in the selection of the works to be exhibited; in the British Museum, wherever man has projected himself most successfully, wherever he has done his best, is shown — aesthetic significance is secondary. Galleries exist to give people a peculiar enjoyment which they can only get from works of art; and if they can relate these joys to history their delight will increase and endure. Therefore there is an interrelation between aesthetic pleasure and history. This is also true of the British Museum, but its objective is larger. It is nothing less than to give as completely as possible the visual spectrum of man's spiritual life.

There is nothing in the United States comparable to the British Museum, but then it is, as far as I know, unique in the world. Our comprehensive museums are different. Their collections are based on aesthetic considerations, and within this framework much that they have assembled is superlative. Among these large municipal museums, K. particularly admires the Metropolitan. In recent years it has, he feels, lost its sense of direction and has been floundering like a badly sailed boat. This, however, is temporary, and when it gets back on course it will regain the admiration of us all. If only the money to be spent for expansion were to be used to make the present building a more beautiful setting for its treasures, it could become the ideal museum, in K.'s opinion, a judgment with which I entirely agree.

K.'s life has been a long series of triumphs: twice Slade Professor at Oxford, Chancellor of York University, Member of the French Academy, honorary degrees from Oxford and Cambridge, et cetera, a career anyone might be proud of. K. is appreciative of these honors, but on the whole he does not greatly value his achievements. His well-deserved peerage, one would think, might have provided unalloyed satisfaction. Not at all. When he was offered a title it took Harold Wilson's considerable persuasive powers to get him to accept it. Now he wishes he had been firmer. I was surprised at his reluctance to become a peer, but he told me his father would not have accepted a peerage "at the end of a barge pole," to use his words. K. inherited the same attitude, which he traces to the enormous pride of the old English industrialists. I suppose he is right. If peerages existed in the United States, I am sure my grandfather would have refused to accept one.

On a recent trip to America K. was awarded a medal by the National Gallery of Art. I was out of town at the time, but I was told that the vast halls and the rotunda of the Gallery were packed with vociferous admirers, eager to shake his hand or even touch him. After the cere-

mony my wife asked K. his impression of this frenzied enthusiasm. Delighted as he was to receive the award, he said, the furor and the mass hysteria were distressing. He added, "I am deeply touched by the appreciation of simple people, many of whom say the most moving things to me, but one has to be a politician, a saint, or a pop star to put up with such an experience."

And K. has none of the characteristics of such public figures. His happiness has come instead from his increasing withdrawal to a small cottage he has built in the shadow of the walls of Saltwood. There he has surrounded himself with the many works of art he has retained and with his library, part of which is in the castle and part in his new house. He goes to London once a week, and spends a night in his chambers in Albany. Otherwise he and Jane live a retired life, which gives him the satisfaction nothing else has produced.

Recently he wrote me, "The thing that gives me, and always gave me, the most happiness in life is writing. As Emerson said, 'the mind celebrates a little triumph every time it formulates a thought.' I had one yesterday and it cheered me up all day."

14

Summing Up

Looking back over thirty years of my own work at the National Gallery of Art, I have been trying to understand why American museums are today in a state of crisis. The outward manifestation of their predicament is the firing or resignation of many of my colleagues, those unfortunate directors who could not carry out their first obligation, to work with their trustees. But the inner explanation for the failure of these able men is, I believe, a lack of conviction, an uncertainty about the basic purpose of art museums. It is impossible to persuade others that you are running an institution successfully if you are not sure yourself what you are trying to do.

As the previous chapter shows, my English colleagues have no doubt about the objectives of the museums they direct or have directed. But this is less true in America. The dubiosity of museum directors in this country is revealed by a favorite cliché of speech-makers, "museums in transition" — ambiguous yet vaguely alarming words! Let us try and see what they are in transition from. As private institutions, art

museums are roughly four hundred years old; as public institutions, they date from the French Revolution. They can trace their ancestry to the *Kunst* or *Wunder-Kabinets* which flourished especially in Teutonic countries. The German nobles were collectors of oddities: the horn of the unicorn, highly carved and ornamented rock crystals, elaborately set jewels, as well as various phenomena of natural history. Their descendants were more sophisticated. They assembled those princely private collections which form the basis of the Louvre, the Kunsthistorisches Museum in Vienna, the Mauritshuis, the Hermitage, the Prado. They gave no thought to public benefit. A prince happened to be a lover of art, and he simply wanted to get the best. This tradition has continued, and European museums are based on the idea of exhibiting the masterpiece, irrespective of whether it is representative or educative or anything else. Such an attitude was so firmly ingrained in European thinking that when the Kaiser Friedrich Museum was started from scratch at the end of the nineteenth century, the collection was chosen on similar principles. The National Gallery in London, founded at the beginning of the same century, was also intended to be like one of the princely museums; but Eastlake, its director during its formative period, with extraordinary foresight and marvelous range of appreciation, got his trustees to buy religious paintings and primitives, mostly of the Italian schools, a type of art previously neglected.

The point of view of European princes, with something of the catholicity of Eastlake, was adopted by American millionaire collectors: Frick, the Wideners, Morgan, Altman, Mellon, and others. The collections they formed were to be of masterpieces. But unlike their princely precursors, what they assembled was intended to go into public museums. Patriotism and popular availability, they thought, would justify their vast expenditures. If the poor, the underprivileged, the "ethnic minorities" stayed away, it was not their concern. In their opinion the museum's obligations ended with the display of beautiful works of art. This attitude in relation to the public still prevails in Europe; yet at the great European art galleries attendance, generally paid, is about equal to attendance, generally free, at the large museums in America. This I find extremely significant. It is proof that myriads of people not only want to look at masterpieces, but are willing to pay to do so. They need no extraneous inducements.

Until recently the directors of European and American museums have had the same basic philosophy. Their primary interest has been the acquisition of masterpieces, a traditional objective. But in recent

years a number of very vocal people, some of them museum profes-
sionals, others artists and critics, have claimed that art museums are out
of touch with the social forces of our time. These forces, they believe,
require museums to be "in transition" — transition to what they have
never precisely stated.

From a good deal of rhetoric, however, it appears that they want
museums to "relate," a favorite word, to more people, to be "democra-
tized" in some way not entirely clear. A typical spokesman for this
point of view is Leo F. Twigg, a black professor who, according to the
New York Times, believes that the young, "having cut their teeth on
psychedelic paraphernalia and light shows . . . perceive in a new and
different way from generations before them. . . . They are not simply
content to stand and look at works of art; they want art they can
participate in." The National Gallery has always been filled with
young people, sometimes with their babies on their backs, sometimes
pushing them in strollers. My impression from watching them is that
they are absorbed in looking at works of art, and that they have no
desire for "art they can participate in," whatever that means. But some
American museum directors have been impressed by this attack on the
value of the masterpiece. They have lost their belief in its power to give
satisfaction and joy.

There are institutions involved in the arts with obvious social obliga-
tions and responsibilities. This is self-evident with history museums and
also with art centers, which in America far outnumber art museums.
They are the logical places to cater to our ethnic groups and to display
our complex heritage with all its blended and unblended minorities.
They should be the organs of their communities, and their governing
boards should be composed of the people of that locality without regard
to wealth or position. The Anacostia Museum in Washington is a suc-
cessful example of what I mean. Its role in a poor community has been
widely acclaimed, and it has received enthusiastic support.

But it does not follow from this that all museums should be related to
community interests, that all should focus on minorities, on the dis-
advantaged and the less well-educated. Some museums should exist for
that vast audience of cultured and culturally aspiring people, who have
rights as well. They are the elite, to use again that unpopular word, and
we are fortunate that they are so numerous. They should not be denied
the pleasure of contemplating works of art, of communing privately
with a favorite painting or piece of sculpture. I spoke of the pleasure
and enlightenment Dr. Miller had received from Rembrandt's *Self-*

Portrait (page 123). The chance for serenity of contemplation is of consequence. The Dr. Millers of this world must have an opportunity to reflect on noble works of art without distraction. It is the duty of museums to see that this is possible. Museums do not exist solely for the noise and turmoil of hordes of schoolchildren!

Dr. Miller and his like are ubiquitous, and in many small towns in America they have built, or been responsible for building, beautiful art galleries. But to find the beautiful works of art to display in their handsome buildings is the difficulty. Meanwhile the opulent museums in our larger cities have storage rooms bulging with treasures. To my astonishment the consciences of curators and directors seem untroubled by this appalling fact, by this indefensible waste. For it is obvious that a painting or a piece of sculpture in a vault is a work of art which is not being put to use.

When I was director of the National Gallery I asked the heads of a number of smaller museums to come to Washington and borrow from our storage whatever would enrich their collections. We lent them a certain number of Old Masters of various European schools — a group of pictures was even designated for that purpose — but available resources for loan were greater in the American section. Though this part of the collection was relatively small when the Gallery opened, subsequently much of the purchasing fund went to its augmentation, for it seemed advisable to buy American paintings while they were still inexpensive. Also, bequests and gifts in this field have been exceptionally rich. Consequently the collection now has thirty-three Gilbert Stuarts, ten Copleys, sixteen Sullys, more than eighty American Primitives, and many Homers, Eakinses, Cassatts, Whistlers, Sargents, Bellows, and Henris, et cetera. But it has always seemed to me important to maintain a proportionate relationship between the painters of our native school and those of other schools. With more than we could show, I was delighted to be able to make our overabundance of American painting available elsewhere. This we have done repeatedly through long-term loans. Such loans should not be confused with temporary exhibition loans, which, as I have said, often result in damage to works of art, and have now reached a frequency I find alarming. But loans that improve the resources of needy small-town galleries are immensely beneficial and relatively safe.

My trustees backed my policy and even agreed insurance would not be required except in transit. Although they felt that the National Gallery was established to serve the public, they did not believe that

this service was to be measured by the number of people entering the building. Too many museum boards, on the other hand, have a fixation about attendance. To increase it they encourage and overfinance publicity departments, special exhibitions, moving picture shows, gadgets of every kind. More interested in quantity than quality, they count the spectators as though they were Broadway producers. The poor director then is expected to play the role of impresario, and if need be to paper the house with a captive audience of schoolchildren.

Under such circumstances I am in favor of falsifying attendance figures. This was the policy at the Metropolitan Museum for many years. When recently the trustees became skeptical and demanded a more accurate count, attendance shrank from over six million to under three million. But I look upon such cheating as harmless. The ghosts which museum guards, clicking away at the entrance, enthusiastically tally disturb no one and leave the galleries vacant for those who can enjoy works of art. When I became director of the National Gallery I found that we had been indulging in the same misrepresentation. I foolishly stopped it; and when I had to ask Congress for my annual appropriation my budget deservedly became more difficult to defend. But even so my requests were always met, and I found that it was unnecessary to try to justify operational costs by the number of visitors served.

The desire to bring more people into the museum appeared briefly in England. Kenneth Clark recalls a meeting of the board of the British National Gallery at which a trustee asked why the attendance at the gallery should not equal that at the Science Museum in South Kensington. K. answered that if the trustees would allow him to devise a mechanism for *Bacchus and Ariadne*, so that in Titian's masterpiece Bacchus actually pursued Ariadne, he would produce an even larger number of spectators. The matter was dropped, and so far as I know attendance at British museums is no longer a matter of interest.

Thus two of the problems of American museums can be easily overcome: faith in the efficacy of the masterpiece can be renewed, visitation can be ignored or falsified. But there remains a basic predicament. The cost of running a museum is increasing astronomically, and in some cases unbalanced budgets even menace survival. There is a perilous lack of money, which trustees must face.

If unlimited funds were indeed available, I would recommend tearing down our present museum facilities and replacing them with pavilions in a park, some large, some small, each pavilion devoted to one aspect of

artistic achievement. Such a park would be a joy to visit. It would be filled with a complex of buildings, none larger than the Frick or the Freer, two galleries everyone agrees to be of perfect size. But this is an ideal solution. We must accept what we have: monolithic institutions under one roof and one administration, and inevitably with insufficient endowment. Yet such small galleries as exist, usually established by one person: a Frick, a Freer, a Phillips, a Guggenheim, a Gardner, a Sterling Clark, are the ones most often mentioned when someone is asked to name his favorite art museum.

The large institutions are on the whole too impersonal to be loved. But love they can do without; money they cannot. And in the midst of their financial crisis it is amazing to be told that like lemmings intent on their own destruction, our major museums all have plans for further expansion. Even now they are monstrously big, and for economy most are forced on certain days to close in part or entirely. But their boards of trustees will not recognize that the colossal size of such edifices is self-defeating, that the law of diminishing returns becomes effective. They should realize that the visitor gets lost, overwhelmed, stultified. When the Metropolitan Museum, the Museum of Fine Arts in Boston, the Art Institute in Chicago, to mention only a few institutions with plans for extension, have completed their new wings, they will be just that much less attractive to the public. It is sad and ironical that even the Frick and the Freer, the perfect galleries as to size, intend to grow larger. Enormousness is a disease endemic among museums. How much wiser these institutions would be to distill, contract, and rotate their collections, and then to distribute to smaller museums what they have no room to exhibit!

As I write these words I beat my breast and say, "Mea culpa, mea culpa, mea maxima culpa." For it was I who proposed the enlargement of the National Gallery of Art. But museum directors are incorrigible. Once they begin spending Other People's Money they will never leave well enough alone.

Index

WITHDRAWN
7-PALISADES

**The Public Library
of the
District of Columbia**

Washington, D.C.

Theft or mutilation
is punishable by law

P.L. 117 revised